THE
BRONX
RIVER IN
HISTORY & FOLKLORE

Stephen Paul DeVillo

The
History
PRESS

Published by The History Press
Charleston, SC 29403
www.historypress.net

Copyright © 2015 by Stephen Paul DeVillo
All rights reserved

First published 2015

ISBN 978.1.54021.380.8

Library of Congress Control Number: 2014959986

This book is respectfully dedicated to my grandfather Ray Augustus Edwards, with whom I first explored the Bronx River.

CONTENTS

Preface	7
Acknowledgements	9
Introduction: A River Journey	15
1. Aquahung	31
2. Jonas the Peacemaker	40
3. The Beaver Does Everything	46
4. Vreedlandt	51
5. Battleground	57
6. Neutral Ground	63
7. Post Road	73
8. Bronx River Red	79
9. Jumpin' Jupiter!	86
10. My Own Romantic Bronx	94
11. Suburbs	102
12. L'Hermitage and French Charley	110
13. Baumgarten's Tapestries	116
14. Ryawa	123
15. Bronx Park	130
16. Movies on the Bronx	139
17. Starlight Park	145
18. Clason Point	154
19. The Mighty Kensico	160

Contents

20. Bronx Valley Sewer 167
21. Bronx River Parkway 174
22. Missing Links 184
23. Maligned River 190
24. Revitalization 198
25. A River Returns 207

Afterword: The Ultimate Bronx River Story 215
Appendix: Organizations and Websites 217
Notes 219
Bibliography 235
Index 245
About the Author 256

PREFACE

This book began with a boy walking along the Bronx River with his grandfather more than fifty years ago. Living in the northern Bronx, we often took our walks along a riverside ribbon of parkland left from a bypassed stretch of the old Bronx River Parkway. On one occasion, we spotted a lone man paddling a canoe down the Bronx River. Astonished at the sight, we agreed that we had never seen such an absurdity. Back then, people didn't *do* things such as paddle canoes in the Bronx River. Neglected and polluted as it was, people didn't go *near* the river, let alone paddle canoes in it. Yet there it was, running through what later became known as Shoelace Park but then was the geographic axis of a boy's childhood universe.

To my mind, though, the Bronx River wasn't really a river at all. Its name was only an empty grandiosity applied to a noisome flow of olive-colored water barely a lazy stone's toss wide. My six-year-old sensibility knew, from all the old black-and-white Tom Sawyer movies on TV, just what a real river was supposed to look like. A real river was the Mississippi, big and wide, with steamboats, towboats and ironclads; Mark Twain and Civil War battles; and tall tales and legendary characters—none of which was to be found on the lowly Bronx River.

The boy grew up, but he never left the Bronx River, and in time, he grew to learn that the Bronx River, in its own way, has *all* these things. It, too, has its legends and folklore, its history and battles and its authors, painters and poets who once walked along it—Edgar Allan Poe and Fenimore Cooper

and, yes, Mark Twain. The once skeptical boy today shares these things with equally dubious visitors and explains that the Bronx River has everything a true river is supposed to have. It has its own story; in fact, it has many stories to tell us, if we but pause to listen.

ACKNOWLEDGEMENTS

History is not a solitary pursuit, and I would like to take this opportunity to thank the many individuals and organizations that have generously and graciously contributed to the creation of this book.

I especially thank my grandfather Ray Augustus Edwards, who many years ago first introduced me to the Bronx River and to the wonders that history can reveal, with additional thanks to my grandmother Neta Edwards. I extend particular thanks to my mom, Patricia Edwards Clyne, who has given me much professional insight into the craft of research and writing and whose personal library of New York State history has been an invaluable resource. Thanks also to my dad, Francis Clyne, with whom I've shared many "rockhounding" expeditions that gave me a hands-on appreciation of the region's geology.

A note of appreciation goes to the official Bronx historian, Lloyd Ultan, who has mentored more than one generation of Bronx historians, and to Angel Hernandez, educator at the Bronx County Historical Society, who together with Professor Ultan and Gary "Doc" Hermalyn promotes the awareness of the Bronx as an interesting and special place. In addition, I am grateful to Laura Tosi, librarian of the Bronx County Historical Society, for access to its vertical files, which have been a treasure-trove of information. Thanks also to the New York City Department of Parks & Recreation and Westchester County Parks for maintaining and expanding the river's accessibility.

A note of appreciation goes to the New York Public Library, New York University's Bobst Library, the Yonkers Library, the Eastchester Historical

Society, the Westchester County Historical Society, the White Plains Historical Society and the Yonkers Historical Society. To the members of the Mount Pleasant Historical Society, I want to say that I enjoyed your company on the Kensico Dam walking tour, and I learned a lot from you all that day.

Tremendous thanks are due to the corps of Bronx historians of the East Bronx History Forum, who have been more than generous in sharing their knowledge, insights and research discoveries with me in the course of writing this book. The conviviality I've found at the forum's monthly meetings at the old Huntington Library on Westchester Square encouraged me to pursue this project, and I extend particular thanks to the following individuals for their contributions.

The support and enthusiasm of the late Bill Twomey will be dearly missed, along with his weekly history column in the *Bronx Times* that never ceased to turn up new surprises. Tom Casey and Tom Vasti have given me much valuable research, and their awesome collections of old-time Bronx postcards have often proven valuable documentation of things that are no longer there. Fellow Bronx River Rambler Hank Stroobants, Woodlawn and Wakefield historian, has given me his invaluable friendship and support and with Mike Gupta has taught me a lot of things I never knew about my old neighborhood on the river. Jorge Santiago deserves special credit for freely sharing his many historical discoveries. Nicholas Di Brino, historian of Morris Park, has generously shared his research, insights and recollections as someone intimately familiar with the Bronx, both "back in the day" and now. The invaluable map he provided of old West Farms was especially helpful in sorting out the history of what might otherwise have been an indecipherable palimpsest of layered urban development. The late Morgan Powell made his brilliant research available through his Bronx River Sankofa website, and his memorable walking tours brought to life the river's African American community history. Thanks also to Nick Vitale and to Peter Ostrander of the Kingsbridge Historical Society, who has shared his knowledge of the area's Revolutionary War history. Rich Vitacco has worked to preserve and present the history of Van Nest and Morris Park and, moreover, has taken the lead to restore the respectful commemoration of the community's fallen veterans. Bob Apuzzo, aboard the restored tugboat *The Bronx*, has done much to recall and preserve the river's maritime heritage, and his research into the lost frigate *Hussar* has breathed new life into an old legend. Anthony Pisciotta has energetically salvaged many artifacts of Bronx history that might otherwise been lost, and his acquisitions have often been fascinating

stories in themselves. Nilka Martell has shared her enthusiasm for the Bronx River in her articles in the *Bronx Free Press*. Chuck Vasser has given me many environmental and historical insights and, as founder of the Butterfly Project, has made a special contribution to the river's revitalization. A special salute goes to Toby Liederman, Violet Smith and Giles and Eleanor Rae, whose own Hutchinson River Restoration Project is undertaking the daunting task of revitalizing a river that, like its sister the Bronx, has suffered much environmental abuse.

I likewise extend my gratitude to a number of additional individuals who have helped advance this project, including the following.

It was a special pleasure to have met Ruth Anderberg, who shared her recollections of the early days of the Bronx River Restoration with me as part of a StoryCorps oral history project. Damian Griffin's environmental knowledge of the river helped make this book possible and, together with master canoe guide Josue Garcia, gave me a priceless midstream perspective, along with all the good times we had paddling the river's Bronx reaches. I've enjoyed sharing notes about the river's early industrial history with fellow Bronx River historian Maarten de Kadt. Our discussion many years ago regarding the question of when the first milldams were built on the river helped germinate the idea for this book. Evan T. Pritchard shared his knowledge of the Native Americans of the New York area and gave insights that helped me untangle some complex historical issues. Pelham Town Historian Blake A. Bell has provided a lot of interesting detail on matters touching the east bank of the Bronx River. Howard Waldman has shared his knowledge of the history of his hometown of White Plains. Jane Williams lent her compositional talents to create an excellent author's photo.

I'm grateful to Richard Forliano, town historian of Eastchester, and the Tuckahoe History Committee for their hospitality in sharing their research and historical collections and for hosting one of our Bronx River Rambles. Gerry Segal and Dan Hamburg, hailing from my old neighborhood of Wakefield, have shared their childhood recollections. Gerry's song and video for "A Kid on the River" delightfully evokes a time when this then maligned river was nevertheless for us a place of adventure. Matt Malina of NYC H_2O shared with me his knowledge of the history of the New York City water supply. Bob and Hillea Ward introduced me to the importance of microinvertebrates, with the lesson that small creatures sometimes carry great import. Leslie Lannon, former director of development at the Bronx River Alliance, has given me much professional advice and support. Alongside her, I've gained a lot of interesting experience in organizing the Alliance's

Upstream Soirées, a series of enchanting riverside evenings featuring the music of the late Ibrahim Gonzalez, a true Bronx original.

Particular acknowledgement goes to Linda Cox, Maggie Greenfield, Ivan Braun, Penny Brown, Teresa Crimmins, Michelle Cropsey, Elaine Feliciano, Valerie Francis, Julia Hitz, Michael Hunter, Claudia Ibaven, Ken Kostel, Robin Kriesberg, Katie Lamboy, Macceau Médozile, Michael Mendez, Alex Nieves, Anne-Marie Runfola, Joseph Sanchez, Elizabeth (Alex) Severino, Martha Schwartz, Saudy Tejada, Michelle Williams and the past and present staff of the Bronx River Alliance for their work in revitalizing the river and building the Bronx River Greenway, as well as for sponsoring the Bronx River Rambles, which have done wonders for focusing my research and prompting me to explore new aspects of the river's history and folklore. I'm likewise grateful to the many people who have joined me on the Rambles over the years and made these explorations truly enjoyable. The Alliance also gave me the opportunity to produce the series of "Bronx River Stories" for its monthly e-newsletter, *Currents*, which in many instances have been the "first drafts" for parts of this book. It's been especially fun to share with friend and Alliance office-mate Maria Sawyer some of our more interesting Bronx River moments.

I extend thanks to Susan Olsen, Brian Sahd and Cristiana Pena of the Woodlawn Conservancy for hosting our explorations of Woodlawn Brook and to Jessica Arcate-Schuler and Elizabeth Ortiz of the New York Botanical Garden for hosting our Rambles through the Bronx River Gorge and for organizing the Thain Family Forest Weekends, which showcased this beautiful reach of the river and provided additional opportunities to share its wonders.

Gail Nathan and Karine Duteil of the Bronx River Art Center have brought a special artistic perspective to the river's revitalization, and BRAC's Teen Project Studio students made a West Farms Ramble a truly unique experience. It was a great pleasure to step aside from the Bronx's past for a few moments to introduce the Bronx's future.

A round of applause is due to the fourth and fifth graders at Hunts Point's PS 48 (the Joseph Rodman Drake School), who carried out the Hunts Point African American Burial Ground project. Led by educators Justin Czarka and Grace Binuya, with the support of Teaching American History project director Philip Panaritis, these enthusiastic young people have brought to light a long-swept-aside part of the river's community history.

A special shout-out goes to my neighbor Drew Mittigia and the students of Christodora for their volunteer work that has made the onetime jungle

of the Bronx River Forest into an example of what community stewardship can achieve. Credit also goes to Rocking the Boat, Youth Ministries for Peace and Justice, the Friends of Shoelace Park, the Friends of Starlight Park, the Friends of Soundview Park, the late Josie Burke and the Muskrateers and the Bronx River Parkway Reservation Conservancy and its indefatigable Vinecutters for their dedicated stewardship along the river.

Lastly, I extend special thanks to the men and women of the Bronx River Conservation Crew—past, present and future. Your dedicated labors have given us all a river worth writing about.

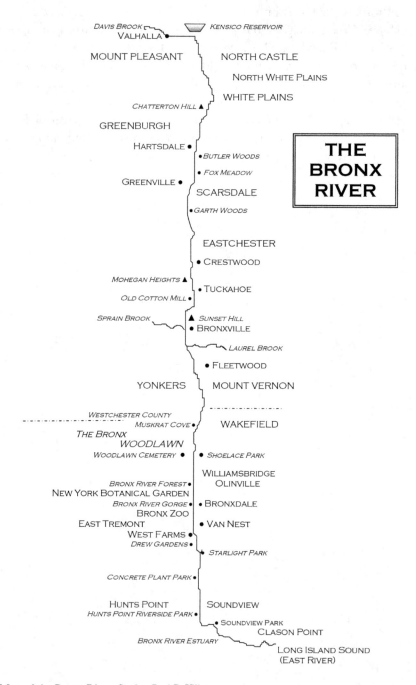

Map of the Bronx River. *Stephen Paul DeVillo.*

Introduction

A RIVER JOURNEY

New York City's only freshwater river, the twenty-three-mile-long Bronx River, flows down from Valhalla in Westchester County through the heart of the Bronx to Long Island Sound. As rivers go, it is a short one: a cyclist can traverse its length in an afternoon, and a sturdy walker can go from source to mouth in a couple of day trips. Yet in its brief length, it is a river of many contrasts.

It is both a very old river and a very young river, following a course as old as the dinosaurs or one carved by the melting glaciers. In some places, it is deep enough to float a barge, while in other places it's shallow enough to wade across. In its course, it flows past some of the wealthiest and poorest communities in the nation, wending its way through native forests, manicured suburban vistas and dense urban neighborhoods. It has suffered rampant pollution and industrial devastation, but in the very depths of its degradation, it inspired people to reclaim it.

People, of course, are relative newcomers to the Bronx River, but in the time that humans have lived along its banks, the Bronx River has served them in many ways. As a transportation corridor, the river and its valley provided a route for Native Americans, European pioneers, soldiers, raiders, spies, farmers, hunters, cattle drovers, bicyclers, canoeists, quarrymen and commuters.

One of the nation's earliest railroads thundered along its side, while barges, schooners and canalboats plied its lower reach. Native trails and some of the region's oldest roads crossed and followed the river's route, and eventually automobiles gained a scenic and speedy path through its level valley.

It has inspired poets, writers, storytellers, artists and historians and set the scene for novels and movies. It has witnessed both the joy of love and the bitterness of partisan conflict, served as a peaceable boundary between neighboring peoples and rimmed bloody battlefields. Industrialists used its ever-flowing waters as a source of power as well as a handy dumping ground, while its more scenic reaches were chosen for bucolic country estates and exclusive suburban enclaves.

It has seen the death of the hemlock, elm and chestnut; the revival of the buffalo; and the return of the beaver, osprey, river eel and alewife.

It was once a longer river, with turns and oxbows that increased its length still further, until the hand of humankind shortened its length and rechanneled its ancient curves to suit the convenience of those who gave the river little regard.

Our journey down the Bronx River begins at Kensico, where Davis Brook burbles down through the hamlet of Valhalla; ducks beneath train tracks, a parking lot and a parkway; and reemerges as the Bronx River. Davis Brook was once a mere tributary of the Bronx River, but since the Kensico Reservoir drowned the Bronx River's original sources, Davis Brook is now regarded as the official headwaters of the Bronx River. A metal sign affixed to a stone bridge in Valhalla proudly proclaims that fact to bemused passersby.

But the Bronx River's springs still flow beneath the calm waters of the sprawling Kensico Reservoir. The reservoir's southeastern lobe, today known as Rye Lake, covers the two spring-fed Rye Ponds that gave rise to the East Branch of the Bronx River, which joined the North Branch at the village of Kensico. The ornamental spillways of the Kensico Dam are no longer used, so these impounded waters, augmented by aqueducts from the Delaware watershed and Catskill Mountains, now have no outlet except through someone's faucet. In every glass a New Yorker draws from the tap, there are a few drops of the Bronx River.

A broad green plaza covers the place below the dam where the Bronx River once flowed south from Kensico Village. Finished just a few months before the Ashoken Dam in 1915, the Kensico barely missed winning the Ashoken's title of the "last of the handmade dams." And "handmade" is no exaggeration. The granite blocks of the dam's façade tell of the brutal work that went into its creation, a story inscribed in the stones' drill marks. Poured concrete would soon after become the standard for dam construction, and so the immigrant stonemasons and quarrymen who built the Kensico would fade into another half-forgotten river story.

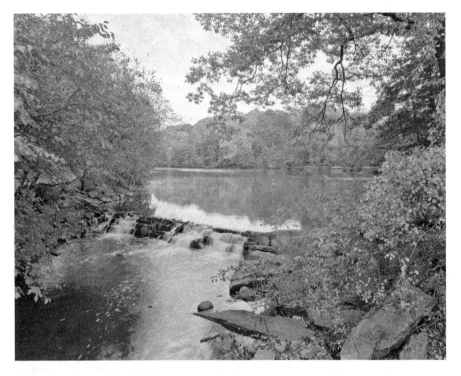

With its low ornamental dam, Bronxville Lake is one of the scenic spots on the Bronx River Pathway. *Library of Congress.*

More than the Bronx River's original sources were lost beneath the reservoir. Part of its human history was lost here, too. The church bell of the drowned village of Kensico is still said to be heard ringing on quiet Sunday mornings beneath the waters of the reservoir, as if in stubborn protest against the taking of its parish by a thirsty city. Lost, too, was the Bowery, the workers' camp that once clustered at the dam site and was, like its ill-regarded inhabitants, dispersed to oblivion once the job was done.

There is a monument to the lost village of Kensico on Route 22 about two miles above the dam; otherwise, it lives on in the memories of the grandchildren of the displaced villagers, and some resentment lingers here still. But while the reservoir's waters covered all trace of Kensico village, the Bronx River's original course is still traced by the seemingly unnecessarily crooked boundary between the towns of North Castle and Mount Pleasant that runs up the middle of the reservoir. Political boundaries sometimes outlast the rivers that once defined them, and the old Bronx River has left its ghost on the map in other places, too.

The Bronx River Parkway also sets forth here. It was opened just ten years after the dam was finished, and a marble plaque tells a triumphant story in terms of buildings removed, factories demolished and land cleared. One wonders what human loss these clearances occasioned, and there's a temptation to scoff at the plaque's claim of "the Bronx River cleared of pollution," until one learns just how bad things were on the river before the Parkway was built.

The Parkway, or rather the Bronx River Parkway Reservation through which it runs, was planned as a buffer to preserve the Bronx River by keeping factories and backyard latrines at a safe remove. The Parkway has long outgrown its original purpose as a leisure time drive way, but the Reservation's pathway will still take the walker or bicycler all the way from Kensico to Bronxville.

Following that pathway, the walker heads down the river from Kensico toward White Plains, through the freshwater marshlands around Dead Man's Lake. These peaceful marshes belie the gruesome Revolutionary War legend that gave the spot its name, and likewise they belie the fact that the river here is running through a narrow corridor between the Parkway and the old New York Central (now Metro North) Railroad.

For most of its Westchester length, the Bronx River is more easily viewed from land than by water. An intrepid canoeist or kayaker can make his way down the whole length of the river and find deep water in places, but the many shallow stretches will require some heroic portaging. Such full-river canoe trips have been done over the years, but not very often. It is thought that the building of the Kensico Dam cut the river's flow by as much as a quarter, but some say that storm water runoff from an increasingly built-up Westchester County makes up for the deficit, though at the cost of trading contaminated runoff for spring-fed water.

South of Dead Man's Lake, the river played a central role in the Battle of White Plains, where Hessians stormed across the river to attack American forces on Chatterton Hill. A monument to the battle sits alongside the Parkway just below Main Street in White Plains, just north of the spot where the river slowed the Hessian momentum enough to turn an easy assault into an indecisive victory.

At White Plains, the river is joined by two of its tributaries. Tompkins Brook trickles down from Reservoir #2 and ducks under the Metro North tracks to join the Bronx just above the White Plains Rural Cemetery. Once known as Great Brook or Long Meadow Brook, Tompkins Brook has known better days.

Another stream, confusingly also called Davis Brook (formerly Golden Pine Brook), joins the Bronx just opposite the White Plains Metro North Station, where one can gaze down from the platform and look for errant oil spills while waiting for a southbound train. Flowing down from urban areas, the Bronx River's tributaries sometimes add more than water to the river.

South of White Plains, the route becomes more scenic, as the river makes its way down to Hartsdale, passing the dramatic rise of ground known as the Rocks of Scilly, so named by a homesick preacher from Cornwall. Hartsdale today is a quiet suburban village, but the river's flow here, augmented by the waters of Hart's Brook, once made it an industrial center. The path winds along an old millpond that once powered one of several gunpowder mills along the Bronx River. This one blew up in a spectacular explosion in 1847, a reminder that the Bronx River's water-powered industry was not always a benign or picturesque affair.

South of Hartsdale, the narrowing valley leaves no room for a footpath among the river, road and train tracks, so the landward explorer must either proceed down the lonesome Pipeline Road or turn east on Fenimore

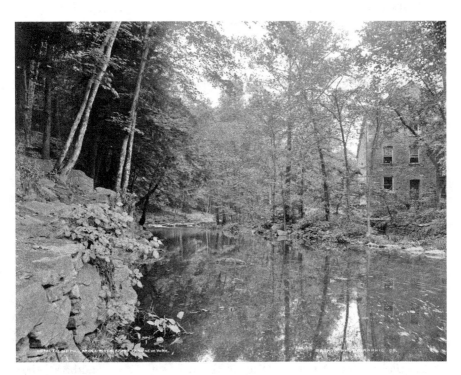

The Bronx River Gorge and the Stone Mill sit amid the native forest in the New York Botanical Garden. *Library of Congress.*

Road to continue down the other side of the river. Here is a clue to part of the river's artistic heritage: Fenimore Road recalls the young James Fenimore Cooper, who was inspired here by a dark chapter of the Bronx River's history to write a novel that launched his literary career.

From Fenimore Road, the route turns south down Fox Meadow Road. Although out of sight of the river for the next mile and a half, Fox Meadow is a more pleasant route than the gloomy Pipeline Road; along it rises a series of magnificent suburban houses that leaves you in no doubt that you are entering Scarsdale, one of the most affluent communities on the East Coast. Named for the foxes that once abounded in these rolling fields, the only foxes found here today are in people's coat closets.

Along the way, there is a preserved piece of the river's forests in Butler Woods, where Fox Meadow Brook flows down to the Bronx River. Shaded by century-old beech trees, this six-acre patch is a pleasant stopover, but you cannot see the river from it—the view is cut off by the Bronx River Parkway, beneath which the tributary ducks through a dark culvert. Butler Woods was donated to the Bronx River Parkway Reservation by the family that owned all of the Fox Meadow. Emily Butler's generosity was good business, too. The Parkway and the sylvan Reservation that surrounded it suddenly made Fox Meadow both accessible and desirable, and so the remainder of the Butler estate was profitably sold and developed. In the 1920s, picnickers could easily cross the Parkway from Butler Woods to eat their brie by the riverbank, but today, traffic and concrete safety barriers make that impossible, and the scenic Butler Woods is little used.

Leaving Fox Meadow behind, one regains the river, and the pathway, at the Scarsdale train station. A bronze plaque on a glacial boulder here memorializes the builders of the Bronx River Parkway, which reshaped the river and made places such as Scarsdale into wealthy commuter suburbs. The visionaries listed on the plaque include the controversial Madison Grant, whose unfortunate social opinions are today but a dimly remembered footnote to the river's history.

But this is no place for dim footnotes. A dam and millpond here make for a pretty waterfall and an entrée to the Garth Woods, one of the more scenic stretches of the pathway. It is said that this pond was originally a beaver pond, and colonial entrepreneurs simply expanded on the work of these engineering rodents to harness the river for their own devices. Crossing over a rustic wooden bridge, a legacy of the early Parkway Reservation, the pathway enters the Garth Woods.

Listed as one of "America's Ancient Forests" by no less an authority than the Sierra Club, the Garth Woods are a preserved remnant of the hardwood

forests that once lined the Bronx River Valley. Crossing and re-crossing the winding river, the pathway leads the walker through a wonderland of hickory and tulip trees, all the more remarkable for the fact that it lies within view of both the Parkway and the apartment houses of Scarsdale.

Leaving Garth Woods, the river follows a smooth, straight course down through Crestwood to Tuckahoe. Another tributary, Troublesome Brook, joins the Bronx at Crestwood. A quintessential suburban watercourse, Troublesome Brook arises from a spring near the seventeenth hole of the Sunningdale Country Club golf course and flows beneath no fewer than four shopping plazas before descending through the upscale neighborhood of Sherwood's Vale and adding its flow to the Bronx River. There's no poetry in the name of Troublesome Brook: prone to flash flooding, the early settlers named it as they found it.

The freshwater marshes in and around Crestwood made the area an agreeable place for wildlife well into the twentieth century. It briefly sheltered a group of fugitive beavers from the Bronx Zoo, who found it an inviting spot until nervous suburbanites summoned the zookeepers. Stories tell of other strange critters spotted in what was sometimes called the "jungle" of Crestwood.

These remnant marshes are a reminder of the place's importance to Native Americans, who named it for the *tuckah* root that they ground to make flour. The European people who settled here found another source of wealth in Tuckahoe, quarrying marble from hills that once abounded in deer. Caring little for aquatic plants or the marshes that grew them, the new people sometimes called the place "Turkey-hoe" or "Turkey Hollow."

From the south end of the marshes, the river flows past the high ground to the west that is now known as Mohegan Heights and the marble-veined ridge on the east that in the quarries' heyday was known as "the Irish Alps" for the Gaelic quarrymen who made their homes here. Newly arrived Italian workers lived downhill by the banks of the river in the buggy floodplain known as "the Hollow." A block of Tuckahoe marble beside the pathway commemorates this vanished riverside industry, which once provided stone to New York's finest buildings, and uphill other monuments stand by the one remaining quarry pit. Other industrial remnants are clustered downstream, including the Old Cotton Mill, where quarrymen's wives and daughters labored to make ends meet (and which is now a popular restaurant).

South of Tuckahoe, the river opens up to form Bronxville Lake, and the stroller has a choice of proceeding down the Bronxville side or the Yonkers side. Bronxville, too, had its origins as an industrial river town, known at first as Underhill's Crossing after James Underhill built a dam here in the early

1700s to power a gristmill. In the 1870s, Underhill's Crossing was developed into Bronxville, named for the river, and for years, it was Westchester's most exclusive suburb.

On the Bronxville side, the looming rise of Sunset Hill holds another reminder of the river's Native American past. It was reputed to have been the home of the legendary sachem Gramatan. The nearby Gramatan Springs once flowed with water tasty enough to be commercially bottled, and they contributed their trickle to the Bronx River through Prescott Brook, now a storm water discharge pipe. The name of the legendary Gramatan was eventually taken by an equally legendary hotel atop Sunset Hill.

At Bronxville, a much greater tributary joins the river. The curious name of Sprain Brook has nothing to do with injured ankles—it comes from the Dutch word *sprankel* (sparkle). This tributary boasts its own tributaries, the Grassy Sprain and the Sunny Brook, which flow down from Valentine's Hill in Yonkers and link with the Sprain just before the Sprain itself joins the Bronx River. Once celebrated for its trout and its pure water, today the Sprain Brook, like its Bronx sister, has the dubious honor of having a parkway named after it. And also like the Bronx, the Sprain sometimes returns the compliment by rising up to engulf its namesake parkway.

The Bronx River is not very popular with the local folks around here, where the Palmer Road Bridge crosses the river to link Bronxville with Yonkers. The Sprain's influx is one of a combination of factors that make this the most flood-prone spot on the river. Bits of debris clinging to the bridges and trees here speak of the violence of the last flood, and residents know that the next one is only a good rainfall away.

Following the mud-painted floodplain south of Palmer Road brings the walker to a short stretch of river pathway that leads to Scout Field, where Laurel Brook flows down through Mount Vernon's Hunt Woods Park. A rejected route for the Cross County Parkway left behind a strip of unkempt parkland just wide enough to embrace Laurel Brook and its ravine. For a side trip, one can head up Laurel Brook in the spring to see an example of the river's changing environment, as the invasive yellow-flowered lesser celandine is gradually creeping its way up Laurel Brook to smother one of the valley's last remaining patches where the once abundant but now endangered skunk cabbage still grows.

Scout Field, with one of the nation's oldest existing Boy Scout cabins, is a pleasant enough spot for strolling along the riverbank, but south of Scout Field, the river pathway ends in a tangle of railroad and highway; the river walker must consult his map and take some wide detours to continue

his way south. Crossing from Bronxville down Gramatan Avenue into the affluent Fleetwood section of Mount Vernon, the oldest of the river's planned suburban developments, the walk is not altogether unpleasant, but about the only glimpse of the river is when you look down from the East Broad Street bridge as you cross over to Yonkers in order to continue down the tantalizingly named Bronx River Road.

The river here follows an artificially straightened course, but the legal boundary between Yonkers and Mount Vernon, seen on detailed land maps, still follows the river's original squiggly course. The landscape grows increasingly urban as you head south past the old settlement of Mile Square, and the river (what little you can see of it) is more neglected-looking.

Yet there is a piece of the river accessible here, too, for ramblers willing to re-cross the river and double back north again. An all but unnoticeable path alongside a Parkway entrance ramp on Mount Vernon's Oak Street leads one to the Oak Street Loop. An isolated half-mile trail follows the river here only to dead-end at an entrance ramp to the Cross County Parkway, forcing the walker to turn back the way he came and resume the route down Bronx River Road. The isolation of the Oak Street Loop makes this an ill-advised place for solitary and vulnerable ramblers to venture into, but even this path has its rewards, with an interesting assortment of exotic trees, remains of old oxbows and another tributary joining the river. Here in what remains of a floodplain, the river has left traces where it has altered its own course over the years, as if asserting its natural autonomy in defiance of planners and engineers.

Heading down Bronx River Road brings one to the entrance to Muskrat Cove, where one must walk north again to view this portion of the river. The doubling back is well worth it, as things change for the better once the river crosses the city line and enters Muskrat Cove. Rather, it crosses the line several times: the squiggly course of the boundary between Yonkers and a northern prong of the Borough of the Bronx here again traces the Bronx River's course as it was more than a century ago. The river's squiggles were straightened out, first by the railroad and later by the Parkway, but the border was never revised; alternate footsteps will land you in either the Bronx or Westchester.

As a leftover stub of the original Bronx River Parkway Reservation, Muskrat Cove was for many years an isolated and nearly forgotten stretch of parkland, with a pedestrian "bridge to nowhere" spanning the river at its northern end, intended for a never-built pathway into Westchester. But in the 1980s, community volunteers, dubbed the "Muskrateers," named and reclaimed Muskrat Cove, turning it from an abandoned cul-de-sac

to a pleasant and tree-shaded (though still dead-end) river pathway. It is a welcome change from the mile-long, river-less detour that brought you here and a harbinger of better things to come. A black basalt monument at Muskrat Cove's entrance proclaims it the northern end of the Bronx River Greenway, and a line carved in the stone shows its route leading south through the heart of the Bronx.

Crossing the river over the East 233rd Street Bridge brings us to Shoelace Park, where the Parkway's original roadbed was abandoned in 1952 when an entirely new route was built on the west bank. While the original parkway of the 1920s preserved some of the river's natural bends and curves as picturesque elements, the engineers of the 1950s had no patience for the picturesque and brusquely straightened the river to make room for the six-lane artery they were building. Deprived of its natural flood-buffering curves and nestled between two sharp rises of high ground—Woodlawn Cemetery to the west and the Wakefield and Williamsbridge neighborhoods to the east—the river periodically overflows here, flooding Shoelace Park and, ironically, shutting down the Bronx River Parkway.

Here, another tributary, the spring-fed Woodlawn Brook, enters the Bronx River almost by stealth, making its way down through the cemetery past the Brookside Mausoleum before being channeled beneath the railroad tracks to enter the river through an outflow pipe. This was once a spot picturesque enough for a stereopticon card that gave Victorian armchair travelers a three-dimensional view of the Bronx River. Although the Woodlawn Brook outlet is now almost invisible, the river does become more scenic here, thanks to the energetic and ongoing reclamation efforts of the Bronx River Alliance's Conservation Crew and the volunteer Friends of Shoelace Park. Just below Woodlawn Brook, a boat launch at East 219th Street marks the point where the river gains a depth consistent enough to float a canoe all the way down to Long Island Sound, barring a few portages around the dams that still remain. It is well worth the trip.

Although the Shoelace Park pathway closely parallels the river, the view from the water is entirely different. Screened by clumps of jewelweed and shaded by overhanging willows, the canoeist can ignore the adjacent parkway as he paddles down the sylvan stream before him. While the view looks primeval, a lot of restoration work went into reclaiming what had been an odiferous and unapproachable waterway. Unlike the builders of the Parkway, the people who reclaimed the river, and maintain it to this day, have no monument recording their names. The river itself is their monument, and you're on it.

The shady river now bears the boater past densely populated and history-laden neighborhoods. At the south end of Shoelace Park, there are still oxbows in the river around which you sweep under the historic William's Bridge crossing of the old Boston Post Road, where Paul Revere once galloped past a place where medieval tapestries would later be woven on the Bronx River, and on under the Duncombe Bridges, a photogenic spot where the old Parkway vaulted the river. Passing the obscure sites of the legendary L'Hermitage and "French Charley's" riverside restaurants (gone for more than a century now), the canoeist paddles on into the Bronx River Forest.

The Bronx River Forest is a showpiece of environmental restoration efforts. As a natural floodplain of the river, the area hosted French restaurants and German beer gardens before it became part of the New York Botanical Garden, which led to it being planted with a variety of specimen trees before it was given back to Bronx Park and left to become a neglected and overgrown jungle. For years the home turf of the "Ducky Boys" gang, it was a place where strangers tread with caution, or not at all. But years of reclamation work have taken out invasive vegetation and cut new trails to make the once-avoided Bronx River Forest into an environmental asset. The creepily named Rat Island (with Leech Beach at its northern tip) splits the river in two here, and the canoeist proceeds down the more navigable western channel. The sight of the huge stands of Japanese knotweed on Rat Island is a reminder that restoration of the forest is by no means a completed task.

Leaving the Bronx River Forest behind, the river enters the New York Botanical Garden and the spectacular Bronx River Gorge. Here the river runs through a new channel carved out by post-glacial action as little as ten thousand years ago, a mere blink on the geological time scale. The high ground on the west bank is covered by one of the very last patches of never-timbered native forest on the East Coast. You're now in the old country estate of the Lorillard family, who loved the beauty of this forest and saw to it that it stayed that way. The New York Botanical Garden has put a lot of effort in recent years into restoring the native forest and reversing the damage of a century's worth of human visitors.

Human visitors here have included some very creative souls. Listen now for the tolling of nearby Fordham University's chapel bell "Old Edgar," a reminder that Edgar Allan Poe once wandered and sought inspiration here. You're paddling alongside the pathways of authors, poets and painters, but it's not a good idea to fall into too deep a reverie while on the water, as you might fall over the Lorillard Dam if you don't pay attention to the "Dam Ahead" warning signs. The paddler must portage his craft around the dam

and rapids here, but at least it's a scenic portage, winding as it does past the historic Snuff Mill, where tobacco and rose petals were fine-ground to soothe nineteenth-century cravings. Known today as the Stone Mill, you can have a truly romantic riverside wedding reception here where the rapids of the Bronx River Gorge smooth out into a burbling shallow bend.

Regaining the river, one paddles down a shaded stretch where colorful but shy wood ducks nest and where the newly returned beavers occasionally foray and enter the Bronx Zoo. The Pelham Parkway Bridge here was an important river crossing long before the Parkway was built, named by the Native Americans *Acqueegenom* ("where the path goes over"). The river widens here to form Lake Agassiz before you come to another brief portage between the two milldams that once supplied water power to the mighty Bolton Bleachery, where today winds the scenic Mitsubishi River Walk.

Paddling through the zoo, one passes the site of the lost village of Bronxdale and enters Bronx Lake, where the zoo's boathouse one stood. Bronx Lake has been silting up over the years, making navigation tricky, but the effort is worth it, as the exposed mudflats are host to such wading birds as curlews, sandpipers and plovers, along with white egrets and blue herons.

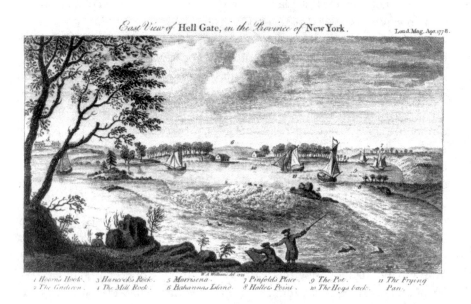

The Bronx River Estuary may be glimpsed on the far left in this old view of the Devil's Belt and the aptly named Hell Gate. *Library of Congress.*

INTRODUCTION

At the end of Bronx Lake is the 182nd Street Dam, built on the footings of the dam that once made wealth for the powerful DeLancey family. The history-minded paddler knows that he's entering Tory country now, a stronghold from which Loyalist "cow-boys" splashed across the river to raid rebel farmsteads and add a new word to the language. The long-vanished DeLancey mansion overlooked the river from what today is the zoo's Wild Asia section.

This used to be a difficult portage, where canoes had to be tipped over and man-handled down the fifteen-foot dam wall before being replaced in the river to wind their way through the narrow channel of the West Farms Rapids. Making your way down from the foot of the dam to the river below, a bit of fun could be had by scuttling down a natural rock slide where the rough Fordham gneiss of the gorge wall has been worn smooth by countless generations of frolicking children.

Today, the site is occupied by a "fish ladder" that allows migratory alewife herring and river eels to make their way from the saltwater of the estuary to the fresh upstream waters and that, incidentally, serves as a handy ramp down which canoes may be safely portaged. The eels and alewives are returning to the river but need access to the upstream freshwater to complete their life cycles. The hand of humankind that long ago barred them from the river with milldams is now making amends, beginning here at the point where tidal salt water meets fresh river water. The eels and alewives come and go from the broad North Atlantic and the far-off Sargasso Sea, but the paddler has only a few miles of a widening and deepening estuary before he reaches his journey's end.

The river now flows through West Farms, the oldest European settlement on the Bronx River. Here, where the brackish tidal water of the estuary meets the fresh water flowing down from Westchester, Connecticut, Yankees used the falls of the Bronx River to power gristmills and sawmills. The river's industrialization began here at West Farms, and by the twentieth century, this had become the place of its profoundest degradation. Steering the canoe through the West Farms Rapids, one passes the backs of buildings that once housed such things as an icehouse and a dye works and, later, an appliance warehouse that tipped its defunct fridges and washing machines into the river. It is hard to believe that at one time the river had become invisible at this spot, its waters literally buried beneath tons of discarded junk. History, though, has its way of coming full circle, for here at West Farms the river's reclamation began in the mid-1970s, when local citizens came together to begin the sometimes barehanded work of removing debris from the river.

Coming out from under the East Tremont Avenue Bridge, the paddler passes Drew Gardens, one of the river's most spectacular revitalization successes, where a community garden replaced a former industrial wasteland. It was once the site of the massive Bolton Bleachery, which migrated down here from Bronxdale in the 1880s and which polluted the river in diverse ways until it went bust in the mid-1920s. After the building was torn down, the site remained a dangerous and rubble-strewn abandoned lot until neighborhood volunteers began its reclamation in the 1980s.

Past Drew Gardens, the river flows by Starlight Park, where an abortive attempt to hold a World's Fair on the banks of the Bronx River was repurposed into a popular amusement park. Abandoned for some seventy years, the amusement park site has only recently been reshaped into parkland, with pathways and a new footbridge over the Bronx River leading to another restored park that was built in the 1950s and also named Starlight Park in honor of the lost amusement grounds across the river.

As the paddler passes beneath the Cross Bronx Expressway, a tall concrete pillar rises out of the river and ends, *Ozymandias*-like, in thin air. This is no relic of an antique land but rather another legacy of Robert Moses. After building the Cross Bronx Expressway across the remnants of Starlight Park, the controversial "Master Builder" sought to connect it with his new Sheridan Expressway. Community opposition, however, stopped him from extending the Sheridan, and the pillar, built to support the connecting ramp, stands today as a monument to the vexation of Moses.

Although passing through an artificially straightened, stone-lined channel, the river is surprisingly beautiful here. The smell of salt water promises deep water and no more portages, and the river widens into a broad basin (actually the terminus of a barge channel), where a cheerful pier and flight of steps form the gateway to Bronx River House, the headquarters of the Bronx River Alliance.

Past the barge basin, the river jogs eastward and crosses under the New Haven (now Amtrak) railroad tracks beneath the mighty Bronx River Bascules. Built in the early 1900s to carry the railroad over the Bronx River, these lift bridges were something of an engineering marvel in their day. They were needed to give clearance for tugboats bringing barge-loads of coal to feed the gas plants on the west bank of the river. But the coal-gas plants are long gone, along with the gaslight era they once illuminated, and the Bronx River Bascules lift no more, but they provide an interesting moment for paddlers passing beneath them—all the more exciting if an Amtrak train comes thundering overhead.

The estuary now broadens out, and the orange silos of Concrete Plant Park beckon. This waterside park is another example of community action on the Bronx River. Once a busy concrete plant where trucks were loaded and dispatched, barrels whirling, to construction sites across the city, the site was abandoned in the late 1980s until sustained community pressure got it rebuilt as a park. The plant's old silos were stabilized and left as a distinctive monument to the Bronx River's industrial past. It's a popular place to fish (watch out for the fishing lines as you paddle by), and there's also a canoe launch from which explorations of the estuary set out.

Soon you're passing Soundview Park. Saltwater marshes here, along with those of the lowlands of Hunts Point on the river's west bank, formed the Bronx River's delta after the glacial torrents carved out the gorge a few miles upstream. Once renowned for its turtles, the salt marshes of Soundview were buried beneath construction debris in the early twentieth century.

Hunts Point's marshes were likewise filled in and are now the site of the great wholesale fruit, vegetable, meat and fish markets that supply New York City and much of the Northeast. But just past the scrap metal yards, there's Hunts Point Riverside Park, another recreational site created from a wasteland by hands-on community action and later redeveloped into an award-winning park. It is also the home of Rocking the Boat, whose student-crafted wooden rowboats are often seen rowing in the river.

This once nearly dead estuary has been greatly revitalized in recent years and now teems with aquatic life, notably striped bass and blue crab, as well as the migratory river eel and alewife herring, among other fishes. These draw resurgent bird populations of heron, egret, osprey, bufflehead, cormorant and kingfisher. At certain times of the year, you might also see such migratory waterfowl as Brant geese, black ducks and golden eye ducks stopping over on their journeys.

Another lost piece of the river's history is coming back here, although it is almost unnoticed but for a few marker buoys. The Bronx River Estuary was once full of oysters, which found it offered just the right degree of salinity amid the abundant nutrients the river carries downstream. Native American settlements on both sides of the river feasted on these succulent shellfish and left behind the mounds of discarded shells that would later clue historians in to the locations of their villages. The oyster beds vanished long ago, but ecologists know that oysters are tremendous "filter feeders," which clarify the waters and help the estuary support other forms of aquatic life. The Bronx River's oyster beds are being painstakingly replanted here as part of the river's overall environmental revitalization.

Leaving the oysters behind, the paddler passes the tip of Hunts Point and the communities of Harding Park and Clason Point, all places with their own curious and sometimes tragic histories. But it is not a time to ponder past history—dead ahead, the river empties into Long Island Sound and a reach of water that old-timers once knew as the Devil's Belt. Known for its strong currents and tidal surges, the troublesome waters of the Devil's Belt funnel down past Barretto Bay, Port Morris, Rikers Island and the North and South Brother Islands to the aptly named Hell Gate. All these places have their stories to tell, but having reached the end of the Bronx River, the weary paddler turns at last and heads for home.

Chapter 1

AQUAHUNG

The Bronx River is either a very old river or a very young river, depending on where you stand (or float). For most of its length through southern Westchester and the northern Bronx, geologists give it an age of about 150 million years, old enough to predate more than one ice age, as well as many dinosaurs. A glance at the topography of southern Westchester will tell you that a river *ought* to be where the Bronx River is, even if the mapmaker forgot to draw in the blue squiggle. But just before it reaches the New York Botanical Garden in the Bronx, the river's course is suddenly no longer so intuitive. Here it abruptly flows into a "new" channel, carved out about 10,000 to 13,000 years ago. This is but a tiny blip in earth time, and geologists talk about it as if it happened just last week.

The primeval Bronx River originally bent to the west at this point, about where the present-day Twin Lakes are in the Botanical Garden. Eroding a channel along a line of soft marble bedrock, it flowed from there down the general route of Webster Avenue to empty into the Harlem River or Long Island Sound.[1] This much is fairly certain, but exactly what caused the change in course is still debated.

The last ice age, known in this area as the Wisconsin Glaciation, had a major impact on the landscape. Among other things, it changed the course of the Hudson River, carving out what many people are surprised to learn is a fjord running alongside the skyscrapers of Manhattan. The glaciers, thick enough to swallow most of these skyscrapers, left abundant evidence of both their arrival and their slow demise: deep grooves carved in the bedrock,

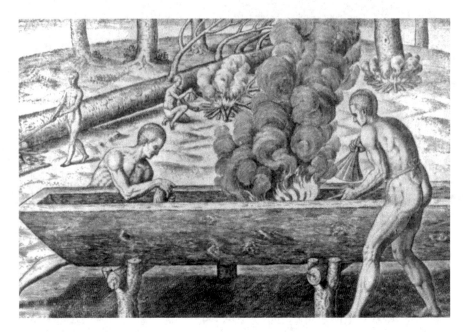

Native Americans paddled the Bronx River in dugout canoes similar to this one being made in Virginia. *Library of Congress.*

erratics, potholes, spillways, dry cascades, kettle ponds, drumlins, recessional and terminal moraines—all sorts of things that make landscape study and geological walking tours so interesting.

We talk about the "retreat" of the glaciers, but it's not as if the glaciers suddenly decided to go back to where they came from. A gradual melt-back better describes the end of the ice age, and it was a prolonged back-and-forth process in which cold periods caused the glaciers to advance once again, followed by another melt-back. The lumpy terrain of the Van Nest neighborhood, as well as other parts of the Bronx east of the river, is a legacy of this indecisive process.

The glaciers locked up a lot of water, and when they finally melted, all that water had to go somewhere. Therein lies the clue to what happened to the Bronx River. The classic theory is that an ice/debris dam formed by unevenly melting glaciers backed up an immense volume of water that eventually found its outlet by carving out a line of soft bedrock (perhaps exploiting an old earth fault) to create the Bronx River Gorge. A more recent study, by geologists Charles Merguerian and John Sanders, proposed something more exciting: the diversion may have been caused by a post-glacial tectonic uplift that dammed the Bronx River and caused

a backup of water that eventually found a new outlet through the Bronx River Gorge.[2]

Whatever the cause of the diversion, evidence in the bedrock above the "new" river channel speaks of unimaginably colossal torrents of water that once thundered down here. On the western side of the Bronx River Gorge may be found water-smoothed cliffs (dry cascades) and deep "potholes" drilled into the bedrock by swirling water, along with numerous boulders carried by the glacier and dropped like so many unwanted souvenirs. Knowing the toughness of the Fordham gneiss bedrock, one can only be impressed by the power of flowing ice and falling water.

Even greater forces, though, may have had a role in shaping the Bronx River's course. As you enter the Bronx River Gorge's northern end, you're crossing Cameron's Line, a deep "suture fault" between the billion-plus-year-old Fordham gneiss of the Manhattan Prong to the west and the younger bedrocks of the Hartland Formation to the east. It seems like a quiet, dull spot, until you realize that continents once collided here. It's all about plate tectonics—or "continental drift," as it's sometimes called. Some 450 million years ago, two supercontinents—Laurasia (a combination of North America, Europe and Asia) and Gondwanaland (South America, Africa, Australia, India and Antarctica)—collided to form the supercontinent of Pangaea.

As the two giants approached each other, the pressures generated by their convergence threw up an arc of volcanic islands that slammed into Laurasia. When Pangaea finally broke apart, a remnant of this island arc remained stuck to North America, in what we know today as the Hartland Formation. The bedrocks of the Hartland Formation are quite different from the dense, ancient Fordham gneiss. In particular the crumbly, mica-laden bedrock in what became the Bronx River Gorge may have presented an irresistible opportunity to a post-glacial river that needed to gouge a new outlet in a hurry.

In human times, the river was known as the Aquahung to the Native Americans who lived alongside it. Generally taken to mean "River of High Bluffs," the origins and meaning of the name Aquahung is open to other interpretations. It may have been merely the name of a place, "a high bank or a bluff," which could describe Hunts Point or several other places along the river. Edward J. Lenik, an authority on the Algonquin peoples of the Northeast, thinks that it might be derived from the Munsee word *akawaltung*, meaning "that which is protected from the wind," an apt description of the Bronx River Gorge.[3]

Historical tradition holds that the Aquahung served as a boundary between two tribes of Native Americans. The Weckquasgeeks lived west of the river, while the Siwanoys, an Algonquin people related to the Mohegans

of southern New England, held the lands to the east stretching into Connecticut. The river was not a hostile frontier, and members of the two nations peaceably crossed over it from time to time. Archaeological finds indicate that Weekguasegeecks, for example, made a summer encampment on Throgs Neck, just as Bronxites nowadays head for Orchard Beach.[4]

A local legend from the early 1800s reflected the tradition that the Aquahung had been a boundary river. The Wishing Rock lay on the bank of the river in what is now Shoelace Park in Wakefield. Set in a grove of willow trees, the story had it that it had once been the meeting place for a young Native American woman and her lover from the opposite side of the river. Despite being of different tribes, their love deepened there on the banks of the Aquahung, and eventually they eloped. With this legend in mind, courting couples from the village of Wakefield would rendezvous at the Wishing Rock to talk of their hopes for the future—and perhaps do a bit more than talk.[5]

Another boulder may hold a clue to the Aquahung's Native American past. In 1980, a petroglyph of a turtle was found on a stone beside an old trail on the east bank of the river in the New York Botanical Garden. Thought to be the work of pre-colonial Native Americans, the significance of this unique find is uncertain. The carving may reference the Turtle Clan, one of the three clans of the Munsees, or perhaps Turtle Island from the Lenape origin myth. Or maybe it simply marked a gathering point—the stone was found on a rise of ground with a nice view of the river below.[6]

The Aquahung flowed along the northeastern extent of a much larger Native American territory called Lenape Hoking, or "the dwelling place of the Lenape." Lenape Hoking was centered far to the south on the Lenape Seepu, or what we know as the Delaware River. Today commonly known as the Delaware Nation, the Lenapes, literally "human persons" or "real people," were one of the largest groupings of Algonquin people in the East.

The Algonquin group was a broad constellation of culturally affiliated and linguistically related tribes that included such Lenape neighbors as the Mohegans and Wappingers. The Lenapes, though, occupied a special place in the Algonquin realm, as they were regarded as a primeval nation, and they were often referred to as "the Ancient Ones," or the "Grandfathers" to the Algonquins. There were three main divisions of the Lenapes. The Munsees, of whom the Weckquasgeeks were a part, occupied the lower Hudson Valley and northern New Jersey. The Unamis lived in central New Jersey and parts of Pennsylvania, and the Unalatohtigos occupied southern New Jersey.[7]

While much archaeological evidence in the Bronx River Valley has been lost over the years, we can nevertheless identify a number of Native American settlement sites along the river. The largest appear to have been down on the estuary. Quinnahung, "long point," was at the foot of Hunts Point, clustered around a freshwater creek named Sacrahong that led to the estuary. If nineteenth-century tradition is to be believed, Quinnahung was a place of some importance: just east of the Hunt family burial ground was a group of glacial boulders known as the "Indian Cave," as well as what was said to have been a Native American council rock. Indian Cave and the council rock, along with Sacrahong Creek, were long ago destroyed by industrial development.

Across the river from Quinnahung, the village of Snakapins (its name possibly derived from *Sean-auke-pe-ing*, or "River-Land-Water Place") was on Clason Point on the east side of the estuary. Excavations in the early twentieth century revealed that Snakapins was a rather large settlement, with some sixty food storage pits and immense middens of oyster shells. These investigations, carried out by Alanson Skinner and Amos Oneroad (of the Menominee nation) under the sponsorship of the Heye Foundation, were the most extensive archaeological digs done along the Bronx River. The artifacts found there enabled archaeologists to identify what they termed the "Clason Point Phase" of late Woodland Period Algonquin culture. The Native American presence there goes back much farther, though: a recent archaeological excavation at the head of Pugsley Creek revealed a Late Archaic hunting camp, some 3,700 to 6,000 years old.

Farther up the river, our knowledge of Native American settlements is less certain. The Bear Swamp, along present-day Bronxdale Avenue east of White Plains Road, was an important resource for Native Americans, and various artifacts turned up over the years (in the early 1800s, a basin for grinding corn was found cut into a rock outcrop) indicate that there may have been a settlement of some kind there, although its name has been lost to history. Local legend has it that Bear Swamp was the last refuge of Native Americans along the Bronx River, where a small band persisted until after the Revolutionary War.

About the only trace of the Bear Swamp you can see today is a gentle dip in the terrain east of White Plains Road. The early colonists called it "Bear Swamp" for good reason: there really were bears in there, and the Native Americans trapped them by driving them between converging wooden palisades. Bears were an important part of the Native American economy. Their teeth and claws were decorations a hunter could wear with pride, and

their hides made wonderfully warm robes and blankets. The meat was tasty and nutritious, and their fat, boiled down, was used as hair dressing or served as an effective sunscreen and insect repellant. Drained by Downing Brook, which flowed into the Bronx River, the freshwater marshes of Bear Swamp were an important hunting ground.

At present-day Williamsbridge, the river crossing of the Sacherah Trail (which became the original Boston Post Road) and its junction with the Common Path (White Plains Road) was known as Conangungh, and there may well have been a settlement there where the river gently flowed through a broad floodplain.[8] Farther upstream, Sunset Hill overlooking present-day Bronxville was reputed to be the home of the sachem Gramatan. While there appears to be little record of a settlement there, the nearby Gramatan Spring—along with Prescott Brook, the long-vanished Crystal Pond and the fertile flatlands of Pond Field—would have made this an excellent location for a settlement. Farther upstream, Quaroppas, by the wide flat plateau known as "the White Plains," was another settlement site.[9]

The Native American economy along the Aquahung combined fishing, hunting and foraging with some sophisticated horticulture. Native American agriculture was founded on the "Three Sisters"—maize, beans and squash, planted together in a mutually supporting system. The tall stalks of the maize supported the beans, and in turn, the beans supported the maize by fixing nitrogen from the atmosphere to fertilize the soil. Rounding out the trio, the big, floppy leaves of the low-growing squash shaded the soil beneath the maize and bean plants, keeping moisture in the soil and discouraging the growth of weeds. The squash also added a needed shot of vitamins A and C into the native diet.

Maize occupied an important place in Munsee lore. Legend had it that maize was first brought to the Lenape people by Grandfather Crow, who dropped a kernel from his beak one day, and from that one germinating kernel all the Lenapes' corn was grown. This entitled Grandfather Crow to special respect—it was taboo to ever kill a crow, even if a flock of them was raiding your corn patch. It was okay for the kids to chuck rocks to scare them off, but never to kill one.

Grandfather Crow notwithstanding, maize appears to have been only a relatively small part of the food supply for the Native Americans along the Bronx River, especially in the large settlements along the estuary, where they could harvest an abundance of seafood, especially oysters. The estuary of the Aquahung was an especially good place for oysters, and massive oyster beds lay a convenient distance just offshore. Lacking steel oyster knives

with which to shuck the shellfish, the Native Americans roasted them on the coals until the shells popped open on their own, or else they took a stone tool and bashed the ends off the elongated shells. In any event, they consumed enormous quantities of this nutritious though low-calorie food, and huge middens of shells dotted the shoreline. One of these middens clued archaeologist Alanson Skinner to the location of Snakapins when he spotted it while taking a trolley car to the Clason Point Amusement Park in the early 1900s.

The quahog clam was also an important food source, and in addition, the purple inner lip of the shell provided the material for the valuable purple wampum (the white beads were more easily made from the inner whorl of the whelk shell). The people on the east side of the Aquahung were known as the "People of the Shells" for their greater access to quahogs, and they were the principal makers of wampum beads.[10] A settlement out by Pelham Bay was known as Laaphawachking, or "the Place of Stringing Beads."[11]

Both the salt- and freshwater marshes along the Bronx River were valuable resources for the Native Americans. Only later would such insect-borne diseases as malaria and yellow fever, introduced by colonists, cause the marshes to be seen as fearsome "swamps" that needed to be filled in. Access to the salt marshes remained important to the Native Americans even as the early colonists claimed them to gather salt hay for cattle fodder. For example, across the sound in Flushing, the sachems who in 1684 confirmed the sale of their lands insisted on the perpetual right to gather "bulrushes" from the salt marshes.

The streams and marshes along the Aquahung yielded food as well as bulrushes. They were prime hunting grounds for ducks and other waterfowl, and turtles were also found along the river's marshy tributaries—one stream flowing through what is today Soundview Park so abounded in terrapins that the colonial settlers named it Turtle Creek. Plants in the marshes could also be foraged: the roots of the aquatic Golden Seal were processed and pounded to make a sort of starchy flour. Named *tuckah*, this later gave the name to the village of Tuckahoe. Native Americans along the Aquahung also had a method of leaching and processing the otherwise inedible acorns gathered from the surrounding forests.

The Native Americans on the Aquahung used canoes to navigate and exploit its estuarial waters. The classic birch-bark canoe today forms a popular image of the Native Americans, and it lent its high-prowed form to the polypropylene craft that today bear canoeists down the Bronx River. But the first canoes that paddled the waters of the Aquahung were wooden dugouts.

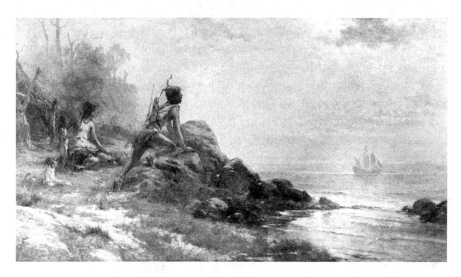

Henry Hudson's exploration was followed by European colonists, who would dramatically alter Native American life. *Library of Congress.*

The durable *wapim-inisi,* or American chestnut, was the Lenape canoe maker's wood of choice, although the close-grained tulip tree, which like the chestnut grew to huge proportions along the Aquahung, could also be used for canoes. The term "dugout" aptly describes the method of manufacture—a felled trunk would be slowly shaped into a canoe by alternately burning out and scraping the wood with stone tools. This laborious process was more efficient than it seems—modern-day experiments indicate that it took a single canoe builder about ten to twelve days of steady work to turn out a smartly finished craft. Unlike the more fragile birch-bark canoe, a dugout could stand up to rocky shorelines and heavy use. They indeed could last a long time, especially in the salty water of the estuary—sunken dugouts hundreds of years old have been dug up and displayed in museums.

Examples of dugout canoes found in this area and depicted in Dutch drawings often included long extensions fore and aft, handy for hauling the canoe ashore and securing it with a rope woven from hemp dogbane. The Lenapes had two main types of canoe: *mahelo* and *amochol. Mahelo* probably referred to the larger models, and these could be pretty sizeable craft—trunks up to forty feet long were fashioned into four-passenger canoes that could manage journeys out into the East River and as far out as Coney Island and Rockaway. Long Island natives even built mammoth six-man dugouts for offshore whale hunting.

Upstream from the estuary, old-growth hardwood forests rose along the Bronx River. Surviving patches in the Botanical Garden and the Garth Woods give some idea of what these forests looked like. Colonists arriving from the long-deforested island of Britain tended to view these woodlands as dark, scary places that needed to be clear-cut to create a "civilized" landscape, but to the Native Americans, the forests were valued resources. Although not without their dangers, the forests could also be places of wonder.

Algonquin legends told of three-foot-tall people, the *Mesingw Wemahtekensis* in the Unami language, who haunted the woods. Generally benign sorts, these little people were especially kind to tearful children they found lost in the woods, and if grown-ups treated them with respect, they'd help them out, too. Evan T. Pritchard, in his book *Native New Yorkers*, described them as dressed all in leather, and apart from their short stature, they were notable for their rabbit-like mouths and butterfly wings on their backs. They'd most likely be seen in the very early morning or at twilight and tended to be more active in the spring and fall. Lost or not, it was a good thing to encounter them, for those who did were often granted great strength and power.

But the strength and power given by the *Mesingw Wemahtekensis* could do little to protect the Native Americans along the Aquahung in the face of the aggression, wars and diseases brought by the European colonists once New Amsterdam was founded in 1624. Within a few years, these original river people of the Aquahung would be but a fading memory in their homeland, and the surviving Munsees would join in the long diaspora that eventually took the Grandfather Lenapes as far afield as Oklahoma, Wisconsin and Canada.[12]

JONAS THE PEACEMAKER

We cannot say for sure which European explorer "discovered" the Aquahung. The Dutch fur trader and explorer Adrian Block and his crew would appear to be the first Europeans to set eyes on the Aquahung, but they seem to have taken little notice of it. Fighting their way through what they understandably named the Hell Gate to explore Long Island Sound in their little improvised vessel *Onrust* in 1614, they may have been too focused on the troublesome tidal currents to notice the Aquahung's outlet amid the salt marshes. Coming up on Westchester Creek, they did note a palisaded Indian village on an elevated spot of ground, and the name of "Castle Hill" remains today. Block and his men went on to explore the Connecticut River and give the captain's name to Block Island, but the Aquahung would have to await for the arrival of another sea captain many years later before it, too, was assigned a European name.

Ten years after Block's voyage, the Dutch arrived to stay. They claimed for New Netherland the territory between the Delaware and Connecticut Rivers but centered their new realm on the Hudson River, establishing their port city of New Amsterdam at the tip of Manhattan Island and a fur trading post up the Hudson at Fort Orange (Albany). To help secure the new country, the West India Company offered "patroonships," by which a gentleman could buy an estate and live there as the lord of the manor, provided he could recruit and bring over tenants.

One of these patroons was Jonas Bronck, who would lend his name to the river that, in turn, would eventually give its name to a borough and

The fur trade made the beaver a commodity, leading to its extinction along the Bronx River. *Library of Congress.*

a county, as well as a parkway, a baseball team's nickname, a zoo, a rude cheer and a cocktail, among other things unimagined in the frontier world of New Netherland.

A Swede by birth,[13] Bronck had been in the Dutch service for many years as a merchant ship captain. Just what prompted him to give up his maritime career at the relatively young age of thirty-nine and settle on the raw frontier of New Netherland we cannot say. Perhaps a growing religious conviction made him anxious to leave behind the ocean and all its wind-burned blasphemies and seek a quiet retirement on dry land.

Bronck sought it in a place he would name Emmaus, after the village outside Jerusalem where the risen Christ revealed himself to his startled fellow travelers. Securing proper title from the Native Americans, on December 3, 1639, he purchased 250 "morgen" (about five hundred acres) of land in what today is Morrisania and Mott Haven in the southwest corner of the Bronx. The payment was a deal that rivaled Pieter Minuit's legendary Manhattan transfer: two guns, two kettles, two adzes, two coats, two shirts and six "bits" (three-fourths of a Spanish "piece of eight" dollar), plus a barrel of fermented cider, which no doubt enlivened the negotiations. Bronck's new property lay below present-day 150th Street, stretching from the Harlem River to the Sackwrahung, or Bungay Creek, and included the trail terminus known as Ranachqua, where traces of a native village would later be found, although it isn't known if the village was occupied at the time of Bronck's purchase.

Swapping land for hardware, shirts and cider may seem a poor business decision, but to the Native Americans at the time, these artifacts of European technology were priceless (the cider, too, as apples had not yet been introduced into North America). In any event, the Weckquasgeek sachems who closed the deal—whose names were recorded as Shahash, Panazarah, Wanacapun, Kneed, Awarazawis and Taquamarke—appeared well satisfied. (Taquamarke would live on in Bronx folklore as "Chief Tagamack.")

Although the Aquahung would become known as "Bronck's River," Jonas's land didn't actually reach the river but rather extended only as far as present-day Intervale Avenue—close but still short of the Aquahung.[14] He may have had some private understanding with the Indians permitting his tenants to gather the salt hay from the river's marshes for cattle fodder, an important benefit in the colonial agricultural economy.

Another popular misconception is that Bronck built the first dam or mill on the Bronx River. There is no evidence for this and many reasons to deny it. The Dutch, coming from a pancake-flat country, had little experience

of milldams and overshot water wheels, building instead wind- or tidal-powered mills. There was no place on the lower Bronx River where Bronck could build a milldam, and in truth, he had no reason to. He intended his plantation to grow tobacco, not grain. Tobacco needed only to be dried and cured, so there was no need for Jonas to grind anything.

Tobacco seems a curious choice of crop for the south Bronx, but in those days, it seemed that nobody could go broke growing tobacco. Global demand for the "sot-weed" was increasing every year, and the Dutch were eager to find some way around the grip held by Spanish and Virginian growers. Bronck wasn't the only would-be tobacco planter in New Netherlands; Wouter van Twiller would try to grow the weed in Manhattan where Greenwich Village is today, with little success.

The Native Americans had grown tobacco, certainly in Manhattan and probably along the Bronx River, too. However, they grew and consumed tobacco only in small quantities, either for ceremonial purposes or an occasional social smoke, and even then it was blended with a number of things such as cedar shavings or the leaves of the kinni-kinnick shrub. The reason for their blended smoking mixture was that their indigenous weed was *Nicotina rustica*, a rather harsh and overpowering smoke when taken by itself. The European market demanded the more palatable *Nicotina tabacum* from South America, which proved more difficult to grow.

The glacial soil of the south Bronx may have been a poor location for growing market-worthy tobacco, but Bronck persisted. He rented land to his tenants on the condition that they would plant mainly tobacco, which of course would be turned in to Bronck as rent. Bronck would then sell the tobacco in New Amsterdam for a tidy profit. His estate included a large shed for curing the leaves, but just how much tobacco (and of what quality) his land actually produced is unknown. His tenants were allowed to grow such foodstuffs as maize, wheat, rye, barley and peas, but the rent was due in tobacco.

Bronck, however, had positioned himself to do more than grow and deal tobacco. Whether by plan or by happenstance, Bronck's estate was situated around Ranachqua ("the End Place"), where a major path came down from the north and terminated at the Harlem River.[15] This would enable Bronck to deal in some of the beaver pelts being carried down the Bronx River Valley. Beaver pelts were what New Netherland was really all about, and the Dutch West India Company was, of course, jealous of its monopoly. In 1638, however, anxious to attract settlers, the West India Company opened up the fur trade to all settlers, making an opportunity for patroons such as

The founding of New Amsterdam drew settlers such as Jonas Bronck, who would give his name to the river. *Library of Congress.*

Bronck. While there is no evidence that Bronck traded in beaver pelts, the Aquahung nevertheless abounded in beaver, and a bit of fur trading would have added to his comfortable retirement.

Something of Bronck's character can be gleaned from the contents of his will, which listed a library of some forty books. Many of these books were in Danish, and most were on religious matters. Such clues point to a reflective, deeply devout man, whose motto on his coat of arms was *Ne cede malis* ("Yield not to evil"), which eventually became the motto of his namesake borough. As a man of peace, Bronck was quite unlike the abrasive Dutch governor William Kieft, whose arrogant attitude toward the Native Americans threatened to provoke a war. As tensions escalated in 1642, Bronck did what he could to temper the passions around him. On April 22, 1642, he convened a peace conference at Emmaus between the Dutch and the Weckquaesgeeks who still lived west of the Aquahung. Whether Bronck chaired the conference or merely hosted it is uncertain, but his good relations with the Weckquaesgeeks were no doubt instrumental in bringing about an agreement that kept the peace for the time being. When the conflagration known as Kieft's War finally lit up the following spring, Bronck's land appears to have remained at peace, although east of the Aquahung the settlements of Anne Hutchinson and John Throckmorton were destroyed.

Jonas Bronck died in 1643 of unknown causes. Some doubt that he would have died a natural death in the midst of a brutal frontier war, but the fact that his will was attested and his estate inventoried down to the kitchen spoons indicates that, whatever happened elsewhere, Emmaus was not burned down. But his settlement did not long survive him. Uncertain how long Emmaus would remain a place of peace, and with the soil probably already depleted by tobacco growing, his widow quickly remarried and his tenants abandoned the property, many of them moving up the Hudson River to Rensselaerswick near Albany, where Peter Bronck (whether Jonas's son or brother we do not know) established a prosperous tavern in a place much better situated for the fur trade. Like so many later immigrants to the Bronx, the residents of the Bronck estate moved "up and out."

Bronck's enduring legacy was his name. His abandoned patroonship was for years after his death known as "Bronck's Land," and the nearby Aquahung was, however erroneously, labeled on maps henceforth as "Bronck's River."

Chapter 3

THE BEAVER DOES
EVERYTHING

Apart from the buffalo, few creatures loom larger in American history than the aquatic rodent *Castor canadensis*, or American beaver.

Once plentiful along the Aquahung, beavers not only inhabited the river and its tributaries but also shaped their courses and determined places where humans would settle. Their departure heralded the river's decline, and their return would symbolize the river's revitalization.

Famous for their dams, beavers' engineering skills are viewed with awe by even sober-sided natural scientists (although flooded property owners sometimes display different attitudes). The beavers' dams are built to maintain a water level in the ponds that will safely cover the entrances to their lodges, enabling them to elude predators. Stoutly built of interlaced branches and securely caulked with grass and mud, the dome-shaped lodges can bear the weight of a man and withstand floods and ice jams. The ponds also serve to preserve and conceal the beavers' carefully accumulated winter food supply.

The need to constantly gnaw and wear down their continuously growing incisor teeth gives the beavers the means with which to cut and trim the lumber they need. Working in groups, beavers will maintain their ponds at the exact level of their choosing, coping with variable water flows by creating stream diversions, feeder canals and spillways. To facilitate the transport of cut logs, beavers will sometimes construct "roads," clearing obstructions from a passageway linking the timber patch with the pond, rather like the "skid roads" used by lumberjacks. They also dig canals for the same purpose,

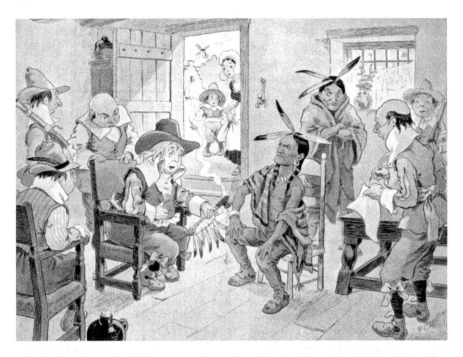

A humorous view of the 1642 peace conference. In reality, Jonas Bronck's good relations with the Native Americans kept Kieft's War away from the Bronx River. *Library of Congress.*

enabling a swimming beaver to nudge a floating log down to the dam site. And to ensure against dam breaks, they will construct one or two subsidiary dams to maintain some water level in case the main dam fails.

All this made the beaver a very special creature to the Native Americans, one that had to be regarded with respect. Marveling at the beavers' hydrological engineering, they considered them thinking animals and termed them the "Old Wise Ones." Their legends spoke of a time when beavers were much larger, had a spoken language and competed with humans. The Creator eventually decided that these uppity beavers were getting out of hand, so he took them down a peg or two, shrinking them to their present-day size and taking away their power of speech. But he left them their wisdom with which to build the dams, lodges and canals at which humans would wonder.

Curiously, there indeed once had been a giant beaver that lived in North America in the wake of the ice ages. We cannot tell from their fossil remains if they could talk, but we can imagine that their six-inch-long incisor teeth would have gotten in the way of intelligible speech. Measuring a whopping eight feet long, the shaggy-haired *Castoroides* might have found it difficult to

fit into the modest Bronx River, and none of its remains have been found there. The old Algonquin legend may contain a trace memory of a time when huge paddle-tails slapped the water.[16]

Descended from giants and possessing a human-like intelligence, the beaver was clearly no ordinary animal to the Native Americans. They were hunted for their meat (the fatty beaver tails were roasted as a special treat) and skinned to make warm winter cloaks, and their fat was used as a treatment for frostbite and stiff joints. Their secreted castorum might even be added to smoking tobacco to induce a calming effect in a contentious council. Nevertheless, beavers demanded careful handling. The beaver's blood was never to be spilled on the ground but rather caught in a vessel and returned to the waters from whence the beavers came. Likewise, the beaver's bones were never to be tossed to the village dogs to gnaw on but rather respectfully gathered up and returned to the river. Failure to do so would jinx a hunter's future luck: there'd be no more beavers for him.

Not that hunting beavers was very easy to begin with. The crepuscular beaver is generally only active at night and is seldom far from a quick escape route into the water. Its lodges were equipped with escape routes, too, and a frustrated hunter attempting to bash open a well-made beaver lodge would find it an exercise in futility.[17] The beaver's eyesight is acute for a rodent, and its highly sensitive sense of smell can detect a human or other troublesome animal at a considerable distance. Once potential danger is detected, the beaver will rapidly slap the water with its tail, sending the alarm to others whether above ground or underwater.

Hunted sparingly and allowed to flourish along the quiet waters of the Aquahung, the beavers' engineering projects here and there may have altered the course of the river. Some of their more spectacular dam constructions were said to have drawn European settlers to particular places along the river, where they would repurpose the beaver ponds into millponds to drive their water wheels. The picturesque dam at Scarsdale was one such colonial millpond, and it is believed to have been built on an old beaver dam. Likewise, the original dam at Underhill's Crossing, which became present-day Bronxville, was said to have been situated at a spot where beaver dams had conveniently altered the course of the river.

Dismissing native tales of the Old Wise Ones, European incomers saw the Bronx River's beavers purely as an economic resource. Back home, the Eurasian beaver (*Castor fiber*) had been hunted nearly to extinction by the end of the Middle Ages, and by the time the Dutch founded New Amsterdam, hardy hunters had begun crossing the Urals in search of beavers in Siberia.

In Europe, the beaver's aquatic habits had hastened its doom. Seeing how it lived in the water, medieval churchmen deemed it a sort of fish, meaning that roasted beaver tails were a permissible dish during the long meat-less Lenten fast.[18] Beavers were also hunted for their anal glands, which secreted the castorum with which they groomed and waterproofed their fur. Worth nearly its weight in gold as a headache remedy, castorum's benefits were not mere superstition—the beaver's habit of gnawing on willow bark concentrated salicylic acid in the castorum, bringing relief for aristocratic head-thumpers brought on by many a merry beaver-tail feast.[19]

The Protestant Dutch may no longer have been concerned with what to eat during Lent, but they saw in the abundant North American beaver another sort of bonanza: hats. Too rough-looking to be a fashionable fur in itself, the value of the beaver's pelt lay in its wooly undercoat. Not for nothing would the motto of the British Hudson Bay Company be *Pro pelle cutem* ("the skin for the wool"). The barbed hairs of the undercoat, or duvet, could be steamed and pressed into a durable and water-resistant felt, just the thing for making the large, wide-brimmed hats that were then coming into fashion. An expensive bit of headgear, a big black "Dutch masters" beaver hat did a masterful job of keeping the rain off your face while letting everyone know that you were a person of consequence.

The Dutch West India Company founded New Netherland primarily for fur trading. New Amsterdam was the outlet for furs sent down the Hudson Valley, as well as from throughout the colony, which the Dutch defined as stretching from the Delaware River to the Connecticut River. The fur trade of New Netherland got off to an impressive start: the same letter that noted Pieter Minuit's purchase of Manhattan also inventoried some 7,246 beaver pelts shipped out that year of 1626.

The complex journey of beaver furs from river to noggin made the hats expensive and desirable. The long guard hairs first had to be removed, and then the undercoat had to be separated from the skin. The furs were not processed in New Amsterdam. Instead they were shipped to *old* Amsterdam, where they were often outsourced to factories in Russia, where processors had a special method of separating the fur that was a closely guarded trade secret.

The beaver's wool would then be sent back to Amsterdam to be processed into felt. Felters used mercury salts dissolved in nitric acid to prepare the wool for efficient felting. This was known as "carroting" from the reddish tips it left on the ends of the hairs. Released by the steam when the wool was pressed into felt, the consequent mercury poisoning often left its destructive effects on the minds of the felt makers, leading to the phrase "mad as a

hatter" (and also the word *mercurial*). Skilled hat makers would then turn the beaver felt into elegant chapeaux, to be shipped anywhere in the world where there were bare heads and loose gold.

To the Native Americans, the allure of the European goods they could get for beaver pelts proved irresistible, and the pelts of the Old Wise Ones soon became a trading commodity. The fur trade meant wealth to the Native Americans as much as it did to the Europeans. "The beaver does everything perfectly well," one Native American remarked. "It makes kettles, hatchets, swords, knives, bread; in short, it makes everything."

In New Netherland, beavers were soon being hunted and trapped on a previously unimaginable scale, and it wasn't long before the Bronx River Valley was hunted out, although a few beavers stubbornly lingered on the Bronx River until the end of the 1700s.

The beaver fur trade would continue for another two centuries, moving on from New Netherland into the farthest corners of North America. By the time the trade sputtered out in the late 1800s—done in by scarcity, changes in fashion and new felt-making technology—trappers would seek beavers in northwest Canada, the Rocky Mountains and down to the headwaters of the Rio Grande.[20] By then, the beaver was entirely extinct in New York State, and in the early 1900s, conservationists would relocate beavers taken from the remnant population on the upper Rio Grande to the Adirondacks in an effort to reintroduce them. These unwilling emigrants would flourish in their new home, but it would take over a century for their descendants to find their way from Old Forge back to the Bronx River.

Chapter 4

VREEDLANDT

B y the time Jonas Bronck died in 1643, the Bronx River had once again become a boundary, this time marking the western edge of a territory the Dutch named Vreedlandt, or the "Land of Peace," extending from the Bronx River to the shores of Long Island Sound. An early example of clever real estate marketing, Vreedlandt was a Dutch attempt to put a buffer between them and the growing Yankee colony of Connecticut.

By the 1640s, settlers from Connecticut were posing a problem to Dutch attempts to maintain the borders of their thinly colonized New Netherland. In vain did they point out that the claims of New Netherland extended to the Connecticut River—the Connecticut men could say in reply that *their* colony extended all the way to the Pacific Ocean. Since the Dutch didn't have enough immigrants of their own to fill the disputed ground between the Bronx River and Connecticut, they opted for a compromise solution that allowed English incomers to settle in Vreedlandt, provided they acknowledged Dutch authority in the area. Calling it the "Land of Peace" would surely make it attractive to English settlers seeking to avoid rising conflicts with the Dutch, Native Americans and one another.

The first of these English immigrants arrived shortly before Bronck's death. As religious refugees for whom the tolerant atmosphere of New Netherland was preferable to theocratic New England, they were willing to acknowledge Dutch authority with little demure. Anne Hutchinson had been expelled from Massachusetts for her antiauthoritarian religious views and settled down in the eastern part of Vreedlandt, near the river that would eventually

bear her name. Hutchinson was followed by John Throckmorton, whose theological views had also made him an uneasy fit in either Massachusetts or Connecticut. His group would settle in the southern part of Vreedlandt, and he would give his name to Throgs Neck.

Hutchinson and Throckmorton had barely settled down before a massive Indian war, instigated by Dutch governor William Kieft, gave the lie to the name of Vreedlandt. Nicknamed "William the Testy" by Washington Irving, Kieft's "first strike" policy, by which he opened the war by massacring Indian settlements at Pavonia and Corlear's Hook, set the tone for what (by Native American standards) would become an exceptionally vicious and bloody conflict.

The same year of Jonas Bronck's death in 1643 saw the massacre of Anne Hutchinson's family by the Siwanoys along with an attack that destroyed and dispersed John Throckmorton's settlement. Like Jonas Bronck, Hutchinson and Throckmorton would both leave their names on the landscape, but the name of Vreedlandt would become no more than a brief historical footnote.

Under a new governor, Peter Stuyvesant, the Dutch nevertheless tried to continue with the Vreedlandt policy. After an initial attempt to expel them, Stuyvesant in 1654 allowed incomers from Connecticut to establish a town that the Dutch named Ostdorp ("East Village") but which the settlers would call Westchester, part of the vast landholdings that Thomas Pell had purchased from the Native Americans with little reference to the Dutch. Ten years later, in the spring of 1664, Edward Jessup and John Richardson ventured across the Bronx River to purchase a tract of land on the west bank from nine Weckquasgeek sachems. Quickly settled by Connecticut farmers, this new settlement located west of Westchester became known simply as the "West Farms."

Jessup and Richardson had earlier made a separate deal with the Native Americans for the peninsula of Quinnahung at the mouth of the Bronx River, which they divided between them. Jessup's portion was shortly after bequeathed to his son-in-law, Thomas Hunt, and the peninsula would become known as Hunts Point.

Both Westchester and West Farms were located at the heads of navigation for their respective waterways, giving the farmers outlets for their produce at a time when it was easier to send produce to New York by water than over such rough roads and trails as then existed. West Farms, however, had something that Westchester lacked: water power. The fall of the Bronx River above West Farms created opportunities to build English-style water mills that could provide more dependable power than the Dutch wind or tidal mills, and sometime in the early 1670s (the exact date is uncertain), William Richardson

Connecticut Yankees built the first mills at West Farms in the 1670s, beginning the Bronx River's industrialization. *Library of Congress.*

built the first dam and mills on the Bronx River at West Farms. Beginning with a gristmill and a sawmill, these became known as "Richardson's Mills" and marked the beginning of industry on the Bronx River.

The establishment of one industry often fosters another, and the existence of a sawmill at the head of navigation at West Farms prompted an early venture into shipbuilding on the Bronx River. A bill of sale dated November 30, 1676, tells of the ship *Susannah* that John Leggett "built in Bronck's River near Westchester, together with masts, lay boat and other materials." Leggett sold the *Susannah* to the New York merchant Jacob Leysler, suggesting that it might have been intended for shipping flour and lumber from the mills at West Farms.

Richardson's Mills marked the beginning of the man-made environmental transformation of the Bronx River, and for the Westchester settlers, this meant trading fish for grind stones. As an estuarial river, the Bronx River likely saw an annual springtime migration of alewife herring. Coming from Connecticut, the West Farms settlers would have been familiar with the alewife. Used both for food and fertilizer, the alewife was an important amenity along New England's coastal rivers, where some of the earliest town laws regulated alewife fishing rights and catch limits. While there appears to be no record of alewife catches in the early years of West Farms,

Richardson's milldam, built right at the river's "fall line" between fresh and salt water, would have quickly shut down the alewife migration.

The English takeover of New Netherland in 1664 removed the last obstacle to English settlement along the Bronx River. With the Native Americans devastated by yet another Dutch-Indian war in 1655, European settlement along the Bronx River now got underway in earnest, and the river became the boundary of a number of new towns and manors. A group of ten Connecticut farmers wasted no time in taking advantage of the English takeover of New Netherland and in 1664 purchased lands from the Native Americans along the east side of the Bronx River in present-day Tuckahoe and Bronxville. On the west side of the river, Adrian van der Donck's old patroonship centered on Yonkers was divided between John Archer's manor of Fordham and that of the newcomer Frederick Philipse, who in 1693 made himself the absolute landlord of a tract that stretched from the Bronx River to the Hudson, from the Croton River on the north to Spuyten Duyvil on the south.

Philipse, though, was preceded by yet another group of Connecticut Yankees who had settled on the west bank of the Bronx River opposite present-day Mount Vernon. Claiming squatters' rights in the face of Philipse's claims, the settlers brought their case to court and succeeded in getting a one-square-mile-tract of land exempted from Philipseburgh Manor. Bounded by the Bronx River, the settlement became known as "the Mile Square." It would be a thorn in Philipse's side and a source of trouble for his grandson.

A few years later, Caleb Heathcote created the manor of Scarsdale across the river from Philipseburgh. Hailing from the Hundred of Scarsdale in England's Derbyshire, Heathcote named the place after his old home, but the name—"scars" meaning rugged outcrops of rock—applied equally well to his new estate along the Bronx River. Granted manorial rights by the British Crown in March 1701, Heathcote quickly sealed the deal with a purchase from the Native Americans, adding it to his purchase of a two-mile-wide land claim from Ann Richbell running from Long Island Sound to the Bronx River.[21] He expanded his purchase a few months later in a deed signed by sachems Patthunke, Beobo and Wapetuck for an additional tract of land on "Bronxes River."

With the English came increasing numbers of enslaved Africans. While slavery itself didn't arrive with the English (the first slaves were brought in by the Dutch in 1626), New York would attain the greatest per capita concentration of slaves of any colonial American city except for Charleston, South Carolina. Indeed, one of the first official acts of the new English government in 1664 was a warrant for the arrest of a runaway slave from New England who had fled

across the border to Vreedlandt. The first population count of the Manor of Scarsdale in 1712 recorded twelve inhabitants, seven of whom were slaves.

Frederick Philipse owned slaves and also trafficked in them, but the lands of his manor were mainly farmed by rent-paying tenants. The first enslaved Africans in the Bronx were probably those brought from Barbados by Richard Morris following his purchase of Jonas Bronck's tract in 1668. In 1697, Bronck's Land officially became the Manor of Morrisania, whose wheat fields were worked by a combination of tenants, indentured servants and slaves.

Another powerful family was established on the Bronx River in 1738 when Richardson's Mills were bought by Peter DeLancey, who promptly became known as "Peter of the Mills." The DeLanceys were a well-established merchant family of Huguenot ancestry, and they had substantial landholdings on the lower east side of Manhattan. Peter himself was the younger brother of Royal Governor James DeLancey, and his West Farms estate encompassed much of the present-day Bronx Zoo. The DeLancey mansion was built on a rise of ground on the east bank of the river, from which Peter could keep an eye on his mills. Peter named his eldest son James in honor of his grandfather, and this James DeLancey would grow up to become an infamous figure along the Bronx River.

A source of pride and wealth, the DeLanceys learned that the Bronx River could be a source of trouble and tragedy as well. A legacy of the post-glacial torrents that carved out the Bronx River Gorge, the river bottom in and around West Farms is dotted with a number of potholes. Known as "suck holes," the action of the swirling waters in these potholes can drag down an unwary swimmer. In 1760, Peter's son Warren drowned in one of these suck holes, perhaps after taking a shortcut across the river by wading through the deceptively shallow waters below the main milldam, as it was suggested.[22] Flash floods caused trouble, too. In January 1767, a sudden midwinter flood damaged the mills and demolished a storehouse in which a number of the DeLancey slaves had taken shelter, sweeping away apples, cider barrels and people. An all-out effort rescued the slaves without loss of life, and the apples were left to bob downstream.

The DeLanceys often entertained visitors, and no visit would be complete without a carriage ride around the estate on which they would show off one of the more curious wonders of the Bronx River: the ninety-ton glacial erratic that still stands today in the Bronx Zoo. To the amazement of visitors, the "Rocking Stone" could be swayed by a single person, although legend has it that a team of twenty-four oxen once failed to dislodge it.[23]

One of the DeLanceys' guests may have left a most unusual housewarming gift. The Scotsman John Loudon McAdam came to New

York in 1770 and became a frequent visitor to the DeLancey estate, where he courted, and eventually married, Charlotte DeLancey. An innovative fellow, young John may already have been thinking of the road building technique that would eventually bear the name of "macadam." Story has it that McAdam tested his idea by rebuilding the driveway to the DeLancey mansion, which would have made it the world's first macadamized road. Present-day (and perhaps not coincidentally named) Adams Street follows the line of the old DeLancey driveway.

One Bronx River visitor the DeLanceys would most certainly *not* have entertained bore tidings of the impending conflict that would eventually cause the DeLanceys to lose their West Farms estate and force some of them into permanent exile. As colonial development advanced, the Sacherah Trail from Kingsbridge was utilized by the Europeans, who called it the Old Westchester Path. In 1693, farmer John Williams erected a bridge to carry the path across the Bronx River (giving the name to Williamsbridge), and the Old Westchester Path, which linked up with the Pequot Path in Connecticut, was designated a royal post road. By the mid-1700s, the Boston Post Road had evolved into the country's first interstate (or rather inter-colonial) highway, linking Boston and New York.

Gather my children and you will hear about the *other* rides of Paul Revere—the ones that took him across the Bronx River.[24] While his famous midnight ride got him into the history books, Paul Revere's more important service to the American Revolution was as a long-distance courier, carrying news and messages back and forth between Massachusetts and the Continental Congress meeting in Philadelphia.

A horseback ride from Boston to Philadelphia was no small undertaking. The unpaved Boston Post Road offered, at best, a bone-jarring ride of several days, but Revere had the skill and stamina needed to repeatedly make the round trip. As the country edged closer toward rebellion against the Crown, it was crucial to maintain a secure line of communication to keep the Continental Congress in Philadelphia informed of developments in Massachusetts.

The contents of Revere's saddlebags bore the portents of a coming conflict that would bring terror and devastation to the Bronx River Valley. In June 1775, George Washington followed Revere's route when he traveled up the Boston Post Road to take command of an American army now in open armed conflict with the forces of the British Crown in Boston. For the DeLanceys, summer afternoon carriage rides to the Rocking Stone would soon be replaced by more deadly undertakings.

Chapter 5

BATTLEGROUND

For a few crucial days in the autumn of 1776, the Bronx River held center stage in American history, as it played a significant role in the Battle of White Plains.

Having forced the British out of Boston, George Washington led a triumphant American army down the Boston Post Road to New York in the spring of 1776, but during the summer that followed, the war went badly for them. A massive force of British and Hessians arrived in New York Harbor in July with the intent of capturing New York City. The Americans lost the Battle of Brooklyn at the end of August, and Washington was barely able to get the battered remnants of his army across the East River to Manhattan. In mid-September, the British crossed onto Manhattan Island hoping to trap Washington in New York City, but a leisurely British advance gave the Americans time to slip past them to the high ground in Harlem. Facing down the British from Fort Washington and Harlem Heights, the Americans were nearly trapped again when British forces landed in the east Bronx with the aim of marching westward and seizing the bridges connecting Manhattan with the mainland. The British, though, were stalled by spirited defenses at Westchester Creek and Pell's Point, and in the meantime, Washington had hurried most of his army off Manhattan Island and northward toward the safety of the Hudson Highlands.

With the British gathered in Mamaroneck and New Rochelle on Long Island Sound, the safest escape for the Americans would have been to head straight north along the banks of the Hudson. Instead, they turned inland to White

Long before his midnight ride, Paul Revere rode across the Bronx River bearing communications between Boston and Philadelphia. *Library of Congress.*

Plains, even though this took them in the direction of the enemy. Vital supplies were stashed in White Plains, and after the material losses of the past summer, Washington couldn't afford to lose another barrel of flour. He would have to somehow get his troops to White Plains ahead of the British and hold it long enough to get the slow-moving supply wagons out of town and safely up the road to Peekskill.

The trick was to get from Kingsbridge to White Plains without running into the British army along the way, and the available maps of Westchester County were neither detailed nor dependable. About the only thing anyone could say for sure about White Plains was that it was in the middle of Westchester County and that the "Brunks" River flowed through it. With the British poised only a day's march from White Plains, the Americans couldn't chance wasting time with a wrong turn, so Washington sent Colonel Rufus Putnam ahead to scout out the route while keeping an eye out for encroaching Redcoats. Putnam found a road to White Plains running up the west side of the Bronx River, and the Americans, keeping the river between themselves and the British, made their way to White Plains.

Fortunately, the Bronx River rose to the occasion to protect the bedraggled Americans. Situated between high rises of ground, the Bronx is known as a "flashy" river, quick to rise after even small amounts of rainfall. Although it had been a dry summer, recent rains had put the Bronx into one of its flashy moods, and it was running high that last week of October. British patrols ranging east of the river could glimpse the American wagon

train strung out on the western side, but lacking bridges and finding no place to safely ford the high running water, they were unable to interfere.

In 1776, White Plains was a small crossroads town, where one of the few bridges over the Bronx River linked the road from Mamaroneck with roads to Tarrytown and Dobbs Ferry on the Hudson, and the White Plains (or York) Road came up the east side of the Bronx River from Williamsbridge. White Plains' central location made it a crucial place to have in order to command central and southern Westchester,[25] but for the moment, Washington's only concern was getting those flour barrels out of town. There was no telling when the British in Mamaroneck would finally get moving, but once they did, White Plains was only a short day's march away.

Washington would have to make a stand in White Plains long enough for the wagons to get safely northward. Luckily, the flat ground of "the White Plains" abruptly ended in a chain of rising hills just north of the town, covering the road to Peekskill and offering good defensive terrain for an American battle line anchored by Silver Lake on the east and the Bronx River on the west. Casting worried glances down the road to Mamaroneck, Washington ordered his troops to dig in while he dispatched four regiments down the river to Scarsdale to provide an early warning of the British advance.

Almost as an afterthought, Washington posted several regiments on Chatterton Hill, which sharply rose 465 feet above the west bank of the Bronx River. Troops and cannons on Chatterton Hill would threaten the British from the side if they deployed on the flat plain to attack the American main line. Ordered to "do the best you can," the Americans fortified the hill's rocky crest with cornstalks, while a young artillery captain named Alexander Hamilton placed his two-gun battery near the hill's highest point.

The British finally arrived on October 28. Several regiments of British Redcoats and their hired Hessian allies[26] were ambushed as they probed along the Scarsdale/Hartsdale border, but this only proved to Washington that the main British force would be heading straight for White Plains down the Mamaroneck Road. Firing from behind a succession of stone field walls, the Americans in Hartsdale gave the British and Hessians a good mauling before retreating through the open farm country toward a ford on the Bronx River below Chatterton Hill.

The British and Hessians cautiously pursued the Americans, but at the ford, the Bronx River's high-running waters made them hesitate. Ordered to cross the chest-high water, the heavily laden Hessians and Redcoats slowly waded through the Bronx River, while the retreating Americans scrambled up Chatterton Hill to join the units already posted there.

Now it was the British commander's turn to pause. As he deployed his troops on the flat plateau of the White Plains, General William Howe was taken aback to see Americans entrenched on the rising terrain north of the town and, worse, atop the hill on the other side of the Bronx River. He may have hoped that a place named White Plains would offer the opportunity for the sort of flat, European-style battlefield to which his soldiers were accustomed. If so, he was disappointed. At the Battle of Bunker Hill in 1775, Howe had learned firsthand how lethal Americans could be once they were dug in on high ground. Unlike European armies, which stood up and maneuvered on chessboard battlefields, the Americans didn't play fair, hiding behind stone walls and breastworks and blasting their attackers with a deadly combination of "buck-and-ball."[27] Still, despite the high-flowing Bronx River and the Americans atop the steep hill beyond it, there was no other option for Howe. In order to assault the Americans north of the town, his troops would first have to turn to the west, cross the Bronx River and capture Chatterton Hill.

The Bronx River aided the American defense: the high water slowed up the assault and left the Hessians and Redcoats facing a climb up the rocky slope

Battered but unbroken American army soldiers stood off the British and Hessians at the battle of White Plains, its flank secured by the high waters of the Bronx River. *Library of Congress.*

60

in sopping-wet uniforms while the Americans fired down upon them. Making things worse, the eight-gun British battery deployed on the lower elevation of Fishers Hill found it difficult to target the crest of Chatterton Hill.[28] Shots fired too low missed the Americans and instead sent six-pound iron cannonballs bouncing down into the struggling British and Hessians. Volleys from the men on the slope likewise proved less than effective due to the tendency of men firing uphill to overshoot. Twice they attempted to storm the hill, and twice they were driven back with mounting casualties.[29] At this point, a regiment of Hessians that had previously forded the river below Chatterton Hill was ordered by its aggressive colonel to charge up its southern slope to support the third assault coming up the eastern face.

Facing two converging enemy forces, the Americans made an orderly retreat down the north side of the hill and across the bridge over the Bronx River to rejoin the main army. Guarded by a forward line of American entrenchments, the bridge was too well covered by muskets and cannons, so Howe made no move to interfere with the retreat. For their part, the Hessians and British atop Chatterton Hill made no effort to pursue either. Their orders had been to take the hill, and they had done exactly what they had been told to do.

What had seemed an easy battle was proving unexpectedly difficult, so General Howe paused to call up reinforcements, while the Americans manned their fortifications, their western flank still protected by the high-flowing Bronx River.[30] And the river would rise still higher. For the next two days, it rained, making it impossible to fire the flintlock muskets of the day and forcing a postponement of the British attack. By the time the weather cleared on the morning of November 1, Washington had pulled his army back and now occupied an even stronger position about a mile to the north.

Once again, an opportunity to trap Washington had been lost, partly thanks to the swirling waters of the Bronx River. With winter coming on, Howe didn't want to follow Washington into the ever more rugged terrain of the Hudson Highlands. After mounting half-hearted assaults on either end of Washington's line, at Miller Hill on the west and Merritt Hill on the east, Howe called off the battle. By eighteenth-century standards, he could claim a victory, and the tattered Americans were going nowhere but to retreat farther north. Instead, Howe turned his forces around and marched back to Manhattan to capture the American garrison left behind at Fort Washington and secure the summer's conquest of New York City.

White Plains thus became a battle from which both sides retreated. Although termed inconclusive by many historians, the Battle of White Plains was a significant event in the struggle for American independence,

and it had several outcomes. Primarily, it marked the failure of the last opportunity to trap Washington and end the Revolution. The day's events also marked the arrival of the Hessians as a respected fighting force. British officers may have been uncertain about these newly arrived "auxiliaries," with their funny-looking waxed moustaches and pigtails, but their difficult attack across the Bronx River and up Chatterton Hill proved their dependability as assault troops, a role they would increasingly fill as the war went on.

The Battle of White Plains also helped make the careers of three people. The young Captain Alexander Hamilton distinguished himself that day atop Chatterton Hill by his cool handling of his two-gun battery (quickly reduced to one by British fire) and would go on to become a key aide to George Washington and eventually a founding figure of the new American republic. The Hessian colonel Johann Rall also won credibility through the initiative he had shown that day in attacking the south face of Chatterton Hill. Distinguishing himself again a few weeks later in the attack on Fort Washington, in December he would be given command of a place called Trenton on the Delaware River, there to be killed in Washington's cross-Delaware attack the day after Christmas.[31]

Lastly, the Battle of White Plains marked the origin of the "Headless Horseman," the hapless Hessian who, according to legend, lost his head at Chatterton Hill and, forever searching for it, found his way down the Tarrytown Road and went on to haunt Sleepy Hollow. Washington Irving would later make him a classic tale of the folklore of the Hudson Valley, but the Headless Horseman was born on the Bronx River.[32]

As the armies marched away, the late autumn twilight closed around the debris and unburied dead on Chatterton Hill,[33] but it would not be the Bronx River's only moment in what would prove to be a long and bitter conflict.

NEUTRAL GROUND

In 1818, a young James (not yet Fenimore) Cooper settled down on a Scarsdale farm and sought to combine a literary career with the life of a gentleman farmer. Legend has it that Cooper, annoyed one evening by a mediocre English novel, decided to write his own book and make a better job of it. His first effort, an English-style novel titled *Precaution*, met with little applause, and his friends urged him to seek out a more American theme for his next book.

Such a theme lay right on his doorstep there by the Bronx River. Since moving to Scarsdale, Cooper had heard a lot about the dark days of the Revolution, which had played out along the river less than forty years before. Cooper's wife, Susan Augusta DeLancey, came from a notorious Loyalist family, although Susan's father, John Peter DeLancey, a retired British army officer, was able to return to his family lands in Mamaroneck after the war. John Peter had made his peace with the new republic, but the DeLanceys were acutely aware that their family name was a curse word in some parts of the valley.

The war was still a living memory in the neighborhood. Locals recalled how the opening clash of the Battle of White Plains took place just down the hill from Cooper's home, as well as how a family hid their last cow from American raiders in a cottage that still bore damage from the attack. Another nearby house was pointed out as General Howe's headquarters, but Cooper's friend and neighbor John Jay had a more interesting tale to tell. Jay had been a member of the "Committee for Detecting Conspiracies" during the war, and he told Cooper how he had once managed his own secret agent—a man who, even years later, he would not name.

Gathering the tales he heard and the history he learned, Cooper produced a historical novel that would be his first success and one of the first American-written bestsellers. *The Spy; or, A Tale of the Neutral Ground* would be set in the troubled lands of Westchester County and the Bronx River Valley, and its central character, the peddler/spy Harvey Birch, is believed to be based on the exploits of a farmer named Enoch Crosby, whom Jay had recruited to gather information on Loyalists and "disaffected persons." John Jay, ever the ethical spymaster, didn't reveal Crosby's identity when he told Cooper his war story, and Cooper, for his part, would always deny that he had based Harvey Birch on Enoch Crosby. Crosby himself had no such qualms and was happy to claim the credit given him in H.L. Barnum's 1828 book, *The Spy Unmasked; or, Memoirs of Enoch Crosby, alias Harvey Birch.*[34]

Crosby was only one of a number of shadowy characters who roamed along the Bronx River in those years. Throughout the Revolutionary War, the Bronx River Valley lay in what was termed the "Neutral Ground," but this placid term in fact denominated a no-man's-land gripped in a bitter civil war in which nobody was allowed to remain truly neutral.

In the eighteenth century, warring armies did not remain in constant confrontation with one another. Between battles and campaigns, they kept a respectful distance, using scouts and patrols to gauge one another's movements and intentions. After the Battle of White Plains, the British army abandoned most of Westchester, pulling back to guard its fortified approaches to the Harlem River crossings. The Americans, for their part, maintained their position in the hills around Peekskill, eventually extending their lines down to White Plains, where the old battleground of Chatterton's Hill became their forward outpost overlooking the Bronx River. The ten-mile swath between White Plains and Kingsbridge was dubbed the Neutral Ground. Both sides would try to control the Neutral Ground; neither fully succeeded.

In such a shadow realm it was vital to know who was who and what they were up to. Venturing through the Neutral Ground and the militarily sensitive zone of the Hudson Highlands, Crosby played a dangerous game. His mission was to discover those of Loyalist sympathies, find out to whom they were connected and learn what trouble they might be plotting. Posing as an itinerant shoemaker, he would often carry papers such as amnesty proclamations that would convince people that he was a British agent. In the course of his work, he was busted several times by the Americans, and his repeated "escapes" eventually raised doubts among the Loyalists, while Patriot vigilantes kept his name on their hit list. Legend has it that his house

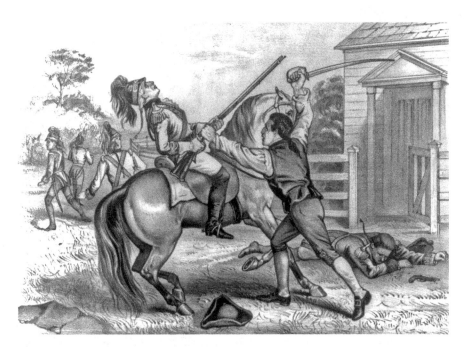

In the Neutral Ground, no one was allowed to remain truly neutral. James Fenimore Cooper's novel *The Spy* was inspired by Revolutionary War incidents along the Bronx River. *Library of Congress.*

was raided one night by both sides simultaneously. The Patriots showed up first, damned Crosby for a Tory and relieved him of his cash, only to be met on the doorstep by the arriving Tories, who promptly robbed the Patriots while cursing Crosby for being a rebel. While this may be just a tall story, it illustrates the dilemma of those living in the Neutral Ground.

Support for the Revolution was by no means unanimous in lower Westchester, and a substantial number of people, for whatever reasons, remained loyal to King George. One prominent Loyalist was the anonymous author of *Letters of a Westchester Farmer.* A series of four pamphlets issued between 1774 and 1775, the *Letters* reflected on "the present confused and distressed state of this, and other colonies" and argued against the movement toward revolt and independence. Considered to be one of the most cogent statements of the Loyalist position, the author of *Letters of a Westchester Farmer* is today known to be Reverend Samuel Seabury of St. Peter's Church by Westchester Creek, but at the time, some speculated that they may have been written by a real Westchester farmer, Elijah Cornell of Cornell's Neck (present-day Clason Point) on the Bronx River estuary.

The most prominent Bronx River Loyalists were the DeLanceys of West Farms, but while they would play major roles in events along the river in the coming years, the Revolution also brought division to this family. James DeLancey would become one of the war's most infamous fighters, but not all members of the family chose to make war on the Americans. For her part, James's mother, Elizabeth, left no doubt as to where she stood, naming their West Farms mansion "Union Hill" in honor of the United Kingdom. Their neighbors and political rivals, the Morris family of Morrisania, would also be a divided clan—Lewis Morris would sign the Declaration of Independence but had to flee his estate for the duration of the war, while his mother, Catherine, stayed behind and proclaimed her support for the king.

In late January 1777, the Americans came south to engage the British. By then, the long retreat that followed the Battle of White Plains had turned around with the victories at Trenton and Princeton. Moving his army into a new winter base at Morristown, New Jersey, Washington ordered his remaining forces in Westchester to divert British attention by attacking their Kingsbridge fortifications. Boldly approaching the British entrenchments, American general William Heath had the misfortune to find himself facing Colonel Robert Rogers, whose exploits as the commander of Rogers' Rangers during the French and Indian War was the stuff of legend. Rogers by then was only a shadow of his former self, but he still had an aggressive spark in him and abruptly ended the siege with a surprise attack that scattered the Americans. A redoubt dug near the crest of the high ground overlooking the Bronx River crossing at Williamsbridge fixed the hill's name ever after as "Gun Hill."[35] The site of the "Old Redoubt" is marked today with a plaque in Woodlawn Cemetery.

More action would follow, as American raiders returned in the spring of 1777, following the White Plains Road east of the Bronx River to attack the Tories at West Farms. A cross-river firefight at Williamsbridge kept the British from attacking the withdrawing Americans, and for more than one hundred years after, a red-painted house in Williamsbridge would be pointed out as the "Revolution House," its planks and window frames said to be shot full of musket balls from that violent afternoon.[36]

In the void between Kingsbridge and White Plains, ordinary farmers and civilians were left to the mercies of either side. Those who could go somewhere else did so; others who couldn't made the best of things. The scouts and patrols sent out by the two armies were only part of the trouble. Militia bands and groups of freelance vigilantes terrorized those believed to be supporting the other side; worse still were the bands of men who claimed allegiance to one side or another but who, in fact, often served no cause but

their own. Pro-American "skinners" descended on Loyalist farmsteads, and their nickname aptly described the thoroughness with which they cleaned out their victims' food and valuables. Skinners were also notoriously adept at trashing the houses they invaded, even going so far as to rip down the wallpaper, which may have inspired their nickname. Then there were the pro-British "cow-boys" who raided the Patriots.

By the end of 1776, intimidation and attacks by Patriot militia and vigilantes on "disaffected elements" had driven many Loyalist families southward to West Farms to seek safety with the DeLanceys. For his part, James DeLancey set about fortifying his West Farms estate into a Loyalist stronghold guarding the main refugee camp clustered around the Morris estates two miles to the south. A log blockhouse was built to defend "DeLancey's Bridge" at what was then the southernmost crossing of the Bronx River, while DeLancey organized a raiding force from among the unemployed refugees.

The first cow-boys splashed not across the Rio Bravo but across the Bronx River. Sallying forth from his West Farms stronghold, James DeLancey led his "Westchester Refugees" in attacks on Patriots up and down the Bronx River Valley. Carried out partly in reprisal for American raids, these forays also supplied the unit's cash flow. The British commanders in New York never recognized the Refugees as a regular Loyalist unit, and perhaps DeLancey, preferring to run his own private war, didn't really want them to. But this meant that they only drew pay on the rare occasions when they were officially called upon to assist a British military operation—a total of just fifty-one paid days out of a seven-year conflict.

Living at the end of a fitful three-thousand-mile supply line, the soldiers in occupied New York were always in need of food and were willing to pay serious money for beef on the hoof. DeLancey was happy to oblige, confiscating cattle from farmers he knew to be Patriot or who were perhaps just not emphatic enough in declaring their loyalty to the Crown. DeLancey had been the high sheriff of Westchester County before the war, so he knew not only the lay of the land but also who stood where politically. Driving the rustled cattle to Kingsbridge, DeLancey's men were dubbed "cow-boys" (and the word would remain an insult well into the twentieth century, western movies notwithstanding).[37]

One of DeLancey's most lucrative raids was in October 1777, when he took his Refugees up to White Plains. Cleaning out several Patriot farms, the raiders came home with three hundred sheep and hogs, nearly one hundred cattle and forty-four barrels of flour, plus two teams of oxen to help haul the loot.

Equally ruthless were the Queen's American Rangers, a Loyalist regiment led by Colonel John Simcoe. Officially clad in green uniform jackets, though often wearing linen hunting shirts, the Queen's Rangers became one of the most effective Tory units of the war and a force to be feared along the Bronx River. Simcoe, with some help from DeLancey, would bring about one of the bloodiest incidents on the Neutral Ground.

On August 31, 1778, the Queen's Rangers set up an ambush along the Mile Square Road at present-day Van Cortlandt Park East. Simcoe positioned a second force of DeLancey's Refugees out of sight down the hillside by the Bronx River and a third group at a farmstead to the west. Their target was a patrol of pro-American Indian scouts that would be coming down the road to get a glimpse of the British defenses at Kingsbridge. These men, Wappingers from Dutchess County who had moved to the Christian mission school at Stockbridge, Massachusetts, had been serving the American cause since the siege of Boston in 1775. Led by Sachem Daniel Ninham and his son, Captain Abraham Ninham, they contributed their talents to the Patriot cause as scouts and guerrilla fighters. Simcoe had a personal score to settle with them: a week before, the Stockbridge men had bested some Queen's Rangers in an ambush. His unit's pride besmirched, the irate colonel was out to exact his revenge.

About one mile south of the Mile Square, Simcoe sprung his ambush, and the Stockbridge men found themselves caught between converging forces and fell back to defend themselves from behind stone walls. No quarter was asked or offered, and by the end of the day, the bodies of Daniel Ninham and seventeen of his men lay on the field, while the broken survivors made their way back up the Mile Square Road. The Battle of Kingsbridge (or the Stockbridge Massacre) is commemorated by a monument in Van Cortlandt Park nearby the mass grave of Ninham and his men.[38]

As bands of armed men ranged its length, the Bronx River became the scene of any number of unrecorded skirmishes and firefights. One that passed into legend gave the river's marshlands above White Plains the gruesome name of "Dead Man's Lake." When local Patriots came upon the body of one of their number floating in the water, killed by local Tories, the Patriot leader Nicholas Odell plotted payback. Knowing that a group of Tories that had gone to raid in Connecticut would be passing by the lake on its way home, he laid an ambush for the men. It was the middle of winter, with the lake and river frozen over. Patriot patience was rewarded when the ambush was sprung on the surprised Tories. Outnumbered and outgunned, they tried to flee the ambush by crossing the ice. The ice broke, and some fifteen Tories drowned in the frigid waters of

the Bronx River. The spot, known to gentler folk as Willow Hole, was for years after called "Dead Man's Lake."

In this irregular tit-for-tat war, river crossings became strategic spots. The lower Bronx had only three good crossings: Williamsbridge was guarded by the Old Redoubt and the proximity of the Kingsbridge forts, and the crossing at West Farms was overseen by a stout log blockhouse, leaving only a ford in between the two. Upstream crossings at Ward's Bridge in Tuckahoe and Hunt's Bridge at present-day Mount Vernon came with handy wayside taverns, making them agreeable forward bases for American raiders and patrols.

Hunt's Bridge stood dangerously far south for the Americans, but on the western bank of the Bronx River, there was a staunchly pro-American enclave known as the Mile Square. The Mile Square was just that, a tract of land exactly one mile square whose eastern boundary was the Bronx River. The whole west side of the Bronx River, from Croton to Spuyten Duyvil, was the Manor of Philipseburgh, owned by Frederick Philipse III, but Connecticut settlers in the Mile Square had successfully claimed squatters' rights and got their patch exempted from the manor. Tenants of the manor were entirely at the mercy of Frederick Philipse, but the independent farmers of the Mile Square owed nothing to anybody and cared as little for King George as they did for Fred Philipse. It was the men from the Mile Square who had organized the Committee of Safety in September 1776 that arrested Frederick Philipse after he forced his tenants to sign a "Declaration of Dependence" affirming their allegiance to the Crown. The manor's tenants were no doubt happy to see Philipse go, but their political loyalties could not otherwise be assumed.

At Hunt's Tavern and the Mile Square, patrolling Americans could at least be assured of a friendly welcome and freely forthcoming information, plus the Mile Square Road was a convenient route down the spine of Valentine Hill and along the high ground west of the Bronx River (this was the route taken by the ill-fated Stockbridge patrol). The strategic value of Hunt's Bridge and Ward's Bridge also made them targets for reprisal raids. A follow-up raid after the 1777 Williamsbridge firefight bagged several Americans at Hunt's Bridge who thought they had outrun the British. In September 1778, the Loyalists attacked and captured Ward's Tavern; to make sure it stayed out of business, they returned two months later and burned it down.

The Stockbridge Massacre and the burning of Ward's Tavern showed that the war in the Bronx River Valley was tipping against the Americans in 1778. The depredations of DeLancey's raiders were clearly getting out of hand, but the Tories could always retreat to a secure base in Morrisania, protected by the blockhouse guarding the river crossing at today's 179th

Street. Lacking artillery, the frustrated Americans could do little more than take potshots at the blockhouse from the opposite side of the river.

An energetic new American commander would turn things around with a burning of his own. Taking command of the American forces in Westchester County at the beginning of 1779, Colonel Aaron Burr hatched his own plan to take down the proud DeLanceys.

One February night just past his twenty-third birthday, Burr led a raiding party galloping down the White Plains Road. Reaching the blockhouse, men dashed forward to toss lamp oil–filled fire bombs through the gun ports, followed by lit torches and hand grenades. In moments the blockhouse was hopelessly ablaze, and its frightened garrison tumbled out to surrender. Burr's raiders gathered the prisoners and vanished into the night without losing a man or firing a shot.

The blockhouse burned to the ground, leaving West Farms open to increasingly bold attacks from American forces. It was the beginning of the end for the DeLancey family, who at the end of the war four years later would be forced to abandon their Bronx River estate and flee the country. For the time being, though, DeLancey regrouped and continued his raids.

The work of DeLancey's Refugees became so troubling that in January 1781, the Americans stormed down the Bronx River in a determined effort to shut down DeLancey's attacks once and for all. On January 24, 1781, a force under General Samuel Parsons launched an attack against the Refugee base in Morrisania, where they killed or captured more than eighty of DeLancey's men. Setting fire to the Refugees' huts, the Americans had the satisfaction of doing a little cattle rustling of their own, making off with a sizeable herd of cattle and horses.

James DeLancey, though, was not going to be easily cowed. On May 13, 1781, he gathered what remained of his old Refugees and launched a daring raid all the way past the headwaters of the Bronx River, surprising a detachment of the First Rhode Island regiment near Pine Bridge on the Croton River. The African American soldiers of the First Rhode Island were some of the finest in the American army, but taken unawares, fifty of them were cut down by DeLancey's vengeful Refugees.[39]

Two months after the massacre at Pine Bridge, it was the Americans' turn to come down the Bronx River. In July 1781, Washington carried out a "Grand Reconnaissance" all the way to Long Island Sound. In spite of everything, Washington had never given up on the idea of recapturing New York City, and now, with a French army at his side, he wanted to scope out the British defenses and see if he could bash his way onto Manhattan Island. To clear the way, a combined French and American force under the Duc de Lazun and General

David Waterbury attacked West Farms. There they seized DeLancey's Bridge and scattered Refugee resistance, while another force pinned down the British in Fort #8 on Fordham Heights. Guided by the young Andrew Corsa, who lived upstream at Fordham, Washington and the Compte de Rochambeau proceeded down to West Farms and from there followed the Bronx River along the West Farms Road to consider possible approaches to Manhattan via either Long Island or across the Harlem River.

The Americans owned the Bronx River that day, but otherwise the prospects for an attack on Manhattan Island didn't look too promising. When word later came that the British general Cornwallis was stuck in a place called Yorktown, Rochambeau persuaded Washington to leave New York alone and take the Franco-American army south to Virginia.

The surrender of Cornwallis in October 1781 didn't immediately end the war, and while the main armies stood idle, the vicious partisan conflict continued along the Bronx River. There was little now left to rob or raid in the Neutral Ground, so the fighting became more a matter of settling old scores and getting in some last licks before the peace treaty was signed. American raiders launched several attacks during the winter of 1781–82, and each of them went badly for DeLancey's men. On one occasion, American raiders went so far as to trash the DeLancey mansion on Union Hill, and legend has it that the redoubtable Elizabeth DeLancey stalled the raiders just long enough for James DeLancey to slip out a rear window. One last attack against DeLancey's crumbling stronghold, on March 29, 1782, would prove to be the war's final action along the Bronx River.

By then the once powerful James DeLancey had seen the writing on the wall and was preparing to sail to England. Now a refugee himself, he would eventually settle in Nova Scotia. He left behind a ruined West Farms estate, a wrecked mansion and various family members, who had to decide for themselves whether to stay or to go. He also left behind his prized horse, a thoroughbred stallion named True Briton.[40] Confiscated by the Americans as a spoil of war (along with the rest of DeLancey's West Farms estate), True Briton would be sold to a Vermont farmer named Justus Morgan, who used the ex-Tory mount to sire the classic American breed known as the Morgan horse.

While the Revolutionary War brought devastation to much of the Bronx River Valley, it oddly helped preserve part of its environment. Today, the Thain Family Forest in the New York Botanical Garden is proudly pointed out as one of the very few tracts of indigenous forest on the East Coast that has never been timbered. During the war, the British, although desperate for firewood, feared the American partisans rumored to infest the place. Legend

has it that the rock shelter known as the "Bear Den" on the west bank of the river was a rendezvous for skinners, and British woodcutters kept well away from this part of the Bronx River.

Apart from the fictional story of *The Spy*, the days when the Bronx River flowed through the Neutral Ground gave rise to some legends. One often-repeated tale concerned the British attempt to sail up the Bronx River. As handed down over the years, the legend has taken various forms. One version is that they tried to sail up the river to attack the American lines at the battle of White Plains. Another has British gunboats engaged in a shootout with American gunboats in the estuary below West Farms. Perhaps the most colorful version has the British admiral ordering a frigate to probe the river channel. When the frigate ran aground on the now-vanished Ludlow Island off Soundview, the enraged admiral ordered the hapless frigate captain to be hanged from his own yardarm.

None of these tales is true, but as with many legends, they do have a thin basis in fact. Attempting to micromanage the war from three thousand miles away, Colonial Secretary George Germain was troubled by reports of American partisan activity in Westchester County when his eye turned to the blue squiggle of the "Brunks River." Taking quill in hand, he directed his commanders in New York to send gunboats up the river and blow those pesky partisans to kingdom come. The Royal Navy knew perfectly well that milldams blocked any notion of navigation above West Farms. Moreover, the lands lining the navigable estuary were in Loyalist hands, so any gunboats sent there would only be blasting their own side. We don't know how Admiral Howe reacted to Germain's memo, but no gunboats—or frigates, for that matter—ever tried to storm up the Bronx River.[41]

Had they done so, they would have spotted a tall white pine tree on the eastern bank of the river just before the first milldam at West Farms. Navy men were ever on the lookout for the straight-trunked white pines, which were perfect for making masts and spars for sailing ships. Indeed, by an act of Parliament, all such white pines in America were deemed property of the Royal Navy and couldn't be cut down without permission, on pain of felony prosecution. But the Royal Navy never got hold of this pine, which remained as a local landmark known as the DeLancey Pine (or the Sentinel Pine) until it finally died and was taken down in 1911. The story had it that the tree was used as a snipers' roost by American infiltrators taking potshots at the Loyalist blockhouse across the river.

The end of the war finally came to a devastated and depopulated Bronx River Valley. Grass grew in the once busy Boston Post Road, and it would be years before Westchester County regained its prewar population. The Bronx River, though, would soon find itself part of the economic rebound of an industrializing new nation.

Chapter 7

POST ROAD

In 1783, Lewis Morris returned at last to his estate in Morrisania. After years of serving as an encampment for Loyalists and British soldiers, Morrisania was tattered but not altogether wrecked. Lewis's half-brother, the peg-legged Gouverneur Morris, was particularly pleased to learn that under the watchful eye of his mother, Sarah, the family wine cellar had been left intact.

Lewis, though, had come home with big plans for Morrisania. With the dust of the war not yet settled, he proposed that Morrisania be designated the permanent capital of the new United States. The place had everything going for it, he pointed out. It was an elevated patch of ground situated among the waterways of a major port city, and it was free of the disease-bearing miasmas of swamps and marshes. Cleared of trees, it was wide open and ready for development.

What Morrisania lacked was a good landward connection to the city, and even though Congress didn't leap at the chance to seat itself by the Bronx River, Morris continued to pursue his ambitions. Ironically, in 1797, the Bronx did, in a way, become the capital of the United States. Heading south from Boston that October, President John Adams learned of the yellow fever epidemic raging in Philadelphia and decided to stop off instead at the Eastchester farm of his daughter, Abigail, and her husband, William Smith. For the next two weeks, while the epidemic in Philadelphia burned itself out, the business of the Executive Branch was conducted out of a (sadly, only recently demolished) Bronx farmhouse.

Cattle drovers coming down the Boston Post Road used the Bronx River to create "watered stock," adding a new phrase to the language. *Library of Congress.*

In that same year of 1797, Morris got approval to reroute the Boston Post Road through Morrisania, with the help of New York attorney general Aaron Burr. Guiding the bill through the state legislature, Burr saw to it that two of his in-laws were appointed commissioners to lay out the route.[42]

Opened in 1800, the new Boston Post Road bypassed Williamsbridge and instead crossed the Bronx River at Bronxdale, following the west bank of the river to West Farms through what today is the Bronx Zoo.[43] The rerouting of the Boston Post Road gave the old settlement of West Farms a new importance as a stopover for cattle and sheep drovers.

In the days before railroads and refrigeration, fresh meat had to be delivered "on the hoof" from upstate farms and pastures. Lopping a full two miles off the old route to New York City, the new road was a welcome shortcut to a long and dusty trail, and in West Farms, the Drovers Inn, located on the Jennings homestead at present-day Boston Road and Jefferson Place, was a welcome respite for the thirsty drovers.

It wasn't just the drovers who were thirsty, though. For the cattle drivers, a particular advantage of the new road was the proximity of the Bronx River. Coming down the last leg of the trip to Manhattan, the cattle were encouraged to drink up. Cows normally drink a lot of water—up to forty

gallons per day—and canny stockmen knew that with a handful of salt tossed into their feed they'd drink a lot more still, ensuring that the water-bloated cattle would fetch an inflated price at the market weigh-in. (This was the original meaning of "watered stock.") Having tanked up on beer and Bronx River water, both cows and drovers would head through Morrisania, over the Harlem River and down to the well-named Fly Market at the foot of Maiden Lane.[44]

Religious pilgrims traveling the Boston Post Road used another traditional site about a mile below the Drovers Inn as their own place of refreshment. At present-day 166th Street, an immense, loaf-shaped boulder of sandstone and gravel known as Pudding Rock had been a popular camping spot, as well as possibly a council rock for Native Americans. While the Lenape name for this landmark has been lost to history, to the local English farmers the huge, purplish rock shot through with small stones looked just like a great big Christmas plum pudding, and so they named it Pudding Rock.

When the new Boston Post Road opened, French Huguenots from New Rochelle would travel down the Boston Post Road to New York City, where they would join their fellows for Sunday worship at the old "French Church" on John Street. Pudding Rock, looming up alongside their route about halfway there, was an inviting spot to pull over for a rest and a picnic, and it became a beloved landmark for the Huguenot community.[45]

Although conceived by a slaveholder, the new Boston Post Road would also serve as a route to freedom. While the Hudson Valley, with its steamboats and river shipping, was a mainline route of the Underground Railroad, the Bronx River also guided enslaved African Americans northward. A subsidiary route of the Underground Railroad ran up the Boston Post Road from the Mott Haven house of Charles Van Doren at today's 145th Street. From Mott Haven, fugitives could follow the Boston Post Road to the Mapes Farm at West Farms. The Mapes family also ran a "Temperance Hotel" alongside the road, so they would have been in a good position to observe who was coming and going through West Farms and, consequently, know when it was safe for their erstwhile "passengers" to attempt the next leg of their northward journeys.

The route north of West Farms is less certain, but fugitives heading up the Bronx River would likely have been able to gain help from long-established Quaker communities in Scarsdale and Chappaqua and, from there, go on to the abolitionist nexus at Peekskill. The quiet burial ground of the Church of St. James the Less in Scarsdale has a small section where a dozen un-

The Bronx River Valley served as a route for the Underground Railroad. Sympathizers in Morrisania, West Farms and Scarsdale offered shelter to the fugitives. *Library of Congress.*

inscribed stones are believed to mark the final resting place of Underground Railroad passengers who died in the course of their freedom journey.

Aaron Burr's involvement in the new Boston Post Road may have directed his attention to the Bronx River, for the river shortly afterward featured in another enterprise of his—a proposal that would have radically altered the river and its future history.

Ever since its days as New Amsterdam, New York City had a water problem. In colonial times, people made do with water drawn from wells, as many as 250 of them, whose water often came up so brackish that even horses shied away from drinking it. North of the city, a copious spring fed the Collect Pond, and the clear water drawn from the Tea Water Pump was peddled from tank wagons to households for brewing tea and other beverages.

By the 1790s, it had become clear that the growing city could no longer depend on curbside wells and tea water wagons, and the question of how to obtain a dependable supply of healthy water began to draw the attention of enterprising minds.

The same yellow fever epidemic that stopped President Adams in his tracks gave the water issue a new urgency. Nobody at the time knew that yellow fever was borne by mosquitoes, and one theory had it that impure

water had something to do with the spread of the disease. With wagons bearing the bodies of yellow fever victims rolling past their windows, the Common Council issued a call for ideas to solve the water supply problem.

Dr. Joseph Brown, one of Aaron Burr's road commissioners, proposed in 1798 that the city tap the Bronx River by building a dam a half-mile below Williamsbridge and channel the water through Morrisania. Crossing the Harlem River via an aqueduct, the water would be pumped by a steam engine to another reservoir on the high ground of Harlem, from which it could flow down to New York City.

Dr. Brown's innovative Bronx River plan was defeated by geology, technological shortfalls and corporate mission creep. A dam at Williamsbridge would achieve an elevation of only about fourteen feet, meaning that a gravity channel through Morrisania, although feasible, would be difficult to lay out.

The high ground of Harlem posed another problem, as the quantity of water and the amount of lift required by the Bronx River project would strain the capacity of the still-primitive steam engine technology, and the sad truth was that in 1798, there was no machine shop in the United States with the skill and technological capacity to build an engine of this magnitude.

The Common Council nevertheless gave Dr. Brown's plan the green light but turned the project over to a private corporation, the Manhattan Water Company, chaired by Dr. Brown's brother-in-law, Aaron Burr. Politics and corporate mission creep now entered the picture, ensuring that the Bronx River's waters would remain untapped for the time being. Historians have debated Aaron Burr's motivations regarding the Manhattan Water Company, but whether by design or happenstance, the company's activities quickly ballooned beyond its original mission.

In the divisive political climate of the day, Burr was a prominent Democratic-Republican, while Alexander Hamilton's Bank of New York was controlled by the opposing Federalists and was unlikely to cooperate with enterprises that would boost the political fortunes of men such as Burr. Burr therefore quietly inserted a clause in the corporate charter enabling the Manhattan Company to use its surplus capital for any purpose consistent with state law.

This enabled the Manhattan Company to establish its own bank, which the directors soon discovered answered another civic need almost as great as that for clean water. Enterprising Republicans, frozen out by the Federalist Bank of New York, flocked to the Manhattan Water Company for loans and other business services, and what had been a subsidiary activity

quickly grew to become the mainstay of the company. Banking was certainly more exciting than pumping water; for the directors of the Manhattan Water Company it was profitable, politically progressive and a great poke in the eye to Alex Hamilton.[46]

Under the circumstances, the technological problems besetting the Bronx River project proved very daunting indeed to the directors of the Manhattan Water Company, and they opted instead for a more modest system, sinking an enormous well into the Collect Pond aquifer and distributing the water from a reservoir through wooden pipes made of bored-through logs. The Bronx River was left to flow unmolested to the Sound.

The retreat of the Manhattan Water Company didn't spell the end of proposals to tap the Bronx River for New York City's drinking water. The idea came up again in 1819, when Robert Macomb proposed tapping the river's source at the Rye Ponds, and the Bronx River would be considered again in the 1830s in the preliminary planning that led to the creation of the Croton system. But it would take another century before Bronx water at last made its way to Manhattan.

Chapter 8

BRONX RIVER RED

By 1791, Alexander Hamilton had come a long way since that October afternoon in 1776 when he aimed cannon shots across the Bronx River at White Plains. The thoughts of the new nation's secretary of the treasury now turned not to gunpowder but to waterpower. Envisioning the country's economic future, his *Report on Manufactures* detailed his recommendations for promoting industry, and not content to stop there, he became an active member of the Society for Establishing Useful Manufactures (SEUM), a New Jersey–based organization that was looking for ways of creating a mechanized American textile industry.

With steam engines still in their infancy, industrial power in those days meant water power. Under Hamilton's direction, SEUM would build the nation's first planned industrial development at Paterson on the falls of the Passaic River.

The Bronx River wasn't part of Hamilton's plans, and its modest fall above West Farms nowhere approached the power or drama of the falls of the Passaic. Still, the Bronx River's drop, combined with a dependable water flow, had been powering mills at West Farms for more than one hundred years, and a new wave of water-driven industry would shortly transform West Farms into an industrial center worthy of Hamilton's vision. And like at Paterson, textiles would become a mainstay of West Farms industry and mark the beginning of the river's environmental degradation.[47]

It was never certain what prompted James Bolton to come to the United States in 1818. At the age of thirty-eight, it was a bit late in life for someone

to be making a fresh start. It was said that he fled England believing that he had killed his opponent in a duel. He hadn't, but by the time he learned this, he had found himself a new future on the Bronx River.

Bolton arrived in an America that was crossing the threshold of the Industrial Revolution, and textiles were a star industry in those early years. The English textile industry had been mechanizing since the 1770s, and with a combination of Yankee ingenuity and industrial espionage, an American textile industry was just getting underway when Bolton landed in New York. In places like Paterson, New Jersey, and Lowell, Massachusetts, new mills were turning out cloth in previously unheard-of quantities, with the raw material supplied by an expanding slave-driven cotton production in the South, itself made possible by the mechanized cotton gin.

Coming from a long-established family in Lancashire,[48] then the cradle of British industry, Bolton knew a few things about textiles. Spinning thread and weaving cloth were just the beginning of a long process that delivered desirable fabrics to the dry-goods counter. The growing output of the Massachusetts and New Jersey mills would need a supporting industry to "finish" the cloth. Such an industry needed a dependable source of fresh water for the bleaching and dying processes, as well as to turn the water wheels. It also needed a river into which it could empty the effluence.

Scouting a suitable site for such an enterprise, Bolton was drawn to a point on the Bronx River at a little village and stagecoach stop named Bronxdale, about one mile upstream from West Farms. There a natural fall in the river could be improved with dams that would collect water and channel it to any number of mill wheels. The spot was safely above the river's tidal line, ensuring an ample supply of fresh water, and the newly rerouted Boston Post Road crossed the river just a stone's throw south of the dam site, connecting it with both the mills of Massachusetts and the market and seaport of New York.

Best of all, the site was available for purchase. The Bronxdale Paper Mill, one of the largest paper mills in the country at the time, had been established there in 1805 and had built dams to channel the enormous quantities of water that paper making required. The mill hadn't prospered, and by the summer of 1819, its owner, David Lydig, was advertising it for sale, with the "never failing stream" of the Bronx River mentioned as an inducement. The mill found no buyers and was totally destroyed by fire in November 1822.

The fire left a clear site for James Bolton, who organized the Bronx Bleaching and Manufacturing Company and began constructing his industrial complex in 1823. Building a three-story stone house[49] from which he could overlook both his mills and the Boston Post Road, Bolton found

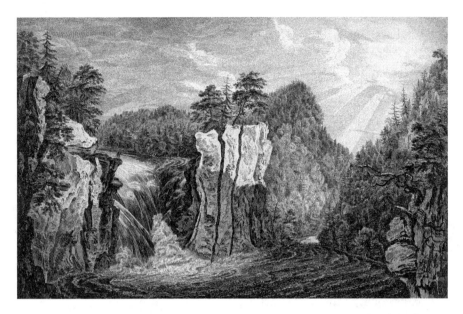

Places such as the Falls of the Passaic (shown here), as well as the more modest falls of the Bronx River, were harnessed for water power, making West Farms an early industrial center. *Library of Congress.*

Bronxdale a pleasant enough place, except for the mud. Runoff from the nearby Bear Swamp kept the place damp enough that young men would inscribe their valentines with the jingle, "Forget me not, forget me never, till Bronxdale mud dries up forever."

However muddy Bronxdale might be, Bolton's cloth would be snow white. The Bolton mill would be one of the first in America to bleach cloth by the use of chlorine, a process that had been introduced in James's hometown in the 1790s. Previously, cloth had been whitened by folks known as "whitsters" using a laborious process of soaking it in buttermilk and laying the cloth out on enormous lawns termed "bleaching greens," where the cloth would be whitened by sunshine. It took a lot of time, labor and water and was a smelly business as well. Chlorine offered an efficient shortcut through this tedious process, but while the Bolton mills soon got the local nickname of "the Bleach," bleaching was just part of the work at Bronxdale.

Newly woven cloth arriving at Bronxdale was known as "gray goods" for the dull but natural color, and pieces were received and sorted out in the "Gray Room." (We still use the phrase "run of the mill" for mediocre products.) Next the cloth was singed to burn off lint and loose threads and then boiled to remove any remaining dirt and foreign matter. "De-sizing"

followed, a series of immersions in mixtures of water, caustic soda and acids. The de-sized fabric was bleached in chlorine for three minutes and then run through ringers and plunged into a neutralizing acid bath. After multiple washings to remove the acids, the cloth was then run through mangles and huge drying cylinders.

After "tentering" machines stretched the cloth to a uniform width, the last step before dyeing was "mordanting." The cloth would be boiled for an hour in water with a chemical "mordant" added to fix the dye. This carried its own hazards: although alum was the most commonly used mordant, the process could also include such things as oxalic acid, copper acetate, tin and arsenic, all of which sooner or later ended up in the river.

The freshly dyed cloth was then rolled through "calendering" machines to give it sheer and silky hand before it was loaded onto wagons and sent down the Boston Post Road to New York. Crossing the bridge over the Bronx River, the teamsters might look down and see the contents of the used-up dyebaths coloring the waters swirling below.

The colorful waters flowing down from the Bleach passed through a West Farms that was itself undergoing a new wave of industrial development. Although water mills had operated on the Bronx River at West Farms since the 1670s, the years following the War of 1812 would bring new industries. The mills at West Farms up to then had been mainly for sawing wood and grinding grain, activities that, apart from the dams blocking the passage of migratory fish, didn't do too much damage to the river's ecology. This was about to change.

An article in the *New York Courier* described West Farms in 1815 as a tidy and prosperous village. It boasted its own school and post office, and its river port berthed seven small (twenty-five- to forty-ton) vessels carrying the output of the gristmills down the East River to New York. The Bronx River was described as "one of the best in the state for manufacturing purposes" thanks to its "constant supply of water," as well as West Farm's "short distance and easy communication by land or water, to and from New-York."

Such publicity drew the attention of businessmen to the industrial potential of the Bronx River. For all its abundance of entrepreneurial spirit, there just weren't many places around New York City where water power could be harnessed for industry. The Bronx's River's fall in elevation meant that until new sources of power came into play, it would serve as New York's industrial heartland.

By then, West Farms needed a new industry. Although one of the earliest grain elevators would be built in West Farms in about 1812, flour milling

declined there following the opening of the Erie Canal in 1825, and this enabled wheat from the Midwest to be economically shipped to New York City. Unable to compete with this output, Westchester farmers turned instead to vegetables, fruit and dairy products, none of which required water mills.

Bolton's wasn't the only operation coloring the Bronx River in the early 1800s. In about 1809, Herman Vosburgh established the Bronx River Paint Company at West Farms, probably making use of an older mill there that ground oil out of linen and flaxseed to serve as the medium of the paint. In those days, all quality paint was lead-based, and the Bronx River Paint Company soon began buying up "pig lead" in quantities of fifty to two hundred tons at a time and offered its customers such fashionable colors as Venetian Red and Spanish Brown. Closed by the economic Panic of 1819, the company apparently sprang back, for by 1830 it was offering its own proprietary color, "Bronx River Red."[50]

Lead also made its way to the Bronx River as glazing for pottery in a factory set up near the paint mill. The West Farms pottery plant offered Staffordshire- and Delft-style ceramics, as well as cheap crockery advertised as "hard burnt and well glazed, and worthy [of] the attentions of purchasers for the country market."

The mills clustered at West Farms could depend on a "never failing" Bronx River that, however low it might run in late summer, still provided enough water to fill the milldams. Sometimes, though, the river sent too much water rushing downstream, and this could be disastrous. The spring flood of 1855 burst the old DeLancey Dam, and the sudden torrent of floodwater wrecked a stone bridge and demolished a mill. The waters rose all the way up to the Boston Post Road before they abated.

By then, a new generation of factories in West Farms no longer needed water wheels, although they still depended on the river. The steam engines that began powering factories in the mid-1800s promised vastly greater speed and energy than the slow-turning mill wheels could provide, but they now needed the river not to provide power but to deliver the coal that fired the boilers that made steam out of Bronx River water. The opening of the Delaware and Hudson Canal in 1830 made it possible to transport high-quality anthracite all the way from the mountains of northern Pennsylvania to the banks of the Hudson, from which barges and canalboats carried it to New York or, rounding Manhattan Island, up the Bronx River estuary to the port of West Farms.

West Farms grew with this infusion of industry. By 1843, it counted 150 homes and 1,200 inhabitants, nearly twice that of the Westchester County

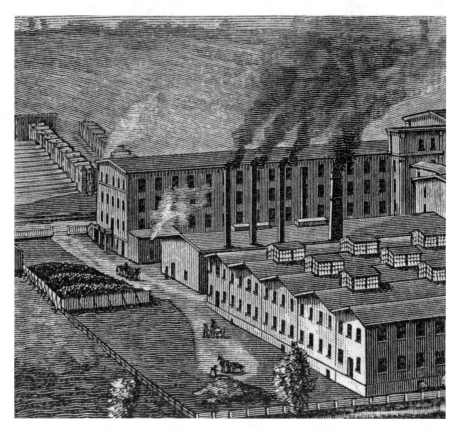

Before moving to the Sawmill River, Alexander Smith wove carpets and woolen army blankets on the Bronx River at West Farms. *Library of Congress.*

seat at White Plains. Its three churches were outnumbered by the village's four taverns, although the score was evened somewhat by the addition of what was described as a "temperance house" (hotel) on the site of the old DeLancey blockhouse. The Bronx River still turned the wheels at a gristmill and a sawmill, but these were now overshadowed by the addition of a rug factory, two carpet factories and a machine shop for fabricating carpet-making machinery. West Farms' attraction for carpet makers was the river water. In those days, all rugs and carpets were made of wool, and the soft water of the Bronx River was ideal for washing wool—ideal, that is, when it wasn't full of effluvia coming down from the Bleach.

West Farms' carpet-making was further enhanced in 1845 when the twenty-seven-year-old Alexander Smith established his Moquette Textile Mills by the Bronx River. Moquette is a woven fabric with a short, dense pile, often used

today as seat coverings in public transportation. But back when ordinary people had to make do with hooked or braided rugs at best, moquette carpeting was a desirable home furnishing for a growing middle class.

At the Moquette Textile Mills, twenty-five carpet looms were overseen by Smith's plant manager, an inventive carpenter with the euphonic name of Halcyon Skinner. During the Civil War, Smith produced blankets for the Union army until his wooden mill buildings burned down in 1862 (rebuilt, they burned down once again in 1864). Perhaps feeling that West Farms had become an unlucky place, Smith decided to move up to Yonkers and build a new plant (in brick this time) by the Saw Mill River, where he could take advantage of Halcyon Skinner's creation of an improved loom to turn out higher-quality Axminster carpet.[51]

The departure of Alexander Smith wasn't a catastrophic loss for West Farms, where textile industries would continue to grow and flourish for another sixty years. In the meantime, a variety of picturesque, noxious and sometimes explosive industries would be established on the river upstream.

JUMPIN' JUPITER!

While West Farms and Bronxdale grew into industrial river towns, a variety of other industries flourished along the length of the Bronx River.

Less than a mile upstream from Bolton's Bleach, a picturesque building became the foundation of one of New York City's great family fortunes. Like the DeLanceys, the Lorillard family was a well-established Huguenot family in New York before the Revolution. Their main business was tobacco, and in their shop in lower Manhattan, they sold smoking blends and laboriously ground "snuff" by mortar and pestle.

All but extinct today, "taking snuff" was a popular habit in the eighteenth century, a way of getting a quick nicotine fix in the days before matches made smoking portable. Instead of heading to a tavern or being home at fireside to light a pipe, a pinch of dried, fine-ground tobacco would be "snuffed," or snorted up the nose. Once snorted, a hit of nicotine would quickly enter the bloodstream, enough at least to fend off cravings for a while. There was, of course, a prescribed etiquette for doing this in public, usually after flourishing a finely crafted snuffbox, in those days as important a part of a gentleman's accessories as silver shoe buckles. (Women took snuff, too, though seldom in public; Betsy Ross, for example, enjoyed snuff, claiming that it helped her eyesight, no doubt after sewing all those flags.)

Emerging from the Revolutionary War, the Lorillards looked for an opportunity to expand their business from their cramped quarters in lower Manhattan. In 1790, Pierre Lorillard purchased a fifty-acre tract of land along the Bronx River about one mile below Williamsbridge,

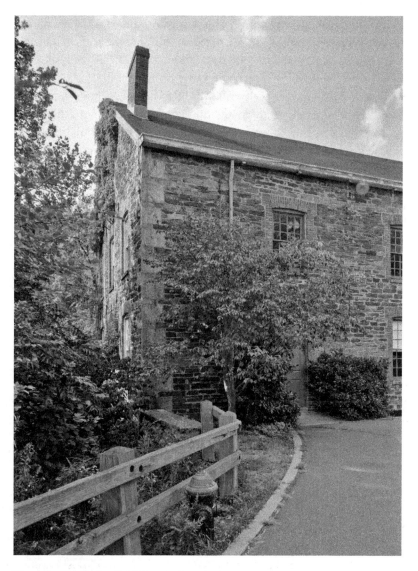

Pierre Lorillard's Snuff Mill made America sneeze and founded a family fortune on the Bronx River. *Library of Congress.*

where the fall of the Bronx River Gorge presented an opportunity to build a milldam.[52]

Pierre Lorillard needed a mill site because he would introduce there two innovations that would revolutionize the snuff business. One was a startlingly simple idea: stone mill wheels had long been used to grind such things as

grain and flaxseed, so why not use them to grind tobacco? Millstones would turn out a lot more snuff than a tired apprentice working a mortar and pestle, and the increased output could then be sold all over the country, making some real money out of the brown powder. The other idea would make people eager to buy the Lorillard's "Best Virginia": dried, fine-ground rose petals added to the snuff made it much more pleasing to the nose.

Soon expanding their operation with a second wooden mill, the Lorillards found themselves the nation's predominant snuff manufacturers and one of the leading families of New York society. They gradually expanded their holdings into a 650-acre estate that comprised most of today's New York Botanical Garden, where from a tastefully designed mansion on the hill overlooking the river they could view the famous "Acre of Roses" that supplied petals to the mills.[53] While they grew their own roses there by the Bronx River, they did not attempt to grow tobacco in the Bronx (that idea apparently died with Jonas Bronck). Instead, they purchased high-quality slave-grown tobacco from Virginia.

In 1840, Pierre Lorillard built a stone mill to replace his aging wooden mills (the Stone Mill you see today).[54] The new snuff mill sported an innovative, nontraditional design: water drawn off the dam's sluiceway ran through the building itself rather than tumble over an exterior water wheel, driving millstones that were located in the basement. It was an excellent piece of industrial design, but unfortunately, the wheels began turning just as dry snuff was beginning to go out of fashion—the new "Lucifer" matches invented in 1827 now made it practical to light up "seegars" or briarwood pipes just about anywhere. The Lorillards had already branched out into chewing tobacco, prompting a quip from the diarist Philip Hone that Pierre Lorillard "led people by the nose, and got them to chew what they couldn't swallow."[55]

Winter posed a problem for water mills, as the seasonal freezing could shut down power for weeks at a time. In the 1800s, at the tail end of the "Little Ice Age," the Bronx River would still freeze over most winters. But while the freezing of the river impeded mill operations, the ice itself was a commodity that drove another Bronx River industry. Back in the days before refrigeration was invented, people got their ice the old-fashioned way: they'd wait for a local lake or pond to freeze up good and thick and then go out with specially designed saws and cut the ice into handy blocks, which would then be stored in a sawdust-insulated "icehouse." As the year wore on, these blocks would be cut into pieces about the size of a cobblestone and used to cool food in what then was literally an ice box.

The "frozen water trade" was an important part of the economy of the northeastern states and a valuable source of income for farmers during the winter months. In this region, ice from the spring-fed Rockland Lake (near Nyack) was renowned for its purity, but many people resorted to more local sources.

The Bronx River was one such source. For efficient ice formation, you needed places where there was quiet, still water, and the stretches of slack water behind the river's milldams were perfect spots for this. While the miller cursed, the ice-man smiled—ice was regularly harvested from the pond behind the Lorillard Dam, as well as from other dams and river-fed ponds. Cope Lake, in the northwestern corner of the present-day Bronx Zoo, produced ice good enough to support a commercial ice harvesting operation between 1875 and 1885. In spite of increasing pollution, ice would continue to be harvested from the Bronx River up to the twentieth century.

Not all industries along the upper Bronx River were as benign as the ice industry, and the sweet-smelling powder turned out by the Snuff Mill had a more sulfurous counterpart upstream. A number of gunpowder mills operated along the river in the mid-1800s, sometimes with lamentable results.

Making gunpowder is an inherently hazardous industry. The process of milling the powder puts a lot of particulate matter in the air, and like coal dust, once it gets to a certain density it can be exploded with the slightest spark. E.F. Haubold's Bronx River Powder Mills at Moringville (today's Hartsdale) proudly advertised its own "Bronx Sporting" brand of black powder for muzzle-loading huntsmen. Sporting powder was ground to a finer grain than military-grade powder, producing more hazardous particles in the air. In the spring of 1847, an estimated three tons of gunpowder went off, killing one man and injuring several. Another explosion three years later finished off the Bronx River Powder Mills. The only traces of these mills today are the millpond and the remains of the millrace alongside the Bronx River pathway.

Suspended particles were the cause of perhaps the worst accident on the river. In 1876, at the Jupiter Powder Mill, located by Muskrat Cove, a worker named David Riehl slipped out the doorway for a quick smoke. The match he struck ignited the gunpowder particles in the air and set off a massive explosion that left a ten-foot-deep crater. The force of the blast hurled the unfortunate smoker into the Bronx River, and two additional men died in the catastrophe. The Jupiter explosion, along with other accidents, including a blast in an explosives factory near West Farms, soon brought to a close a brief but combustible chapter of Bronx River history.

In the days before mechanical refrigeration, ice was harvested from the Bronx River and stored in insulated icehouses such as this one. *Library of Congress.*

The 1800s saw many other industries start up along the Bronx River. Near the river's source, a small hamlet known as Wright's Mills ground grain and sawed lumber before the Revolution. Renamed Robbin's Mills (and eventually Kensico), by 1848 the place also hosted two woolen mills, along with a wagon-spring and carriage factory.

The woolen industry had a long history on the Bronx River due to the soft quality of the water, which made it good for washing wool. Anthony Miller set up a wool fulling mill on Long Meadow Brook above White Plains as far back as 1721. Swain's Mill stood at the south end of Bronxville Lake, which was formed by its milldam. There had been a wool carding factory here before the Revolution, but in 1840, James P. Swain expanded it and renamed it Bronx Mill. In 1844, Swain purchased the old Underhill Mill downstream and developed it into a water-powered complex that combined the manufacture of screws and wagon axles with a gristmill. A thrifty sort who believed in not wasting space, Swain pastured a small herd of cows on the grassy strip between his mills and the river, adding a pastoral touch to the industrial scene. About that time, Alfred Ebenezer Smith built his own axle factory on the river across from Swain's operation, where he and his men could enjoy a view of Swain's cows.

Downstream at Tuckahoe, another textile industry utilized the Bronx River. The Cotton Mill began operating in 1805, and by the time of the Civil War, it was manufacturing rubberized garments and ground cloths for the soldiers in the field. The Cotton Mill was eventually overshadowed by a pharmaceutical plant on the other side of the river that in the early twentieth century pioneered the production of gelatin capsules. Stretching along the east bank of the Bronx River south of Bronxville, tan yards and a leather goods factory drew vat water and emptied tannic runoff into the river. At Hunt's Bridge, a gristmill was joined around 1825 by a screw factory, the beginning of a manufacturing district that still runs along the east bank of the Bronx River in Mount Vernon.

At Tuckahoe, the Bronx River Valley's geology would give rise to an industry that would help build New York City, and other places as well, for more than one hundred years. Soft white marble (sometimes known as Inwood marble) underlies parts of the valley, although in many places it is too low grade to be useful for anything but making quicklime. In 1820, though, Alexander Masterton discovered an enormous vein of building-quality marble running along the ridge on the east bank of the river at Tuckahoe.

The Masterton Quarry at Tuckahoe yielded a clean, dense white marble, just in time to supply the new architectural vogue for Greek Revival that sought to make churches and public buildings look like ancient Greek temples, complete with marble colonnades. A number of quarries soon opened up along the ridge (running down today's Marbledale Road) to supply the demand. Quarried blocks were at first drawn by oxen (as many as thirty yoke for the bigger pieces) to Eastchester, from which they were sent by barge down to New York. In the 1850s, the addition of a railroad spur enabled top-grade Tuckahoe marble to be to be sent down the Bronx River by rail.

Tuckahoe marble not only was used for many public buildings in New York City but was also shipped far afield. A marble block inscribed "Masterton & Smith" may be seen inside the shaft of the Washington Monument at the 140-foot level. Tuckahoe marble was also used in the City Hall in New Orleans and the columns of Soldier Field in Chicago. Closer to home, it was used for such grand edifices as the 1866 Asbury Centennial Methodist Church, which may be glimpsed from the Bronx River Pathway near Tuckahoe. Lesser-grade blocks of marble were scavenged for quarrymen's houses that one can see today while strolling around Crestwood.

Grown wealthy thanks to the output of his quarries, in 1835 Alexander Masterton built himself a country house that still stands in Bronxville. There he gained a reputation as a generous host, in particular entertaining a wide

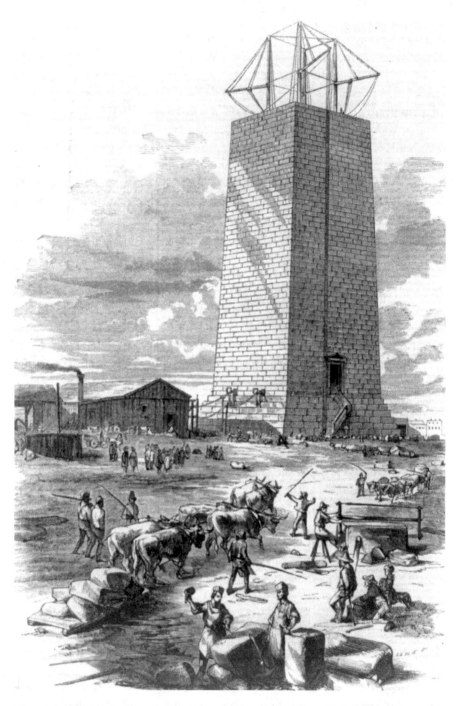

Quarried alongside the Bronx River, for nearly one hundred years Tuckahoe marble went into some of New York's finest public buildings, as well as the Washington Monument. *Library of Congress.*

variety of artists and creative people, giving Bronxville an early cachet as an art-friendly place.

The settlement where his quarry workers lived was not so elegant. Variously known as North Tuckahoe or Marbledale, in the 1850s it was nicknamed "Sebastopol" after the famous Crimean War battleground. The name likely honored numerous booze-fueled battles where fists and pry bars would be joined by flying marble chips. The marble chips had a keen edge to them, and flung sideways, they could inflict quite a nasty gash.

The quarrymen of Sebastopol would contribute to another nineteenth-century conflict in July 1863. Enraged by the inequities of the new military draft and fearful of freed slaves migrating north to compete for already low-paying jobs, bands of quarrymen marched down the river, threatening African Americans and disrupting rail service in concert with the Draft Riots then ablaze in New York City. The burning of the telegraph office at Williamsbridge impeded government forces being sent to the city, where the deadly riots continued for five days.

Sebastopol was also known as the "Irish Alps," due to the largely Gaelic quarrymen who lived there. As the century drew to a close, Italian immigrants joined the workforce at the quarries, but they found themselves banished from the Irish Alps to make their homes down in the buggy floodplain of the Bronx River known as "the Hollow." The construction of the Bronx River Parkway in 1925 would erase most traces of the settlement in the Hollow, but the descendants of these Italian quarry workers remain a vital part of today's Tuckahoe-Crestwood community, where the Westchester Italian Cultural Center flourishes alongside the Bronx River.

Like most other Bronx River industries, the Tuckahoe Marble quarries are today only a memory. The deep pit of the Masterton Quarry may still be seen in Crestwood, although the other quarries have long since been filled in, their traces visible only to a sharp-eyed investigator. By the 1900s, the quarries were largely played out in terms of top-quality stone, and the passing of the Greek Revival fad led to the diminishment of the market for what good-grade marble was still being lifted from them. By the time the once-mighty Masterton Quarry closed in 1930, its main business was selling marble chips for use in making carbonated soda. Turning aside from its once-rollicking past, the now upscale suburban town of Crestwood was a gentle enough place to be painted by Norman Rockwell.[56]

While a variety of industries set up along its banks in the mid-1800s, the Bronx River never entirely became an industrial stream, and parts of it remained sylvan enough to inspire the work of poets, authors and painters.

Chapter 10

MY OWN ROMANTIC BRONX

I n August 1824, the Marquis de Lafayette returned to New York to begin a triumphal tour of the new republic that he had helped to create. Making his way to Boston, he entered the old Tory village of West Farms, where people lined the road to cheer one of the last living links to the Revolution, and men unhitched the carriage's horses to pull the vehicle themselves as a show of adulation. Leaving behind the mills of West Farms, the Marquis took a side trip down to Hunts Point, where the locals commemorated the occasion by dubbing the country track leading to the Bronx River as Lafayette Lane (today Lafayette Avenue).

Lafayette's time along the Bronx River was brief, but in that short afternoon, he saw two contrasting views of the stream he had once known as the "Brunks" River. While at the growing mill town of West Farms, new industries such as textiles, paint and pottery were tinting the waters and poisoning the riverbanks, yet the short detour to nearby Hunts Point also revealed a spread of palatial country estates, a peaceful, marsh-lined estuary and a river still bucolic enough to stir the imagination of a poet. The river was lined by Osier willows, said to have been introduced by Gouverneur Morris as ornamental trees. The profusion of these "basket" willows provided local people the springy twigs, or withies, with which they wove baskets.[57]

The peninsula was named for the Hunt family, whose mansion overlooked the Bronx River and Long Island Sound. As the young century wore on, the Hunts would be joined by other country estates: Hoe, Simpson, Faile, Dater, Tiffany, Fox, Watson, Dickey, Spofford, Whitlock and Cassanova—all

names commemorated by local streets and avenues. Together they formed a distinctive, upscale community known as the "Hunts Point Set."

Far from the urban industrial neighborhood it later became, in those days Hunts Point was a sort of miniature Hamptons, the kind of place any well-connected person would be glad to receive an invitation to for a leisurely country weekend. But behind the well-tended farms lurked a dimmer heritage. The nation's first census in 1790 recorded 156 African and Indian slaves in Hunts Point, and slavery would not be fully abolished in New York until 1827, more than two years after Lafayette's visit.

Tending the vegetable farms and maintaining the lifestyle of the grand houses, the enslaved people in Hunts Point lived out a largely unnoticed and anonymous existence.[58] The names of the few individuals that we know of have come down to us through wills, in which they were parceled out like any other chattel, or from newspaper advertisements for "runaways." One African American family from Hunts Point named Willis sought refuge behind British lines in New York City during the Revolution and were recorded among the refugees evacuated to Nova Scotia at the end of the war.

Another member of this African American community was the legendary figure of Bill Swan, one of the Hunt family slaves who was engaged (or forced) to guide the British frigate *Hussar* through the treacherous waters of Hell Gate in 1780. After the ship was wrecked on Pot Rock off Morrisania, a nearly drowned Bill made it ashore, but attempts to revive him proved futile, and he was buried in the nearby slaves' cemetery. Whether he was a fully qualified Hell Gate pilot or just a local waterman pressed into service remains uncertain, but local legend later had it that Bill Swan was a Patriot who wrecked the British vessel on purpose.

Such legends cloaked an uneasy reality. Although slavery had been a part of the local economy and social structure since Dutch days, by the time of Lafayette's visit it was becoming an uncomfortable memory that many would rather see swept behind the veil of oblivion. Like the continued existence of slavery, the memory of the divisive times of the Revolutionary War was a faded and little-perceived presence in Hunts Point, recalled only through a curious legend and ghost story.

As the tale was told, back in the dark days of the Revolution Bessie Warren was the daughter of Simon Warren, the proprietor of the King's Arms tavern in Hunts Point. Despite its name, the tavern was a regular meeting place for the local Sons of Liberty, who opposed British authority, and at their evening gatherings, they discussed plans for taking action

against King George's supporters, of which there were quite a few at large in southern Westchester.

One night, a handsome, mysterious stranger came to the tavern and quickly won Bessie's heart. The two arranged a rendezvous for his next visit to the tavern, perhaps with plans to elope. On the appointed night, Bessie waited for her lover at the top of the hill. He didn't appear, and instead Bessie heard gunshots resounding from the direction of the tavern. She made her way down the hill only to learn that the stranger had been revealed as a Tory spy sent to listen in on the Sons of Liberty meetings. He'd been run off, Bessie was told, and he wouldn't be coming back.

Desperately hoping that none of the rebel bullets had hit their mark, Bessie clung to the belief that her lover was still alive and would make his way back to her. As time went on, the distraught girl took to wandering around the area and waiting patiently at their rendezvous atop Hunts Point Hill. The mysterious stranger never returned, and it was said that Bessie died of a broken heart—or perhaps by her own hand, for she was buried in an unmarked grave on the hillside. For years after the Revolution, locals told of seeing a spectral figure wandering the hillside at night. It was said to be the ghost of Bessie, still forlornly searching for her lost lover, although some thought that the apparition might be that of the murdered stranger.[59]

While the shade of Bessie Warren flitted about the hillside, the Hunts Point Set welcomed a living visitor from the urban depths of Manhattan. Like Lafayette, Joseph Rodman Drake's time on the Bronx River would be brief, but in that time, he would write an enduring ode to it.

Trained as a physician, Drake kept an apothecary

Joseph Rodman Drake praised the Bronx River in poetry and asked to be buried along its banks in what is today Drake Park in Hunts Point. *Library of Congress.*

shop at the foot of the Bowery, near Chatham Square. Situated near the notorious "Five Points," the place would make anyone long for a weekend getaway. A relative of the Hunt family, Drake often made his way to their estate at Hunts Point. There amid fields, orchards and salt marshes, Drake discovered the beauty of a still unindustrialized part of the Bronx River.

Beset with tuberculosis, Drake found along the Bronx River relief from the stressful, smoke- and dust-filled city that he knew was slowly killing him. He took joy in the river's sylvan upstream reaches, while down at Hunts Point the estuary's salty sea air provided a balm for his ravaged lungs. He poured his feelings for this "gentle river" into a poem titled simply, "Bronx." Describing his impressions of the river's natural beauty, he looked with dread on his inevitable return to the "dull world of earthly blindness" in lower Manhattan and closed the poem with a wistful stanza:

> *Yet I will look upon thy face again,*
> *My own romantic Bronx, and it will be*
> *A face more pleasant than the face of men.*
> *Thy waves are old companions, I shall see*
> *A well-remembered form in each old tree,*
> *And hear a voice long loved in thy wild minstrelsy.*[60]

Although "Bronx" is Drake's only poem that directly references the Bronx River, his poem "The Culprit Fay" also stemmed from his love of rivers. In the summer of 1819, Drake joined in a convivial conversation with James Fenimore Cooper and the poet Fitz-Greene Halleck when the discussion turned to the inspirational beauties of Scottish streams. Despite having just moved to the banks of the Bronx River in Scarsdale, James Cooper had not yet blossomed into an American novelist and joined Halleck in denying that American rivers possessed the romantic qualities of those of the "Auld Country." Drake, having already found beauty and romance aplenty in the Bronx River, insisted otherwise, and he wrote "The Culprit Fay" to prove his point. Although the poem is set in the Hudson Highlands, it likely drew its inspiration from Drake's wanderings along the Bronx River and its saltwater estuary at Hunts Point.[61]

Joseph Rodman Drake died of tuberculosis in September 1820. As his health declined, he expressed a wish that he be buried along the banks of his beloved Bronx River. His friends in the Hunt family honored that wish, burying him in their family cemetery at the foot of the peninsula by the Bronx River and the old Native American settlement site of Quinnahung.

More than twenty-five years after Drake's untimely death, another eminent poet and author would seek inspiration along the banks of the Bronx River. In May 1846, Edgar Allan Poe, together with his wife and mother-in-law, took up residence in what was then the village of Fordham, renting a small cottage from John Valentine for $100 per year. The move to what was then considered the rustic countryside was prompted by the fact that Poe's young wife, Virginia, was dying of tuberculosis. In those days, there was no treatment or cure for tuberculosis other than rest and fresh air, and the little cottage on the hill west of the Bronx River could offer just that.[62]

Fordham offered a refuge to Poe as well. Fresh from his success with "The Raven," Poe had begun writing a series of articles, "Notices of the Literary People of New York," for the popular magazine *Godey's Lady's Book* in which his biting comments had alienated many of the most influential people in the New York cultural scene. It was a good time to remove himself to Fordham, where the nearby New York & Harlem Railroad offered convenient access to the city but whose twenty-five-cent fare would keep pesky visitors to a minimum.

Edgar Allan Poe sought inspiration along the Bronx River and may have described the Bronx River Gorge in "The Domain of Arnheim." *Library of Congress.*

While rumors of Poe's insanity flashed through the press (he was variously said to be confined in the New York Lunatic Asylum in Utica, the Bloomingdale Asylum in northern Manhattan or out on Long Island somewhere), Poe was delighted with his new home in Fordham, surrounded as it was by blossoming cherry trees. Virginia was delighted as well, but the charm of the place could do little to halt the progress of her deadly disease.

Virginia Poe died at the end of January 1847, and a devastated Edgar tried to cope

with his grief and keep on working. As the cherry trees once again bloomed around the cottage, Poe found congenial friends among the Jesuit priests at the new St. John's College at the bottom of the hill near the Bronx River. Father Edward Doucet welcomed the eminent author and extended to him the use of the college library. Poe enjoyed the company of the urbane Jesuits of the faculty and would often join them in the evening for a game of whist. "They were highly cultivated gentlemen and scholars," Poe would recall, who "smoked, drank, and played cards like gentlemen, and never said a word about religion."

St. John's College may have provided Poe additional inspiration beyond books, whist and good company. The tolling of the college church bell could be clearly heard at the Fordham cottage and is believed to have inspired Poe's poem "The Bells." The college bell of today's Fordham University would be affectionately known to generations of students as "Old Edgar" in Poe's honor.

The college grounds led down to the Bronx River (the southwest part of the present-day New York Botanical Garden was originally part of the St. John's campus) and provided a convenient route where Poe would take his customary long afternoon walks. Poe could cross the wooden bridge beside the snuff mill and amble along the river and millrace. The path led past the scenic rapids of the Bronx River Gorge, while the air around the mills would have borne the sweet, grassy smell of grinding tobacco laced with the perfume scent of rose petals. Today, minus the smells, the river here still invites quiet contemplation.

Just what Poe was thinking on these long walks (the newly built Croton Aqueduct was another favorite ramble of his) we do not know, but we do know that Poe composed some of his classic stories and poems during his sojourn by the Bronx River, a residence that turned out to be the last years of his life. The aforementioned "The Bells," along with "Annabel Lee" and "Ulalume," stand out among the poems he wrote there, as do the classic tales "The Cask of Amontillado" and "Hop Frog," as well as the scientific essay "Eureka," which has led some to credit Poe with first thinking up the "Big Bang" theory of the origin of the universe.

Apart from the reflective solitude it offered him, did the Bronx River directly inspire any of Poe's work? That is more difficult to say. Certainly his descriptive story "Landor's Cottage" was based on his Fordham home, and his description of the narrow valley leading to the cottage and its magnificent tulip trees may owe something to the Bronx River Gorge and its native forest, then as now notable for its old-growth tulip trees. The Bronx River Gorge

may also be glimpsed in the preceding story "The Domain of Arnheim." Part of this tale describes a boat journey up a river through a deep but narrow rocky gorge in which "the long plume-like moss which depended densely from the intertwining shrubberies overhead, gave the whole chasm an air of funereal gloom." The upriver journey leads to a broad crystalline lake—perhaps the millpond behind the Lorillard Dam? While he wrote to his friend Sarah Whitman that "The Domain of Arnheim" "expresses *much of my soul*," Poe otherwise left few clues as to the exact sources of his inspirations, leaving scholars to speculate.[63]

Like Joseph Rodman Drake before him, Poe's time on the Bronx River would be brief. He departed from Fordham at the end of June 1849 to embark on the long, strange journey that ended with him being found in a near-comatose state in a Baltimore tavern. He died a few days later, on October 7, 1849, and the cause of his death is still debated.

The Bronx River drew painters as well as poets. Some of the later Hudson River School painters, most notably Sanford Gifford, found a scenic subject in the neighboring Bronx River. Gifford's 1862 painting *On the Bronx River* captured a luminous winter twilight over a frozen river and is considered a classic.

Another painting of the late Hudson River School, William Rickarby Miller's *On the Bronx River* (1887), was chosen for a 2013 exhibition at the Phillips Museum of Art in Lancaster, Pennsylvania, as an illustration of the early encroachment of human development on the rural landscape. Miller is also known for his painting of the *Bronx River Dam* above the old Lorillard Snuff Mill.

As the nineteenth century wore on, other artists would come to paint the Bronx River, with exhibitions of emerging painters frequently including at least one Bronx River scene. Many were local New York artists such as David Johnson, who exhibited his *Spring on the Bronx River* at the Union League in 1878.

Paintings of *The Lorillard Road* and the Snuff Mill by one Miss Halsey prompted the *Brooklyn Eagle* to comment in 1893 that this, "with other scenes along its shores, showed what a rich country for artists the environs of the Bronx [River] are." Edward Rorke was another enthusiastic Bronx River painter in the 1890s, and his work included a depiction of the Bolton Bleachery. Francis Hopkinson Smith, the writer best known for his Bronx River short story, "A Day at Laguerre's," was also an artist who worked along the Bronx River. J.M. Slaney's 1890 *Ice Houses on the Bronx River* is part of the collection of the Museum of the City of New York. And there were many others of lesser renown. In all, some thirty-five professional artists painted the Bronx River in the nineteenth century alone.[64]

As an artistic subject, the Bronx River's fame was wide-ranging: the Peace Institute, a school of realist female artists, exhibited pastel scenes of the Bronx River at the North Carolina State Fair in 1894. The Philadelphia Society of Artists displayed *The Bronx River* by William Hart in 1882. In far-off Idaho, the western painter Arthur J.E. Powell included his paintings of *Low Tide on the Bronx River* and *Bronx Kills, New York* in a 1917 exhibition.

Hudson River wasn't the only prominent school of art whose members painted the Bronx River. Ernest Lawson, part of the New York–based "Ashcan School" is better known for his paintings of the Harlem River, but his 1910 depiction of *The Bronx River* hangs in the collection of the Metropolitan Museum of Art. Richard Hayley Lever of the British St. Ives School painted a watercolor of *The Bronx River* around 1930.

The Bronx River's artistic heritage wasn't confined to traditional landscapists. The modernist painter Oscar Bluemner painted a colorful abstract vision of the Bronx River at one of its least bucolic places: the industrial strip along the river in Mount Vernon. *Evening Tones* (also known as *Bronx River at Mount Vernon*, 1911–17) is part of the collection of the Smithsonian American Art Museum.

The art of the Bronx River also embraced the emerging medium of photography. At an 1893 exhibition at the Brooklyn Academy of Photography, lantern slides of the Bronx River by A.S. Barney stood up well alongside his pictures of Yellowstone and Niagara and were "much applauded."

The Bronx River's artistic inspiration continues to this day. In Westchester County, the painter Hilda Green Demsky combined art and environmentalism to document litter pollution in her 1994 exhibition "Sound Effects." In 2007, she mounted an exhibition at the Eastchester Public Library of her paintings depicting "The Bronx River: A Great Community Resource in Westchester County."

The 1980s saw the beginning of a revived arts scene in the Bronx. In 1982, the Bronx River Restoration opened its Storefront Gallery at 1087 East Tremont Avenue. In the spring of 1983, the Bronx Council on the Arts sponsored the exhibition there, "11 from 39," of eleven Bronx artists who had been working in improvised studios in the disused school building of the old PS 39. In 1987, the Storefront Gallery gave rise to the Bronx River Art Center, which remains today in its historic West Farms location. Following in the footsteps of Sanford Gifford, Edgar Allan Poe and many others, artists and poets young and old continue to seek artistic inspiration along the Bronx River.

Chapter II

SUBURBS

In 1850, the poet, architectural critic and travel writer Nathaniel Parker Willis took a journey up the Bronx River. He found the Bronx "a lovely little river," but "it seems invidiously cut off from sympathy. Private grounds enclose its banks wherever they look inviting. For so pretty a stream and so near New York, it is very little celebrated."

Along its upper reaches, Willis saw a Bronx River "aristocratically fenced in" by wealthy country estates and gentleman farmers, but even as he ventured upstream, the river's suburban transformation was getting underway. The first planned suburban development on the Bronx River, however, would be anything but aristocratic. In 1850, a group of skilled industrial workers—termed "mechanics" in the language of the day—gathered at a meeting on New York's Lower East Side to form the Industrial Home Association No. 1. Fed up with grasping landlords, high rents and poor housing, these men pooled their capital in a cooperative venture to purchase a tract of land on which to pursue a dream of individual homeownership.

Purchasing a group of five old farms in the town of Eastchester about a mile east of the Bronx River, the association laid out streets and avenues and divided the ground into quarter-acre lots on which the members could build their own homes. Casting about for a suitably patriotic name for their new village, they named it for George Washington's home of Mount Vernon.

Although convenient to both the New Haven and New York & Harlem Railroads, the Mount Vernon mechanics soon discovered that they had traded high rents for expensive commutes, and so by the late 1850s, the

Industrial Home Association was planning a new venture to bring industry to the village with the erection of a machine shop, soon to be followed by a screw factory on the banks of the Bronx River. Incorporated in 1893, Mount Vernon, today proclaiming itself "The City of Happy Homes," has retained its blue-collar roots, and an industrial "railroad corridor" still stretches along Mount Vernon's side of the Bronx River.

The Industrial Home Association's venture was made possible by the railroads that only recently had begun to connect Westchester County with New York City. Chartered in 1831, the New York & Harlem Railroad at first connected New York City with the village of Harlem in upper Manhattan. By the 1840s, the railroad had its sights set on another Harlem: the Harlem Valley in upstate Dutchess County, where iron mines and dairy farms created a potential for freight profits. The way from Harlem village to the Harlem Valley lay along the Bronx River.

Once it got the go-ahead to cross the Harlem River, the railroad reached Fordham in March 1841, and by September 1842, it reached the Bronx River at Williamsbridge. From there, the tracks followed the river, and regular service began operating from White Plains and Tuckahoe (originally named Bronx Station) in 1844. A few years later, the New York, New Haven & Hartford Railroad reached an agreement with the New York & Harlem to build a junction alongside the river at Wakefield and run its trains down the NY&H tracks to New York City, enabling service from an East Mount Vernon station handy to the new mechanics' cooperative village.

Like many emergent technologies, railroads at first often seemed to be a solution in search of a problem. Business leaders in New York City, happy with what the canals and seaport could deliver them, at first questioned the need for railroads and had been reluctant to invest in them. Cornelius Vanderbilt, known as "Commodore" for his extensive involvement in steamboats and ferries, was one of these reluctant investors, too, although once converted to the idea of railroads, he threw all his considerable energies into building and acquiring them.[65] It could be an uneasy transition for any venture capitalist: early railroads tended to be speculative ventures, often proceeding on the principle of "build it and they will come," with routes and stations laid out in places where it seemed business would likely develop. This future-guessing strategy didn't always work, and many early railroads failed or fell far short of expectations.

Milk and marble, though, made the New York & Harlem one of the successful ones. Fresh milk hauled daily to New York City from the farms of Morrisania was joined by marble from the quarries of Tuckahoe to build

the growing city's public buildings, and along with the output of the iron foundries of Mott Haven, they helped sustain the NY&H's bottom line in its early years. But passenger traffic from the small stations scattered among the crossroads of the Bronx River Valley turned out to be lucrative as well. In the 1840s, a substantial number of New York businessmen had already bought themselves country houses along the Bronx River, and the coming of the railroad meant that with a quick means of getting to their businesses in Manhattan, they could now spend most of their free time away from the noise, smoke and dirt of the city.

Influenced by the Victorian "cult of domesticity," prosperous gentlemen sought to insulate their families and homes from their business lives, and the distance afforded by the railroad made this much easier to do. Indeed, as the rapidly expanding city engulfed such upscale enclaves as Bond Street and Hudson Square seemingly before the paint could dry, establishing a home in the country far outside Manhattan was the surest option for those wealthy enough to afford it. Leaving behind the urban business world with all its dubious characters and moral ambiguities, a gentleman could return every evening to a family securely cocooned in the countryside.

To encourage such frequent travelers, the New York & Harlem became the first railroad to introduce multiple-ride ticket purchases that "commuted," that is, offered a discount on regular one-way fares—hence the word *commuter*. Commuted fares were still no cheap seats—as the mechanics of Mount Vernon discovered, they could be a burdensome expense to the non-affluent.

The railroad's connection of the Bronx River Valley with New York City, along with its introduction of commutation fares, made possible the first wave of suburban development along the Bronx River in the 1850s. Before the railroad, a journey from a country home in central Westchester to the business district in New York City would have taken hours by horse and carriage. On the railroad, that trip could be accomplished in about forty-five minutes. This meant that frequent, even daily round trips were practical, and a country house, once a place built to retire to, could now be a home from which one could comfortably pursue a career.

The next planned suburban development also happened in Mount Vernon, when the Fleetwood Farm was bought in 1853. Fleetwood, though, would be entirely unlike the blue-collar cooperative venture that preceded it a few miles to the south; instead, it became a model for the posh commuter suburbs that would be associated with Westchester County. It would be divided and sold as miniature country estates, with substantial, individually

designed homes set on multi-acre lots. Too small for gentleman farmers (indeed, anything but ornamental landscape gardening was frowned upon), Fleetwood was designed as a place for affluent businessmen and successful professionals. Graced with its own train station, Fleetwood today is part of the city of Mount Vernon, but with the Cross County Parkway dividing it from the rest of Mount Vernon, it keeps its own separate identity.

The booming economy of the Gilded Age spurred a new wave of development along the Bronx River in the years after the Civil War. In 1888, the Yonkers Park Association was organized to develop an area along the west bank of the river around a small railroad whistle-stop north of Tuckahoe. Watson Realty, a major development firm, took over the project in 1905 and, for sake of a more upscale designation, named the community Crestwood in honor of the wooded rise of ground it occupied. In 1907, it persuaded the New York Central to upgrade the Yonkers Park whistle-stop

Transportation tycoon "Commodore" Vanderbilt encouraged suburban development along the river by introducing commutation fares. *Library of Congress.*

to a full service station and rename it Crestwood to avoid confusion with the Yonkers station on the Hudson River.[66]

Just downstream from Yonkers Park, what would become the river's most exclusive community owed its beginnings to a patent medicine. William Van Duzer Lawrence was a highly successful marketer of such proprietary nostrums in a time before federal regulations. His best-selling product, and the one that built his fortune, was the plainly named "Pain Killer." By 1890, though, Lawrence was looking to step away from the pharmaceutical industry. Having bought himself an estate in the village of Underhill's Crossing by the Bronx River, Lawrence saw an opportunity for a new venture that would ensure himself agreeable surroundings for his retirement.

In 1890, Lawrence commissioned the architect William Bates to design a planned suburban community within the village that had been renamed Bronxville in honor of the river. The enclave of Lawrence Park was the result. Having had some difficulty subdividing and laying streets through a rocky and wooded tract, Lawrence was not about to leave the architecture of these houses to the varied whims and tastes of his buyers. Instead, he hired Bates, and a succession of other noted architects, to design and build the houses of Lawrence Park, gradually filling in the development with three or four individually designed homes per year.

Lawrence had no difficulty attracting the sort of buyers he found suitable, and by the late 1890s, Lawrence Park had developed a reputation as an art colony. Lawrence had not actually planned it to be an artist colony in the usual sense—and certainly not as a gathering place for bohemian, flamboyant or struggling creative types. Lawrence Park built its reputation as a home for respected, well-established and affluent artists. The community embraced both the literary and visual arts. Writers included Edmund Clarence Stedman ("the Poet of Wall Street") and the novelist Kate Douglas Wiggin, best known for *Rebecca of Sunnybrook Farm*. A particular celebrity among Lawrence Park's corps of authors was Elizabeth Bacon Custer, who spent her long widowhood defending and rehabilitating the reputation of her late husband, General George Armstrong Custer. Visual artists included William H. Howe, famous as a painter of cows and pastoral scenes; the muralist Will Low; and the engraver Lorenzo Hatch.[67]

As a finishing touch to his development of Bronxville, Lawrence in 1897 commissioned the building of the Hotel Gramatan just east of the Bronx River atop Sunset Hill. Rebuilt twice following disastrous fires in 1900 and 1908, it quickly gained popularity as an exclusive summer resort where one could relax and quaff the healthful waters of the nearby Gramatan Spring.

By the 1920s, the Hotel Gramatan had become one of the social centers (some would say *the* social center) of Westchester County. The place to see and be seen, the Gramatan hosted innumerable balls, social occasions and political events, and it was where a young John F. Kennedy learned his first ballroom dancing steps. There was also an occasional arched eyebrow and whiff of scandal. The famously mismatched couple of "Peaches" and "Daddy" Browning stayed there prior to their sensational 1926 divorce trial in White Plains, and tabloid reporters took rooms there, too, their typewriters resounding along the corridors. Events at the Gramatan drew their share of merry widows and gay divorcées—perhaps not for nothing did a few local youths climb up on the roof in 1945 to unscrew light bulbs to make the sign read, "Hot Grama."

Situated between the urbanized cities of Yonkers and Mount Vernon and the quarry town of Tuckahoe, Bronxville was unabashedly promoted as a socially exclusive place to live, and a combination of restrictive deed covenants and various "gentlemen's agreements" between buyers and sellers ensured that for

Patent medicines founded the fortune that built the elegant suburb of Bronxville and its exclusive artists' colony of Lawrence Park. *Library of Congress.*

107

years the village would remain securely white and, for the most part, Anglo-Saxon and Protestant as well. (The arrival of Joseph P. Kennedy and his family, shortly after the construction of the magnificent St. Joseph's Catholic church in 1928, marked a tentative diversification of a still exclusive community.)

By contrast, upstream Scarsdale, whose heritage included Quakers, immigrants and free African Americans, would develop as a more socially liberal though no less upscale community than Bronxville.[68] A rural village defined by large country estates through most of the 1800s, Scarsdale started to develop as a suburban community shortly before 1900, when the Arthur Suburban Homes Company developed the George Arthur Farm into Arthur Manor. Scarsdale's major development, however, would await the coming of the Bronx River Parkway.

More working-class communities developed along the southern third of the river, where modest wooden dwellings mixed with factories and businesses. South of Mount Vernon, the villages of Washingtonville and Wakefield began to grow in the mid-1800s. A village center for the surrounding countryside, Wakefield was (and remains) home to one of the oldest African American communities along the Bronx River.

On the west side of the river opposite Wakefield, developer Edwin K. Willard founded the Woodlawn Building Association in the 1870s to transform hillside farms into a residential community. The steep sides of this hilltop site sloping down to the Bronx River perhaps inspired the village's volunteer fire company's name of Avalanche Hose. Woodlawn got a boost, along with its enduring ethnic character, in the 1890s, when largely Irish tunnel workers building the New Croton Aqueduct settled in the western part of Woodlawn, promptly nicknamed "Irishtown." Woodlawn remains a home neighborhood to the "Sandhogs," and a memorial near the portal to Water Tunnel #3 commemorates the twenty-three men who died in the course of constructing this mammoth project.

Abutting the village of Woodlawn was another Woodlawn, this one planned as an upscale suburb for the dead. In the mid-1800s, Victorian sensibilities sought new ways to bury and honor their dead, something other than the gloomy, crowded churchyards of yore with their scary carved death's heads and morbid epitaphs. Instead, landscape architects designed "garden cemeteries" in which winding, tree-shaded pathways invited people to stroll and reflect. Such cemeteries were maintained through restrictive agreements (not unlike those found in other suburban developments) regulating the appearance and uses of the purchased plots. Sections of these cemeteries were sorted by the size and cost of plots, ranging from areas of grand mausoleums

down to modest single interments. Affluent purchasers would often have to purchase a perpetual care endowment to keep their plots' appearance in proper trim, and custom-designed monuments and mausoleums would have to be approved by the cemetery before construction. Completing the suburban metaphor, individual plot owners would sometimes hire landscape architects to custom-design the plantings and layouts.

The first such cemetery in New York was the Green-Wood Cemetery, opened in 1856 in what then was the rural fringe of Brooklyn. Opened in 1863 on farmland rising above the west bank of the Bronx River, the Woodlawn Cemetery could offer an easier trip via the New York Central. Special funeral cars, or even entire funeral trains, could be arranged with the railroad, and at the Woodlawn Station, horse-drawn hearses and carriages would meet the funeral trains at a specially built sidetrack. Mourners could refresh themselves at the Woodlawn Inn by the cemetery gate that specially catered to funeral parties.

Like the Green-Wood Cemetery, Woodlawn incorporated many existing natural features into the landscape design. One of these was a tributary of the Bronx River. Burbling from a spring near the crest of the ridge that divides the Bronx and Hudson River watersheds, Woodlawn Brook flowed down to the Bronx River, and with a dam creating a scenic lake from its marshlands, it served as a reflective and meditational element in the landscape.[69]

Woodlawn shared another feature with Green-Wood. Despite the suburban-style economic segregation and restrictions, Woodlawn was founded as a purely secular burial place, without religious, ethnic or racial barriers imposed on prospective purchasers. Although famous as the scenic last home for many of New York's Gilded Age elite, Woodlawn in time would come to reflect the diversity of its surrounding Bronx River communities.

L'HERMITAGE AND FRENCH CHARLEY

S outh of Williamsbridge, the Bronx River Greenway passes through the scene of a colorful but nearly forgotten chapter of the river's social history. French Charley's, along with the legendary L'Hermitage and the flourishing French-speaking community that surrounded it, helped introduce Americans to the pleasures of French cuisine and made the Bronx River a dining destination. Today, French Charley's is only dimly remembered by a local place name to which a variety of misinterpretations have been attached.

Like many other immigrants, François Laguerre sought his fortune along the Bronx River. His family in France had never recovered from the impoverishment brought on by the Napoleonic Wars, so in the 1840s, Laguerre came to New York, where he established a small downtown restaurant.

In those days, French cuisine, indeed fine dining restaurants in general, was something relatively new in the United States. While the wealthy had their private chefs and exclusive clubs, dining out for most people still meant bread, beef and muddy ale at a local tavern. The tasty and nutritious fare offered by French country cooking was an attractive alternative for the city's growing middle class. Laguerre's cooking skills made his modest venture a success, and before long he was on the lookout for more ambitious opportunities.

Sometime in the 1860s, Laguerre learned that there was a small French-speaking community living up in Westchester County at a village called Olinville that straddled Williamsbridge on the east bank of the Bronx River. There was nothing exotic in the choice of name—the village was named

for Stephen Olin, a Methodist bishop from Vermont, who bought the land as an investment.

Flowing past Olinville, the Bronx River offered Laguerre the potential to build something better than a tiny downtown restaurant. Here he could create a riverside country resort like the ones he had known in France, where people venturing out of the city would enjoy classic French cooking in a relaxing, *plein air* setting. It would be a *restaurant* in the full, original French meaning of the word—a place where people would come to be restored.

It was a chancy venture—at a time when New York City didn't extend much farther north than 23rd Street, the villages of

Author and artist Francis Hopkinson Smith enjoyed dining at L'Hermitage and described it in his story "A Day at Laguerre's." *Library of Congress.*

Olinville and Williamsbridge were then far out in the countryside. They didn't even have their own volunteer fire department—when a major fire broke out in June 1875, a fire company had to be called all the way from Morrisania. There were no fire hydrants, so the firemen had to run their hoses down to the Bronx River and hand-pump the water. The Morrisania men nevertheless had the situation in hand when a rival team from Westchester Town arrived and ordered them to leave, since Williamsbridge was in the Westchester company's territory. The Westchester men, however, didn't have enough hose to reach the Bronx River, so instead they salvaged themselves a cask of whiskey and left. A third firefighting team, summoned by the insurance company, eventually arrived and put the fire out, but by then a big part of Williamsbridge lay in ashes.

Rural Williamsbridge nevertheless had a stop on the New York Central within easy walking distance of L'Hermitage, and the beauty of the river there offered recreational possibilities beyond eating and drinking. While people could enjoy a leisurely dinner by the Bronx River, they could also go boating on the river or stroll along its banks. Less than a half hour by train

from Manhattan, it would be a place that New Yorkers could easily come to for a day out—or perhaps even stay over and make a weekend of it.

Enthused by the river's beauty and potential, Laguerre drew on his modest savings to sink $1,000 into purchasing eighteen lots adjoining the Bronx River. Partnering with a fellow Frenchman with the resoundingly Gallic name of Contant Aresene Baudoin, Laguerre opened his new place, named L'Hermitage, in 1874.

From the start, L'Hermitage would be the real thing, staffed by the kind of authentic French characters that made a visit there more than just a good meal. While the gustatory artistry of Laguerre and his wife sent enticing aromas wafting from the kitchen, the taciturn Baudoin lent a touch of intriguing mystery as the "man with a past." Known simply as "the Frenchman," rumor had it that Baudoin was a defrocked monk. Whoever he was, Baudoin was an experienced sommelier who knew how to keep a good wine cellar. Laguerre's lovely daughter, Lucette, provided the necessary touch of romance. The quiet, long-lashed girl was the darling of the regular patrons, who dubbed her "Lucette of the Velvety Eyes."

Word soon got around that L'Hermitage was a destination well worth the train ride to Williamsbridge, and a variety of artistic, adventurous and epicurean New Yorkers made the trek to the Bronx River. Novelist Henry James, himself no stranger to Continental cuisine, dined at L'Hermitage, as did the writers Mark Twain and Bret Harte. Francis Hopkinson Smith, a writer and artist who painted along the Bronx River, was especially fond of L'Hermitage and wrote it up in his 1892 book, *A Day at Laguerre's and Other Days.*

While some made L'Hermitage a day trip, for others it was the home base for a Bronx River weekend. Laguerre welcomed boaters and canoeists, who could tie up their craft for an agreeable stopover on a day's river paddle. Laguerre eventually added a few bungalows that could be rented out, and small hotels nearby also catered to boaters and weekenders. One could also bring home a bit of old-world craftsmanship as a souvenir of the visit: Laguerre had a small shop selling hand-painted French-style toleware. Wherever you were along the river, L'Hermitage wasn't hard to find: a huge American flag, painted on sheet metal, "flew" over the site and announced the place to arriving train passengers. Trees and grape trellises shaded an open-air dining pavilion, where, according to an 1889 *Harper's Weekly* article, one ate, "taking plenty of time for the meal, for there is a lazy air about the place conductive to quiet and artistic ease."

Part of the distinct charm of L'Hermitage was its setting amid the French village of Olinville. Exactly what first drew these French immigrants to the

banks of the Bronx River is uncertain, but by the mid-1800s, they had formed a distinct ethnic community. There is little memory or trace of this vanished community today, except for the curious name of Magenta Street, which may have been named in commemoration of Napoleon III's 1859 victory.[70]

The origins of the Olinville French community are vague, but a community of French lace-makers may already have been there when Laguerre arrived. Lace-making had become mechanized by the 1870s, and the Olinville community eventually staffed the Liberty Lace factory by the Bronx River at 216th Street and, later, at a much larger factory on 229th and Bronxwood Avenue, which continued in business until the 1960s.[71]

Oddly enough, the first lace factory in Olinville did not employ people from the local French community. The English firm of Duden & Company, perhaps following its ethnic prejudices, at first brought in English workers from Nottingham when it built its lace factory in the early 1880s. In the spring of 1885, a reduction in wages led to a strike and a lockout, and the management decided to employ the local French as strikebreakers. This created ill feelings between the two groups that escalated into a brawl in which gunshots were fired at the intervening police.

The French culture of Olinville eventually helped bring another tradition-driven textile industry to the Bronx River. In the same year of 1892 that Francis Hopkinson Smith published *A Day at Laguerre's*, William Baumgarten established a factory for making Gobelin-style medieval tapestries just across the river from L'Hermitage (this curious story will be fully told in the next chapter).

L'Hermitage became the "anchor business" around which other restaurants and leisure resorts clustered along that stretch of the Bronx River. With French Olinville adjoining the largely German Wakefield, the Teutonic crowd soon staked out places along the river. In 1874, the same year that L'Hermitage opened, August Reidinger inaugurated his German dance hall and restaurant in the picnic grounds of Bellevue Park at the foot of present-day Magenta Street, almost directly across the Bronx River from L'Hermitage. Just below L'Hermitage on the west bank of the river, Voelker's Schuetzenpark opened in about 1890. As the name "Schuetzenpark" suggests, it was a place where you could take part in organized shooting matches and then relax in an authentic German *biergarten* featuring "oom-pah" bands and lager beer from the breweries of Morrisania. If nothing else, the resounding rifle fire served to remind everyone of who won the Franco-Prussian War, never mind Magenta.

The French, though, had another redoubt on the west side of the Bronx River flanking Voelker's Schuetzenpark. There, where the river had

French restaurants along the Bronx River were joined by German beer gardens and shooting parks. *Library of Congress.*

carved itself a cutoff across the neck of an old oxbow, a little island was the location of French Charley's, named for its popular proprietor, Charles "French Charley" Mangin. Although it never gained the literary cachet of L'Hermitage, French Charley's left an enduring neighborhood place name long after L'Hermitage and Voelker's were forgotten. Like L'Hermitage, French Charley's was a garden restaurant where one could enjoy French food along the Bronx River. Reached via a wooden bridge crossing the river's main channel at the foot of Olinville's Elizabeth Street (today's Rosewood Street), the tree-shaded islet, originally called Cowslip Island for its profusion of wildflowers, became known as "French Charley's Island." Unlike the other two resorts, French Charley's Island still remains; although the oxbow was long ago filled in, the island's outline may still be traced in an isolated and undeveloped section of parkland.[72]

The merry times along the Bronx River faded with the end of the 1800s. Contant Baudoin died at the age of seventy-five in 1900, and after her father passed away, Lucette Laguerre continued L'Hermitage under the management of Charles "French Charley" Mangin. Under its new regime, though, the legendary garden restaurant lost much of its old luster. Perhaps it had something to do with the old French community breaking up, or maybe the increasing pollution of the Bronx River made dining by its banks a much less attractive idea than it had been thirty years before. In any event, French Charley's takeover of L'Hermitage didn't work out. By 1904, Charley Mangin was out of the restaurant business altogether, living on as a local character driving a horse-drawn bus bringing people from the train stations to the Bronx Zoo and Botanical Garden. The old L'Hermitage kept up a shadowy existence, with the aging Lucette still keeping the restaurant running as late as 1914, when the Bronx River Parkway Commission condemned it for the planned Parkway Reservation.

In time, the memory of L'Hermitage passed away, and the name of French Charley's was variously assigned to a baseball field, the general area of the Bronx River Forest, a neighborhood bar and, finally, as the official name of a playground. French Charley, people said, had been a homeless hermit who lived down among the thickets of the river's overgrown floodplain.

Chapter 13

BAUMGARTEN'S TAPESTRIES

Just below Gun Hill Road, a ruined monument commemorates a unique episode of the Bronx River's industrial history. The monument marks the site of a factory that once manufactured hand-made Renaissance-style wall tapestries.

In the mid-1800s, the vogue for Gothic Revival architecture spurred an interest in medieval art, and by the 1890s, this had morphed into a taste for the French Renaissance. Gilded Age multimillionaires were busy outdoing one another in building luxurious Renaissance-style mansions wherein they could fancy themselves latter-day princes and patrons of the arts.

These mansions needed appropriate decorations, and that meant draping their cold limestone walls with colorful woven tapestries—and not just one or two but entire rooms covered with them. The demand created a brisk market, and although antique tapestries could be bought in Europe at quite reasonable prices, dealers and decorators such as William Baumgarten soon found the demand outrunning the supply.

While some collectors insisted on only antique tapestries, demand was brisk for authentic modern productions, which could be commissioned and tailor-made to fit the architectural measurements of one's new chateau. Among the tapestry makers of Europe, none was held in such high regard as the Gobelin factory outside Paris. Gobelin's roots went well back: it had been founded in the 1700s by Louis XIV, who recruited its workers from a community of tapestry weavers in the southern French village of Aubisson. The Aubisson community itself stretched back generations, all the way, as

A fashion for the French Renaissance inspired William Baumgarten to establish his tapestry workshop by the Bronx River at Williamsbridge in 1890. *Library of Congress.*

their own tradition had it, to Egyptian weavers shanghaied to Rome by Emperor Nero.

To William Baumgarten, there seemed no good reason why such tapestries could not be produced here in the United States. He was a dealer and a recognized expert in tapestries, and on one of his buying trips to Europe, he met Jean Foussadier, a master weaver from Aubisson who had recently been part of a short-lived attempt to weave Gobelin-quality tapestries at Windsor,

117

England. Baumgarten was familiar with the Aubisson weaving community, having recently commissioned a new tapestry there. The collapse of the Windsor venture had left Foussadier out of work, and as he spoke excellent English, he was willing to immigrate to the United States. Moreover, he would bring along his wife and family, themselves skilled in tapestry weaving and repair, and together they could form the nucleus of a new community of weavers.

In 1892, Baumgarten installed Foussadier and his family in an old stone house at Williamsbridge, a place he knew well from his visits to L'Hermitage across the river. Built at the beginning of the 1800s, the house had seen better days, having recently served as a hotel, but with a flourishing grape arbor and a set of stone steps leading down to the Bronx River, it was a suitably romantic location for weaving medieval tapestries.

If the Bronx River at Williamsbridge seemed an odd place for a tapestry factory, the site sat amid the existing French community of Olinville, making it a compatible place for him to establish his immigrant weavers. Williamsbridge, though, offered one overwhelming advantage: the waters of the Bronx River itself.

The classic Gobelin tapestries had long been prized for their vivid colors. The secret, it was believed, was a small stream called La Bièvre that flowed through the Faubourg St. Marcel in Paris. The Gobelin workers drew its water to make their dyes, and it was the peculiar nature of La Bièvre's water that made such colors possible.[73] La Bièvre was a long way from the Bronx, but at Williamsbridge, miles upstream from the pollution of Bronxdale and West Farms, the Bronx's water matched the chemical composition, or the content of "dissolved vegetable substances," of the waters of La Bièvre. This meant that Baumgarten's workers could mix their dyestuffs on-site and produce colors, eventually stretching to some sixteen thousand hues, shades and tints, that were every bit as good as those of the old Gobelins.[74]

Baumgarten assembled five workers at his Williamsbridge factory, and by the end of 1893, the first-ever American Gobelin tapestries were ready for sale. These were a pair of "portieres" measuring seven feet, six inches by three feet, seven inches, depicting classical personifications of Summer and Fall. They had each taken Baumgarten's crew four months of steady handwork to produce, and they were priced at $600 apiece, or about three-fourths of a year's wages for one of the workers who produced them.

While Baumgarten expanded production, Jean Foussadier remained the core of the operation. Jean and his son personally handled the delicate task of mixing the colors and hand-dyeing the wool yarns and silk threads, using

always the salubrious waters of the Bronx River. Not for them were the newfangled coal-tar dyes being used in the textile factories down the river or such colors as mauve or magenta (unknown to medieval weavers). In keeping with the authenticity of their tapestries, at Baumgarten's only traditional vegetable and mineral dyes were used, prepared the old-fashioned way with mortar and pestle.[75]

Among the workers was Jean's daughter, Adrienne Foussadier. Adrienne had been born deaf but had learned to speak quite well and became a well-liked figure in the little community, charming people with her sunny disposition as she strolled about beneath her fashionable parasol. She was the only female tapestry weaver at Williamsbridge and one of the very few anywhere, as the male-dominated industry considered tapestry weaving too arduous for women to perform well. Nevertheless, Adrienne's mother was a skilled weaver, too, although at Baumgarten's she handled tapestry repair, undoing damage and production line errors.

Baumgarten's quickly gained a reputation for producing magnificent tapestries that any connoisseur could hang with pride. Baumgarten tapestries, it was said, were as good as anything from Gobelin and perhaps even better, as many thought the venerable Gobelin factory wasn't quite what it used to be.

"The passion for tapestries has been growing on both sides of the Atlantic," opined the *New York Times* in 1903, as Baumgarten rode the crest of the French Renaissance fad. By then, the Williamsbridge enterprise was being described as the second-largest tapestry factory in the world, employing between eighty and one hundred men and women and able to take on such orders as the one for ten huge tapestries destined for the Rhode Island statehouse.

Another large order was woven for financier Charles M. Schwab's new mansion rising above the Hudson River on Riverside Drive at 74th Street. Designed to drape both the parlor and the enormous dining room of Schwab's chateau, Baumgarten had the first pieces—classical depictions of the four seasons, along with pieces titled "Abundance" and "A Love Message"—displayed at the 1904 St. Louis World Fair.

A larger order still, fourteen pieces in all, went to Grey Towers, the new home of industrialist William Welsh Harrison in Glenside, Pennsylvania. The set remains intact to this day: Grey Towers, a National Historic Landmark, is part of Arcadia University. Baumgarten also sold pieces to such discerning buyers as J.P. Morgan and Mrs. E.H. Harriman.

William Baumgarten died at the age of sixty in April 1906. His brother, Emil, took over the management of the company, but within a few years,

rival firms in New York City were competing for a declining tapestry market. While the Baumgarten Company gradually turned from large-scale productions to tapestry upholstery, Baumgarten's onetime partner, Albert Hertier, set up his own tapestry factory in a stable loft on Manhattan's East Side and referred to the Williamsbridge factory as if it were defunct in a 1911 interview. It wasn't quite. At the end of 1912, Baumgarten & Company exhibited at the National Society of Craftsmen two miniature models of the tapestry looms it had developed in the Bronx: a Williamsbridge High Warp Loom and a Williamsbridge Low Warp Loom. "These looms tell more clearly than anything else could," ran one review, "the story of how tapestries are made and the manner in which William Baumgarten & Co. have executed hundreds of tapestries for the leading families of America."

But time had run out for the Williamsbridge factory. In 1914, what remained of the Baumgarten Tapestry Works was condemned and demolished for the construction of the Bronx River Parkway. In 1925, William's son, Paul, constructed the now-vandalized monument. It faced the new roadway across the river, and its dedication ceremony stood in wry contrast to the Parkway's dedication ceremonies that year at Kensico.

Connected to the Baumgarten site is the saga of the *Bronx River Soldier*, which once stood on an empty pedestal that remains in the river there. The pedestal originally supported a footbridge constructed by John B. Lazzari as a convenient way across the river from his home opposite the tapestry factory. But when workers and visitors to the tapestry factory started using the footbridge as their own shortcut and trespassed across Lazzari's property, Lazzari took the bridge down.

This left the bridge's granite pier standing empty in the river, but Lazzari soon found another use for it. Sometime earlier, a stone Civil War soldier had been carved by the Italian-born sculptor John Grignola as part of the monument that the Oliver Tilden Post No. 96 of the Grand Army of the Republic was erecting for its veterans plot in Woodlawn Cemetery. The visor of the soldier's cap was broken when the statue arrived, so the GAR post rejected it and decided instead to have one cast in less fragile metal.

Lazzari was a partner in the monument firm of Lazzari & Barton, which was located alongside the cemetery. Seeing the rejected statue in Grignola's studio one day, he thought it was still too nice to be left in a dusty corner, so he had the visor repaired and shipped the statue to his home by the Bronx River. After he took the bridge down, in the spring of 1898 he installed the statue on the empty bridge pier, facing north as per the custom of the day.[76] To mark the occasion, he tapped the date of 1898 onto the pier, making the

Lace making was another tradition-driven textile industry in the French community of Olinville. *Library of Congress.*

statue into sort of a memorial to the Spanish-American War, which may not have been Lazzari's intention at the time.

The French workers at the Baumgarten tapestry factory may have lost their shortcut over the footbridge, but they nevertheless made the *Bronx River Soldier* into their own monument. The soldier's Civil War kepi cap and uniform being virtually identical to the French uniforms of the 1870 Franco-Prussian War, the tapestry men waded across the river and painted the statue in a proper French *horizon bleu.* Lest there be any confusion as to whose side he was on, they painted the soldier's cap in the French red, white and blue tricolor.

Whatever he may have commemorated, the *Bronx River Soldier* stood guard in the river long after the downfall of the tapestry factory amid the construction of the Bronx River Parkway. It remained a local landmark until 1964, when one of the Bronx River's spring floods swept it off its repurposed pedestal. When the waters receded, the Parks Department recovered the statue, but this time the *Bronx River Soldier* was busted for sure, with both legs broken off at the knees. The broken soldier languished for years in a Parks Department warehouse until Bert Sachs of the Bronx County Historical Society got in touch with the elderly Charles Augustoni, who for years worked at Woodlawn Cemetery maintaining mausoleums and who could

advise how the statue could be restored. The restored *Bronx River Soldier* wasn't returned to the river to await the next flood; instead, in August 1970, it was erected on the grounds of the historical society's Valentine-Varian House, safely uphill from the Bronx River's raging waters.

Likewise standing just uphill from the Bronx River, the soldier's metal "brother" had its own role to play in neighborhood folklore. The Oliver Tilden Post was formed by veterans of units that were recruited in the then heavily Irish neighborhoods of Morrisania, Mott Haven and West Farms, and the statue moreover stood alongside the thriving Irish neighborhood of Woodlawn. For years, it was said, somebody would slip into the cemetery every March and paint the statue bright green in honor of St. Patrick's Day.[77]

Chapter 14

RYAWA

The curious name of Ryawa Avenue at the bottom of Hunts Point looks like it *ought* to be an old Native American name. It isn't, and therein lies the tale of how the Bronx River three times missed out on hosting a World's Fair along its banks.

By the 1880s, the heyday of the Hunts Point Set was fading as the industrial development of the city began to encroach on this once-isolated peninsula on the Bronx River delta. Coal smoke now besmirched the balmy salt air that had soothed Joseph Rodman Drake, and the ghost of Bessie Warren was seen no more. But there was still romance, spiced with a bit of danger, to be found on Hunts Point.

Like Ryawa Avenue, the name of Casanova Street isn't what you might assume it to be. It was not named for the eighteenth-century Venetian adventurer whose amorous exploits made his name a byword for randy behavior; rather, it commemorates an upstanding and valiant Cuban family who once lived there.

The mansion overlooking Barretto Bay that became known as the "Cradle of Cuban Liberty" was originally called Hommock Manor by the wealthy merchant Benjamin M. Whitlock, who built the house in 1859. But to people in the neighborhood, it was better known as "Whitlock's Folly."[78] The four-story building was intended to overawe the Hunts Point Set, but in truth, it was overbuilt, over budget and, to most observers, generally over the top. Costing an astonishing $350,000 (about $10 million in today's money), the brownstone behemoth boasted one hundred rooms and was fitted

out with solid gold doorknobs. Among the mansion's quarters was a large wood-paneled room furnished in the style of Louis XIV, as well as a secret chamber reached through a hidden door and containing an enormous iron safe. Beneath the mansion lay a series of large stone vaults that Whitlock, an importer of wine and brandy, likely intended to use to store his vintage stocks, although legend would later have them put to other purposes.

Whitlock's glory days at Hunts Point, though, were short-lived. An outspoken Southern sympathizer, his business was heavily invested in what would soon become the Confederacy. He was consequently bankrupted by the outbreak of the Civil War and died in August 1863. Before the war, he was also involved in proposals to forcibly annex Cuba to the United States as a slave territory—an ironic background to subsequent activities at the mansion.[79]

In 1867, Whitlock's mansion was bought by the Cuban sugar planter Innocencio Casanova. The following year, the Cuban insurrection known as the Ten Years' War broke out, and Innocencio's daughter, Emilia, founded the revolutionary organization Las Hijas de Cuba (Daughters of Cuba) to support the rebels. Innocencio and Emilia, together with Emilia's husband, the newspaper editor Cirilio Villaverde, devoted their energies and fortunes to supporting the cause of Cuban independence, right there in the house whose previous owner had plotted Cuba's foreign seizure. The great underground vaults of the mansion were now said to have stored arms and munitions that were transferred to various gun-running vessels sheltering in Barretto Bay—perhaps, as one rumor had it, through a secret tunnel that led from the vaults out to Duck Island in the inlet of Leggett's Creek.[80] As an additional irony, one of the vessels used by Casanova was the *Virginius*, a former Confederate blockade runner.

Despite the efforts of the Casanovas, the Cuban uprising failed in 1878, and by 1890, the mansion was left vacant. The immense empty building, with its Victorian mansard roof, looked like a haunted house, and indeed such was the belief in the neighborhood until Whitlock's Folly was finally demolished in 1905.[81]

The ashes of the Ten Years' War had barely cooled before major changes to the landscape of Hunts Point would engulf the Cradle of Cuban Liberty. The recent development of nearby Port Morris made the flat riverside terrain of Hunts Point increasingly attractive as an industrial site—or perhaps for something more spectacular. In 1883, the old Barretto estate and Barretto Point were bought by developers with the intention of making Hunts Point the site of a World's Fair.

Although Egbert Viele failed to bring the Columbian Exposition to the Bronx River, Hunts Point quickly developed into an industrial/residential community. *Library of Congress.*

Hunts Point had by now become part of New York City, thanks to the 1874 annexation of lands west of the Bronx River, but the isolated, marshy ground of the lower peninsula was a long way from being a practical place to host a world's fair. The honor instead went to Paris, France, in 1889. Still, the idea of holding a World's Fair in New York City (even if on the then farthest edge of town) remained a twinkle in many eyes and awaited only a more energetic and focused developer.

In 1890, the remains of the old Whitlock/Casanova estate were sold to the East Bay Land Improvement Company, which combined it with other land purchases on lower Hunts Point to create what real estate developers would later term an "assembled site" stretching across the bottom of the peninsula from the Bronx River to Barretto Bay. The company was headed by Egbert Ludovicus Viele, who as the city engineer in 1865 had drawn up a topographical map of Manhattan so precise that is still referred to today. Viele's misfortune was to repeatedly conceive of visionary plans that would be at first rejected only to have their innovative features later adopted by others. In the 1850s, he had produced a plan for Central Park that was set aside as being too naturalistic, although some of Viele's ideas would be incorporated into Frederick Law Olmsted's 1857 design for the park. In 1866, he designed an underground four-track railroad to run up Broadway;

rejected at the time as impractical, his idea for separate express and local tracks would become part of the subway designs in the next century.

It would be likewise with Viele's plans for Hunts Point. Viele proposed developing the site to host the upcoming 1892 Colombian Exposition; the honor was instead assigned to Chicago, where Daniel Burnham would create the White City. Like other ideas of Viele's, the concept of using a World's Fair to spur development would later be taken up by others, notably by Robert Moses at Flushing Meadows Park. Still, the dream wouldn't die for Bronx boosters, and twenty-five years later, one more attempt would be made to bring a World's Fair to the Bronx River upstream at West Farms, but that is a tale for another chapter.[82]

Under the direction of Egbert Viele, the East Bay Land Improvement Company proceeded with the industrial development of the lower end of Hunts Point, filling in the salt marshes, extending rails from the New Haven tracks and constructing piers at Barretto Bay. The curious name of Ryawa Avenue commemorates this: running across what had been intended as a World's Fair site, the name is instead an acronym standing for Rail Yard and Warehouse Area.[83]

Hunts Point's country estate days ended with the close of the nineteenth century. On January 4, 1900, Mary Hoe, the widow of Richard March Hoe, whose rotary printing press factory flourished in nearby Longwood, sold the fifty-three-acre Brightside estate that had been in the family since the 1850s. Within a few years, the remaining estates on the peninsula had sold out as well, leaving a lot of open land and a golden opportunity for large-scale urban development.[84]

By then, the American Real Estate Company had its own ambitions to develop Hunts Point as a planned community. Foreseeing a day when the extension of the city's subways into the Bronx would end Hunts Point's isolation, the company envisioned an integrated industrial/residential community. The high ground near the likely subway and commuter rail stops would be set aside for apartment buildings. People living there would be able to commute to jobs in Manhattan or otherwise walk downhill to work in the factories and warehouses clustered in the lowlands along the Bronx River and Long Island Sound. The city began laying out streets in 1911, and the following year saw the erection of Hunts Point's first apartment building, the Meehan Community Building.[85]

An unusual industry would serve as the "anchor" for the upland development of Hunts Point. In 1911, the American Banknote Company built a massive complex near the crest of the hill. Master engravers there

turned out state-of-the-art stock, bond and securities certificates for the growing financial industry in New York, as well as stamps and paper money for a number of South American and Asian countries. For quality control, they employed their own in-house counterfeiter to spot security flaws and suggest improvements. Downhill by the Bronx River, the American Safe and Lock Company provided the means of keeping these securities secure.

Across the street from the American Banknote Company, a Hunts Point holdout developed its own unique industry. The Corpus Christi Monastery had moved to a still rural Hunts Point in 1889, where behind its gray stone walls a community of nuns baked the communion wafers used throughout the Catholic Archdiocese of New York. Although strictly cloistered, the nuns of Corpus Christi nevertheless felt a sense of responsibility to the growing community around them and in time donated their spare land to form the Manida Playing Fields, for years Hunts Point's only active recreational space.

By 1920, when the new IRT Subway station at Hunts Point Plaza opened alongside the 1912 New York, Westchester & Boston station, nearly all trace of Hunts Point's rural past had been erased, and the community had become the urban/industrial neighborhood we know today. Although Hunts Point was one of New York's first planned communities, the urban planning by private real estate interests left out a number of non-income-producing amenities, notably parks. The loss of nearby Oak Point—whose beach and meadowlands were taken over in 1905 by the New Haven Railroad for a new rail yard—was only slightly compensated for by the city's construction of a bathhouse on Barretto Bay in 1910. Although one hundred years later this would be the berth of the Floating Pool, at the time the bathhouse's location near the untreated discharge of a trunk sewer ensured that it wouldn't remain there for long.

Although by now nobody would term the Bronx River estuary "romantic," the memory of Joseph Rodman Drake nevertheless served to secure a small patch of the bucolic Hunts Point he had known.

In drawing up their plans for Hunts Point neither the American Real Estate Company nor the East Bay Land Improvement Company had given any thought to recreational space. Although a new generation of reformers and urban planners had begun to recognize the need for open space (John Mullaly had spearheaded the city's purchase of six parks in the Bronx in 1884) for a working-class neighborhood in a day of sixty-hour, six-day workweek, leisure and recreation were not deemed significant lifestyle issues. At first, the neighborhood's only recreational space was the playing

field known as the Bronx Oval, and that would shortly become the street intersection known today as Hunts Point Plaza.

That left the Hunt family cemetery on what had been a small hummock in the marshlands at the bottom of the peninsula. With the salt marshes being filled in, the spot was now prime industrial space, so the little cemetery would have to be removed to make room for progress. A plot had been privately purchased in Guilford, Connecticut, to which the burials would be relocated, but a group of history-minded citizens stepped in with a petition to preserve the burial ground as a park. Apart from the graves of members of such founding Bronx families as the Hunts and Leggetts, the plot also held the grave of Joseph Rodman Drake, who had asked to be buried alongside his beloved Bronx River. Secured by an iron fence, the burial ground became the centerpiece of the small Joseph Rodman Drake Park in 1910. As an extra literary touch, the streets around the park were named for various nineteenth-century American poets, many of whom are all but forgotten today. Forgotten, too, or perhaps simply ignored, was the African American burial plot on the other side of the old Hunts Point Road, which would be covered over and left unmarked, to be rediscovered more than one hundred years later.

While a few small truck farms and the remnants of old fruit orchards still clung to the west bank of the estuary, by 1900 the lower Bronx River had been turned into an industrial stream. To secure barge access to such enterprises as coal yards, cement plants and a lighting gas manufacturing plant, the federal government was brought in to dredge a barge channel up the estuary as far as 174th Street. (A request to dredge out neighboring Pugsley Creek for similar purposes was turned down.)

Upriver from Hunts Point, West Farms continued to flourish as a textile manufacturing center. The Metropolitan Dye Works was established alongside an icehouse on the east bank of the Bronx River at 180th Street, and following a disastrous fire and the taking of the land for Bronx Park in 1888, the Bolton Bleach Works had moved downstream from Bronxdale to establish an even bigger plant on the west bank of the river. In its new location, the Bolton company added a new specialty to its line of products: printed souvenir handkerchiefs. To produce these, the Bolton company employed its own in-house engraving department to create the copper rollers from which these colorful handkerchiefs would be printed, ensuring that dissolved copper and acid would be added to the river's already impressive list of industrial pollutants.

At West Farms' river port, the flow of business was brisk enough to require the appointment of a professional stevedore. Originally meaning

a cargo handler who worked from the deck of a vessel (as opposed to a longshoreman, who worked from the pier), *stevedore* had come to mean a contractor who hired work crews and organized the loading and unloading of vessels.

Little is known today about Ann Hanson, who won the appointment as West Farms' stevedore, but she successfully managed the job into the 1890s. In the hard-nosed world of the waterfront, a female stevedore was a rare thing indeed, and Ann Hanson was perhaps unique in New York's maritime history. But to the boatmen who had just exchanged pleasantries with Aunt Sarah Titus as she raised the drawbridge for them at Westchester Avenue, the sight of Ann Hanson giving orders on the piers at West Farms wouldn't have seemed so strange.

Affectionately known to river men as "Aunt Sarah," Sarah Titus managed the drawbridge that spanned the river at Westchester Avenue. Her husband, William, was the original bridge keeper, but when William died in 1857, Sarah took over his post. Bridge tending on the active Bronx River channel in those days was pretty much a 24/7 job, so Sarah lived with her son, George, in a small cottage on the west bank of the river near the present-day entrance to Concrete Plant Park.

Sarah knew every captain on the river and could recognize the distinct whistles of their boats as they passed to and from the port at West Farms. (Watermen would modify their crafts' steam whistles to give each one its own individual sound.) She kept the key to the bridge's control house under her pillow when she went to bed, knowing that at any time in the night the toot of someone's tug could call her out to raise the bridge.

Sarah was fond of her job, and she often said that her happiest hours were spent on the Bronx River, where she could exchange a bit of friendly banter with passing boatmen. So attached was Sarah to her drawbridge that when New York City deputy bridge commissioner Matthew "Rocky" Moore tried to take her job away and give it to some Tammany Hall hack, Sarah stood her ground and refused to surrender her key. If Moore thought that the aging Sarah would be a pushover, he was wrong, and Aunt Sarah became one of the few New Yorkers in those days who defied Tammany Hall and won.

After some forty-five years of holding the bridge over the Bronx River, Aunt Sarah Titus finally died of pneumonia on New Year's Day 1902. Commissioner Moore now could place his own man on the job, but he found that he had to hire two men to do the work that Sarah had managed by herself.

Chapter 15

BRONX PARK

When Gouverneur Morris helped frame the 1811 street plan for Manhattan, many people could hardly believe that the city would ever grow as far uptown as 155th Street. But spurred by a postwar economic boom and new waves of immigration, by the 1870s the city was doing just that, and city planners were looking at Westchester County for room to expand New York's land and tax base. With the agreement of the state legislature, in 1874 they annexed the portion of Westchester south of Yonkers and west of the Bronx River.

While most City Hall (and Tammany Hall) planners saw the new "Annexed District" in terms of industrial development and increased tax revenue, others saw opportunities for advanced urban planning. Outside the urbanized areas of Morrisania, Mott Haven and Port Morris, the Annexed District was still mainly rural, offering an attractively blank slate for progressive-minded urban visionaries. With so many parts of the city already densely built with little thought given to human amenities, the open grounds of the Annexed District would be a place where, with a bit of applied foresight, they could avoid the mistakes of the past.

One of these visionaries was John Mullaly, editor of the *New York Herald*, who in 1881 founded the New York Park Association to advocate for the establishment of new parks beyond Manhattan. Mullaly and the park association made no small plans: they proposed six parks in all, not only in the Annexed District west of the Bronx River but also in the lands east of the river that were still part of Westchester County. Three of these parks would

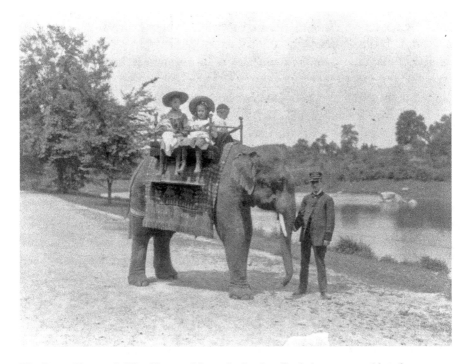

The Bronx Zoo made West Farms a leisure destination. Back then, you could go for an elephant ride along the Bronx River. *Library of Congress.*

be immense indeed—Van Cortlandt, Pelham Bay and Bronx Park—joined by three somewhat smaller parks: St. Mary's, Claremont and Crotona.

These new parks moreover would be linked together by a system of "greenbelts," first designed between 1865 and 1877 by Frederick Law Olmsted and John Croes as part of a comprehensive plan to develop the northern Bronx as a "permanent suburb." The street plan eventually laid out by the city in the 1890s would be considerably less than suburban, but key features of Olmsted's greenbelt idea would be retained. The centrally located Bronx River would be the linchpin of the system, and Mullaly envisioned extending Bronx Park with a "parkway" along the Bronx River that would preserve its scenic lands for recreation.

Encompassing the old Lydig and Lorillard estates, the proposed Bronx Park straddled a river border that John Mullaly was sure would not stand for long. Like Joseph Rodman Drake before him, Mullaly had fallen in love with the Bronx River and was anxious that Bronx Park in particular be established to preserve this scenic reach of the river from possible development. Extending Olmsted's original idea, Mullaly foresaw the need to secure the waters of the

entire length of the Bronx River to protect it from pollution, and he proposed extending Bronx Park northward all the way to the river's headwaters. He was confident that this would be made possible by the city's eventual annexation of White Plains and the Westchester towns below it. Although this third wave of annexation never happened, Mullaly's idea did become a reality some thirty years later when the Bronx River Parkway was created.

The legislation creating the new parks was passed by the state legislature in 1884. After surviving some legal challenges and controversies, it became a reality in 1888, and the lands of the new Bronx Park were formally acquired by New York City.

Although the territory of Bronx Park was mostly uninhabited, the taking process did involve some relocations. The Lorillard family had long ceased grinding snuff at their Bronx River mill, and their company was instead manufacturing the newfangled cigarettes at a plant in Jersey City. With their old Bronx River estate being incorporated into Bronx Park, they moved on to Newport, Rhode Island, then just beginning its long career as a fashionable community for the wealthy.[86]

Likewise, the Bolton Bleachery downstream was ready to relocate. The burning of the paper mill had cleared the site for its arrival on the Bronx River in 1818, and nearly seventy years later, another disastrous fire helped prompt its departure. At 3:00 a.m. on the night of April 27, 1887, there was a loud explosion that rocked Bronxdale "like an earthquake," followed by a fire in the main mill that shot flames fifty feet into the air. Four explosions followed that tore off the roof and blew off the end of the building.

While people gathered to fight the fire as best they could with water drawn from the Bronx River, plant manager William Birchall went on a mad midnight horseback ride to summon help from the surrounding towns. He first galloped to Fordham to turn out the volunteer fire department and then sped south to Morrisania to alert the firefighters there. All these efforts were in vain; the explosions and fire, possibly caused by a steam explosion in the drying cylinders, left much of the Bolton Bleachery in ruins. The company had barely begun to rebuild when word came that the land would be taken for the new Bronx Park. The news may have caused a sigh of relief, for the Bolton Company soon acquired a site downstream at West Farms where a larger, integrated and purpose-built plant would enable it to expand and modernize.[87]

The ink was scarcely dry on the city's acquisition of Bronx Park before two major public institutions were casting their eyes on it.

In the autumn of 1888, the Torrey Botanical Club began discussing the idea of establishing a large public botanical garden in the city of New York. The

The zoo's boathouse offered a pleasant experience on the Bronx River, as long as you didn't go over the dam. *Library of Congress.*

largely intact Lorillard estate that had just been incorporated into the new Bronx Park appears to have been the only site it had in mind, despite the fact that the 250-acre tract still straddled New York City and Westchester County on either side of the Bronx River. In April 1891, the club obtained an act of incorporation from the state legislature establishing the New York Botanical Garden with an ambitious scientific, educational and recreational agenda.

In the summer of 1895, work got underway to transform the site into a botanical garden along the lines of England's Kew Gardens. To bring this about, however, they would need to add a number of bridges over the Bronx River to fully connect the two sides of the garden. Work was held up, first by the city laying a sewer trunk line through the northern garden property in 1896 and then by a temporary railroad trestle that crossed the river to carry rubble excavated from the nearby Jerome Park Reservoir to fill in the marshes along Westchester Creek and Pelham Bay.

The New York Botanical Garden's first bridge was the single arch bringing the main driveway over the Bronx River to connect with an entrance at the northern end of the garden. Known today as the "Burke Bridge" in what is now the Bronx River Forest, this was built in 1903. Next was the long, five-arched bridge downstream, constructed in 1904 and 1905. Like the Burke Bridge, this bridge is also no longer on the grounds of the NYBG, today

carrying Southern Boulevard (Kazimiroff Drive) to its connection with Allerton Avenue.

West of the Bronx River, behind the site of the copper-domed Beaux Arts museum lies an expanse of low, marshy ground, possibly a remnant of the river's original pre-glacial course. Between 1904 and 1905, the New York Botanical Garden landscaped this area, filling in the marshlands and creating a pair of ornamental lakes in their place. To bring the driveway across these "Twin Lakes," a granite bridge was built in 1905. (Today ending at the northern boundary fence of the garden, this bridge is used for staff parking.)

One legacy of the old Lorillard estate was the "Blue Bridge" crossing the Bronx River at the northern end of the gorge. Although picturesque, the aged wooden bridge wouldn't stand up to the expected numbers of visitors, but for the time being, it was kept in service, with an unpaved temporary road cut through to connect it with the rest of the garden's driveways. To replace it, in 1906–7 the New York Botanical Garden built a bridge from glacial field stones scavenged from old stone walls on the property. The pretty Boulder Bridge wasn't quite up to the garden's growing needs, or to the spring floods of the Bronx River, and it was eventually replaced by a modern granite and concrete bridge in the 1950s.

Most picturesque of the garden's Bronx River bridges would be the high-arched concrete-steel bridge that spans the gorge below the Lorillard Dam. Specially designed by the New York City Parks Department landscape architect Samuel Parsons, what is now known as the Hester Bridge was built in 1910 and replaced a rickety wooden footbridge that crossed the river in front of the dam.

Just south of the garden, the Parks Department built a bridge to carry the new Pelham Parkway across the Bronx River in 1906. By way of laying its own claim to the bridge, the New York Botanical Garden had it named for the pioneer Swedish botanist Carl Linnaeus and dedicated it with great ceremony on May 23, 1907, the 200th anniversary of the great naturalist's birth. In naming the bridge, it was perhaps anticipating the expansion of the garden: the intervening parklands between the garden's southern end and the Linnaeus Bridge were added to the New York Botanical Garden in 1915.

South of the Linnaeus Bridge, the New York Zoological Society was established on the southern part of Bronx Park. The zoological society was formed out of a growing realization of the need for the conservation of wildlife and other natural resources, a realization made urgent by the seemingly impossible extinction of the passenger pigeon, along with the near-extinction of the American beaver and bison.

New York had already seen plenty of zoos and menageries (P.T. Barnum's among them) in which animals were often exhibited in conditions barely above the level of a carnival freak show. Organized by a group of Progressive conservationists that included William T. Hornaday and Theodore Roosevelt, the zoological society from the outset was determined to reach far beyond the mere display of exotic animals. Humane practices (as they were understood at the time) would govern the exhibition of animals, which would be integrated into the society's broader mission of educating the public, along with scientific research and conservation advocacy.

All this would require far more space than an empty city block or fairground, and once the new parks were established, the zoological society began to study the map in search of a suitable location for what would be not a mere zoo but rather a state-of-the-art "Zoological Park." The vast extent of Pelham Bay Park was first considered but was deemed too remote to draw the public the society intended to educate. In Bronx Park, the 265-acre Lydig (former DeLancey) estate was much better located, and it had the additional advantage of the Bronx River flowing through it, both as a scenic element and a natural source of water.

Construction began in 1898, and the New York Zoological Park opened to the public in 1899.[88] Like the New York Botanical Garden, the Bronx Zoo planners saw the remnants of the river's industrial heritage as potential scenic enhancements. Unlike the garden, the zoo's reach of the river sported *two* dams, and the zoo made use of both of them. The twin dams at the Bolton Bleachery site were restored and improved with a rustic stone facing to provide a scenic waterfall. Flanking the zoo's northern entrance, the lake behind the dams was named Lake Agassiz after the Swiss-born naturalist Louis Agassiz, with "Monkey Island" set aside for various primates to sport upon. West of Bronx Lake, the old ice harvesting pond was renamed Cope Lake in honor of the paleontologist Edwin Drinker Cope and served as a peaceful setting for the zoo's immense aviary. The Lydig milldam at the southern end of the zoo was extended and modernized to form Bronx Lake, to be the site of a restaurant and boathouse. Overlooking the dam on the east bank of the river, mill owner David Lydig's mansion stood on the site of the old DeLancey homestead. It had been the Lydig summer home, but the old house was torn down in favor of a scenic pavilion overlooking the river (today the site of Wild Asia).

The zoo became the location of one of the zoological society's first great conservation projects when several pairs of the nearly extinct American

bison were brought there to breed in protected, controlled conditions by the Bronx River. The project was successful, and the bison (after a stopover in Van Cortlandt Park) were reintroduced to preserves on the Great Plains. Today, the buffalo roam in Wyoming and South Dakota, but like so many other Americans, they, too, can trace a Bronx ancestry.

Not all the zoo's efforts on behalf of endangered animals went so smoothly. A group of captive beavers—the first beavers on the Bronx River for more than one hundred years—proved to be an unremitting headache for the zookeepers. Led by such characters as Old Scrooge and Big Brown Joe, the "Old Wise Ones" engaged in an ongoing battle of wits with their managers over such issues as regulating the water level in their pond, and occasionally they'd slip out of their assigned space to make merry with the ducks and giraffes. The ultimate beaver escapade happened in 1921, when six of them tunneled to the bank of the Bronx River and made their way up to Crestwood in Westchester. Perhaps thinking themselves safe from any cross-border pursuit, they began to settle down in the Crestwood marshes. Nervous reports of big rodents came to the attention of the zoo, which sent out an expeditionary force to bag the beavers and bring 'em back alive. By then, though, beaver reintroduction programs in the wild were proving successful, so the zoo quietly ended its troubled relationship with *Castor canadensis.*

While the beavers would use the Bronx River to get out of the zoo, another aquatic mammal used the river to escape *into* the zoo. Jerry, a three-hundred-pound California sea lion, was part of a private exhibition upstream at the Bronxville Nurseries, but in November 1927, he left behind his fellow sea lions Nell and Molly-o and slipped out of the tank and into Sprain Brook. From Sprain Brook, he made his way down the Bronx River in search of the ocean. Jerry successfully negotiated the Lorillard and Bolton dams, only to be stymied by the high drop of the 182nd Street Dam. Jerry instead lingered in Bronx Lake by the zoo's boathouse. The zoo, though, already had enough sea lions of its own, plus a perfectly good sea lion pool, so it assisted Jerry's pursuers as they improvised a sea lion trap out of upended rowboats and a screen door. His two-day escapade at an end, Jerry was hauled back to Bronxville.

There were a few other escapes in the zoo's early years, notably a wolf that broke into somebody's basement and a panther that spent a few days stalking along the Bronx River, occasioning no small degree of nervousness in the neighborhood. The panther was soon caught without injury to anyone, but it was not the only predator roaming along the Bronx River in those days.

With Bronx Park open to the public and surrounded by still rural communities, there were people who saw no reason why they shouldn't go hunting along the Bronx River. Organized nocturnal raccoon hunts, complete with dogs and lanterns, were taking place along the river into the 1900s, but mostly the problem was bird hunters. The problem was so great that in 1900, G.O. Shields, president of the League of American Sportsmen, organized a voluntary Sunday patrol with John Rose and Rudolph Bell from the zoo's security force. The Sunday bird patrol went armed and occasionally traded gunshots with hunters, whom they arrested when they could. The wooded gap along the river between the zoo and botanical garden was then an especially popular spot for bird hunters. The hunting phenomenon was seen in terms of the ethnic communities then living along the river: Italians were said to shoot song birds to make "bird pie," while the Germans went for duck, along with squirrels and rabbits. The New York City Parks Department finally appointed Henry Van Benschoten as Bronx Park's full-time game warden in 1905.

The establishment of Bronx Park also brought about the disappearance of Bronxdale Village. With the Bolton Bleachery gone and the Boston Post Road cut off by the Bronx Zoo, Bronxdale lost its importance. Apart from being the home of the Bleach, it had been a stagecoach stop on the Boston Post Road, where at Johnson's Tavern (later the Planters Inn) coaches would pull over to water their horses (and passengers). Now reduced to a decaying village, Bronxdale was seen as an opportunity to expand the zoo.

To strengthen its case for the seizure of Bronxdale Village, the descriptions put out by the zoo eerily prefigured the descriptions of riverside "blight" that would later justify land seizures for the Bronx River Parkway. "The village itself is an unsightly nuisance," zoo director William T. Hornaday plainly stated. "I don't see anything picturesque about it. We took a census of its dogs some time ago and found a great surplus of ill-bred curs."

The timeworn and cur-ridden Bronxdale Village was by then admittedly no Currier and Ives tableau. Strung out along the intersection of the Boston Post Road and Shadfish Lane, the village had no sewers or running water and, apart from the Bolton mansion, was mostly decaying cottages. South of the village lay the Neal estate, which would be separately acquired and which zoo president Madison Grant had persuaded the owners to leave forested. Rumor had it that the house lots of Bronxdale were being bought up by some shady syndicate for resale at high prices to the city, but in fact, many of the lots were still owned by the Boltons and Birchalls.

Not waiting to acquire Bronxdale Village, the zoo went ahead and set up its model farm on the grounds immediately south of the village, leveling the ground and fertilizing it with rich "black dirt" dug up from an old glacial pond nearby. Beyond its educational function, the six-acre farm proved surprisingly productive. Irrigated by well water, by 1900 it was reportedly producing fifteen tons of turnips and other root vegetables, five thousand bunches of celery, 2,500 cabbages, eight thousand heads of lettuce, two hundred melons and three hundred pumpkins. It also included a 150-bird dovecot, and a fifteen- by twenty-four-foot root cellar dug into the side of a hill, along with six chicken houses and a greenhouse nursery to supply the zoo's landscaping needs and produce exotic trees and shrubs for its animal exhibits. There were also fish tanks for stocking the Bronx River and feeding the penguins.

Apart from the boathouse, the zoo left the rocky slope along the west bank of the river—the southernmost extremity of the Bronx River Gorge—undeveloped, except for a scenic walking path that followed the river just east of the Boston Post Road. On the east bank of the river, a pathway led to a scenic pavilion on the site of the DeLancey/Lydig mansions. Looked after by a full-time forester, the forest on the west bank remains today, though seldom visited or remarked upon.

While Bronx Park fulfilled John Mullaly's hopes for preserving that scenic reach of the river, part of the river's social diversity was lost in the process. In the fields just north of Bronxdale Village, a band of about 100 to 150 Roma or Romani people (in those days commonly referred to as "Gypsies") would set up camp for a few weeks each year. While their horses were left to graze, the women would wash their clothes in the Bronx River, and in a time-honored manner, the men and boys would comb the neighborhood to see if any pots and pans needed mending.

With the establishment of Bronx Park, the New York Botanical Garden and the New York Zoological Park, nearly two miles of the river's most scenic reach were now enclosed by protected parklands. But as John Mullaly foresaw, this by itself would not end the Bronx River's problems.

Chapter 16

MOVIES ON THE BRONX

The Bronx River's relationship with early moviemaking began with a historical irony. More than a century after DeLancey's raiders made "cow-boy" a curse word, the Bronx River at West Farms became the childhood home of the actor who turned cowboys into good guys.

Born in Newburgh, New York, William S. Hart had for a time lived out west near the Sioux reservation in South Dakota. There, according to his account, he was befriended by Sitting Bull, learned the Lakota language and acquired the Lakota name of Chanta Suta (Strong Heart).

In the 1880s, the young Hart returned east when his dad got a job as a millstone dresser in West Farms, maintaining the grinding stones of the water-powered mills that still clustered along the Bronx River. An avid outdoorsman, Hart would later fondly recall his days in West Farms, where he swam in the Bronx River and skated on the ice behind the milldams in the winter. As he grew into his teens, his first job was working on one of the ice wagons that sold ice harvested from the Bronx River.

Pursuing a career as an actor, Hart was drawn into the new movie industry just as it was making its shaky start in the New York area. With its stock characters and simple plot lines, Wild West stories were a popular genre in the days of silent one- and two-reelers, and with his life experiences, Hart could bring authenticity to his portrayals of western characters. Unusually for his time, Hart also insisted on a sympathetic depiction of Native Americans, whom he occasionally portrayed as well.

After a Bronx River boyhood in West Farms, silent film actor William S. Hart made "cowboy" synonymous with "good guy." *Library of Congress.*

Sometimes called "the grandfather of all cowboy heroes," Hart developed the classic character of the "good badman" throughout a sixty-movie career ranging from *Hell's Hinges* (1916) to *Tumbleweeds* (1925), retiring from the movies just before the dawn of the "talkies." He numbered among his friends Bat Masterson, Wyatt Earp and the western artist Charlie Russell. But not everyone in Hollywood was his friend—after Buster Keaton produced a devastatingly precise satire of the long-faced, taciturn Hart, the cinematic cowboy refused to speak to him.

It cannot be said for certain if Bill Hart filmed any of his movies on the Bronx River, but the creation of Bronx Park in 1888 made the river an easily accessible "back lot" for early moviemakers. Many of these were "startups" with little more than a camera and a penciled script, with sunny rooftops sometimes serving as filming stages. Lacking sophisticated studios, early moviemakers made use of available outdoor spaces. Back in the dawn of silent movies, location shoots weren't the sort of production they are today. There was no need to bother with permits, street closures, caterers, location vans or parking. Shooting outdoors then meant loading up a Model T and driving down to the park. The site may have been selected by a location scout, or perhaps they'd just drive around until they saw a likely spot. The cameraman would set up his tripod, and the scene would usually be shot in one or at most two "takes." If someone remembered to pack a picnic basket, the crew might enjoy lunch along the Bronx River before heading back to the studio.

It is impossible to completely list the silent films that contained scenes shot along the Bronx River. More than 90 percent of all silent films made have been entirely lost, and their film credits seldom mentioned locations anyway.

Nevertheless, four early movie studios operated within a short distance of the Bronx River. Rivers being one thing not easily simulated in a studio, they would have used the Bronx River for various location shots.

The first of these was the Edison Studio at 2826 Decatur Avenue in Bedford Park, just one block south of the Bolton mansion. Built in 1906, this was one of the first purpose-built film studios anywhere. Made of concrete from the Edison Portland Cement Company, it was described as "a rock-hewn temple."[89] Although in the list of movies it made there is no film specifically set in the Bronx, the Edison people frequently filmed outdoor scenes along the Bronx River in nearby Bronx Park.

In 1912, D.W. Griffith's American Mutoscope & Biograph Company moved up from 14th Street to 807 East 175th Street in West Farms. A stickler for authenticity in scenes and settings, Griffith made extensive use of location shoots, and the directors working with him would likely have used the Bronx River when a plot element called for it. An example of Griffith's use of river scenes was the climatic escape scene in *Way Down East*, which Griffith filmed on Vermont's White River, using plywood "ice floes." Not that Griffith would stick around to see the real ice floes on the Bronx River—with the onset of each winter, he and the studio crew would pack up and head out to sunny California on a "Biograph Special" train, eventually moving to California for good. Years later, the old West Farms building was occupied by Gold Medal Studios, which until the 1970s flourished as one of the biggest film studios outside Hollywood.

Although most famous for *The Perils of Pauline* and the (literal) "cliff hangers" that she later filmed on the Palisades, Pearl White started her movie career in the studio of Pat Powers in the north Bronx in about 1910, where she made a number of (mostly lost) one-reel dramas and comedies. Pearl's perils along the Bronx River didn't last for long. In 1911, Powers's studio burned down. Studio cameramen dutifully filmed the catastrophe, and Powers used the footage for a subsequent movie about the San Francisco Earthquake.

Thanhouser Studios in New Rochelle was another company that filmed on the Bronx River. One of its earliest leading ladies was Mignon Anderson. Although the slim, petite Anderson had the perhaps inevitable nickname of "Filet Mignon" at Thanhouser, she was no wallflower. Like Pearl White, she was famed for doing her own stunt work. Among her cinematic feats was a daring rescue filmed on the Bronx River when, playing the sweetheart of a policeman in the 1912 *With the Mounted Police*, she leapt into the water to rescue her hapless beau, who had gotten himself bound and gagged and tossed into the river by the bad guys.

D.W. Griffith (center) made silent movies in West Farms. For a number of early filmmakers, the Bronx River served as a handy back lot. *Library of Congress.*

The Bronx River's greatest cinematic moment would be the night the *Titanic* "sank" in the estuary off Hunts Point. Hunts Point locals would fondly recall it for years after, although the actual film would be lost and forgotten. A replica of part of the *Titanic*'s side was constructed in the carpentry shops of the Union Railway alongside the Bronx River on Randall Avenue, along with a wood-and-canvas "iceberg."

For added authenticity, the climatic disaster scene was shot at night, lit by flares and arc lights, as extras leapt over the side into the Bronx River. The replica ship was designed so as to be collapsed in stages to simulate its final sinking. People from near and far gathered on the shoreline to witness the unique spectacle and would still be talking about it years later.[90]

A mile upstream from Hunts Point, Starlight Park played its own role in the early film industry, although as far as is known no silent film was shot there. But silent films were played there, by the swimming pool, no less, using the newly invented Pearl Screen (the original "silver screen") that enabled films to be visible in the daytime. While would-be starlets posed by the pool for publicity pictures, bathers could splash about while viewing Charlie Chaplin, Felix the Cat or perhaps even Betty Boop.

For one magical week in June 1922, Starlight Park visitors had the chance to rub elbows with some real silent film stars. One of the many groups that held events at Starlight Park was the Film Players Club, an organization that boasted five thousand members in the days when the burgeoning film industry was still centered in the New York area. That year it held a "Carnival Week" to raise money for its benevolent fund. Actors and actresses mingled with the crowd, and there was no telling who you might spot by the pool, on the dance floor or out on the playing fields. Pearl White? Fatty Arbuckle? Mignon Anderson? Dorothy Gibson? Florence Lawrence? Who knew? Movie players also performed skits in a special theater, while for the more serious-minded there were seminars and how-they-do-it talks.

No discussion of the Bronx River's role in movies would be complete without mentioning *Marty* and *The Wanderers*. Although the Bronx River does not appear in any scene in the 1955 movie *Marty*, the screenplay was written by the native Bronxite Paddy Chayefsky, and the film was shot on location in a number of recognizable spots in the neighborhoods along the Bronx River, including Arthur Avenue, Gun Hill Road and White Plains Road, making it beloved by Bronx old-timers. The Stardust Ballroom of the old RKO Chester Theater is the setting for one of the movie's opening scenes and was a historic location in itself.

Situated on West Farms Square within view of the river, the old RKO Chester was one of the cinematic landmarks of the Bronx. The eastern anchor of a stretch of East Tremont Avenue between Grand Concourse and West Farms Square that once hosted over a dozen theaters (including several Yiddish-language theaters), the RKO Chester opened in 1927 as a combination vaudeville and movie palace. Its name reflected that of the new Twenty-fifth Ward that was formed by the city's 1895 annexation of the lands east of the Bronx River. Casting about for a name for this new territory that contained both Westchester and Eastchester, the city planners decided to split the difference and name it simply "Chester." The name never quite caught on, but it was chosen by RKO for what was intended to be a central entertainment complex for the Bronx. Fabulously appointed, complete with a grand Wurlitzer pipe organ, the RKO Chester was nevertheless soon eclipsed by the opening of the even grander Loew's Palace on the Grand Concourse. Nevertheless, the RKO Chester remained a destination venue for many years before it declined and closed in 1967. In the forty-year half-life that followed, it was used as a furniture warehouse and, finally, as an auto repair garage, remnants of its lost grandeur fitfully glimpsed in the grimy shadows before the building was torn down in 2011.

Like *Marty*, the 1979 film *The Wanderers* was set in the neighborhoods along the Bronx River. Based on a novel by local author Richard Price, *The Wanderers* was inspired by the area's local history, albeit a history many locals might have preferred to forget, of youth gangs along the river in the 1950s. The film included such groups as the Fordham Baldies and the legendary Ducky Boys, who ruled the area of "French Charley's" and the Bronx River Forest back in their day. A notable scene featuring the Fordham Baldies was actually filmed deep within Ducky Boys territory on the Burke Avenue Bridge over the Bronx River.

Although the Fordham Baldies are long gone and silently shrieking heroines no longer dive fully clothed into its waters, the Bronx River continues to win cinematic distinction. In 1981, the film *Bronx River Restoration* by the Boston-based Urbanimage Corporation won the top award at that years' American Film Festival. Today, the river's natural beauty and the ongoing progress of its revitalization engage emerging video artists working with the Bronx River Art Center. Taking their own first steps in filmmaking, these young people perhaps unconsciously walk in the footsteps of early movie pioneers along the Bronx River.

Chapter 17

STARLIGHT PARK

The legendary Starlight Park, one of the Bronx River's great amusement grounds, grew out of a long, raucous history that included one last attempt to host a World's Fair in the Bronx.

In 1874, the Bronx River once again became a political boundary, this time marking the northeastern edge of New York City. With the approval of the state legislature, New York City annexed the portion of lower Westchester County west of the Bronx River that made up half of the present Bronx. It wouldn't be known as the Bronx yet; annexation simply made this new territory into the Twenty-third and Twenty-fourth Wards of New York City. As such, it didn't have a particular name. City Hall politicians and newspapers generally referred to it as the "Annexed District," while business leaders and real estate developers preferred to promote it as the "North Side."

West Farms was now on the edge of town, with a bridge across the Bronx River leading to the southern stump of Westchester County, which placed it in an interesting position. Although it had long had its share of inns and taverns along the Boston Post Road, West Farms had never exactly been Sin City. Indeed, apart from its churches, one of its most prominent establishments was the Mapes Temperance Hotel.

With a growing number of "blue laws" in New York City attempting to contain and regulate drinking, gambling and other forms of behavior deemed immoral, that bridge over the Bronx River became an inviting gateway to a free-play zone out of the reach of city authorities. The east bank of the river soon became notorious for all sorts of drinking dives,

groggeries, gambling dens and who knew what else. Westchester County, of course, had its own blue laws, but despite complaints about the cross-river carrying-on, the county sheriff was seldom motivated to take the long ride down from White Plains just to bust a shebeen or shut down a crap game.

The hot times on the river's left bank didn't last very long. In 1895, the second phase of the annexation process brought in the territory east of the river, forming what today we know as the Bronx. For the time being, though, the combined territory was still known as the Annexed District or North Side; the river wouldn't give its name to the Bronx until three years later, when New York City was reorganized into its five present boroughs.

The left bank of the Bronx had quieted down under the watchful eye of the law, but nevertheless a precedent had been established. With the Bronx Zoo established just upstream, the once quiet village of West Farms was becoming a leisure destination. Convenient to the new tourist traffic, the Bronx Casino was established just south of the zoo's southern gate on Boston Road. A casino in those days meant a combined dining and multi-entertainment complex, not necessarily involving gambling. Whatever might have gone on in its back rooms, the Bronx Casino made its fame for its restaurant, dance hall and bowling alleys.

Located alongside the last stop of the new elevated train that opened in 1905, the Bronx Casino was also an easy stroll from the zoo's new boathouse. In 1907, the zoo set up a large wooden boathouse and restaurant on the newly named Bronx Lake behind the rebuilt Lydig milldam. There visitors could rent rowboats, while the less athletic could take a ride on a powered touring boat. Almost immediately, daring young rowers began to frighten their sweethearts by rowing to the lip of the dam and getting stuck on the edge of the waterfall. On the boathouse's very first day of operation, a boat with two men and two women nearly went over the falls, the water flow being then swollen by spring rains. They were rescued without loss of life, but even with a warning cable stretched across the approach to the dam, rowers would still get into trouble, and the zoo maintained a small electric-powered boat to pull them back from the brink of doom. Strollers along the pathway below the dam could take in the drama—or simply pause to admire the waterfall.

Shortly after the boathouse opened, the zoo made a bid to place an even greater tourist attraction on the Bronx River. As part of the 1909 Hudson-Fulton Celebration, a replica of Henry Hudson's eighty-five-foot-long *Halve Maen* (*Half Moon*) was built to serve "as an instructive and picturesque feature of the water celebration." Constructed in Holland, the little wooden vessel

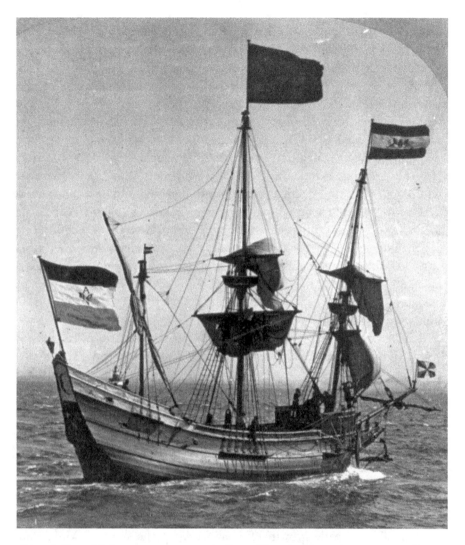

Although Henry Hudson never came near the Bronx River, the zoo sought to moor a replica *Half Moon* in Bronx Lake in 1909. The boat went to Albany instead. *Library of Congress.*

was carried across the Atlantic on a modern ocean liner and spent the year 1909 sailing up and down the Hudson lending its presence to the festivities.

Once the celebration was over, there was a question of what to do with the replica *Half Moon*. Seeing an opportunity, officials at the Bronx Zoo put in a bid to have it hauled up the Bronx River and placed on permanent display in Bronx Lake. Despite the zoo's enthusiasm, the Hudson-Fulton commissioners decided that since Henry Hudson had never ventured

anywhere near the Bronx River, a more appropriate berth for the *Half Moon* would be somewhere on the Hudson instead.[91] But this would not be the Bronx River's last encounter with a historic vessel.

About this time, there was a proposal to create an additional lake on the Bronx River in West Farms. In 1906, the amusement park firm of Melville & Schultheiser, proprietors of Fairyland Park in Paterson, New Jersey, announced plans to open a "temperance amusement park" on lands leased from William Waldorf Astor on the east bank of the river between Tremont Avenue and East 174th Street. While a temperance amusement park may seem an oxymoron, in today's terms we may think of it as a "family-friendly" sort of place, meaning that there'd be no booze, freak shows or hootchy-cootchy dancers. Melville & Schultheiser let it be known that the amusements and rides would all be imported from England, where they knew a few things about maintaining propriety. As a scenic finishing touch, the Bronx River would be widened into an artificial lake along the park site, where temperate park visitors could stroll and eat their watercress sandwiches.

Melville & Schultheiser never got the city's permission to widen out the Bronx River, and its plans for a temperance park at West Farms consequently fell through. The empty site, though, lay alongside what was becoming an elevated train and trolley car hub at West Farms Square, and in a sense, it was already "zoned" as a place of amusement. In less than ten years, an energetic band of Bronx boosters would eye the site for something more grandiose than a temperance park.

In 1914, the Bronx was an up-and-coming place. With the opening of the first subway lines in 1905, thousands of people were following the "Old Tenement Trail" up from the overcrowded east side of Manhattan and were filling in entire new neighborhoods. The new borough's promoters, mindful of the steady growth of New York up the stem of Manhattan Island, confidently predicted that before long the city's center of business and industry would be in the south Bronx.[92]

The Bronx became its own county in 1914, and to celebrate this proud moment, a special borough flag (the first of New York City's boroughs to have one) was unfurled, bearing the coat of arms of Jonas Bronck and his motto *Ne cede malis* ("Yield not to evil"). A lavishly furnished, Beaux Arts Bronx Borough Courthouse was also opened that year, signaling that the Bronx had arrived as a place of significance. The only thing needed to really put the Bronx on the map was to have the Bronx host a World's Fair. It seemed a good idea at the time.

The still empty West Farms site of the abortive temperance park looked like an excellent place for what the promoters grandly envisioned as the Bronx International Exposition of Science, Art and Industries. The space was a bit small for an international exposition, but it was well situated for mass transit to bring people in from across the Bronx, up from Manhattan and down from Westchester and southern New England. Located at the end of the newly dredged shipping channel in the Bronx River, small craft and even excursion boats could tie up there and bring additional visitors.

But as planning for the exposition got underway, it began to run into trouble. The outbreak of war in Europe that August would seem to have cast a pall over ambitions for an international exposition, but then everyone knew that the war would be over by Christmas anyway. It wasn't, and the exposition's groundbreaking on August 1, 1916, was overshadowed by the massive munitions explosion at Black Tom, Jersey City, less than two days before. The promoters stubbornly forged ahead and confidently submitted a proposal to the U.S. Congress for support. With war clouds gathering, Congress promptly turned them down.

Even the New York, Westchester & Boston Railroad nixed their request for a special train station at the exposition site. Opened in 1912, the "Million Dollar a Mile Railroad" joined the New Haven right-of-way at a spot alongside the site, and with the New Haven, it could have provided first-class rail service to the exposition. Perhaps sensing that the exposition would be a flop, neither the NYW&B nor its parent New Haven were willing to invest the money or effort and left exposition service to their existing stations at East 180th Street and West Farms. But the New Haven station at West Farms was literally on the wrong side of the tracks and would force patrons to take a roundabout detour to reach the exposition gate. Few would.

Likewise, the promoters' bid to have their event officially recognized as a World's Fair fell through. Unendorsed by any international governing body, the Bronx International Exposition of Science, Art and Industries opened on May 30, 1918, with a name longer than its guest list. Reconceived as a fair promoting postwar international trade, only one country (Brazil) ever exhibited there, and by then the United States itself had been in the war for more than a year. As a World's Fair, the Bronx International Exposition was pretty much a non-starter.

This was perhaps no surprise to the organizers, the Bronx Expositions Corporation, which by then had cannily configured the space to be more of an amusement park than an industrial exposition. The exhibition-less Exhibition Hall was hastily converted into a skating rink and dance hall,

and with a lick of paint and few more rides squeezed in, the lights went on the following spring on what was now called the Bronx Exposition and Amusement Park, to be renamed Starlight Park in October.

The pool would be what people most remembered about Starlight Park. Fed with filtered salt water pumped in from the adjacent Bronx River Estuary, it featured an artificial wave-making machine and had a sand-strewn artificial beach along one side. It was huge, too, big enough that swimming out to "the Cascade" floating at the deep end was a feat any athletic chap could show off for his girlfriend. The Cascade was a large tiered buoy that could hold about two dozen people at a time. An occasional venturesome girl might swim out there as well to attract the attention of the lifeguard; according to neighborhood folklore, Burt Lancaster was a lifeguard there in the summer of 1933 while he was dating a girl from nearby Morris Park.

The Starlight Pool wouldn't be a fond memory for everybody, however. Like most other private facilities in the area, an unwritten but strictly enforced rule was that it was for whites only. Others attempting to swim there would be escorted, none too gently, off the premises.

Next to the pool, Starlight Park's biggest attraction was the roller coaster. Designed by the noted coaster master L.A. Thompson, this double-tracked "joy ride through the clouds" formed an impressive backdrop to the pool and gave the impression that the place was much bigger than its limited twenty-eight acres. Together, the coaster and the pool made Starlight Park a photogenic destination for aspiring models and Broadway starlets to pose in their woolen swimsuits for professional portfolio pictures.

Then there was the Coliseum, a destination in itself.[93] A prefabricated steel building, it had originally been erected in Philadelphia for the 1926 Sesquicentennial Exposition celebrating the 150th anniversary of American independence. When the Philadelphia show was over, the Starlight Park operators purchased the building, had it disassembled and transported it on fifty railroad flatcars up to Starlight Park, where it was bolted back together.

At Starlight, it seated up to fifteen thousand people for a wide variety of events. It was perhaps most famous for boxing. The great boxing promoter Mike Jacobs (for whom a block of West 49th Street was nicknamed "Jacobs' Beach") had his first solo boxing promotion there with a then unknown Jake LaMotta, who became renowned as the "Bronx Bull." Another boxer who starred at the Coliseum was Tami Mauriello, who deserves a special space on the roll call of intrepid Bronx characters. The Bronx-born Mauriello had a birth defect that left one leg shorter than the other, making it difficult for him to back up, so his strategy was to always press ahead no matter

what. Mauriello had his own enthusiastic fan club called "the Gangbusters," whose members showed up en masse at his fights waving toy Tommy guns (just try that today).

There was plenty more than boxing to be seen at the Coliseum. There were six-day bicycle races and midget car racing, a then popular spectacle that the Coliseum shared with the nearby Castle Hill Speedway. There were exhibition basketball games featuring the long-haired House of David team all the way from Michigan.[94] When the Ringling Bros. and Barnum & Bailey Circus came to town, the Coliseum was its Bronx venue. There were popular music performances, too. Yiddish songstress Fanny Brice (the original "Funny Girl") played double shows there once. Convinced that her newly capped teeth were throwing off the pitch of her singing voice, she asked the manager after the first show where there was a good dentist in the neighborhood. Directed to one on Tremont Avenue, she ducked out, had her teeth filed and returned for the second show none the worse for wear.

Echoing the original intentions of Starlight Park, the Coliseum occasionally hosted industrial expositions, such as the 1933 Pure Food Fair, which promoted the virtues of supermarkets and prepackaged foods to a still skeptical public. The Coliseum was also a venue for political events, notably by the Communist Party, which commanded a substantial following in New York in the 1930s. The party held its annual Picnic Day at Starlight Park and celebrated the tenth anniversary of its newspaper, the *Daily Worker*, with a grand bash at the Coliseum, along with benefit events held for striking Appalachian coal miners.

Starlight Park had a small stadium and playing fields located in the space between the New York, Westchester & Boston and the New Haven Railroad tracks. Soccer was the main sport played there, featuring a number of professional and local semipro teams. Starlight Park was the home of the New York Giants soccer team before the pro football team took the name. It also hosted cricket matches, then as now an avidly pursued sport in the Bronx's West Indian community. (These included the Primrose Cricket Club, which is still active in its home neighborhood of Wakefield.) And then there were special shows that couldn't fit into the Coliseum, such as the stuntman Hugo Zaccini, the original "Human Cannonball," who demonstrated his shot-from-a-gun act at Starlight Park in 1929.

For the more culturally engaged, Starlight Park could offer greater things than human cannonballs. One of the first musical events there was a performance by the Russian Symphony Orchestra in July 1921. It was not

only a first for Starlight Park, but it was also the first outdoor summer music festival held in the Bronx.

The success of the Russian Symphony Orchestra may have inspired what became one of Starlight Park's signature events: the free opera performances. Sponsored by a group of New Yorkers that included Mayor Fiorello La Guardia and the concert violinist Efrem Zimbalist, the Free Open Air Opera of New York mounted full-scale productions of classic operas beginning in 1926. The productions always enjoyed a capacity crowd—in those days, the opera was a popular and familiar art form to many people in the local neighborhoods. Bronx historian Bill Twomey later recalled how the Starlight Park productions sparked his dad's love of opera, and he remained a lifelong devotee long after Starlight Park was gone, listening to the *Metropolitan Opera Hour* on TV on Sunday afternoons.

The Open Air Opera organizers made a point of recruiting the supporting cast from the local neighborhoods. In a day when many homes still included a parlor piano and Saturday music lessons, this wasn't difficult to do. The locals would be joined by a leading cast that included professional singers from the Metropolitan Opera and a first-class orchestra.

The operas were broadcast live over Starlight Park's own radio station, WKBQ, which also had a regular late evening program called *Opera in Bed*. Apart from the chancy weather, the drawback with the open-air site was the competition from the passing trains, but with the right timing, the arias wouldn't be drowned out.

One educational element in Starlight Park, left over from the defunct Bronx Exposition, was a historic submarine. The *Holland 9* was the first submarine commissioned by the U.S. Navy, put into service in 1900. Soon rendered obsolete by advancing technology, the navy sold it to a Philadelphia scrap metal dealer who eventually sold it to Dr. Peter Gibbons, who in turn donated it to the Bronx Exposition as part of its Science and Industry display. The exposition organizers didn't know quite what to do with this fifty-three-foot, seventy-five-ton vessel, so they mounted it on a pedestal on the midway and left it there while the exposition morphed into Starlight Park, serving as both a curiosity and no doubt a handy rendezvous point ("meet me at the Submarine").[95]

The submarine would vanish in the downfall of Starlight Park. Despite its popularity, the deepening Depression stressed the finances of Starlight Park, and following a disastrous fire in 1932, it went bankrupt in 1937. The pool continued on for a while, operated by an outside contractor as the "Starlight Plunge," while the *Holland 9* was sold for $100 to a local scrap metal dealer.

In 1942, the U.S. Army took over the Starlight Park site, converting the Coliseum into a truck depot, while it planned to use the pool for training purposes. Fire returned to take what was left of Starlight Park in 1946. Built as temporary structures for the Bronx Exposition, Starlight's buildings and pavilions were made of lathe-and-plaster "mast" like those of Chicago's White City, and they burned just as fiercely. Remains of the pool were obliterated by the construction of the Cross Bronx Expressway in the 1950s, and the rechanneling of the river took out the river's oxbow, where many attractions had been located. Although designed as a temporary, prefab structure, the Coliseum would outlast everything else at Starlight Park. Taken over by New York City Transit after the war as a bus depot, it was finally taken down in 1997 to make room for a more modern, purpose-built facility.

In the 1950s, a second Starlight Park, an undistinguished set of ball fields, would be opened on the opposite bank of the Bronx River. But for years after, Bronx old-timers could look across the river at a rubble-strewn and weed-choked no-man's-land and recall a Starlight Park that for them had been a place of joy, music and romance.

Chapter 18

CLASON POINT

A t the Bronx River's mouth, opposite Hunts Point, the peninsula of Clason Point[96] once bid fair to outdo Coney Island as an amusement destination, until a ghastly accident gave rise to a unique Bronx River community.

Clason Point Park opened in 1899, the same year as the Bronx Zoo upstream. But while the Bronx Zoo, or rather New York Zoological Park, pursued an uplifting educational mission, Clason Point was pure entertainment. Getting there was half the fun: at first lacking the trolley or train connections that Coney Island enjoyed, Clason Point was reached instead via ferries, steamers and excursion boats from Manhattan, Long Island and Port Morris. (There was also an airstrip later on, which didn't last for long but gave Clason Point's volunteer fire department its name of "Aviation Hose.")

In the mood for fun after a bracing boat ride, people arriving at Clason Point were greeted by a smorgasbord of merrymaking opportunities. There were all sorts of rides, including a coaster and a huge one-hundred-foot Ferris wheel, along with such things as a "Gyroplane" and the "Frolic." For the more earthbound, there were picnic grounds and a bathing pier, along with a dance pavilion that stretched out over the waters of Long Island Sound. A number of satellite businesses and restaurants also clustered in and around the park: Dietrich's, Gilligan's Pavilion, Killian's Grove, Higgs' Camp Grounds and Kane's Park and Casino.

The Inkwell would be the most memorable feature of Clason Point Park. Said to be the largest saltwater swimming pool in the world, its

water was pumped in directly from the dubious waters of the sound. Unfiltered and unchlorinated, the murky inshore seawater inspired the pool's enduring nickname.

Looking out from Clason Point, on summer evenings the dark waters of the Devil's Belt sparkled with the lights of other amusement grounds across the sound. North Beach in Queens (today the site of LaGuardia Airport) was home to two large amusement parks: Gala Park, which opened in 1901, and the adjoining Stella Park, which opened in 1907. Unlike the family-friendly atmosphere fostered at Clason Point, the North Beach parks were boozier places, in effect an enormous beer garden, the sort of place where Tammany Hall figures held their annual supporters' picnics and "chowders," where clam chowder was the least of liquids consumed.

When trolley service at last came down Soundview Avenue in 1910, an additional amusement park, Fairyland, opened alongside Clason Point Park. Leased from the same company that ran Clason Point, Fairyland has left little imprint on the local memory, but it nevertheless outlasted Clason Point's tragic demise, closing in 1935.

Kane's Casino included a small amusement park of its own, Kane's Park. A premier spot for dining and dancing, Kane's was a place where Prohibition could be winked at. The Bronx River estuary, along with Westchester Creek, Pugsley Creek[97] and the various coves, inlets and marshes around the shoreline made a convenient landing zone for imported alcoholic beverages. Situated at the end of a peninsula surrounded on three sides by water, Kane's was well positioned to receive these deliveries.

Rumrunning gave Kane's an extra cachet of edginess and danger, and shady figures seen about the place were said to be gangsters, among them the legendary Bronx-born gangster Dutch Schultz. "The Dutchman" was rumored to have an arrangement that ensured that the beer flowing from Kane's taps was supplied by none but his organization. Or else.

Booze and badmen notwithstanding, there was another side to Kane's. When the Catholic parish of Holy Cross Church was founded in 1921, it originally held its Sunday morning services in Kane's Casino, although they were occasionally interrupted by the rumble of beer barrels being brought in to supply the afternoon's and evening's secular festivities. The building of Holy Cross Church in 1923 put an end to this odd arrangement, but it remained a neighborhood legend.

The greatest achievement of Kane's Casino was being the birthplace of Betty Boop. Born across the river in Hunts Point, the big-eyed Helen Schroeder got her start in show business singing at her uncle's casino. The diminutive, dark-haired girl with the squeaky voice and signature "boop-oop-

a-doop" (improvised one night when she forgot a line to a song) made a great hit with the clientele of Kane's, and Helen (now calling herself Helen Kane) was soon launched on a successful vaudeville and stage career. In 1930, she caught the eye of Grim Natwick, an animator at Max Fleischer Studios, who used her caricature and squeaky singing voice as the inspiration for a dog character in a cartoon called "Dizzy Dishes." Two years later, Natwick morphed the dog into a fully human character sporting Helen's dark spit curls and large, wide-set eyes, and "Betty Boop" was born.[98]

A popular place long after the repeal of Prohibition made drinking legal again, Kane's Casino flourished as a drinking, dining and dancing destination throughout the 1930s. There one could dance to the tune of Joseph P. Ferro's "Bronx River Foxtrot" and perhaps enjoy one of the period's signature drinks, a "Bronx Cocktail" (gin, vermouth and orange juice, said to be a favorite of F. Scott Fitzgerald).[99] Kane's Casino outlived both Clason Point Park and Fairyland until it caught fire and burned down in 1942.

Higgs' Beach was another satellite of Clason Point Park, offering swimming in the Bronx River Estuary, along with a campground and summer bungalow colony, until a horrible accident shut down the amusement park and prompted the evolution of Higgs' Beach into Harding Park, one of the most distinctive communities along the Bronx River.

It all started with the Ferris wheel. The giant Ferris wheel was a focal attraction at Clason Point, but it had its share of bad luck. The Devil's Belt was a place where summer storms could suddenly brew up and hit with fury, and in the days before Doppler radar and satellite forecasting, amusement parks were especially vulnerable to such nasty surprises. An early summer thunderstorm seemingly came up out of nowhere in June 1911, and the wind knocked the fully loaded Ferris wheel off its axle. Then, to make things worse, lightning struck the wheel, temporarily flash-blinding many of the already panicky passengers. With some difficulty, the passengers were rescued with ladders, and miraculously nobody was killed.

Another sudden brew-up in June 1922 proved fatal. This time, a microburst of one-hundred-mile-per-hour winds blew the fully loaded Ferris wheel apart and hurled part of it into Long Island Sound. Seven people were killed and dozens more injured. Clason Point tried to carry on, only to be hit by multiple lawsuits and a fire a few months later that caused extensive damage to the park. By then, it was no doubt suffering from competition with Starlight Park, which had a cleaner pool and was a lot easier to get to. Shortly after the fire, Clason Point Park was bankrupt and out of business.

This left Higgs' Beach as a satellite without a planet. With Clason Point Park now defunct, there were far fewer campers staying over, but the view down Long Island Sound across the Bronx River Estuary was something just too good for the "regulars" to walk away from. With a wink and a nod from owner Thomas Higgs, people began converting the campsites into year-round bungalows. Before long, the one-hundred-acre Higgs' Beach had grown into a settled community of 240 families, with an ethnic mix of Irish, Germans, Swedes, Norwegians, Finns and Italians, many of whom fished or otherwise made their living on the waters of Long Island Sound. In 1924, they patriotically named their improvised community Harding Park after the late but still popular twenty-ninth president and settled down to enjoy their own version of normalcy by the Bronx River.[100]

The place lacked paved streets and sewer lines, but seemingly out of the purview of city bureaucrats in a remote corner of the Bronx, it wasn't such a bad setup, especially once the Depression set in. The place was heavily damaged in the hurricane of 1938, but they rebuilt and remained. Living in the bungalows that they had often built with their own hands, the residents of Harding Park continued to pay land rent for their plots to a succession of owners, with repeated attempts to purchase the land rebuffed. One small victory came in 1950, when the tenants succeeded in getting a court ruling that their plots were subject to the city's rent-control law.

It is good to live unknown to the law, as an old Gaelic saying has it, but the 1950 court case hastened the end of Harding Park's obscurity and drew the ire of Robert Moses. With big plans for reshaping the postwar city, Moses had little patience for what he saw as a tatterdemalion bunch of freeloaders in Harding Park—the "Soundview Slums," he called it. Moses planned to raze Harding Park and replace it with an upscale waterside housing development. While the residents fought back as best they could with protests and lawsuits, Moses's plan finally died when questions were raised in the press about the favorable terms of the proposed sales of property to prominent Bronx politicians.

Before retreating from Harding Park, Moses left a spiteful parting shot. He built a long jetty paralleling the shoreline of Harding Park, ostensibly to create a marina but actually, it was said, to make Harding Park unlivable. Not part of the city's sewer system, the jerry-built community sewers of Harding Park emptied directly into the Bronx River, where tide and current would flush away the effluvia. The jetty would block this tidal action, making the "marina" an odiferous cesspool. The residents knew this, but having no legal claim to the offshore waters, there was little they could do except

protest and throw tomatoes at the dump trucks. Moses was confident that after a hot summer or two, the residents would move away of their own accord. They didn't.

Instead, Harding Park hung on. In 1978, the last private landowner, Federated Homes, walked away from the site, and the city took over Harding Park for tax delinquency, making it then the largest contiguous section of city-owned residential land in New York.

Founded by one accident, Harding Park got its future secured by another bit of happenstance when about this time Pepe Mena took a wrong turn and found himself driving down a seeming road to nowhere on Soundview Avenue. Stumbling on the riverside bungalow community, he was charmed—the place looked very much like the little seaside villages in his native Puerto Rico. Purchasing a home there at the first opportunity, Pepe Mena would do much more than fish and enjoy the sunset in Harding Park. Forming the Harding Park Homeowners Association, he pushed ahead the long-stalled negotiations with New York City for individual land purchases, sewer construction, street paving and the "grandfathering" of old bungalows that had been built prior to the city's building codes. Mena's efforts were crowned with success, and today Harding Park thrives, sometimes called "Little Puerto Rico" by new residents who, like Pepe Mena, found in Harding Park their own isle of enchantment.

North of Harding Park, the streams and salt marshes of Soundview that once made Clason Point nearly an island suffered a more ignominious fate. An ecologically rich expanse abounding in ducks and turtles, the salt marshes were cut through by Dairy Creek, Barnett's Creek and Cedar Brook, with the historic landmark of Black Rock looming over all.

An introduced disease unknown in pre-European times, malaria had been endemic in the area throughout the nineteenth century, believed, as the name implies, to arise from the "bad air" or miasma from decaying marshland vegetation. The discovery in the early 1900s that mosquitoes, in fact, spread malaria prompted a campaign by the city to eliminate its wetlands. The salt marshes along the lower Bronx River were specifically targeted in 1909 for systematic ditching and draining.

Ditching and draining, however, would only go so far in the low-lying Soundview marshes, so the city eventually opened them up for landfill. There was little planning, regulation or oversight to this filling in; Soundview was simply understood to be a place where construction and demolition debris (and who knew what) could be dumped, with no questions asked. The process got a boost in the 1930s when demolition

debris, originally from Brooklyn "slum clearance" projects that had first been dumped on Rikers Island, was hauled over to Soundview to make way for the city's new jail complex.

The debris dumping (which also filled in most of nearby Pugsley Creek) eventually transformed Soundview from low-lying marshlands to a bluff rising in places some twenty feet above the Bronx River. An unstable ground for construction, the site was leveled off and in 1937 named Soundview Park.[101]

Debris dumping was only part of the accelerating degradation of the Bronx River in the early twentieth century—a degradation that would reach a degree that prompted a bold plan to preserve the river.

Chapter 19

THE MIGHTY KENSICO

The creation of the Annexed District in 1874 posed a problem to city planners: it needed a water supply. The Annexed District was blessed with an abundant number of springs and wells, and these had been adequate to supply the district's farms and small villages. But to support an increased population, more would be needed. The Croton Aqueduct ran right through the area, but the growth of Manhattan had already taxed the 1842 aqueduct to its limit. While plans began to be discussed for exploiting water sources far afield of New York, an old idea was dusted off as an interim measure: making use of the Bronx River.

Proposals for tapping the Bronx River went as far back as the Manhattan Water Company in 1798, and the idea had been revived again in the 1830s, only to lose out to the Croton River. With the open fields of the Annexed District invitingly poised for profitable development, if only water could be found to supply the houses and tenements, the eyes of engineers turned once again to the Bronx River. But now, to ensure a reasonable quality of water, they would have to go all the way to the river's headwaters.

Named in 1849 for the local Native American sachem Cokenseko, the mill village of Kensico was nestled at the confluence of the Bronx River's two northernmost branches.[102] The North Branch flowed down from a junction with the Byram River, and the East Branch issued forth from the copious springs that formed the Rye Ponds, flowing to a confluence with the curiously named Bear Gutter Brook before joining the North Branch.

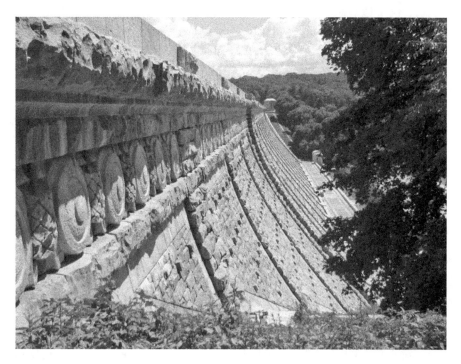

Completed in 1917, the Kensico Dam cut off the northernmost parts of the Bronx River, making Davis Brook in Valhalla the river's designated headwaters. *Photo by author.*

The running waters of both Bronx River branches had made Kensico an important mill site since the early 1700s. It also possessed a unique distinction among Bronx River villages as one of the places the legendary Old Leatherman passed through. An itinerant hermit dressed entirely in crude leather clothes of his own manufacture, the Old Leatherman walked a regular 365-mile circuit through Connecticut and New York in the years following the Civil War. As he offered no explanation of himself, people wondered who he was and what drove him to pursue the life he did, but he was understood to be harmless, and folks would often feed him or give him some tobacco before he continued on his way. Following a route that seldom varied, his visits to Kensico were as regular as clockwork, and kindly farmwives would often bake an extra loaf of bread on the days they knew the Leatherman was "due." He slept in caves and rock shelters along his route, and ever since he was found dead in 1889, the identity and motivations of the Old Leatherman have been avidly discussed by local historians.

Nestled in a deep valley about four miles north of White Plains, Kensico's picturesque location and abundant water sources made it an excellent spot

for building a reservoir. Doomed by its geography, Kensico would become the village that died by both fire and water.

The first Kensico Dam, completed in 1885, was a straightforward granite and earthen embankment. Its reservoir came up to the southern end of the village, and the waters were channeled southward through a pipeline paralleling the Bronx River (beneath what is still today called Pipeline Road) down to the Annexed District. There it filled the Williamsbridge Distributing Reservoir, the present-day Reservoir Oval Park, situated near the crest of Gun Hill, from which it could flow by gravity to most corners of the growing Annexed District.

New York City wasn't the only entity using the Bronx River for drinking water. Above Kensico at the far northern extremity of the river's North Branch, developer Victor Guinzburg dammed the Bronx River in 1903 to make a reservoir for the North Castle Water Company. Filling a deep wooded ravine that had been known as the "Dark Hollow," Lake Heaptauqua remains on the map to this day, and while the name looks Native American, it isn't. As a wry comment on his protracted negotiations with the town of North Castle, Guinzburg gave the lake the pseudo-Algonquin name of "Heap-talk-qua." Stuck for the cost of building a second dam in 1913, Guinzburg blithely named the new lake "One-on-me."[103]

Downstream from Lake Heaptauqua, the talk wasn't so humorous. Although scenic carriage roads lined the attractive new reservoir and there were proposals to develop Kensico as a resort area, the proximity of the village and farms to the river and reservoir was causing problems. With a growing awareness of water-borne diseases, New York City's Board of Water Supply was anxious to preserve the purity of the reservoir, but it discovered that even that far up contamination was creeping into the water. So, a squad of health inspectors ventured forth to find out why. A close-up examination revealed that Kensico was not always the pretty village depicted on its postcards. Pollution was entering the reservoir from a number of ill-kempt properties adjoining it—in one instance, the inspectors discovered a long-dead horse still in its stall just yards away from the river, its owner protesting that with so much to do, he hadn't had time to bury it.

The end result was that the city used condemnation proceedings to take ownership of several properties adjoining the river, and once the occupants were moved out, the buildings were set alight and burned to the ground. This created a sanitary buffer zone to protect the waters of the reservoir, but the battered Kensico Village was yet to suffer a last, and fatal, insult.

The 1898 consolidation of Greater New York further strained the city's water supply. In the spring of 1900, a report plainly stated that the existing Croton and Kensico Reservoirs could only supply the Bronx and Manhattan for another five years, never mind the three other new boroughs of Brooklyn, Queens and Staten Island. Part of the solution was the construction of a New Croton Aqueduct, followed by the extension of the Croton reservoirs behind a New Croton Dam. Completed in 1905, the 240-foot-high New Croton Dam was then the largest masonry dam in the world, and it quite submerged the original Croton Dam three miles upstream.

The New York City Board of Water Supply didn't for a moment imagine that the enlarged Croton system would be a permanent solution, and the cement had barely hardened on the New Croton Dam before it was already planning for a truly epic engineering project: bringing in water from the Catskill Mountains. The proposed Catskill system would need its own receiving reservoir close to the city, and the planned route for the Catskill Aqueduct pointed straight at Kensico.

The year after the New Croton Dam was finished, planning began for a mammoth new Kensico Dam that would doom what remained of Kensico Village, which was now right at the bottom of where the new reservoir was going to be. Parcels of land were appraised and condemned, and the owners paid what the state determined a "fair value." Families had to make their own arrangements to relocate in such surrounding towns as Armonk and Valhalla, sometimes dismantling and moving their houses to new locations.

The hamlet of Valhalla was about to become the northernmost settlement on the Bronx River. The place had an interesting history—it was not, as one might suppose, a German or Scandinavian community. The train station was originally called Kensico, but when Kensico Cemetery got its own "Kensico Cemetery" stop, it caused confusion. To settle the matter, the wife of the village postmaster, a great fan of the newly introduced Wagnerian *Ring* cycle operas, proposed calling it Valhalla for the pagan paradise of Odin, Thor, Brunhilde and the Valkyries.

Construction of the new Kensico Dam began in 1913 and was finished in 1917 at a cost of more than $15 million. Masonry for the dam, enough to build a good-sized Egyptian pyramid, came from the granite quarry at Cranberry Lake two miles to the east over narrow-gauge railroad tracks. Crews began by digging straight down to solid bedrock, work that entailed months of blasting and a number of fatal accidents. Work gangs then began laying the concrete blocks that would form the dam's core. The technology of poured structural concrete then being still in its infancy, concrete was cast

into large standard-sized blocks that, after curing for three months, were cemented together as masonry.

Ultimately, 1,500 men would work building the Kensico Dam, and their story is part of the lost history here. Most of the laborers would be Italians, who in the early 1900s were the new wave of immigrants and thus next in line for the bottommost jobs. Coming as they did from the land of Michelangelo, Italians were assumed to be good at stonework, with the added benefit that they could be paid even less than the wages begrudged to African Americans.

Like the Irish workers who built the original Croton Aqueduct, the Italians were not a welcome presence in the rural communities in which they labored. On the job and off it, they faced overt discrimination and unspoken disdain. At least one local Catholic church accepted Italians as congregants but would not permit them to be married in the church sanctuary—nuptials for Italian couples instead had to be performed in the church basement. Money often trumped race, however, and local hotels, rooming houses, stores, restaurants and saloons gladly drew their share of the workers' meager pay envelopes.

In those days, the Italian workers were treated as a disposable labor supply, and in the recessionary years that followed the Panic of 1907, there were always more applicants ready to take the place of any troublesome or recalcitrant (or injured or deceased) laborer. Some of them came and went without even leaving their names behind—unwilling to wrestle with polysyllabic Latin names, foremen often simply recorded laborers as "Italian No. 1," "Italian No. 2" and so on. With little in the way of protective gear or job safety practices, work on the dam could be deadly. To this day, it is uncertain how many men were killed building the Kensico Dam, and estimates range from as few as eight to twenty or more. The underground work building the Catskill Aqueduct was even deadlier, so much so that one remorseful contractor committed suicide over the casualty rate.[104]

At Kensico, the workers' encampment was dubbed "The Bowery" as a byword for disordered squalor. The Kensico's Bowery was far from it, though. A mounted police force kept order (and discouraged labor protests) in the temporary village that also included a school for the children, along with sewing classes for the women and English language classes for the men. Not a trace of this village remains; today, summer sunbathers stretch out on the green lawns of Kensico Dam Park that cover the site.

More than 300 feet high and 1,830 feet long, the completed Kensico Dam holds 30.6 billion gallons of water. It receives water from the Schoharie and Ashokan Reservoirs in the Catskill Mountains via the Catskill Aqueduct,

The Kensico Dam was built with ornamental spillways. *Photo by author.*

as well as from the Cannonsville, Neversink, Pepacton and Roundout Reservoirs through the Delaware Aqueduct (completed in 1945). Closer to home, it receives Croton System water from the Croton Falls, Muscoot, New Croton and West Branch Reservoirs. After Kensico Dam Plaza became a county park in 1963, the granite face of the dam has become a Westchester icon, and the dam is listed on the National Register of Historic Places.

Together with the Ashokan Dam in the Catskills, the Kensico can share the title of the "last of the handmade dams." Built to a classic design and covered with granite facing, it represents one of the last dams of its kind. With its conventional end-to-end straight wall, the Kensico is what engineers term a "gravity dam," as it derives its stability from its sheer weight. The granite blocks covering its face are more than decorative—they lend essential weight to the structure. Visitors today can look at the drill holes on these granite blocks to glimpse the hard manual labor that went into their quarrying.

But just four years after the Kensico was completed in 1917, the Swiss engineer Fred Noetzli proposed a radically new design concept for dams: "arch support," which by bending inward against the weight of the water

would transfer some of the stress onto the anchorages at either end of the dam. This meant that less material would be needed to construct such a dam, making it cheaper to build and with a greater margin of safety. While engineers tested and refined Noetzli's arched-dam design in the mid-1920s, the development of poured concrete technology also proceeded apace, with the result that the next generation of high dams in the 1930s would be arched concrete dams, leaving the once-celebrated Kensico looking old-fashioned.

The new Kensico Dam completely drowned the sources and lopped off the three northernmost miles of the Bronx River. Whereas the old dam had an outflow that allowed the surplus waters of the Bronx River to continue flowing down their old course, every drop in the new Kensico Reservoir was "spoken for," with their only outlet being through somebody's faucet. The spillways at the new dam were ornamental only, supplying such things as an ice skating pond at the base of the dam. Consequently, the onetime tributary of Davis Brook tumbling through Valhalla became the designated headwaters of the Bronx River, and the remaining stub of the Bronx River's Northern Branch above the reservoir was now considered a continuation of the Byram River. But the springs of the old Rye Ponds still flowed beneath what was now Rye Bay of the reservoir; to this day, every glass of tap water drawn in New York City contains a few drops of the Bronx River.

The memory of Kensico Village, and a lingering anger at its seizure by a thirsty New York City, still persists in the area's folklore. A monument stands alongside Route 22 on the east side of the reservoir, about two miles north of the dam at a spot approximately overlooking the village's site, now under some sixty feet of water. The monument features a grinding stone from one of Kensico's mills, and nearby one can still make out the trace of the old Mile Square Road that once led down to it.[105]

Although Kensico's buildings were thoroughly dismantled before the water flooded the reservoir, people here, as they do in other such places, like to imagine that the drowned village is still down there, its buildings intact as sort of a watery Brigadoon. It is said that if you stand alongside the reservoir on a calm day, you can glimpse the steeple of Kensico's Methodist Church beneath the water's surface. Others say that if you go up to the top of the dam on a quiet Sunday afternoon, you can still hear the church bell mournfully tolling for its lost village of Kensico.[106]

BRONX VALLEY SEWER

In the summer of 1905, the *New York Tribune* editorialized on the state of "that once lovely stream," the Bronx River. It was no longer the romantic river of Drake nor the sylvan stream that enchanted John Mullaly. The *Tribune* instead described a "turbid, reeking, stinking thing that used to be the Bronx. The water is as foul as the outpourings of a sewer; the rocks are coated with slime and filth like the walls of a cesspool; the fishes are dead, birds shun the stream and rank weeds have replaced the dainty flowers that once bloomed at its margin."

Things had reached such a state that even a leather tannery at Bronxville had complained of the pollution and was filing a lawsuit against the City of White Plains upstream. This seemed rather like a bowling alley complaining about noisy neighbors, but there was some merit to the suit. The tannery was a specialized operation, tanning deerskins to produce the extra-fine leather that padded piano keys. Having lost its access to the water of Prescott Brook, it had instead filled its vats with Bronx River water, only to have the leather ruined by what it claimed was the excessive acidity of the water coming down from White Plains.

The *Tribune*'s reporting wasn't a new revelation. The Bronx Zoo had hardly opened before the Bronx River's water was found to be making the animals ill. The river had been one of the reasons the zoo was located in Bronx Park, but now the directors wondered if that was such a good idea after all. Although the main core of the zoo's exhibits were clustered around Astor Court, uphill and out of sight of the Bronx River, the awful state of

the water was an embarrassment, especially in the peak visiting months of summer. The zoo had planned to use the river as a recreational attraction, with the new boathouse and riverside strolling paths, but these benefits were jeopardized by the pollution that made the river smell worse than the animal pens. "There is not one good reason why the City of New York should have a foul stream of water flowing through six miles of its northern territory," fumed the zoo's director, William T. Hornaday. "There is no good reason why the Bronx River should not be saved for all future generations and converted into a feature of permanent beauty and usefulness."

North of the zoo, the river's wretched state was having an adverse impact on humans, too. As more people settled in the urbanizing neighborhoods of Olinville, Williamsbridge and Wakefield, the area was gaining a reputation of being a sickly place, especially in the summer. Such a reputation could hinder development plans, forcing local officials to take notice. As the son of a beer brewer, the Bronx's new borough president, Louis Haffen, knew a thing or two about water, and he took note of the sorry state of the Bronx River. "The beautiful Bronx," he said in a speech after the exceptionally dry summer of 1899, "is beautiful no longer. It is a quiet, dead little stream, except after heavy storms. In summer there are three or four inches of scum on the water and not a drop of water flows over the dam in three months." Echoing John Mullaly's idea from fifteen years before, Haffen suggested that the city manage the entire length of the river.

Although industries along the river bore their share of the blame, much of the problem flowed from ordinary homes in the growing towns and suburbs in the Bronx and Westchester. Believing that dilution is the solution to pollution (it isn't) and that running water purifies itself (it doesn't), towns, villages and businesses had no compunction about emptying their untreated sewerage and storm water runoff directly into the Bronx River. Even in the short reach of the river between Bronxville and Mount Vernon, a reporter found no fewer than six businesses, including a hotel and a beer brewery, that had built their own private sewers to the river. Individual homeowners, too, in bottomland settlements lacking town sewer connections pragmatically built their outhouses right on the riverbank, using the river as sort of a perpetually flushing toilet. Some homeowners and developers simply connected their sewerage discharge pipes to the nearest storm water conduit.

When not polluting its waters, various agencies sought to alter the river to suit their own purposes. In the autumn of 1905, the New York Central Railroad was in the process of expanding its rail yards at Wakefield and rearranging its trackage as part of its electrification program. To make room, the railroad

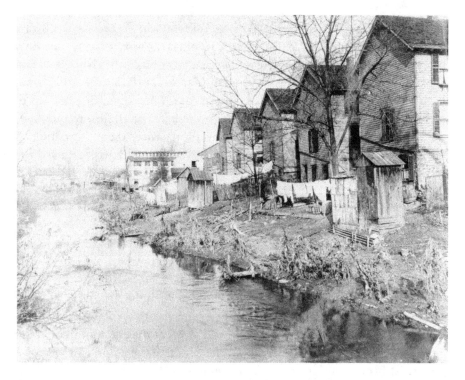

Riverside outhouses combined with industrial pollution led to outbreaks of "duck cholera" in the early 1900s that prompted a movement to reclaim the river. *Library of Congress.*

moved the Bronx River westward into a new channel (the westernmost track still runs atop the river's former channel between 239^{th} and 240^{th} Streets). The railroad had previously enlarged its yards at North White Plains, in the process relocating Dead Man's Lake westward and rechanneling the river into an old stone quarry to create a new lake.

When not brusquely altering the course of the river, the New York Central's electrification program was in some ways a positive step, for the coal-fired railroad had damaged the river in a number of subtle ways mostly unrealized at the time. By switching away from coal-burning locomotives, the railroad eliminated its picturesque plumes of coal smoke (to the delight of trackside housewives), as well as the enormous residue of ash and cinders, both of which could leach mercury and other hydrocarbon byproducts into the river. On the other hand, creosote, adopted in the early 1900s as a preservative for wooden ties, would eventually be found to be a pollutant, encouraging a switch to concrete ties at the end of the twentieth century.

The New York Central wasn't the only railroad with its eyes on the Bronx River. In the Bronx, the Interborough Rapid Transit Company was only narrowly prevented from building on a scenic section of the river. In its first construction phase in 1905, the elevated train ended at 180th Street and Boston Road, just below the Bronx Zoo's southern gate. The expansion plan was to continue straight ahead, plowing through the lands of the Bronx Zoo and Botanical Garden and finally crossing the Bronx River on an "ornamental bridge" on its way to Williamsbridge. The work would have destroyed the forested area along the river then known as "The Glen," considered one of the beauty spots on the river. A combination of community opposition and pressure from well-connected directors of the New York Zoological Society blocked this expansion, but it took another ten years to finally persuade the IRT to build its "el" on its present-day route crossing the river at West Farms and running up White Plains Road.

The Bronx River's troubles weren't all in the water. In 1904, the Bronx Zoo's chief forester, Herman W. Merkel, noticed that the American chestnut trees in the park were dying. He quickly contacted Dr. A.W. Murrill at the New York Botanical Garden. Murrill soon saw that the chestnut trees in the garden were dying, too, and set about determining the culprit. In 1906, he published his conclusion that this previously unknown disease of chestnut blight was caused by a fungus entirely new to science that he named *Diaporthe parasitica*.[107] Further investigation revealed that the disease had possibly emerged on Long Island ten years earlier. Of Chinese origin, the fungus had likely arrived in imported timber and was spread by airborne spores, as well as on clothes, shoes and tools, finding in the American chestnut a host that lacked the disease resistance of its Chinese counterpart.

By the time the fungus was identified, the blight was already widespread. Beginning at the Bronx Zoo, the Bronx River Valley was the blight's initial vector into the continental interior, and within a year, nearly all American chestnuts in the Bronx were infected. By the spring of 1907, the blight had already reached Poughkeepsie, spread across the Hudson River and worked its way as far south as Trenton, New Jersey. The microscopic spores infiltrated the bark through holes and cavities and caused cankers to grow that eventually strangled the chestnut trees by cutting off their flow of sap. There was no known remedy, although a host of quack "tree surgeons" did a brisk business with a variety of ineffective nostrums.

Once one of the dominant trees of the northeastern woodlands, the durable American chestnut, with its close grain and warm brown color, had been a favorite of dugout canoe crafters and cabinet makers and was also

widely used for tannin, fence posts and shingles. Its chestnuts, too, when not roasting on the open fire, fed farmers' pigs that roamed "hog wild" through the woods. Within a decade, though, the American chestnut would be history, apart from a few isolated survivors in remote woodlands. By 1913, the consulting landscape engineer for the Bronx River Parkway Commission found that the blight was so far advanced throughout the Bronx River Valley that there was nothing he could recommend except to remove all the chestnut trees from the Parkway's route.

The chestnut blight would not be the last of the Bronx River's arboreal woes. The fungal disease of white pine blister rust arrived hard on the heels of the chestnut blight in 1906, and yet another fungal infestation, Dutch elm disease, swept through the area in the 1930s, killing a tree that thrived in the Bronx River's moist bottomlands. In the 1980s, the hemlock wooly adelgid, an invasive aphid-like insect, arrived in the Botanical Garden's Hemlock Forest and started sucking the sap from the hemlocks. Although it had survived as one of the last untrammeled stands of hemlock in New York State and was, in fact, the southernmost forest of the Canadian hemlock (*Tsuga canadensis*), thanks to the wooly adelgid, by the 1990s hardly a hemlock was left in the Hemlock Forest, forcing the Botanical Garden to change its designation to the Native Forest (present-day Thain Family Forest).

As the Bronx River reached the nadir of its ecological degradation at the end of the 1800s, the Bronx Valley Trunk Sewer would be the first governmental attempt to alleviate its pollution. In 1895, the New York State legislature created the Bronx Valley Sewer Commission to study the feasibility of constructing a trunk sewer to collect and carry away the wastes of towns and cities along the Bronx River. The commission also looked into the idea of a park and a roadway along the Bronx River but recommended that the notion be "dismissed from further consideration" and that only enough land be taken to accommodate the width of the trunk sewer.

The study was financed jointly by the City of New York and the County of Westchester, and early on, the commission considered simply enclosing the river in one long underground conduit and using *that* as the trunk sewer. The idea had some appeal as a solution to the river's flooding problems, but the Bronx River's very proclivity to flash flooding saved it from being thus buried. Consulting engineers calculated that the sudden surges of flash floods would burst the pipes of any conduit.

Instead, the commission's initial proposal was for a trunk sewer that would drain both the Bronx and Hutchinson River basins, emptying the untreated wastewater offshore into Long Island Sound at some point near

City Island. The idea was hardly greeted with enthusiasm by the residents of Pelham or City Island, and in any event the City of New York pulled out of the joint sewer project. The city was at the time building its own system of then state-of-the-art combined storm/sanitary sewers and was happy to let the County of Westchester deal with its wastewater by itself.

In the end, Westchester's Bronx Valley Trunk Sewer would relieve the Bronx River of some of its pollution only to deposit it into the Hudson instead. After a long process of designing the system and taking land for its route through frequently contested condemnation proceedings, the County of Westchester constructed the fifteen-mile-long sewer between 1905 and 1911. With New York City out of the picture, it couldn't run the sewer down all the way to Long Island Sound, so instead the line was turned west at Mount Vernon and the wastewater was pumped to lift it over the high ridge of Valentine Hill, from which it flowed down to the Hudson at Ludlow in South Yonkers. In 1931, the first sewerage treatment plant would be built at Ludlow that grew into the present-day facility, whose eternal flames of vented methane gas entertain passing rail commuters.

The Bronx Valley Trunk Sewer diverted some of the most egregious sources of pollution from the Bronx River, but by no means did it solve the entire problem. In 1911, an unknown disease was observed to be killing the waterfowl along the river in the Bronx Zoo. Indiscriminately killing some 125 mallard ducks, Canada geese and snow geese, the disease turned Bronx Lake into an avian charnel house, to the distress of zoo officials and weekend boaters. The zoo had seen a similar infection sicken its waterfowl back in the dry summer of 1904, but this time it was far worse. The mysterious ailment, termed "duck cholera," spread to Lake Agassiz and Cope Lake, but it was noted that waterfowl only died on bodies of water that were fed by the Bronx River. It took no leap of the imagination to link duck cholera to the river's ongoing pollution, and it was clear that more comprehensive action was needed to preserve the Bronx River. The next step in the river's rehabilitation had, in fact, already been proposed.

Long ago, Joseph Rodman Drake had debated with James Fenimore Cooper and Fitz-Greene Halleck over the merits of the Bronx River compared with romantic Scottish streams. Now, oddly enough, one of those romantic Scottish streams would play a role in preserving the Bronx River. In 1901, William W. Niles visited Scotland and was enchanted by the beauty of the River Ness as it flowed out of Loch Ness. Toward the end of the river's twelve-mile journey to the North Sea, it flows through the town of Inverness, and Niles was struck by how, even

in such a populous area, the Scots had managed to keep the River Ness uncluttered and pollution-free. Why not the Bronx River?

While the Bronx Valley Trunk Sewer project was slowly getting underway in Westchester in 1905, Niles proposed a New York State Assembly bill that pursued an idea first recommended by John Mullaly in 1884, rejected by the Sewer Commission in 1895 and picked up again by Borough President Haffen in 1899. Niles's bill would appoint a state commission to consider the idea of reclaiming the Bronx River by establishing a public park running its length from Bronx Park all the way up to its headwaters at Kensico. Too late to make it into the 1905 legislative session, the bill was reintroduced in 1906, and its proposal for a "Bronx Valley Park" would become the basis for the Bronx River Parkway.

BRONX RIVER PARKWAY

In 1925, two identical inscriptions, one cast in bronze at the southern terminus and the other carved in stone at the northern end, celebrated the completion of the Bronx River Parkway in triumphant terms:

> LENGTH OF PARKWAY *16 MILES*
> AREA *1200 ACRES. 370 OLD BUILDINGS REMOVED,*
> FIVE MILES OF BILLBOARDS REMOVED, TWO
> MILLION CUBIC YARDS EVACUATED AND
> SURFACE COVERED WITH TOP SOIL.
> *30,000 TREES & 140,000 SHRUBS PLANTED,*
> THIRTY SEVEN BRIDGES & VIADUCTS BUILT
> AND SIXTY FOOT BRIDGES.
> THE RIVER CLEARED OF POLLUTION
> AND THE NATURAL BEAUTIES
> OF THE VALLEY RESTORED

The recitation of these fulsome statistics told only part of the story. The creation of the first Bronx River Parkway was the culmination of a twenty-year-long saga that combined good intentions, mixed motivations, innovative thinking and human costs.

William Niles's bill calling for a commission to study the feasibility of establishing a public park along the length of the Bronx River was passed in 1906, and the commission was promptly appointed by the governor.

The noted conservationist, historic preservationist and Bronx Zoo founder Madison Grant was named chairman, assisted by commissioners James G. Cannon and Dave H. Morris, with William W. Niles serving as secretary and J. Warren Thayer as engineer.[108]

Examining the state of the river, the commission duly documented what was already well known: the Bronx River was a wretched mess. No armchair travelers, the commissioners personally inspected the river from Bronx Park to Kensico and were aghast at what they found. The Bronx River, they reported, "is rapidly becoming an open sewer." In many places along its length, they noted "a low class of development and increasingly unsanitary conditions. These already constitute an intolerable nuisance and serious menace to public health, apparently being neglected until some disastrous epidemic shall bring it forcibly to public attention." In time, the Parkway Commission would identify no fewer than 154 sources of pollution on its sixteen-mile stretch of the Bronx River.

The commission recommended the creation of a reservation along the river's length, providing a buffer zone of between three hundred and one thousand feet in width to keep dwellings and industries at a safe remove. "The only final remedy" to the river's degradation, it emphasized, "lies in reclaiming the entire river, and the acquiring of the lands along its course to prevent all discharge of sewage and other pollution and the continuance of noxious river conditions." The proposed reservation would add up to about 125 acres in the Bronx and 900 acres in Westchester, with the possibility of adding other parcels of land here and there.

Plans for the proposed reservation were drawn up in consultation with several other agencies that had an interest in the area, notably Westchester County, whose Bronx Valley Trunk Sewer project was about to get underway. The Parkway and sewer projects, the commissioners happily pointed out, could advance hand-in-hand: land acquired for the Parkway would serve as the location of the sewer line and vice-versa. There was also the New York Central Railroad and the New Haven Railroad, as well as the Bronx Borough President's Office, which had its own plans for a Bronx Boulevard running from Bronx Park to Woodlawn. The interests of all these agencies would have to be coordinated to make the Parkway a reality.

The creation of the Parkway would shield the river from pollution, but it would not necessarily leave the river unaltered. "Modification and regulation of the river channel" (i.e., dredging and rechanneling) would be done to help control flooding, while strategic placement of low dams would create a series of lakes offering water deep enough to permit boating and canoeing

in the river's otherwise shallow northern reaches. The idea was greeted with enthusiasm by water sportsmen. New York City comptroller Herman A. Metz looked forward to establishing a competitive rowing course along the Bronx River in cahoots with the Westchester Rowing Club. "If we ever get the Bronx River Parkway through to Westchester," he enthused, "the Bronx River can be made a miniature Thames."[109]

Looking ahead to what they believed to be the all-but-inevitable annexation of these lands by New York City, the report recommended the appointment of a three-man commission that would be empowered to acquire the necessary land, oversee the creation of the Reservation and administer it when finished, keeping it out of the hands of both Tammany Hall and the New York City Department of Parks.

In the 1907 report, the commission referred to "the development of a superb River Parkway." Perhaps mindful that the idea for a combined park and roadway had been shot down by the Sewer Commission just twelve years before, the commissioners left the exact meaning of "parkway" vague, focusing on the reclamation of the river and the development of its parklands. Nevertheless, when the Bronx Parkway Commission Act was signed into law in May 1907, the act provided for the construction of a driving road through the Reservation.

When the Sewer Commission dismissed the roadway proposal in 1895, the word *automobile* hadn't been coined yet. There were few "horseless carriages" in the country, mainly playthings of wealthy and adventurous hobbyists. Things had changed, though, by the time the Bronx River Parkway Commission was convened. The Long Island Motor Parkway would be opened in 1910 by William K. Vanderbilt as a private road, where Bill and his buddies could stage their annual Vanderbilt Cup Race on a securely paved track, free from wandering farm animals and pesky policemen.[110] Such races were increasingly popular, and a purpose-built GJG racing car would be manufactured near the Bronx River in White Plains. For many people, "motoring" was increasingly replacing the Sunday afternoon carriage drive. At first, finding places to drive wasn't so easy: children on Manhattan streets would sometimes stone the intrusive automobiles, and the *New York Times* printed complicated driving routes to guide weekend city motorists to scenic destinations.

The demand was clearly there, but although the Bronx River Parkway seemed to be, in our modern terms, a "shovel-ready" project, it wasn't—another seven years would pass before the first pick hit the dirt. The joint New York City–Westchester County project would be, in the words of historian Barbara

R. Troetel, "more a shotgun marriage than a love match," with knotty issues of funding and land acquisition needing to be resolved.

The principal point of contention was proportioning the costs. Officials in Westchester pointed out, not unreasonably, that the county had already laid out funds to acquire lands for its sewer project, lands whose acquisition would at least partly underlay the Parkway as well. New York City officials, by now no longer confident of their eventual annexation of the lower part of the county, were leery of funding a project that would mainly benefit Westchester—barely three miles of the proposed parkway would run through the Bronx. In the end, they settled on a simple three-to-one split: 75 percent of the funding would come from Westchester and 25 percent from New York City.

City Hall, perhaps irked that the appointment of the Parkway Commission adroitly removed Tammany Hall from the picture, continued to drag its feet. In June 1907, shortly after the Parkway Commission bill was signed by the governor, New York mayor McClellan signed his own bill creating a reservation on both sides of the river above Bronx Park and authorized the taking of lands for that purpose. Although presiding over a burst of civic construction that included the Manhattan Bridge, Mayor McClellan remained cool to the Parkway project and gave the impression that he signed the Parkway bill only reluctantly.

The incoming administration of Mayor William Jay Gaynor continued to delay the project with objections over funding and the amount of land to be taken, stalling the actual start of the project to 1913. The construction lag in the Bronx section of the Parkway exasperated its supporters, who saw it as a badly needed alleviation of the problem of automobiles on city streets. "This parkway would give New York City businessmen a chance to go home in their automobiles," grumbled Theodorus Van Wyck, "without killing a lot of men, women, and children."

Although some people were already thinking of it as a commuter route, the Bronx River Parkway design emphasized the "park," unlike its Long Island predecessor and the many successors to the name. The idea was to present scenic vistas to leisurely motorists. At its southern end, the Parkway linked up with two major attractions: one could drive into the New York Botanical Garden and then continue through it to the northern gate of the Bronx Zoo, where you could park your Oldsmobile at the Rockefeller Fountain. At the northern end, a picturesque brick-paved roadway took motorists to the top of the Kensico Dam.

Parkway designers took an Olmstedian approach to the Parkway's landscape, working in harmony with natural features to create sort of a

controlled wilderness rather than a formal urban park. The commissioners brought in the Bronx Zoo's chief forester, Herman W. Merkel, as a landscape consultant. Merkel was joined by the NYBG's director-in-chief, Nathaniel L. Britton, who signed on as the Parkway's horticultural consultant. Under their advice, formal gardens and exotic trees and shrubs were mostly avoided in favor of appropriate native plants, arranged so as to form a naturalistic landscape. Some seventeen thousand dead and diseased trees (including the last of the American chestnuts) were removed from the Parkway route, and thirty thousand trees and 140,000 plants and shrubs were planted. The Bronx Zoo assisted the landscaping process through generous donations of fertilizing "zoo-doo."

Keeping with the naturalistic design philosophy, many of the river's existing curves and oxbows were left intact, to be crossed over by picturesque low bridges. Here and there a small dam might be added to create a burbling waterfall and swan-graced pond. The adjoining New York Central tracks were concealed as best they could be by densely planted trees and shrubs. As part of the roadway's scenic charm, the commission hired such architects as Charles Stoughton to design its bridges and overpasses.

While the Parkway route involved some 1,400 property owners, the commission prided itself on making only minimal use of eminent domain, in many places relying on the donations of wealthy landowners. This worked well enough in Westchester, but in the Bronx, a more straightforward use of condemnation proceedings was used to clear away riverside settlements that the commissioners dismissively referred to as "Italian tenements." Although described in condescending terms, these homesteads were often substantial, though working-class, dwellings. Some of these homeowners chose to have their houses lifted from their foundations and moved off the boundaries of the Reservation.

Relative newcomers to Bronx River neighborhoods, Italian immigrants along the river's bottomlands drew the particular disdain of Madison Grant and the commissioners, who even pointed to their gardens as evidence of squalor and disorder, illustrating commission reports with photographs of the "unsightly" patches of tomatoes, grapes and zucchini growing in their backyards. Among the 370 "old" buildings removed by the Parkway were entire streets and small communities, notably at Rosewood at the very southern end of the Parkway and "the Hollow" upstream at Tuckahoe.

The commission mandated the removal of such noxious industries as coal heaps and tanning yards, but it also eliminated some picturesque and benign industries as well. These included the legendary restaurant/

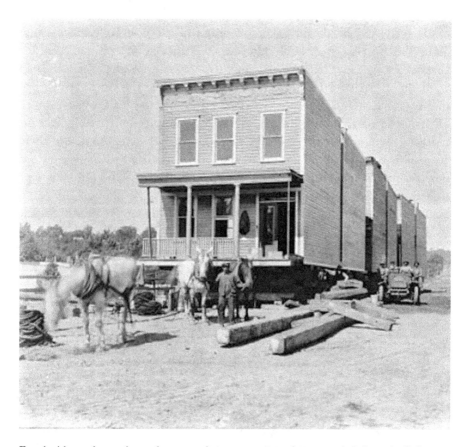

Faced with condemnation orders, some homeowners opted to move their houses off the Bronx River Parkway Reservation. *Library of Congress.*

resort of L'Hermitage, still run by Lucette of the Velvety Eyes, as well as Baumgarten's unique Bronx River tapestry factory at Williamsbridge. Lucette and L'Hermitage quickly faded into oblivion, but the late William Baumgarten's son, Paul, was bitter at the demolition of the tapestry factory. His response was to build a monument on the site of the vanished factory.

Apart from the human grief it caused in places, the Parkway Commission did energetically pursue the cleanup of the Bronx River Valley, chronicling its achievements in its annual reports. Among the statistics, the commission's claim of five miles of billboards removed was no hyperbole. More than forty years before Lady Bird Johnson launched her highway cleanup campaign, advertising billboards cluttered the banks of the Bronx River, standing end to end and even overlapping one another in a bid to catch the eyes of passing train travelers.

Once the billboards and debris were out of the way, Reservation lands along the river were carefully landscaped with new topsoil and tree and shrub plantings. In other places, nature itself was improved upon in the best tradition of Frederick Law Olmsted. Below Scarsdale, the Garth Woods was one of the last stands of old-growth forest along the Bronx River, noted for its towering tulip and hickory trees. The commission carefully ran the roadway along the western edge of the woods to preserve as much of them as possible and then built a rambling pedestrian pathway through the trees. The Bronx River's natural curves through this stretch of bottomland were utilized as opportunities to build a series of rustic-style wooden footbridges, beginning with a long bridge that carried the pathway south of the Scarsdale train station, crossing the Bronx River below the waterfall of a colonial-period milldam. Recently restored by the Garth Woods Conservancy, this woodland stretch remains one of the most attractive parts of the Reservation, especially in the fall and at tulip-blossom time.

Although conceived with the goal of "reclaiming" the Bronx River, the Parkway did nothing to rehabilitate the lower reach of the river running from the outflow of Bronx Lake in the zoo to its confluence with Long Island Sound at Hunts Point. This reach of the river was outside the bounds of the Parkway Commission and was written off as an industrial stream. More than fifty years would pass before reclamation efforts reached this part of the river.

The Parkway was not designed or intended to be a transportation artery but rather a leisure-time drive for people who could afford their own automobiles. Comprising just two lanes in each direction and with a speed limit of thirty-five miles per hour, the Parkway essentially went from nowhere to nowhere, beginning at the northernmost entrance to the New York Botanical Garden and ending at the plaza of the Kensico Dam. Nevertheless, people did use it as a commuting route, and the growth of auto ownership ensured that within a few years Sunday traffic jams on the narrow roadway were becoming commonplace.

The strip of parkland through which the Parkway ran in the north Bronx was not laid out to invite its use by the mainly auto-less working-class neighborhoods of Olinville, Williamsbridge and Wakefield. The route of the Parkway closely paralleled (and at one stretch was contiguous with) Bronx Boulevard. The one-and-a-half-mile stretch through today's Shoelace Park did not, apart from a small plaza at the war memorial at the foot of East 219th Street, offer an entrance to neighborhood residents. Pedestrians wishing to make use of the park would have to jaywalk across Bronx Boulevard, step

over a high curb, jaywalk across both lanes of the Parkway and clamber over a wooden guardrail to get to the park grounds along the river. With no stoplights or pedestrian crossings, weekend traffic on the Parkway made this a hazardous enterprise at best.[111]

The Parkway nevertheless had some positive impact on north Bronx neighborhoods. The opening of the Parkway brought real estate developers to Olinville who lined the stretch of Bronx Boulevard above Gun Hill Road with a series of upscale, early Art Deco apartment buildings.[112] Here and there substantial private homes were built, too, such as the elegant gray stone mansion built by the Cuneo family at 219th Street.

Although it banned commercial vehicles and was not intended as a commuter route, the Parkway was nevertheless understood to be of economic value. In a speech to a city planning conference in 1917, Parkway engineer Jay Downer unabashedly pointed out that the purpose of the Parkway was not just to preserve the Bronx River but also to provide an axis for the development of the city's suburbs. The Parkway certainly spurred what Downer termed "the best class of development" along its Westchester route. A notable example is the Fox Meadow section of Scarsdale, which before the Parkway had been the private estate of the Butler family. Approached by the Parkway commissioners, Emily Butler donated the land they needed for the roadway and also donated a tract of woodland to add to the Reservation, the present-day Butler Woods. Emily's generosity had a payoff; knowing the impact the Parkway would have, she surveyed and began selling lots in the now very desirable Fox Meadow estate to individual home builders, who would build some very fine homes there indeed.

As a driveway of the affluent, the Bronx River Parkway inspired a number of destination attractions along its route. A prominent example was the Westchester County Convention Center in White Plains, sited so as to be visible and convenient to Parkway drivers. Bronxville's landmark Gramatan Hotel was another early beneficiary of the Parkway, and its fashionable mission-style architecture was echoed by the Parkway Casino in Tuckahoe. Said to be a favorite stop-off of Franklin Roosevelt, the Parkway Casino was also said to attract some shadier figures and to have been a speakeasy during the Prohibition years. Although it never attained the high-toned cachet of the Gramatan Hotel, the Parkway Casino survived Prohibition, and into the 1960s, it remained a premier place for dining and dancing, advertising in newspapers as far away as Philadelphia.

Perhaps not all destinations along the Parkway attracted the sort of people Madison Grant had in mind when the Parkway was conceived. The White

The Parkway Casino in Tuckahoe was a popular dinner and dancing destination, attracting a future president and perhaps some shadier characters as well. *Photo by author.*

Tower Lodge in Mount Pleasant drew much of its traffic from the Bronx River Parkway. An upscale hotel resort abutting the Rockefellers' Pocantico estate, the White Tower Lodge was, despite its name, owned and operated by African Americans, and in the 1930s, it was one of the few such places that weren't racially "restricted." Among its frequent visitors were the

automobile enthusiasts of the Hyacinths Club of Harlem, who organized periodic motorcades that set forth from Sugar Hill and made their way up the Parkway to events at the White Tower Lodge.

Some Parkway attractions gave rise to legends. The Leewood Golf Club was founded in Tuckahoe in 1922, just ahead of the Parkway's opening. Soon established as one of Westchester's leading golf courses, Leewood's most famous member was Babe Ruth, whose memory is celebrated in the Babe Ruth Room, a lounge off the men's locker room full of his pictures and memorabilia. An avid golfer, when the Yankees were in town Ruth would often drive up the Parkway to Leewood for a round of golf before heading back to Yankee Stadium in time for the opening pitch. It is said that the underpass beneath the train tracks that connects Leewood Avenue to the Parkway was built expressly for the Babe to enable him to make a quick getaway on game days.

One odd legend that arose during Parkway construction prompted action by the Westchester County legislature. The route of the Parkway through Bronxville required the leveling of a rise of ground called Money Hill. An old rumor that the hill had been a burial spot for Captain Kidd's treasure, or perhaps the ill-gotten gains of long-ago counterfeiters, sparked intense interest as the steam shovels approached Bronxville. The hubbub reached White Plains, where the legislature took the stories seriously enough to pass an enactment asserting the county's claim to whatever treasure was found there. None ever was.[113]

Twenty years after it was first proposed, and after twelve years of construction (including a two-year hiatus due to World War I), the Bronx River Parkway was formally opened on November 5, 1925. As if to emphasize the Parkway's Westchester orientation, the inaugural ceremonies were held at its northern end near the Kensico Dam. There were no ceremonies at the Bronx end, other than the dedication of Paul Baumgarten's monument to his father's demolished tapestry factory.

The Bronx River Parkway brought the Automobile Age (and its possibilities for suburban development) into focus, and as the cheering died down, there were already plans afoot for the Cross County Parkway and other roadways that would bear the name of "Parkway" but which would serve different purposes than the Bronx River Parkway.[114] In time, the Bronx River Parkway itself would be reshaped into another kind of roadway.

Chapter 22

MISSING LINKS

The construction of the Bronx River Parkway and the Bronx Valley Trunk Sewer was only a partial victory for the Bronx River. While the two projects did remove the most blatant sources of pollution from the river, along with the remaining riverside industries above West Farms, they didn't entirely eliminate the river's contamination and degradation.

Hailed as a triumph of design and an inspiration for such constructions as the Merritt Parkway in Connecticut and the Blue Ridge Parkway in North Carolina and Virginia, as a roadway the Bronx River Parkway nevertheless fell short of full functionality. Its lanes were narrow, and while they served well enough at first, they were rather tight for the supersized touring cars that hit the road in the late 1920s. The Parkway, moreover, had no breakdown lane or shoulders on which cars could pull over. Intended to discourage picnicking and flower-picking, the lack of shoulders or pull-overs guaranteed congestion once traffic began to increase.

Moreover, the Bronx and Westchester segments of the Parkway didn't link up. The Bronx portion ended at East 233rd Street, forcing motorists to detour west across the 233rd Street bridge and turn north along Webster Avenue and Bronx River Road to reach the Yonkers/Mount Vernon end of the Parkway. A "Bronx River Parkway Drive" would later connect the two segments across an attractive stone bridge at East 229th Street, from there running beneath the railroad tracks and East 233rd Street and then north by an access roadway to the Westchester portion.

From the perspective of 1925, the Parkway commissioners could be well satisfied with their work, having provided for what they understood to be the

The Bronx River Parkway enhanced the scenic value of the river with low ornamental dams, such as this one that forms Bronxville Lake. *Photo by author.*

Parkway's primary constituency: motorists. For non-motorists, there were several large gaps that sometimes left the "park" out of the Parkway. With priority given to constructing a continuous automobile road, distance walkers and bicyclers weren't then considered important constituencies. With access to automobiles becoming more widespread, in those days many people looked at walking as a somewhat lower-class or even eccentric activity, and with the 1890s bicycle fad long over, bicycles were increasingly left to children. Serious walkers, for their part, preferred such deep woodland tracks as the Long Path or the Appalachian Trail, whose access points they could now, ironically, reach by automobile.

Nor was the Bronx River made fully navigable for canoeists and boaters, despite early notions of making the river a miniature Thames for recreational boating. In most of Westchester, the river's shallowness made this an impracticable goal without major alterations to the riverbed, but even in the deeper waters in the Bronx, no provision was made for canoe and boat launches, except for a landing placed by Charles Stoughton at the end of a flight of stairs leading to the river between the twin Parkway bridges at Duncombe Avenue.

For walkers and bicyclers, the Parkway offered no pathway connecting the Bronx and Westchester, and perhaps, in view of the blue-collar neighborhoods that lined the Parkway in the Bronx and Mount Vernon, that was the way it was intended to be. There had been concerns raised in Westchester about the Parkway drawing the "wrong element" into its suburban arcadia, and whether planned that way or not, a disconnected Parkway answered these concerns quite well.

The last stretch of the Bronx pathway was built alongside the Bronx River Parkway Drive in the early 1930s. Following the banks of the rechanneled Bronx River, the pathway ended abruptly just short of the Mount Vernon border after crossing a "bridge to nowhere."[115] Walkers crossing the bridge found themselves staring at the railroad embankment with no further pathway. Those desiring to walk to Westchester would have to double-back and continue their journey along city streets.

In Mount Vernon, the pathway existed only as an isolated segment beginning at Oak Street and running north to a dead-end at an on-ramp for the Cross County Parkway. The continuous non-motor pathway resumed two miles north of Oak Street at Scout Field in Bronxville, albeit with one more "missing link" between Scarsdale and Hartsdale.[116]

Within twenty years of its opening, the Bronx River Parkway would already be seen as quaint and obsolete, but the period following World War II would bring major transformations to both the river and the Parkway. Just beginning his career when construction finished, Robert Moses nevertheless had had his eye on the Bronx River Parkway since the 1930s. In the summer of 1945, with the war not quite over, he unveiled a comprehensive highway plan for New York City that involved, among many other projects, the widening and extension of the Bronx River Parkway. Plans gathered little dust in the Randall's Island office of the "Master Builder," and in 1950, construction began to turn the Bronx River Parkway into a full-fledged transportation artery.

The Bronx portion of the old Parkway had been little more than an appendage to its main stem in Westchester, but Moses's plan would bring about a dramatic change with consequences for the Bronx River. In the north Bronx, the new six-lane parkway entailed the abandonment of the old roadway and the building of a new route on the other side of the river, necessitating the rechanneling of the river and the straightening of some of its remaining oxbows. Although the abandoned 1925 roadway was left in place, the realignment opened a one-and-a-half-mile-long strip of parkland to neighborhood residents. The unnamed park was

With a pathway through an old-growth forest and rustic bridges crossing a meandering Bronx River, the Garth Woods are a prime attraction on the Bronx River Parkway Reservation. *Photo by author.*

furnished with three new playgrounds for the kids and a pair of bocce courts for the old fellows.[117]

The realignment also made for a seamless connection between the Bronx and Westchester portions, converting the former Bronx River Parkway Drive into entrance/exit ramps. The six-lane roadway extended into southern Westchester, where to accommodate its width engineers squeezed the river into a concrete canal. North of Mount Vernon, the Parkway was kept to a more modest four lanes that, for the most part, followed the roadway's original alignment.

The southward extension of the Parkway compromised some of the very parklands the original Parkway had been built to benefit. Pressing on from its old terminus at Rosewood, the route sliced off parts of the New York Botanical Garden and Bronx Zoo, running over the zoo's Bronxdale farm and prompting the garden to relinquish the wooded bottomlands north of Southern Boulevard, along with a substantial strip of land on its eastern rim. Illustrating the truth of the old adage that "it's an ill wind that blows nobody any good," the ironic result of the new Parkway was to increase the freely accessible acreage of Bronx Park.

The Parkway extension also had the unintended result of expanding Soundview Park at the river's southern end. Moses originally planned to continue the Parkway all the way down through Soundview Park to a terminus at O'Brien Avenue in Clason Point, making the Parkway finally true to its name by having it parallel the entire existing length of the Bronx River. A strip of still-open land north of Soundview Park that had previously hosted strawberry farms and a postwar veterans' Quonset hut settlement was appropriated for the Parkway's route, but here the Parkway ran into community opposition.

To Moses, Soundview Park was literally a dump that a highway could only improve, but to residents of the growing postwar community there, it was a valuable piece of open space fronting on the Bronx River and Long Island Sound. Nor did people in Clason Point and Harding Park, who had already fended off a rapacious Robert Moses, relish the prospect of a major highway emptying into their quiet, out-of-the-way community.

In the end, the new Bronx River Parkway was stopped at the edge of Soundview, coming to an abrupt terminus at the otherwise undistinguished Story Avenue. Unused lands taken for the route were instead attached as sort of a "panhandle" to Soundview Park and converted into a series of playing fields. The Bronx River Parkway extension was, after all, only a footnote to the 627 miles of highway that Moses would construct; engaged with building the Cross Bronx Expressway, Moses quietly let Soundview go.

Robert Moses wasn't the only one with big plans for the Bronx River. In 1946, the Bronx commissioner for public works, Arthur V. Sheridan, unveiled plans for a bold makeover of the Bronx River Estuary. Sheridan had visited Paris during his service in World War I, and like many visitors, he was entranced with the place and wanted to bring a piece of it home. Inspired by the quaysides of the Seine, he proposed that the Bronx River from East Tremont Avenue to Hunts Point "be given the medieval frills of walled sides, longitudinal piers and quays." Sheridan's proposal to the U.S. War Department (which then had jurisdiction over seafronts and navigable rivers) would be part of a broader attempt by the Borough President's Office, the Bronx Board of Trade and the Bronx Chamber of Commerce to secure for the Bronx waterfront "merited ranking within the Port of New York" from the federal government, which presumably would free up some development money.

Sheridan made his pitch at a hearing chaired by Colonel Clarence Renshaw of the U.S. Army Corps of Engineers, which also considered proposals for widening the estuary to one hundred feet and dredging a barge turning basin

at 172nd Street. The turning basin (at the present-day site of Bronx River House) would eventually be constructed, but otherwise Sheridan's vision of a stone-quay Parisian-style Bronx River faded into oblivion.

Shortly before he died in a car crash in 1952, Arthur Sheridan gave his support to Robert Moses for another highway paralleling the Bronx River. Moses would name it the Sheridan Expressway in honor of his old ally, but the project that began in 1958 would end in a partial defeat for him. Peeling off from the Bruckner Expressway at 163rd Street, the 1.29-mile roadway was intended to carry commercial traffic that was banned from the Bronx River Parkway. Planned to extend all the way to I-95 at the present site of Co-op City, community opposition stopped the project dead at East 177th Street, where an embankment and a pair of support columns, "the Pillars of Moses," mark the site of Sheridan's never-built connection to the Cross Bronx Expressway across the site of the old Starlight Park.[118]

While Arthur Sheridan dreamed of Parisian quaysides, to Moses the Bronx River Estuary was little more than another geographical complication to deal with. With the agreement of the War Department, he had the Bronx River closed to navigation above the 172nd Street turning basin and installed a low weir dam just above the turning basin to emphasize the fact. Closure of the river to navigation above 172nd Street gave Moses a free hand to reshape the river according to the needs of his highways. He straightened the river at Starlight Park (lopping off another oxbow) and armored the banks of the straightened channel to keep the willful river from threatening the foundations of his new expressways.

This work obliterated what little remained of the old Starlight Park, abandoned since the early 1940s. The old Starlight Park held no nostalgia for Robert Moses, who detested amusement parks in general as low-class, disorderly places. A sincere believer in open space and exercise, Moses compensated the neighborhood for the imposition of the Sheridan Expressway with a new park built on the leftover grounds of a gaslight plant on the opposite bank of the river from Starlight Park. Somewhat confusingly naming the new park Starlight Park, Moses leveled the ground for playing fields, though without checking to see what lay in the subsoil.

In the decades that followed the highway projects of the 1950s, the impact of increasing urbanization, economic decline and unresolved environmental issues would combine to bring the Bronx River to a new low point.

Chapter 23

MALIGNED RIVER

On June 13, 1930, Westchester County celebrated a special "Bronx River Day" at the newly opened County Convention Center. The day's festivities showcased the suburban communities along the river, with a short play by the Bronxville Women's Club and music by an eighty-voice children's chorus. County officials had good reason to be pleased with the impact that the Bronx River Parkway was having on the growth of the county (and its tax revenues). For many people in the river communities, though, the Bronx River was anything but a cause for celebration.

The Bronx River Parkway was hardly complete before its shortcomings were being noticed. In particular, the construction of the Parkway had not only failed to solve the flooding problem, but in some ways, it had made things worse. In an editorial comment on the commission's 1918 report, the journal *Landscape Architecture* questioned the Parkway's ambition of controlling the river. "In our time we have seen it abandon one curve and break through at the narrow neck, leaving the old oxbow," the editor pointed out. "Can it change its habits now and be confined in rockwork channels? Is there not something lost if it is so confined?"

Constructing the route through several of the river's natural floodplains, the Parkway's designers were content to leave some of the river's existing curves and oxbows in place as scenic elements. The safety of the roadway, though, demanded that these curves and oxbows be somehow made to stay put.

The problem lay in fluid dynamics and fluvial geomorphology, sciences not fully understood at the time of the Parkway's construction. Oxbows—also

By the 1960s, even the showcase Garth Woods was showing wear and neglect. Downstream, things were much worse. *Library of Congress.*

known as meander loops or horseshoe bends—are created by the tendency of water to pull away from flowing in a straight line. This applies to mighty rivers as well as to the raindrops running down your windowpane. Water following such a meander loop actually requires less energy to keep moving than it would to follow a straight channel. A principle called "helicoidal flow" dictates the growth and development of oxbow loops. A secondary type of turbulence that forms around the main current in a river channel, helicoidal flow causes water along the outer curve of a bend to speed up and eat into the riverbank, while at the same time, the water on the inner curve slows down, allowing it more time to deposit silt.

Once an oxbow gets started, its tendency is thus to keep deepening the bend until it starts to curve back on itself, at which point the river will eventually break through the narrow neck, forming a "cutoff." Sometimes this will create a new island, and sometimes the river will carve itself a new main channel across the cutoff, abandoning the old oxbow and starting the process anew. The Mississippi is notorious for this (the story is told of the

farmer who went to bed in Tennessee and awoke to find himself in Arkansas) but the sharp-eyed observer will spot abandoned channels and oxbows at several places along the Bronx River, too.

What all this means for the Parkway driver who finds the Bronx River kissing his hubcaps is that while riverbanks can be armored with stone to frustrate helicoidal flow, the water and the silt still have to go somewhere. A floodplain is nevertheless still a floodplain, and the river cares naught that a roadway runs through it. Denied the ability to carve new channels or access flood-buffering marshes, the floodwaters will rise out of the armor-banked river and create a traffic tie-up for the morning news.

Further, the problem of flash flooding was exacerbated by the very suburban development along the river that the county officials had been so eager to celebrate. Development along the steep slopes on either side of the Parkway meant the proliferation of impermeable surfaces—rooftops, driveways, streets and sidewalks, plus the impermeable surface of the Parkway itself—with the result that rainwater that had once been absorbed by the soil and foliage was now sent flowing straight down to the river. Along the way, it would pick up dirt and particles that would add to the silting up of the river channel, making the flooding problem a little worse each year.

Storm water brought its own problems. In Westchester, the Bronx Valley Trunk Sewer had diverted sewerage from the river, but storm water runoff nevertheless picked up a lot of bacteria from the debris it swept from the streets, to say nothing of illegal household sewer hookups, some of which wouldn't be discovered for another sixty years. In the Bronx, the city's system of combined sewers created periodic outflows of untreated sewerage combined with already contaminated storm water. Runoff also produced high levels of phosphates in the Bronx River. Commonly ascribed to overfertilized lawns and golf courses, but also coming from everyday detergents, phosphates fed late-summer blooms of toxic algae in the estuary, depleting oxygen and killing native fish and aquatic plants.[119]

Hailed for "saving" the Bronx River, the Parkway was itself a source of the river's continuing contamination. Runoff from the roadway's ever increasing traffic—oil and grease, asphalt and rubber particles, sand and salt—all made their way into the Bronx River. Apart from the air pollution, engine exhaust deposited lead onto the roadway and foliage, from which it was washed into the river until tetraethyl lead was phased out of gasoline in 2006, more than eighty years after the Parkway was opened.[120]

Along the Reservation, the carefully chosen trees and shrubs planted by the Parkway Commission had to compete with a growing number of

invasive plants. In the 1920s, the destructive impact of such invasives was just beginning to be realized; focused on cleaning pollution from the Bronx River, the Parkway Commission had made little provision for their active control. Consequently, by the 1960s, the Bronx River Valley had become a showcase of invasive species.

Some were bad and others were worse. Introduced into the United States as an ornamental garden plant, Japanese knotweed (*Fallopia japonica*) holds pride of place as the nearly indestructible king of Bronx River invasives. Growing up to eight feet high in dense patches along the river, knotweed is an undeniably beautiful plant, whose large sprays of white flowers draw admiration in August. Unfortunately, beneath the photogenic flower sprays, it hogs soil nutrients and its leafy canopy shades out other plants, native and invasive alike. Unlike the renowned southern plague-plant kudzu, knotweed doesn't even hold the soil together, its root system being too shallow to prevent erosion.

Garlic mustard (*Alliaria petiolata*) keeps a much lower profile than Japanese knotweed and wreaks its damage in more subtle ways. Apart from crowding out native forest flowers such as toothwort, chemicals in garlic mustard are toxic to butterfly larvae. Other chemicals in garlic mustard suppress the growth of native tree seedlings by affecting the mychorrhizal fungi associated with native trees. Along the Bronx River Estuary, the aromatic mugwort (*Artemesia vulgaris*) colonized the waste grounds of the landfilled Soundview Park, to the exclusion of nearly everything else. Related to ragweed, mugwort is also a major allergen, contributing to both hay fever and asthma in a part of the Bronx already suffering from excessive rates of asthma.

Two other invasives introduced as garden ornamentals, Asiatic bittersweet (*Celastrus orbiculatus*) and porcelain berry (*Ampelopsis brevipedunculata*), threaten the ecosystem of the Westchester reaches of the Bronx River. Asiatic bittersweet was introduced along the river in the Bronx in 1939, and it quickly got loose, thanks to birds that ate its berries and dispersed its seeds along the river. Working as if in tandem, the woody, high-climbing bittersweet smothers trees, and the lower-growing porcelain berry does the same for native shrubs and woodland understory.

In the twenty-first century, the Bronx River's already impressive array of invasive species would be joined by lesser celandine and mile-a-minute. Lesser celandine (*Ranunculus ficaria*)—also known as fig buttercup or, better still, pilewort[121]—is yet another introduced ornamental plant that has slipped out of people's gardens and gone rogue along the Bronx River. With its carpet of dark green leaves and large buttercup-yellow petals, it

is sometimes referred to as the "spring messenger" because it is one of the first flowering plants of spring. Spreading aggressively and colonizing moist river bottomlands, lesser celandine displaces other spring plants, notably the native skunk cabbage (*Symplocarpus foetidus*), which by 2012 had almost entirely vanished from the Bronx River Valley.

Although its name appears to be an exaggeration, the creeping mile-a-minute (*Persicaria perfoliata*) sometimes does seem to move faster than morning traffic on the Bronx River Parkway. Fond of stream banks and roadway shoulders, mile-a-minute climbs trees and shrubs to maximize its exposure to sunlight, smothering its hosts in the process and rendering once-open parklands impassable. Once established, mile-a-minute uses the flowing waters of the Bronx River for widespread seed dispersal.[122]

In the 1960s, economic decline and urban decay added to the depressed environment along the lower Bronx River. The once-flourishing industrial town of West Farms had entered into a rapid decline even before the Depression took hold on the Bronx. The collapse of the Bolton Bleachery, in particular, heralded the downfall of West Farms.

Under the leadership of Thomas Bolton Jr., the company had managed its transition from Bronxdale and was up and running in West Farms by 1890. The Bolton family was an integral part of the West Farms community. Their new home was a nine-acre estate at Boston Road and 175th Street, and Thomas's wife, Mary Frances Johnson Bolton, taught school in West Farms and served as a director of the Peabody Home for Aged and Indigent Women, which opened its building at 179th Street and Boston Road in 1901. In 1903, the Boltons moved to a new home on Marion Avenue in the newly developed suburb of Bedford Park, with the Birchall family living on the opposite corner. Thomas Jr. enjoyed taking extended walks along the Bronx River, presumably upstream from his textile plant that daily added new colors to the river that nature never intended.

Thomas Jr. died in 1911 and left the firm to his oldest son, William. Business fell off after World War I, and the Bronx Company found itself increasingly unable to compete with mills in the low-wage, nonunion South. By 1926, the once mighty Bolton Bleachery was defunct, and its West Farms buildings were torn down to reduce the city's tax assessment. In 1927, Frederick Fox eyed the vacated site for a modern multi-industrial development modeled on the acclaimed Starrett-Lehigh Building on Manhattan's West 27th Street, but the plan foundered following the 1929 stock market crash.

By then, other textile businesses had abandoned West Farms and headed south. In September 1928, one of the last of them, the Bronx Finishing

Corporation, announced that it was liquidating its New York operations and was moving to South Carolina. The coming of the Depression one year later gave a last kick to an already bereft West Farms. One longtime mill worker, deserted by the industry he had worked in all his life, went down and hanged himself by the Bronx River.

The site of the demolished Bolton plant would remain a rubble-strewn neighborhood hazard for another forty years, but the memory of West Farms' industrial heyday would linger. For years after the last of the textile plants closed, local belief was that if you stepped into the polluted Bronx River, it would turn your blue jeans orange, even though in the 1930s some kids would swim in the deep water below the Tremont Avenue Bridge to retrieve coins tossed in the river by passersby. To some, the passing of industrial West Farms inspired a twinge of nostalgia. "In Bronxdale first, and later in West Farms / It helped to add to many ladies' charms," historian Frank Wuttge would poeticize about the Bolton Bleachery in 1967. "Its memory stays, though now an empty spot / The voice of Bolton calls 'forget me not.'"

By the 1960s, abandonment and economic devastation in its adjoining neighborhoods added to the woes of the lower Bronx River. *Library of Congress.*

The last remnant of the river port of West Farms was a small fleet of fishing "head boats" captained by Ed Berlin. Beginning in the 1930s with a pair of repurposed excursion craft named *Claire I* and *Claire II*, Berlin operated his charter fleet from the old piers below Westchester Avenue for nearly sixty years, bearing sport fishermen out to try their luck on Long Island Sound. The last vessel of the Bronx River fishing fleet, the *Bronx Queen*, met its end in December 1989 when it hit an unknown underwater object and sank outside the Ambrose Channel at the approach to New York Harbor. Although all nineteen passengers were rescued from the water, two later died of hypothermia, and a grief-stricken Ed Berlin announced that he was leaving the charter business. For West Farms, it was the end of a three-hundred-year maritime history.

Downstream, West Farms' sister community of Hunts Point was experiencing its own free fall. Replenished with a new immigrant community, Hunts Point had flourished in the 1940s and '50s as a cradle of Latin music, but in the 1960s, an accelerating cycle of redlining, abandonment and neglect devastated the community. Occupying the lower west bank of the estuary, where basket willows, orchards and vegetable truck farms once grew, the establishment of the mammoth Hunts Point Terminal Market in 1962 barely kept the neighborhood economically alive as other longtime industries closed shop or moved out. Even so, the Market was a mixed blessing: diesel exhaust from thousands of idling trucks helped boost the area's asthma rate to the highest in the city.

Depressed neighborhoods, constricted civic budgets and a cash-starved Parks Department added up to a pattern of neglect and abuse that by the late 1960s again made the once romanticized Bronx River a byword for a maligned urban stream. With nobody looking out for it, or seeming even to care, the river from West Farms down to Hunts Point became a dumping ground. In West Farms, a warehouse occupying an old mill building discarded unwanted appliances out the back door and into the river, to the point where the river itself could hardly be seen beneath the mound of stoves and refrigerators.

Flowing through the economically stressed neighborhood of West Farms, in the early 1970s the Bronx River once again served as a boundary, this time between rival youth gangs. The Latino gangs Savage Skulls and Savage Nomads dominated the west side of the river, while the east side of river belonged to the African American Black Spades. Like the demarcation line on the Glienicke Bridge in Cold War Berlin, the African/Latino boundary was the middle of the East Tremont Avenue

Bridge, and only the most daring soul would scurry over the line to leave his graffiti tag on opposing territory.

This hostile faceoff was ended by a member of the Young Spades from the Bronx River Houses named Kevin Donovan, who experienced a cultural and political epiphany on a trip to Africa. Changing his name to Afrika Bambaataa Aasim, he returned home to form the Bronx River Organization as a progressive alternative to the Black Spades. In 1977, Afrika Bambaataa effectively ended the Bronx River cold war by extending an invitation to Latino gang members to cross the bridge and join a party at the Bronx River Houses. The Bronx River Organization became the foundation for the Universal Zulu Nation, and the peacemaking party at the Bronx River Houses Community Center is said to be a birthplace of hip-hop.

Neglected parklands along the river were put to uses unimagined by John Mullaly when he sketched the boundaries of Bronx Park in 1884. The overgrown bottomlands relinquished by the Botanical Garden north of Southern Boulevard became the home turf of one of the Bronx's legendary youth gangs, the Ducky Boys. Armed with slingshots and glass marble ammunition, the Ducky Boys were never quite as violent as the movie *The Wanderers* made them out to be, but they were nevertheless a force to be reckoned with. Named not for the 1950s "duck's ass" hair style but rather for their original meeting place at the "Duck Pond" (Twin Lakes) in the Botanical Garden (or "the Botanicals," as they called it), they held the grounds known as "French Charley's" between the Duncombe Bridges and the Botanical Garden against a host of neighboring gangs that included the Allerton Avenue Gang, the Burke Avenue Gang and the fearsome Fordham Baldies from Belmont.

The chief Ducky Boys hangouts were the arches of the Stone Bridge carrying Southern Boulevard over the Bronx River (where some of their now ancient graffiti may still be found) and "Leech Beach" at the northern end of "Rat Island" in the Bronx River. Neighborhood legend erroneously credits them with heisting the payroll of the Botanical Garden, although they did on more than one occasion hijack the garden's tourist tram and drive it into the Bronx River.

The fortunes of the Bronx River had all but reached their nadir by the beginning of the 1970s, but the depths of the river's degradation would inspire a series of volunteer citizen actions that, in time, would produce a remarkable turnaround.

REVITALIZATION

The revitalization of the Bronx River would start at the very place of its deepest degradation. West Farms had been where industry first began on the Bronx River; it was where the bleaching and dyeing mills had sent their worst pollution into the river, and with industry long gone, West Farms became the scene of the river's worst trashing.

To NYPD Bronx Borough commander Anthony Bouza, the condition of the Bronx River at West Farms made no sense. Flowing alongside his Westchester home, the river was a "bucolic, sylvan, beautiful place," Bouza recalled. By contrast, in the South Bronx, "it was a yellow sewer. There were lots of tires, hundreds. Old refrigerators, auto bodies. One or two occasional human bodies."

Anthony Bouza had grasped the link between crime and the local environment. As a police captain in Harlem, he had trees planted on the sidewalks in front of the precinct station houses. Asked by a puzzled patrolman why he was doing this, Bouza told him, "because I want [the local residents] to have beauty and nature…They lead to civilized behavior." Years later, he would expand the thought: "Trees are not going to produce miracles of safety in our violent society, but their presence is important. They are a statement of caring. Their absence is a testament to neglect. The residents do get the message."

Hoping to bring some beauty and nature to West Farms, in 1974 Bouza organized community meetings to discuss ideas for cleaning up the Bronx River and assigned Sergeant Philip Romano, who was active in the Fifty-

second Precinct Community Council, to develop and coordinate the cleanup effort. Romano invited Ruth Anderberg to attend one of these community meetings. Hearing plans discussed for a river cleanup, Anderberg thought they could go a step further: "Why don't we restore the river instead of just cleaning it?"

The idea of an environmental restoration of the Bronx River, instead of a mere trash cleanup, would, at this time and place, strike many people as a quixotic enterprise, but if Bouza ever thought so, he didn't show it. Instead, he looked at Ruth Anderberg and simply replied, "You do it."

Ruth Anderberg had always been a "do it" kind of person. As a young woman, she had volunteered for the U.S. Army Women's Auxiliary Corps (WACs) in World War II, and she didn't serve in the typing pool either: she drove a two-and-a-half-ton truck, the legendary "Deuce-and-a-Half" that veterans will tell you was no easy vehicle to handle. After the war, she moved to Fordham, where she worked as a secretary at Fordham University. Visiting the adjoining New York Botanical Garden at least once a week, she encountered the beauty of the Bronx River as it flowed through the Bronx River Gorge. She had also noted the abject condition of the Bronx River at West Farms while waiting for a bus to the 1964 World's Fair. The squalid river at West Farms was a harsh contrast to the optimistic vision of midcentury progress she found at the fair in Flushing Meadows.

With the encouragement of Anthony Bouza, Anderberg retired from her secretarial job and founded the Bronx River Restoration in 1974.[123] The moment was almost exactly three hundred years after the first water mills had been built on the river, and the restoration would begin, appropriately enough, at the very place where the first mills rose at West Farms. With little funding and virtually no government commitment, she would have to build this project literally from scratch. Having to start somewhere, she gathered community volunteers and began with the mega-junk pile that covered the river between East Tremont Avenue and East 180th Street. "You couldn't see the river for all the garbage that was in there," she recalled. "You could practically walk across it." Luckily, she knew her way around heavy equipment from her days in the army, and she borrowed a tow truck to assist the neighborhood volunteers in lifting the heavier items out of the river.

Apart from washing machines, cars, motorcycle hulks and a never-ending number of old tires, some truly astonishing things would turn up in the course of the river's cleanup. Among them would be the left-behind artifacts of a changing neighborhood, such as an old parlor piano and a wine press, a common household appliance in the days of Prohibition. An

exciting moment came in the spring of 1996 when four large old bones were found in the riverbank just north of East Tremont Avenue. These were listed as "obviously from a dinosaur or some other large prehistoric animal." Dinosaurs on the Bronx River, or perhaps the giant beaver *Castoroides*? The bones were eventually identified as being from some farmer's ox.

The cleanup at West Farms took more than the work of one season, or many seasons. The Great Junk Pile proved durable enough to call in the National Guard—or rather, the New York State National Guard Auxiliary, which loaned the BxRR a truck and winch in 1996. The environmentally minded Governor George Pataki would later dispatch National Guard Auxiliary personnel to the Bronx River to lift vehicles out of the river.

From its start, the Bronx River Restoration actively engaged the West Farms community and its youth in particular. The locally recruited Youth Conservation Corps would not merely clean up the river channel but create an environmental asset for the old industrial river town. In June 1976, the project succeeded in gaining a $35,000 grant from the New York City Department of Environmental Conservation to fund the Conservation Corps' work for that summer. The BxRR recruited fifty neighborhood youth, who enthusiastically went at it using borrowed garden tools. Although the summer's work fell short of entirely cleaning the river environs in West Farms and building a riverside boardwalk, a bold start had certainly been made.

The Youth Conservation Corps would return to the river in following summers. By the summer of 1979, it had grown to sixty-three members. Funding could still cover little more than their $2.90-per-hour stipend, but Anderberg would devise some creative improvisations using the means at hand. To stabilize the crumbling riverbank beneath the Restoration's headquarters, there were old tires. The neighborhood had lots of them. Apart from the tires already in the river, a nearby garage was paying trash haulers $0.40 apiece to take them away and were delighted to instead donate them to the cause. The youths carefully stacked the tires along the riverbank, filling them up with pulverized brick and concrete rubble from demolished factory buildings. To secure them in place, boiler tubes scavenged from an abandoned factory were hammered down through the filling. Using these "locally sourced" materials, the Restoration secured the riverbank, and this improvised embankment has withstood thirty-five years of Bronx River floods at the time of writing.

The New York Botanical Garden had already launched its own Bronx River Project in 1973 as part of its Environmental Education Program. The project undertook a comprehensive environmental survey of the river in

its Bronx reaches, recruiting twelve local high school students who worked alongside NYBG personnel. Under the leadership of artist Axel Horn and environmental activist John Sedgwick, the project studied every aspect of the river, from algae to pottery shards, and established a base of environmental knowledge on which subsequent revitalization projects would build.[124]

There had already been some tentative explorations of the navigability of the Bronx River. On April 12, 1970, Bronx borough president Robert Abrams joined Westchester County executive Alfred Del Bello for a canoe trip to see firsthand the condition of the Bronx River and perhaps create the basis for a joint cleanup project. Wearing dress shirts and neckties, the two politicians were probably the best-dressed paddlers the river had seen in years. The trip didn't last long: Abrams and Del Bello promptly got stuck on a midstream sandbar and collided with another canoe, and nothing more seems to have come from this pioneering voyage.[125]

A more serious exploration was launched a few years later. On April 11, 1977, the Bronx River Canoe Expedition set forth on a two-day trip to traverse the entire length of the Bronx River. Captained by Gary "Doc" Hermalyn of the Bronx County Historical Society, the intrepid paddlers may have felt an affinity with the old-time French *voyageurs*, as they had to undertake some heroic portaging as they worked their way down the shallow Westchester reaches of the river. A second expedition took place on April 29, 1978, and the trip that would be repeated in the spring of 1999.

The Bronx River Restoration labored on through the 1970s and 1980s. In 1979, it won for the Bronx River designation as an American Heritage River, and in 1980, it unveiled the Bronx River Restoration Master Plan. Surveying the entire length of the river, the Master Plan included a Bike and Pathway System linking the Bronx and Westchester, a proposal that would become the foundation for the Bronx River Greenway.

In 1983, Nancy Wallace, who first encountered the Bronx River as a member of the White Plains City Council, came downstream to expand the BxRR's mission. Building on the Youth Conservation Corps, the BxRR launched an in-school environmental education program in 1985, followed by an after-school program in 1989. These environmental education programs focused on water monitoring, teaching the students the skills they needed to assess and record the quality of the Bronx River's water. In 1992, the BxRR instituted the Nature Day Camp, an outdoor summer program on the river.

Under the influence of Axel Horn, the arts became an integral part of the Bronx River Restoration. Continuing an artistic heritage on the Bronx River

that stretched all the way back to Sanford Gifford and the Hudson River School painters, in 1987 a new organization, the Bronx River Art Center, was incorporated under the directorship of Gail Nathan to provide arts-based youth education programs, encourage and exhibit local Bronx artists and use multimedia fine arts to promote river awareness and revitalization.

Up the river from West Farms, Fred Singleton brought together the Conservation Corps with a team of Boy Scouts in the summer of 1984 to unearth the long-abandoned river pathway running along the oxbow below the Duncombe Bridges. The Ducky Boys had long since faded away, but helicoidal flow had wreaked its havoc in the meantime, depositing several feet of silt that buried the pathway. A similar challenge was met by community volunteers at the river's northernmost Bronx reach. The neglected pathway leading to the "bridge to nowhere" had become overgrown and cluttered with the hulks of abandoned cars. Wakefield resident Josie Burke perceived the beauty beneath the debris and organized volunteers from Woodlawn and Wakefield to clean up and maintain the area. Naming the place "Muskrat Cove" and dubbing themselves the "Muskrateers," year by year they gradually succeeded in getting the hulks removed, trash picked up and flowers planted; soon, the overgrowth abated.

The Bronx River Restoration moved ahead with its plans in the 1990s. Under the direction of Diane Sargent and with the participation of the Bronx Activist Committee, the BxRR in 1993 drew up a plan for a Bronx Greenway that would expand and build on Frederick Law Olmsted's concept of a greenbelt system. The Bronx Greenway Plan would inspire subsequent projects, such as the Bronx River Greenway, the South Bronx Greenway, the Hutchinson River Greenway and the Bronx link of the Hudson River Valley Greenway Trail.

By the late 1990s, momentum for the revitalization of the Bronx River was building. The BxRR was discovering a truism of community-driven projects: one good deed inspires others—even small successes will encourage more to follow. The Bronx Council for Environmental Quality under I.C. Levenberg-Engel and Dart Westphal took an active role in protecting the Bronx River, while Jorge Santiago pursued the issue of continued contamination and industrial dumping in the lower Bronx River with the Department of Environmental Protection. Restitution settlements obtained by the New York State Attorney General's Office would enable a number of educational and restoration projects.

From its hilltop headquarters that overlooked the old Williamsbridge Reservoir, the Mosholu Preservation Corporation also became an active

Founded in 1974, the logo of the Bronx River Restoration referenced West
Farms' history as a water-powered mill town. *Author's collection.*

part of the revitalization of the Bronx River. In 1995, Con Edison joined
with the Bronx River Restoration and the New York City Parks Department
to establish a Bronx Riverkeeper Program, naming Josie Burke of the
Muskrateers as the Bronx's first "Riverkeeper," to be joined by a team of
volunteer Riverkeepers. Some of the river's best successes, however, arose
from unexpected origins.

A rambunctious dog named Zena helped inspire the creation of Hunts Point Riverside Park. Like many others, Majora Carter had grown up in Hunts Point with little awareness of the Bronx River. While Carter was walking the dog at the end of Lafayette Avenue one day, Zena, as dogs will often do, scampered straight for the nearest body of water. Picking her way through a frightful-looking dumping ground, Majora carefully followed and was surprised to find herself standing on the bank of the Bronx River Estuary. It was a pretty view, too, once you turned your back on the garbage: the shoreline faced the green-clad northern end of Soundview Park.

The space itself wasn't very promising. It was an undeveloped stub at the end of Lafayette Avenue, where the old Lafayette Lane had once led down to the river, possibly set aside for a never-built bridge over the river. The result was a chunk of no-man's-land sandwiched in between the Hunts Point Market and a scrap metal yard, with a disused fur processing factory on one side and a garlic warehouse lending a certain piquant aroma to the atmosphere. One of the city's few remaining railroad grade crossings crossed the entry to the space along Edgewater Avenue, carrying occasional freight trains in and out of the Hunts Point Market.

Majora Carter organized neighborhood residents to transform the dump into a recreational space, eventually getting it recognized as a New York City park. Her unexpected Bronx River moment led to her organization of Sustainable South Bronx, which would, in time, spur the creation of Barretto Point Park, plan a South Bronx Greenway and establish the Bronx Environmental Stewardship Training (BEST) program to train neighborhood youth in environmental stewardship and practical "green jobs" skills in such things as storm water management and heat-abating "green roofs."

A key organization in the Hunts Point Riverside Park project was The Point Community Development Corporation. Established in 1998 by Josephine Infante, The Point saw in Carter's idea an opportunity to create some badly needed recreational space in Hunts Point, which had even less parkland than West Farms. "We have lots and lots of waterfront, but absolutely no access," noted Paul Lipson, The Point's executive director. "We started thinking, 'There's Chelsea Piers and the Hudson River Conservancy. Why shouldn't we have some waterfront too?'"

Hunts Point Riverside Park soon drew a most appropriate "anchor" organization. In 1998, Rocking the Boat was established by former *Clearwater* director Adam Green, with the goal of developing local high school youth through teaching them wooden boatbuilding skills. At RTB's shop, historically authentic "Whitehall" boats, once the workhorse

rowboats of New York Harbor, were crafted from scratch—beginning with timber donated by Pete Seeger from his farm on the Hudson River. Setting up in the remains of the old fur processing factory, RTB utilized the park's river access to teach the students maritime skills and initiated environmental stewardship programs.

Upstream from Hunts Point Riverside Park, the west bank of the river was occupied by the abandoned site of the Transit Mix Concrete Company. The city proposed using it for a trucking route, but Mel Rodriguez and David

Alexei Torres-Fleming makes a statement at a hearing regarding the proposed Concrete Plant Park. Community activism was crucial to the revitalization of the Bronx River. *Omar Friella.*

Shuffler of Youth Ministries for Peace and Justice saw in the rusting concrete plant the potential for a riverside recreational space. Fulfillment would take many years of community activism, but led by Alexei Torres-Fleming, YMPJ eventually succeeded in having the site turned into a scenic park that preserved some of the old concrete plant's silos as an iconic memorial of the river's industrial past.

In 1998, the West Farms Friends of the Bronx River—led by such activists as Juanita Carter, Nessie Panton, Michelle Williams and Perquida Williams—stepped forward to steward the new river park that the BxRR had created. The narrow park behind the old mill buildings was first called Bronx River Park, but following a "name-that-park" contest, it was officially named Restoration Park in honor of the Bronx River Restoration; the Friends planted a butterfly garden under the guidance of the Bronx Zoo's Butterfly Project creator, Chuck Vasser.[126]

Farther upstream, community action was stirring along the river's length in Westchester County. The Bronx River Parkway had been placed on the National Register of Historic Places in 1990, and in 1995, New York State designated it a Scenic Byway. In 1997, the Bronx River Parkway Reservation Conservancy was organized to steward the 807-acre Reservation, by now a Westchester County Park. The BRPRC convened periodic cleanups along the river, while its Vinecutters program undertook the Sisyphean task of abating the river's choking growth of invasive vines. The conservancy would inspire and bring together other local organizations such as the Garrett Place Association in Yonkers and the Garth Woods Conservancy in Scarsdale.

The upsurge in community engagement with the river's revitalization was celebrated on June 13, 1998, with the Bronx RiverFest in Shoelace Park, but while the Bronx RiverFest marked a high point in the revitalization effort, the following year would prove more significant still.

A RIVER RETURNS

The year 1999 would be a watershed one for the Bronx River Restoration. After twenty-five years, its once quixotic-seeming venture was inspiring more and more community activism, not only on the Bronx River but also on dozens of other rivers across the country that were now being looked after by community-based Conservancies, Friends, Alliances and Coalitions. Along with its namesake river, the Bronx itself was emerging from its own depths of degradation. For the first time in generations, the Bronx was less a place to be from but rather a place to take pride in being a part of.

The Bronx River Restoration's long work drew the attention of the New York City Parks Department as the 1990s came to a close. Witnessing the ribbon-cutting of the new river park that local youth had literally unearthed from beneath six feet of silt and debris, Parks Commissioner Henry Stern saw a great future potential. "I thought it was a beautiful river," he recalled, "and I wanted to find ways to clean it up and make it accessible to people." Back in his Central Park office, Stern proclaimed that 1999 would be the Year of the Bronx River and pledged the support of the Parks Department to the river's revitalization.

To make this happen, Stern brought together the Partnership for Parks and the Urban Resources Partnership to form the Bronx River Working Group. Coordinated by Jenny Hoffner, the Working Group gathered together the growing number of organizations concerned with the Bronx River and produced a *Bronx River Action Plan* that included a Bronx River Greenway. The Working Group produced its own newsletter, the *Bronx River Biweekly*,

and compiled the Bronx River's first-ever map and guide, premiered at a special event sponsored by Con Edison at the New York Botanical Garden on February 23, 1999, to inaugurate the Year of the Bronx River. The evening was a time to look back on past accomplishments and look forward to the future. Marcel Woolery Jr. proudly posed with Ruth Anderberg and recalled "how we got into the river, with our hip-length boots, and cleaned out portions of the river by hand."

Henry Stern's enthusiasm continued unabated. On November 19, 1999, he watched a crane lift yet another auto body out of the river and announced his vision for a Bronx River Greenway from the Westchester border to the river's mouth. Knowing that this would be no small project, Stern projected that the Greenway would take until about 2010 to complete and would cost some $60 million, to be raised from a combination of private, state and federal grants by a public/private partnership.

The 1998 Bronx RiverFest had been all well and good, but for a more photogenic event to launch the Year of the Bronx River, the first Golden Ball Festival would ceremoniously float a three-foot golden sphere down the river as "a symbol of the sun, energy, and spirit of the Bronx River." On April 24, 1999, the Golden Ball was launched at Tuckahoe, accompanied by a small flotilla of canoes. Classical flutist Connie Grossman provided musical accompaniment, while the procession was accompanied on land by dancers from the Hunts Point–based Arthur Aviles Typical Theater. Along the route, there were community presentations, cleanups and tree plantings. The Golden Ball ended the day at Hunts Point Riverside Park, where Partnership for Parks announced the establishment of a new Waterways and Trailways field office that would support citizen-based restoration efforts.

"It's almost spiritual in nature," Nancy Wallace had noted a few weeks before the Golden Ball Festival. "We're starting to see the river as one universal link between all these communities—in a way unifying them. I think the greatest is that once these people get involved, they'll stay involved. We're starting to see an everlasting community commitment to the river."

In the spring of 2000, the Golden Ball was joined by the first annual Bronx River Amazing Boat Flotilla, which gathered some fifty canoes into a grand procession to Hunts Point Riverside Park. The second Golden Ball on October 14, 2000, was honored by a visit from New York governor George Pataki, who that summer had again dispatched New York State National Guard personnel to help with the river's cleanup. The work that summer was further assisted by Bette Midler's Corpswork 2000.

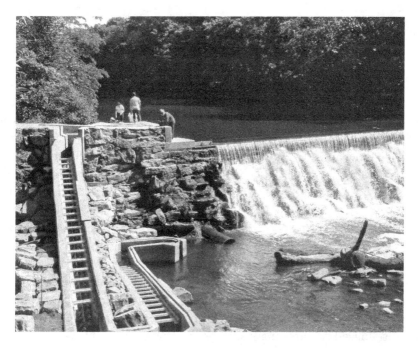

Beginning in 2015, the fish ladder at the 182nd Street Dam opened the river to migrating eels and alewife herring (as well as canoeists) for the first time in more than three centuries. *Bronx River Alliance.*

The Bronx River Working Group had successfully boosted the river's stewardship to a whole new level, but the time had come to transform it into a more solidly founded independent organization. On November 21, 2001, the Bronx River Alliance was inaugurated at a reception held at the Bronx Zoo's new Dancing Crane Café, where its Zen-inspired fish-and-leaf logo was unveiled.

The Bronx River Alliance soon enlisted the enthusiastic support of Congressman José Serrano, who over the next ten years would secure upward of $30 million in federal funding for Greenway, revitalization and educational programs while the Alliance set about engaging the support of New York City Council members, state and federal agencies, corporations, local businesses, private foundations and individual donors.

The Bronx River Alliance attracted a list of more than one hundred partner organizations, ranging from long-established institutions to the plethora of local "Friends of" groups working up and down the length of the river. The Alliance organized its efforts into distinct but interoperating Greenway, Ecology, Education and Outreach programs and recruited a

full-time Bronx River Conservation Crew from the local community. To ensure that its programs were founded on a firm set of principles, in 2006 the Alliance produced a *Bronx River Greenway Plan* and an *Ecological Restoration and Management Plan*. The following year saw the publication of *Bronx River Classroom: The Inside Track for Educators*, with river-oriented curriculum plans. In 2010, by the *Bronx River Intermunicipal Watershed Management Plan*, a strategy was established to coordinate the workings of some thirteen separate municipalities and address the fact that the Bronx's water quality still fell short of the standards set by the 1972 Clean Water Act, due largely to the bacterial contamination caused by storm water and combined sewer outflows. The Alliance also took a leading role in organizing the city-wide S.W.I.M. (Storm Water Infrastructure Matters) coalition and, in the meantime, recruited volunteers to monitor water quality at established locations.

The Bronx River Alliance's first decade saw the opening of a chain of new parks along the river. Hunts Point Riverside Park was transformed into an award-winning design that opened in 2006, and Concrete Plant Park was opened in 2009, featuring a river esplanade, a canoe launch and an iconic set of stabilized concrete plant silos. Starlight Park was refurbished as a link in the Bronx River Greenway in 2013, with a pedestrian bridge over the Bronx River, new playing fields and a canoe landing.

Existing parks were also refurbished as part of the Greenway route. Muskrat Cove received a makeover as a repaved bike path, and at Shoelace Park, the Alliance engaged local residents to produce a *Shoelace Park Master Plan* featuring new pedestrian entrances, storm water management features and the realignment of flood-prone pathways. New Greenway paths were built to complete its southern end in Soundview Park, followed by a restoration of part of the area's once-extensive salt marshes by the Army Corps of Engineers.

Inspired by the progress being made, businesses along the lower river came forward to support the revitalization through sponsorships and in-kind donations. Sims Metal Management installed its own storm water management system at its recycling yard alongside the estuary, and across the river at the ABC Carpet & Home Warehouse Outlet, the Waterwash park created a storm water–managing wetland park.

Upriver in Westchester County, stream bank stabilization was carried out in White Plains, and the County Center parking lot was transformed into a showpiece storm water management system. The Bronx River Parkway Reservation Conservancy launched its Vinecutters project to tackle the invasive vines smothering the river's trees and organized community cleanups.

In Scarsdale, the Garth Woods Conservancy restored one of the most scenic spots on the Parkway Reservation. On City Island, the Hutchinson River Restoration Project rose to the challenge of stewarding the Bronx River's sister waterway. Even the venerable Kensico Dam got a major spruce-up in time for its ninetieth birthday, with a steam-cleaning of its ornamental granite facing, and following 9/11-related security-mandated retrofits, the walkway atop the dam was reopened to pedestrians in 2012, where they could once again listen for the drowned church bells of Kensico Village.

The river's long and varied history received new respect, too, with a growing corps of Bronx River historians brought together by the East Bronx History Forum and the BxRA's "Bronx River Rambles" walking tours. Morgan Powell's Bronx River Sankofa revealed long-buried aspects of the river's African American history, while a student project at PS48 in Hunts Point established the location of the African American burial ground at the foot of the peninsula. Upstream from Hunts Point, the Friends of

Scheduled for completion in 2016, the Bronx River Alliance's Bronx River House will provide offices, educational facilities, community space and canoe storage. *Kiss + Cathcart, Architects.*

Westchester Parks designed and installed a series of informative signposts along the Bronx River Pathway, where viewers could use their cellphones to hear each site's story—narrated by Dan Rather, no less.

Dr. Eric W. Sanderson of the Wildlife Conservation Society applied the spatial analysis and digital mapping techniques of his acclaimed Mannahatta Project to create the Welikia Project in 2010. Named for a Lenape term meaning "my good home," the Welikia Project will re-create the past terrain and environment of all five boroughs of New York City.

Environmental work by the Bronx River Conservation Crew included salt marsh restorations, erosion prevention, storm water management and the never-ending task of clearing blockages, litter and debris, as well as the abatement of such invasives as Japanese knotweed and garlic mustard and planting native trees and shrubs. A showpiece revitalization effort was the Bronx River Forest north of the Botanical Garden, where restoration work, assisted by the Gaia Institute and the youthful volunteers of Christodora, revealed the beauty of this natural floodplain.

Another landmark event, the 2005 Bronx River BioBlitz, revealed the flourishing biological diversity of a recovering river. Over the course of a weekend, volunteers recorded all forms of life on and in the river, from osprey to algae. Meanwhile, a study by Professor Joseph Rachlin of Lehman College revealed an astonishing array of fish in the river. Volunteer educators Bob and Hillea Ward initiated a microinvertebrate education program at the New York Botanical Garden, teaching students how to monitor and analyze such pollution-sensitive creatures as mollusks, flatworms and mayflies. Once past the "ick factor," the students learned a lot, and the project would be an important part of the ongoing monitoring of the river's health.

New York's iconic animal, the American beaver, had (apart from zoo fugitives) been absent from the Bronx River since the end of the 1700s. In 2007, though, the Wildlife Conservation Society confirmed the presence of a beaver on the Bronx River. Promptly named in honor of Representative José Serrano, José the Beaver puttered about along the river between the zoo and Botanical Garden, relieving his hermit's existence by sheltering an occasional visiting muskrat in his lodge. In 2010, José's solitude was broken by the arrival of another beaver, named Justin by a Bronx Zoo contest. As of 2014, José and Justin have produced no progeny, leading to speculation that they may be of the same sex.[127]

While José and Justin gnawed their way around the riverbanks, an even longer-absent native species was reintroduced into the Bronx River in 2006 and 2007. The alewife herring (*Alosa pseudoharengus*) had once fed Native

Americans and colonists until milldams blocked their annual migrations to their freshwater spawning grounds.[128] To ensure the reintroduction's success, a "fish passage" was built in 2013–14 at the river's first barrier, the 182nd Street Dam, where it also benefited the American eel (*Anguilla rostrata*), another returning native that, opposite to the alewife, lives most of its life in fresh water but returns to the ocean to spawn.

At the Bronx River's mouth, a project was underway to reestablish the eastern oyster (*Crassostrea virginica*) as a vital part of the river's ecosystem. River estuaries are ideal locations for oysters, and the waters around New York were once full of them, but overfishing, pollution and outbreaks of typhoid shut down the fishery in the late 1880s, and later invasions of starfish and oyster drills finished off what little remained. Oysters, though, are champion filter-feeders, making them a valuable factor in cleansing polluted waters.

With this in mind, a pilot program to restart the Bronx River's oyster beds installed a small reef opposite Soundview Park in 2006. In 2013, the Hudson River Foundation and NY/NJ Baykeeper, with the Bronx River Alliance and Rocking the Boat, expanded it into a full acre using 120 tons of clam shells and 125,000 oyster spat grown by students at the New York Harbor School.[129]

In the summer of 2014, construction began on the Alliance's Bronx River House in Starlight Park, which will include offices, classrooms, boat storage and a community room, geothermal heating and cooling, rainwater collection, solar panels and (non-invasive) vines covering the exterior to help keep it naturally cool. Meanwhile, work continues on the Greenway's last links: Starlight Park Phase II and West Farms Rapids (aka Restoration Park). The antepenultimate link, the "Ranachqua Connector," opened in October 2013, joining East 180th Street and Pelham Parkway.

Today, in the second decade of the twenty-first century, the Bronx River is cleaner, healthier and more accessible than it has been in living memory, but that is not to say that its future is secure. As an urban river flowing past some 2 million people, the Bronx River continues to face challenges that require its ongoing stewardship. Bacterial contamination of the water remains ever-present and continues to spike to dangerous levels following rainfalls. Phosphate pollution contributed to exceptional algae blooms on the lower estuary in the summers of 2012 and 2013. Accumulating silt and sand are making the river noticeably shallower in places, exacerbating flooding problems and threatening the river's hard-won navigability. Invasive plants continue to flourish along the river and seem to sneer at the best efforts to contain or abate them. And of course, litter, floatable debris and

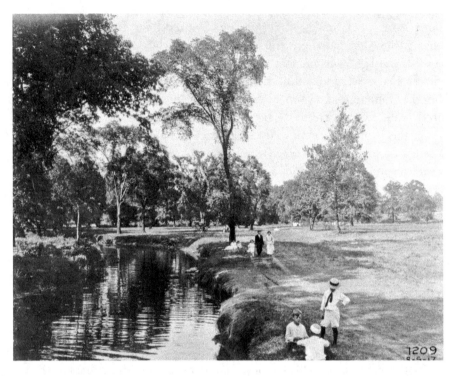

Restoration or revitalization? While we cannot restore the Bronx River to what it was in 1609—or even 1925, when this picture was taken—sustained community stewardship can keep a revitalized river an accessible natural resource. *Library of Congress.*

the occasional old tire still make their way into the river, making continued monitoring and maintenance a necessity to keep the revitalized Bronx River a valued resource for the people of the Bronx and Westchester County.

They say you never cross the same river twice, and the ever-flowing, never-failing Bronx River has seen many changes since the days when Native Americans gathered its oysters and European colonists harvested its salt grass. Sometimes shaping its own course, sometimes altered by the hand of humankind, the Bronx River still inexorably flows through the heart of the Bronx.

THE ULTIMATE
BRONX RIVER STORY

O ne of New York's most enduring urban legends is the tale of the alligators that haunt the sewers, said to be the descendants of souvenir baby 'gators brought home from Florida only to be discarded and flushed down the toilet. Folklorists trace the origins of this story to the 1935 discovery of juvenile caimans in an East Harlem sewer. Little known, though, is a curious incident that happened on the Bronx River three years before.

On June 29, 1932, a pair of boys wandered into the headquarters of the Bronx River Parkway Police near Tuckahoe bearing what looked like a dead three-foot-long alligator. They explained to the startled cops that they had found the thing at a wide spot on the river known as Crestwood Lake. Not only that, they claimed that they saw two or three more alligators—live ones!—moving about in the water.

Chief William J. Byrne hastily organized an alligator hunting expedition for dawn the next day, while newspaper reports spoke of "swarms" of alligators lurking in the "jungle" of quiet Crestwood. Since there was no procedure in the Parkway police manual for apprehending live alligators, Byrne reached out to the local community for advice. One helpful chap coached the policemen on how to produce what he said was the alligator mating call. Another recommended using liver as bait—'gators loved liver, he assured them, and they'd literally walk across the water to get at it, whereupon they could be easily caught in ordinary fishermen's hand nets.

Armed with fishing nets and fresh liver, Byrnes's intrepid 'gator posse combed the river the next day but never found a single alligator, let alone

the reported swarms of them. As for the dead critter the boys dragged in, it turned out to be a crocodile anyway. But the Bronx River alligators had nevertheless made headline news.

So, the next time you hear the old alligators-in-the-sewers story, just smile, knowing that while legendary saurians may roam the sewers of Manhattan, the humble Bronx River had them first.

Appendix

ORGANIZATIONS
AND WEBSITES

Bike the Bronx. www.facebook.com/Bike_the_Bronx.
Bronx African American History Project. http://www.fordham.edu/
 academics/programs_at_fordham_/bronx_african_americ.
Bronx Council for Environmental Quality. www.bceq.org.
Bronx Council on the Arts. www.bronxarts.org.
Bronx County Historical Society. www.bronxhistoricalsociety.org.
Bronx River Alliance. www.bronxriver.org.
Bronx River Art Center. www.bronxriverart.org.
Bronx River Parkway Reservation Conservancy. www.bronx-river.com.
Bronx River Sankofa. http://bronxriversankofa.wordpress.com.
Bronx Tourism Council. www.ilovethebronx.com.
Bronxville Historical Conservancy. http://bronxvillehistoricalconservancy.org.
Christodora. www.christodora.org.
City Parks Foundation. www.cityparksfoundation.org.
East Bronx History Forum. www.bronxnyc.com.
Eastchester Historical Society. www.eastchesterhistoricalsociety.org.
Friends of Shoelace Park. www.facebook.com/FriendsofShoelacePark.
Friends of Soundview Park. www.facebook.com/soundviewpark.
Friends of Starlight Park. www.facebook.com/Friends_of_Starlight_Park.
Friends of Westchester County Parks. www.friendsofwestchesterparks.com.
The Gaia Institute. http://thegaiainstitute.org.
Hudson River Foundation. www.hudsonriver.org.
Hutchinson River Restoration. http://www.
 hutchinsonriverrestorationproject.org.

Metropolitan Waterfront Alliance. www.waterfrontalliance.org.

New York Botanical Garden. www.nybg.org.

New York City Department of Environmental Protection. www.nyc.gov/dep.

New York City Department of Parks & Recreation. www.nycgovparks.org.

New York State Department of Environmental Conservation. www.decny.gov.

NYC H$_2$O. www.newyorkcityh2O.org.

NY/NJ Baykeeper. www.nynjbaykeeper.org.

Outdoor Afro. http://www.outdoorafro.com.

Partnerships for Parks. www.facebook.com/partnershipsforparks.

The Point CDC. www.thepoint.org.

Rocking the Boat. www.rockingtheboat.org.

Sustainable South Bronx. www.ssbx.org.

Transportation Alternatives. www.transalt.org.

Vinecutters. http://vinecutter.com.

The Welikia Project. https://welikia.org.

White Plains Historical Society. www.whiteplainshistory.org.

Wildlife Conservation Society/Bronx Zoo. www.bronxzoo.com.

The Woodlawn Conservancy. http://woodlawnconservancy.org.

Yonkers Historical Society. www.yonkershistory.org.

Youth Ministries for Peace and Justice. www.ympj.org.

NOTES

Chapter 1

1. The Bronx River's outlet was historically considered Long Island Sound, until the reach between Throgs Neck and Hell Gate was re-designated as part of the East River in about 1900. For historical and hydrological reasons, I refer to it as Long Island Sound throughout.
2. For a fuller explanation see Merguerian and Sanders, "Bronx River Diversion: Neotechtonic Implications."
3. Aquahung or Aquehung? Nineteenth-century sources generally spell the river's Native American name with an *e*, although in the twentieth century, the *a* spelling predominated. This may all stem from somebody's typographical error circa 1900, but I find the *a* spelling more pleasing. Since the name is a transcription from an unwritten Native American language through the medium of seventeenth-century Dutch, either one may be more accurate (or neither).
4. In recent years, some authorities have questioned the tradition that the Aquahung was the boundary between two divergent native groups. Evan T. Pritchard points out that the Algonquins tended to think in terms of watersheds, with rivers being the defining centers of territories rather than their boundaries. Others have raised doubts that there really was a distinct Siwanoy tribe east of the Aquahung at all. It is entirely possible that the Weekguasegeecks, in fact, occupied both sides of the Aquahung. Paul Otto (*Dutch-Munsee Encounter in North America*) and Pelham historian Blake Bell ("There Were No Native Americans Known as Siwanoys") advance a strong argument for this view.

5. The legend died out around the time of the Civil War, and the old Wishing Rock may have vanished amid Parkway construction in 1925 or 1952. While its exact location remains uncertain, it might be the boulder that lies just below the bridge at 229th Street. Today all but completely buried beneath a riverbank restoration project, this rock had been a rendezvous and hangout for neighborhood teens into the 1970s.

6. The age and authenticity of this carving have been called into question. It may be viewed today in the Edith Haupt Conservatory of the New York Botanical Garden.

7. Some authorities consider the Weekguasegeecks to have been Unamis rather than Munsees.

8. Conangungh may have been the origin of the name of Gun Hill, which rises on the opposite bank of the river. Also spelled Cowangong, the name meant something like "the boundary beyond," situated as it was on the eastern bank of the Aquahung.

9. The name of White Plains owes its origin to the river, as the fields were often wreathed in morning mist when the sun touched the waters of the Aquahung. An alternative explanation is that the wind shaking the abundant white balsam trees there turned up the leaves' pale undersides.

10. Although an important trade item, wampum was never used by the Native Americans as a form of currency, at least not until the Dutch started manufacturing and using it as such.

11. An early Westchester historian erroneously placed Laaphawachking at White Plains, the name supposed to refer to a chain of beaver ponds. William Wallace Tooker in 1900 placed it in Pelham and suggested an alternate translation as "a plowed field or plantation."

12. Although officially unrecognized, the Ramapough Lunaape Nation still maintains a Lenape identity in the Ramapo Mountains west of the Hudson.

Chapter 2

13. For many years, it was believed that Bronck was a Dane, based on his apparent fluency in the language, and perhaps with a nod to the small Danish community that lived in Morrisania in the early twentieth century. Nevertheless, Bronx Historian Lloyd Ultan conclusively demonstrated that Bronck was born in 1600 in the village of Komstad in the Swedish province of Småland.

14. Also known as Springhurst Creek and Leggett's Creek, the brook originated at Crotona Lake and still ran down the west side of Intervale Avenue to Long Island Sound up to the early 1900s.

15. Ranachqua is also the name of the New York City Parks Department Bronx Borough Headquarters and the longtime home of the Bronx River Alliance,

although situated opposite the Bronx Zoo at a considerable remove from the original Ranachqua. The correct pronunciation is probably "wan-*ach*-qua," being that the Lenape language lacked an *r* sound.

Chapter 3

16. Legends aside, *Castoroides* is not considered to be an ancestor of the American beaver.
17. Exasperated farmers have been known to use dynamite.
18. A distant echo of the Lenten tradition, in Canada today BeaverTails™ or Queues de Castor™ are a popular fried dough pastry made by BeaverTails Canada Inc., shaped like a beaver tail and served with all sorts of toppings never imagined by medieval Europeans.
19. Castorum was known as far back as the Greeks and Romans, and over time it was prescribed for an absurd range of ailments, including gout, epilepsy, tuberculosis, sciatica and insanity. Latter-day fur trappers had a more pragmatic use for castorum, as a scent-bait for their steel traps.
20. When England's Prince of Wales showed up at the theater one night in 1825 wearing a newfangled silk top hat, the market for beaver felt went into a steep decline, helped by new techniques for making felt out of cheaper rabbit and nutria fur.

Chapter 4

21. Heathcote's purchase of the Richbell claim is commemorated in a mural in the Scarsdale Post Office.
22. Quite likely the same fifteen-foot-deep pothole in front of the present 182nd Street Dam where two neighborhood youths drowned in 2009.
23. The Rocking Stone rocks no more. Shortly after it became part of the Bronx Zoo, nervous officials had it shored up, lest some overly enthusiastic visitors caused it to "rock and roll."
24. The Boston Post Road in 1775 crossed the Bronx River at Williamsbridge, climbed up Gun Hill, swung southwest on Reservoir Place and continued on the approximate line of Van Cortlandt Avenue East before crossing Spuyten Duyvil Creek at Kingsbridge Avenue and West 230th Street. The present-day Boston Road was laid out in 1797.

Chapter 5

25. This central crossroads location is why White Plains was named the county seat in 1752.

26. Often incorrectly termed "mercenaries," the Hessians were mainly conscripts whose regiments were rented out to the British by various rulers of small German states. Most, though not all, hailed from the principality of Hesse-Cassel, hence the name.

27. A few balls of buckshot were added on top of a regular bullet, which combined the lethality of a shotgun with that of a smoothbore musket. Americans also had a distressing tendency to target enemy officers, several of whom were hit in the attack on Chatterton Hill.

28. Lacking any mechanism to absorb downward recoil, eighteenth-century field guns couldn't elevate their barrels more than a few degrees. Making things worse, Howe's guns were manned by sailors borrowed from the Royal Navy, who were entirely unaccustomed to handling field cannons.

29. Estimates of British/Hessian casualties vary, but even the low estimate of 250 would have been a shockingly high price to pay for such a small objective. Some accounts claim British/Hessian casualties of more than 360.

30. By some accounts, the Hessians tried to improvise a log bridge across the Bronx River, but this appears to have made no impact on the battle.

31. Johann Rall is believed to be buried somewhere beneath a church parking lot in downtown Trenton.

32. A headless Hessian in Basking Ridge, New Jersey, has sometimes been claimed as Irving's inspiration.

33. The Americans found the remains of unburied Hessians when they reoccupied Chatterton Hill in 1778, and human remains were said to have been found there when the Battle Hill neighborhood was developed in the 1920s. Various attempts to memorialize the battle fell short over the years. On the battle's centennial in 1876, the cornerstone for a fifty-foot-high monument was laid at the corner of Battle and Washington Avenues, but nothing more came of that. A motion to create a Battle of White Plains National Military Park in 1926 was left unfunded, but the battle's sesquicentennial that year was nevertheless commemorated by a reenactment that, strangely, included tanks. Today, the Battle of White Plains Park atop Battle Hill features an excellent array of informational signboards. A cannon mounted on a boulder marks the battlefield for those driving by on the Bronx River Parkway.

Chapter 6

34. A native of the present-day Bronx, Philip Honeywell, acted as a spy for the Patriot side and was also believed to have been the model for *The Spy*. Honeywell is buried in St. Peter's churchyard, Westchester Square.

35. According to an old land deed, the hill was known as "Great Gunn Hill" as far back as 1699. Bronx historian John McNamara thought it might have

been an alternate spelling of "Guion Hill," although it might also have been derived from the Native American place name of Conangungh. Another possible source for the name of Gun Hill was an incident early in 1776 when cannons dismounted from the Battery in lower Manhattan were stashed at the top of the hill.

36. The Revolution House was demolished for the eastward extension of Gun Hill Road early in the twentieth century.

37. Variously known as the "Refugee Corps" or the "Westchester Refugees," DeLancey preferred the name of "Westchester Light Horse" for his irregular unit, but "cow-boys" is the name that stuck. Children in this area played "cow-boys and skinners" long before the game evolved into "cowboys and Indians," and the *cow-boys* were the designated bad guys.

38. The location of the grave is not certain but is probably back in the woods at the spot originally known as "Indian Field," a patch of ground west of the Devoe farmstead that remained treeless while the surrounding fields reverted to woodland in the late 1800s. Local legend has it that war cries and sounds of the battle are sometimes heard resounding from these woods late at night. The Devoe farm lane remains today as part of the John Muir Nature Trail. Daniel Ninham is also commemorated at the annual Daniel Ninham Intertribal Pow-Wow at Ninham Mountain in Putnam County. The names of the fallen men are inscribed on individual bricks at the Mohican Veteran's Memorial of the Stockbridge-Munsee Community Band of Mohican Indians in Wisconsin, where the event is referred to as the "Bronx Massacre."

39. The Yorktown Historical Society is planning to erect a monument to the battle of Pine Bridge in Downing Park in Yorktown.

40. DeLancey was said to have killed a man for riding that horse without his permission.

41. This myth was nevertheless enshrined on a circa 1930s New York State historical marker for the Bronx River located at the Boston Road entrance to the Bronx Zoo. According to the marker, "During the Revolution, the British Fleet was ordered to 'Proceed up the Bronx and attack the Yankees in hiding above.'" Don't believe everything you read by the roadside.

Chapter 7

42. Burr did not profit from the new Boston Post Road. Although he had acquired real estate alongside the new road, he divested himself of it before the road was completed.

43. The footings of the original bridge are visible just above the current concrete bridge that leads to the Zoo's Bronx River Gate. The stretch of the Boston Post Road running through the zoo is today the zoo's Jungle World Road, and

it emerges once again as the Boston Road at the zoo's Asia Gate, only to be redesignated as Third Avenue south of West Farms Square.

44. The name of the Fly Market was derived from the Dutch word *vly*, or ravine, although the English rendition of *fly* was an equally accurate description for what was a combination open-air meat market and butchers' shambles.

45. After centuries as a landmark to farmers, Indians and Huguenots, the Pudding Rock was blown up in the early 1900s to make way for tenements.

46. The Manhattan Water Company continued to supply New York City's water right up to the opening of the Croton system in 1842. The bank eventually became the Chase Manhattan Bank.

Chapter 8

47. Curiously, Alexander Hamilton did have a brief connection to the West Farms textile industry. An entry in the cashbook of his New York law practice noted the handling of a matter of lease rights involving a dam built on property leased from Oliver DeLancey before the war by Joseph Browne and intended to store water for a bleaching operation. David Lydig, who took over the confiscated DeLancey estate after the war, wanted to know where he stood in terms of leasing rights. Lydig's lawyer referred the matter to Hamilton's office for a fifty-pence retainer, although the outcome isn't recorded.

48. The town of Bolton (originally Bolton-le-Moors) is named for them. Known for cloth weaving since the Middle Ages, Bolton became a leading center of textile production in the mid-1800s.

49. The house was torn down in 1904, but Bolton's descendants still preserve its cornerstone at the family home in Connecticut.

50. Bronx River Red was probably a variant of the brownish Tuscan Red. Taste-makers of the day decreed earthlike colors for the exteriors of houses, colors that blended well with the country landscape and projected an air of proper Victorian sobriety.

51. Alexander Smith Carpets remains today a respected name in high-end carpeting, and the long-vacated Yonkers mill buildings are part of a historic district. One last bit of bad luck would dog Alexander Smith: he would win election to Congress only to die on election night as the returns were coming in.

Chapter 9

52. There may have been a wooden mill of some kind at the site before the Lorillards took over. The Lorillard Dam you see today is the one built in 1840; the original 1790 dam may be glimpsed beneath the waters behind

the present dam. Both dams channeled water into a sluiceway that ran along the line of the present-day canoe portage path to the mills about a quarter mile downstream.

53. The present-day Peggy Rockefeller Rose Garden in the New York Botanical Garden provides historical continuity with the Acre of Roses. The Lorillard mansion burned down in 1922, but the carriage house and groundskeeper's cottage remain to give some idea of the opulence of the estate.

54. Following a privately funded renovation, the Snuff Mill is now officially named the Lillian and Amy Goldman Stone Mill, although the National Register of Historic Places still lists it as the Lorillard Snuff Mill. For their part, the Lorillard family has long since divested itself of any interests in the tobacco industry. After the Botanical Garden was founded, the old mill was used for equipment storage and then, for many years, as a riverside café. At one time, it was reputed to be haunted, but with no record found of by whom or what. Today fully refurbished (complete with a state-of-the-art storm water management system), it is a romantic spot for such catered events as wedding receptions.

55. The Lorillard Company eventually pioneered manufactured cigarettes, and its 1870 factory still stands in Jersey City, today used as artist lofts. Story has it that the name of the "Old Gold" brand was inspired by the legend of the lost treasure of the British frigate *Hussar*, sunk in 1780 off Morrisania. Another Lorillard innovation would be the gated community, the first of which was founded by Pierre Loillard IV in the Ramapo Mountain hamlet of Tuxedo, New York, where, yes, the "tuxedo" was invented.

56. His illustration for the November 1946 cover of the *Saturday Evening Post* depicted the morning commuter rush at the Crestwood train station, with no hint of the quarries that once operated just a quarter of a mile away.

Chapter 10

57. The Osier willow is today sometimes used in ecological restoration and brownfield remediation projects as a hyperaccumulator of such industrial pollutants as cadmium, chromium, lead, mercury, petroleum hydrocarbons, selenium, silver, uranium and zinc.

58. Alongside the Hunt family cemetery, there is an unmarked burial ground for slaves. Ignored and covered over when the park was created in 1909, its existence was revealed by a group of fourth and fifth graders at Hunts Points PS 48 (the Joseph Rodman Drake School). Led by educators Justin Czarka and Grace Binuya, with the support of Teaching American History project directors Philip Panaritis and Brian Carlin, between 2011 and 2013 the students carefully collated historical evidence pointing to the probable

location of these unmarked burials. In the summer of 2013, they were able to get a team of scientists from the U.S. Department of Agriculture to conduct soil surveys using ground-penetrating radar, which turned up "anthropogenic features" beneath a picnic area alongside the fenced burial ground.

59. At one time, it was speculated that "Bessie Warren" might have been one Elizabeth Willett, who is buried in the Hunt family cemetery. Elizabeth Willett died in 1772, well before the Revolution, but legends seldom concern themselves with inconvenient facts.

60. These lines are inscribed on a memorial plaque by the river in the New York Botanical Garden.

61. Edgar Allan Poe, a critic with rather forceful views of what constituted good poetry, considered "Bronx" the best of Drake's poetry, "altogether a beautiful and lofty poem." Nevertheless, writing in the *Southern Literary Messenger*, Poe had hard things to say about "The Culprit Fay" ("the greater part of it is destitute of any evidence of imagination whatever").

62. This also accounts for Montefiore Medical Center's location at the peak of Gun Hill, not far from the site of Poe's cottage. Montefiore was founded as a hospital specializing in lung diseases, and when it moved to the Bronx in 1911, wind-swept hilltops were still considered the best places to treat tuberculosis victims.

63. One interpretation of "The Domain of Arnheim" is that it describes a soul's journey, perhaps also inspired by Thomas Cole's series of paintings "The Journey of Life," which Poe may have seen when it was exhibited in New York. Although "The Domain of Arnheim" is not among Poe's best-known works today, it has nevertheless excited considerable artistic interest over the years. The surrealist painter René Magritte was a tremendous fan of Poe, so much so that on his first visit to New York in the 1940s, the Poe Cottage was the first place he wanted to visit. Magritte created two different paintings titled *The Domain of Arnheim*, as did such modernist painters as James Ensor and Albert Leindecker.

64. See Kenneth W. Maddox's list in the Hudson River Museum's 1993 exhibition catalogue, *Westchester Landscapes: Pastoral Visions, 1840–1920*.

Chapter 11

65. The New York & Harlem would lead the list of more than one hundred separate railroads that eventually would be combined into the New York Central.

66. The station was actually on the other side of the Bronx River in North Tuckahoe, but the developers were keeping the still hard-knuckled quarry town at a safe remove.

67. The Bronxville Historical Conservancy preserves a collection of paintings by Bronxville artists in the Village Hall. Lawrence Park, and a number of individual houses within it, is on the National Register of Historic Places.

68. Two nineteenth-century houses on Saxon Woods Road are thought to be relics of the African American community that once lived in Scarsdale.

69. After a brief diversion under the train tracks, Woodlawn Brook joined the Bronx River at a spot scenic enough to be the subject of a three-dimensional stereopticon card for armchair travelers. This view can no longer be seen today. When in the early 1900s the city sliced away part of the hillside to extend Webster Avenue north of Gun Hill Road, Woodlawn Brook was channeled into a deep drain and now joins the Bronx River from the end of a rather un-scenic outflow pipe. Two additional tributaries, now vanished, also flowed down from Woodlawn.

Chapter 12

70. Magenta was a small town in northern Italy where French forces won a resounding victory over the Austrians. The event was a great point of pride to the French, and to commemorate it, a Parisian dressmaker dubbed a new purplish-rose color "magenta." Being that the street wasn't named Magenta until 1900, the choice may have been that of the new immigrant Italian community there in a gesture of Franco-Italian amity. On the other hand, it may have had something to do with the surname of its surveyor, Rudolph Rosa. Nearby Bartholdi Street may also celebrate a Franco-Italian connection.

71. The original Liberty Lace site is known to neighborhood old-timers as the Pyro Plastics factory. The building still stands, although today it is a Pentecostal church.

72. There is still room for some uncertainty here. The oxbow island was noted on an 1895 Sanborne insurance map as "French Charley's Island." It was also formerly known as Dubois Island for its owner, Charles Dubois, who inherited the land in 1888, leaving the slim possibility that the American-born Dubois was another "French Charley," although there is no evidence that this nickname was applied to him. While the island's buildings as shown on the 1895 map are consistent with an outdoor restaurant/resort, French Charley's resort was certainly defunct by the time Charles Mangin wound up driving a van. In 1906, the island's new owner, Francis D. Evans, filed a plan to construct a two-story wood-framed factory building. The proposed factory was never built, and eventually the Bronx River Parkway Commission filled in the oxbow and demolished.

Chapter 13

73. The name La Bièvre, curiously enough, was a medieval French word for beaver.

74. Ironically, by then the waters of La Bièvre had themselves been compromised by urban pollution, forcing Gobelin to try to replicate the original water in a chemistry lab.

75. Some carpet manufacturers in Scotland would stick to the old dye preparation methods up until the 1960s. John Byrnes's 1997 play *Slab Boys* focused on a group of apprentices preparing dyes in 1957 by methods not unlike those used by Baumgarten fifty years earlier.

76. The general practice for statues in local Civil War memorials was for Union soldiers to face north and Confederate soldiers to face south. This was more strictly adhered to in the South than in the North, and the GAR monument in Woodlawn Cemetery would, in fact, be erected facing south. Statues on battlefields would be set up facing the enemy line, regardless of compass direction. Although not intended to commemorate any particular event, the Bronx River Soldier stood just about one hundred yards from where the Williamsbridge telegraph office was burned in the 1863 Draft Riots.

77. The GAR's successor, the Oliver Tilden Post No. 26 of the Sons of Union Army Veterans, annually honors the veterans buried there by planting flags, but it does not attempt to paint the statue.

Chapter 14

78. The name of Hommock Manor evokes the nature of the lands around the lower estuary as they existed then. "Hommock" is an older spelling of "hummock," or a slight eminence of dry land surrounded by water and marshes. Whitlock's house sat on just such a hummock, about twenty acres in extent.

79. Although Whitlock opposed secession, some of his in-laws were much more deeply involved in the conflict. His brother-in-law, William Lawrence "Larry" McDonald, worked as a smuggler, spy and Confederate secret agent, and Larry's brother, "Gus" McDonald, was implicated in the November 1864 Confederate plot to burn New York City.

80. Landfill has covered this inlet, and the site of Duck Island is now beneath the lower end of Tiffany Street.

81. There would yet be one more mystery attached to the mansion. In January 1922, a unnamed recluse known only as "the Man of Mystery" was found dead the bottom of one of the mansion's water cisterns, which was said to have been a secret entrance to the Whitlock mansion's tunnels.

82. Robert Moses may have taken inspiration from the plans of Egbert Viele and the promoters of the abortive International Exposition in West Farms to use a World's Fair to help channel development; in any event, that is exactly how Moses got a mammoth dump site transformed into Flushing Meadows Park.

83. Egbert Viele is commemorated by Viele Avenue; likewise the East Bay Land Improvement Company got East Bay Avenue named for it, even though there never would be an East Bay labeled on the local map.

84. Sunnyslope, the 1860 home of Richard Hoe's brother, Peter, still stands just uphill from Hunts Point Riverside Park. Today the home of the Bright Temple AME Church, it is the last remaining mansion in Hunts Point.

85. Funded in part by the chance discovery of buried treasure on the site: a box full of cash left behind in the ruins of the old Macy mansion.

Chapter 15

86. In Newport, they purchased an ocean-side property they named the Breakers. Eventually, they moved on from Newport to found the country's first gated community at Tuxedo, New York, and sold the Breakers to the Vanderbilt family, who built a whole new "cottage" there that became a National Landmark.

87. Torn down in the late 1920s, the Bolton plant site in West Farms is presently Drew Gardens.

88. Until recently, the official name would remain the New York Zoological Park. Director Hornaday was anxious to change the perception of zoos from amusing menageries to centers for wildlife education and conservation, and consequently he always hated the nickname of "Bronx Zoo."

Chapter 16

89. Although the Edison Studio is long vanished, the building that occupies the site today is named the Edison Apartments.

90. Murray Haas, who recollected this story for Bronx historian John McNamara in 1971, did not remember the name of the film or which studio produced it. I would like to think it was the 1912 one-reel film *Saved from the Titanic*, but I can find no evidence to conclusively make the connection. Made by the Éclair American Company of Fort Lee, New Jersey, *Saved from the Titanic* was released just one month after the disaster, and it had the distinction of starring an actual *Titanic* survivor, Hoboken-born Dorothy Gibson. Haas recalled the date as being about 1914–15, but after nearly sixty years, he might have misremembered the year. No prints of *Saved from the Titanic* are known to exist, and likewise several other *Titanic* silents from that time have been completely lost.

Chapter 17

91. After serving a duly instructive and picturesque purpose for some years, the *Half Moon* replica was lost to fire in the 1930s. The replica currently seen along the Hudson River was built in Albany in 1989.

92. The Hub at Third Avenue and 149th Street was already a major entertainment district, with the Bronx Opera House and a number of Vaudeville venues. It was there that the "Bronx Cheer" originated, given its name by annoyed entertainers, who then spread its fame throughout the country.

93. Often referred to as the Bronx Coliseum or the Starlight Park Coliseum, the official name of the place was the New York Coliseum, a name eventually assumed by Robert Moses's 1962 building on Columbus Circle.

94. The House of David was a religious sect whose men did not cut their hair or shave their beards, making them quite a sight in 1930s America. Founded by a group that had determined that Benton Harbor, Michigan, was the original location of the Garden of Eden, it operated its own Eden Amusement Park there and sent exhibition basketball and baseball teams touring the country.

95. The *Holland 9* (or *Holland 1* to the U.S. Navy) was built by the Irish inventor John Philip Holland, whose first submarine, the *Fenian Ram*, had been built in 1874 for the Irish Fenian Brotherhood. At the time the *Holland 9* was on display in Starlight Park, the *Fenian Ram* was also on display downstream on the grounds of the Clason Point Military Academy. The *Fenian Ram* is today preserved in the Paterson Museum in New Jersey, but intriguingly, a third *Holland* craft, an experimental one-man sub, may lie beneath Long Island Sound somewhere near the mouth of the Bronx River.

Chapter 18

96. Generally pronounced "clow-son" rather than "class-on."

97. A possibly apocryphal story has it that when Charles Addams was developing his popular "Addams Family" cartoon series into a TV show in the 1960s, he at first gave the name of "Pubert" to the previously unnamed eldest child. Uneasy network censors asked for another name, whereupon, gazing at a wall map of New York City, Addams's eye fell on Pugsley Creek, and so the character of Pugsley Addams was named. Whether or not it lent its name to the Addams Family character, the creek is actually named after an eighteenth-century landowner Talman Pugsley.

98. Another singer, Mae Questal, actually supplied the voice for the cartoons. Max Fleischer would later testify under oath that Helen Kane was not the inspiration for Betty Boop. Kane had sued Fleischer in 1934, claiming that

he had improperly appropriated her signature "boop-oop-a-doop" line. The two-year-long trial produced some delightfully absurd transcripts deconstructing "boop-oop-a-doop." (Was it "boop-oop-a-doop," "boop-boop-de-boop," "boop-a-doop-oop" or "boopy-doop-a-doop"?) In any event, Kane lost the suit; the court ruled that Max Fleischer could indeed take her boop-oop-a-doop away.

99. Before it went out of fashion, the Bronx Cocktail would have one more brush with history. In 1944, a mysterious woman code-named "Agent Bronx" for her preference for this drink would play a key role in the Allied deception effort leading to the Normandy invasion. The identity of "Agent Bronx" remains classified.

100. President Warren Harding died of a heart attack, some said too conveniently, in 1923, just as a complex of scandals known as "Teapot Dome" erupted and made the history of his brief administration a byword for high-level corruption.

101. Neighborhood legend has it that Moses originally wanted to name it Lafayette Park but was persuaded by local people to instead call it Soundview Park. The name originated with a nineteenth-century developer who wanted to showcase the neighborhood's proximity to Long Island Sound, before the 1898 consolidation of New York caused mapmakers to assign these waters to the East River.

Chapter 19

102. It had previously been variously known as Robbins Mills, Fishers Mills and Wright's Mills, depending on the dominant mill owner at the time.

103. Lake One-on-me is currently called Whippoorwill Lake.

104. The death toll for the Catskill Aqueduct would reach 237 men; an additional 92 died building the New Croton Aqueduct.

105. Not to be confused with the Mile Square Road in Yonkers. The village of Armonk was originally also called Mile Square.

106. You can indeed still hear Kensico's church bell tolling on any Sunday. Not to spoil a good story, but the church bell was given to Valhalla's United Methodist Church, where every week it rings out to summon a living congregation.

Chapter 20

107. It was later renamed *Endothia parasitica* and is now known as *Cryphonectria parasitica*.

Chapter 21

108. Madison Grant is a problematic figure. A committed preservationist and conservationist, he played a key role in saving the California redwoods (the Madison Grant Forest is named for him) and the American bison. He also authored the New York State Deer Law to ban "unsportsmanlike" hunting practices and was a key founder of the Bronx Zoo, whose humane (for its day) exhibition policies he helped shape. He is, however, best known for his involvement in the eugenics movement and as the author of *The Passing of the Great Race*, a seminal manifesto of "scientific" racism that is still in print on the Internet and from various back-alley publishers. The enlightened exhibition policies at the Bronx Zoo, moreover, did not prevent his approval of the exhibition of Ota Benga, an African pygmy, in the Primate House at the same time the Bronx River Parkway Commission was beginning its work in 1906. These issues are thoroughly explored in a number of recent books noted in the bibliography. Although his name is on monuments to the California redwoods and on the Bronx River Parkway, apart from a portrait in the boardroom, Madison Grant is nowhere commemorated on the grounds of the Bronx Zoo.

109. In one of those odd little quirks of history, water sportsman Herman Metz was also president of the Consolidated Color and Chemical Company, a major manufacturer of textile dyestuffs, some of whose products may well have been among the dyes being emptied into the Bronx River.

110. The Vanderbilt Cup Race was only held once on the Long Island Motor Parkway. After four spectators were killed in an accident in the inaugural 1910 race, the parkway was deemed too hazardous for road races. Vanderbilt extended and operated the parkway as a private toll road, charging an exorbitant two dollars per vehicle. The Long Island Motor Parkway shared the fate of the old Bronx River Parkway—part of the old roadway survives today as a bicycle and pedestrian pathway in Queens' Cunningham Park.

111. The oddly named "Niles Triangle," actually a semicircular overlook, was built in 1938 to honor William W. Niles. Although it opened to the roadway, no provision was made to enable cars to pull over, nor was a safe crossing provided for neighborhood residents.

112. Woodlawn and Wakefield historian Hank Stroobants has researched and documented these buildings. For the most part still standing today, they are an easily overlooked part of Parkway history and an example of the economic impact of parkland.

113. This may be an example of a portable legend, as there was also a Money Hill located at the foot of the Croton peninsula on the Hudson River, which was a more logical place to bury pirate treasure than the Bronx River.

114. A persistent legend is that German engineers came over in the 1930s to study the Bronx River Parkway. While this may be true, I have found no evidence for it. The German Autobahn, as it was eventually constructed, is an entirely different roadway in both design and purpose from the Bronx River Parkway, being a militarily strategic network of high-speed motor transportation arteries (to this day there are no speed limits on the Autobahn).

Chapter 22

115. The pathway originally proceeded over and then under the bridge at East 229th Street, with another underpass beneath the 1952 roadway, but in recent years, this link has become unusable, compelling a detour across the East 233rd Street Bridge to reach the pathway's northernmost segment. The pathway from the Woodlawn station to the "Bridge to Nowhere" was named "Muskrat Cove" and was restored by neighborhood activists beginning in the late 1970s; it is now the northernmost link of the Bronx River Greenway (albeit still a dead end).

116. The missing link in Scarsdale was dictated by the river's constricted valley running between the high ground of Greenburgh and Scarsdale's Fox Meadow neighborhood. Recent proposals to squeeze in a pathway linking Scarsdale and Hartsdale have been a point of contention with some neighborhood residents.

117. Not until 1976 would this parkland be formally dubbed "Shoelace Park," although recent New York City Parks signage proclaims it "Bronx Park."

118. Opened to traffic in 1962, the utility of this one-and-one-third-mile stubway has long been questioned by community activists, who recommend its demolition and replacement by parkland that would facilitate access to the revamped Starlight Park. Nevertheless, renewed proposals for the Sheridan's extension have continued to pop up as recently as 1997.

Chapter 23

119. In May 2009, the Westchester legislature voted to ban all phosphate fertilizers as of January 2011.

120. Health concerns about tetraethyl lead had been raised in the mid-1920s shortly after the additive was introduced.

121. It got the name of "pilewort" for being used as a perfectly ineffective remedy for hemorrhoids.

122. It's also known as the Devil's tail and giant climbing tear-thumb for the lacerating barbs on its stems.

Chapter 24

123. The word *restoration* has been commonly used since the first days of the Bronx River Restoration Project in the 1970s, but in recent years, questions have been raised about just what is meant by a restoration of the Bronx River and whether that is an achievable goal. The broad consensus is that since there is no way we can actually restore the river to what it was in 1609—or, for that matter, 1809—*revitalization* is, therefore, the preferred term today.
124. Axel Horn was a painter who had studied under Thomas Hart Benton (in the same class as Jackson Pollack, no less). He later became a director of the Bronx River Restoration.
125. The newspaper report failed to note the exact location of this event.
126. Currently known as West Farms Rapids.

Chapter 25

127. Which sex remains uncertain. There is more than an even chance that either or both of them may be female. Like all rodents, beavers migrate from their home lodge upon reaching maturity. Female beavers, however, have a much greater migration range (up to nine miles) than male beavers (four miles).
128. The legendary Squanto (Tisquantum) taught the newly arrived Plymouth Pilgrims about these spring migrations, and he also showed them how to use alewives to fertilize their cornfields, a technique used by New England gardeners to this day. The alewife feeds bluefish and striped bass, schools of which will often follow the returning alewives for many miles up estuaries and rivers. Alewives are also the only known host for the freshwater mussel known as the "alewife floater," a native filter feeder.
129. Oyster spat are so called because the larvae were believed to be literally spat out of the oyster. And they look it, too.

BIBLIOGRAPHY

Books and Publications

Allen, Thomas B. *Tories: Fighting for the King in America's First Civil War*. New York: HarperCollins, 2010.

Apuzzo, Robert. *The Endless Search for the HMS Hussar*. New York: R&L Publishing, 2008.

Bolton, Arthur T. *James Bolton of Bolton: His Descendants, and An Industrial Heritage*. Clinton, CT: self-published, 1972.

Bolton, Reginald Pelham. *Indian Life of Long Ago in the City of New York*. New York: J. Graham, 1934.

Bolton, Robert. *History of the Several Towns, Manors and Patents of the County of Westchester*. New York: C.F. Roper, 1848.

Bone, Kevin, ed. *Water-Works: The Architecture and Engineering of the New York City Water Supply*. New York: Monacelli Press, 2006.

Borkow, Richard. *George Washington's Westchester Gamble: The Encampment on the Hudson and the Trapping of Cornwallis*. Charleston, SC: The History Press, 2011.

Bronx Board of Trade. *The Bronx: New York City's Fastest Growing Borough*. Bronx, NY: Bronx Board of Trade, 1921.

Bronx Parkway Commission. *Reports*. New York: Bronx Parkway Commission, 1907–18.

Bronx River Alliance. *Bronx River Classroom: The Inside Track for Educators*. Bronx, NY: Bronx River Alliance, 2007.

———. *Bronx River Greenway Plan*. Bronx, NY: Bronx River Alliance, 2006.

———. *Bronx River Intermunicipal Watershed Management Plan*. Bronx, NY: Bronx River Alliance, 2010.

————. *Ecological Restoration and Management Plan*. Bronx, NY: Bronx River Alliance, 2006.

Bronx River Restoration. *Master Plan*. Bronx, NY: Bronx River Restoration, 1980.

Brookhiser, Richard. *Gentleman Revolutionary: Gouverneur Morris: The Rake Who Wrote the Constitution*. New York: Free Press, 2003.

Burrows, Edwin G., and Mike Wallace. *Gotham: A History of New York City to 1898*. New York: Oxford University Press,1999.

Calver, William P., and Reginald P. Bolton. *History Written with Pick and Shovel*. New York: New-York Historical Society, 1950.

Cantwell, Anne-Marie, and Diana diZerega Wall. *Unearthing Gotham: The Archaeology of New York City*. New Haven, CT: Yale University Press, 2001.

Caro, Robert A. *The Power Broker: Robert Moses and the Fall of New York*. New York: Alfred A. Knopf, 1974.

Chang, Jeff, and DJ Cool Herc. *Can't Stop Won't Stop: A History of the Hip-Hop Generation*. New York: St. Martin's Press, 2005.

Clyne, Patricia Edwards. *Hudson Valley Faces and Places*. Woodstock, NY: Overlook Press,, 2005.

————. *Hudson Valley Tales and Trails*. Woodstock, NY: Overlook Press, 1990.

Cook, Harry T. *The Borough of the Bronx, 1639–1913*. New York: self-published, 1913.

Crestwood Historical Society. *A Brief History of Crestwood*. Yonkers, NY: Crestwood Historical Society, n.d.

Daigler, Kenneth A. *Spies, Patriots and Traitors: American Intelligence in the Revolutionary War*. Washington, D.C.: Georgetown University Press, 2014.

Davis, Ronald L. *William S. Hart: Projecting the American West*. Norman: University of Oklahoma Press, 2003.

De Kadt, Maarten. *The Bronx River: An Environmental and Social History*. Charleston, SC: The History Press, 2011.

Disturnell, J. *A Gazetteer of the State of New York*. Albany, NY: J. Disturnell, 1843.

Dolin, Eric Jay. *Fur, Fortune and Empire: The Epic History of the Fur Trade in America*. New York: W.W. Norton & Co., 2010.

Dugmore, A. Radclyffe. *The Romance of the Beaver*. Philadelphia, PA: J.B. Lippincott, 1913.

Franklin, Wayne. *James Fenimore Cooper: The Early Years*. New Haven, CT: Yale University Press, 2007.

Galpin, Virginia M. *New Haven's Oyster Industry, 1638–1987*. New Haven, CT: New Haven Historical Society, 1989.

Galusha, Diana. *Liquid Assets: A History of New York City's Water System*. Fleischmanns, NY: Purple Mountain Press, 2002.

Gonzalez, Evelyn. *The Bronx*. New York: Columbia University Press, 2004.

Gottlock, Barbara, and Wesley Gottlock. *Lost Amusement Parks of New York City: Beyond Coney Island.* Charleston, SC: The History Press, 2013.

Gratz, Roberta Brandes. *The Battle for Gotham: New York in the Shadow of Robert Moses and Jane Jacobs.* New York: Nation Books, 2010.

Grogan, Louis V. *The Coming of the New York and Harlem Railroad.* Pawling, NY: self-published, 1989.

Grumet, Robert S. *First Manhattans: A History of the Indians of Greater New York.* Norman: University of Oklahoma Press, 2011.

Hall, Edward H., and Richard Frisbee, eds. *Water for New York City: A 300-Year History of Water Sources for New York City Culminating in the Construction of the Ashokan Reservoir and the Catskill Aqueduct.* Saugerties, NY: Hope Farm Press, 1993.

Hannon, James. *Lost Boys of the Bronx: The Oral History of the Ducky Boys Gang.* Bloomington, IN: Author House, 2010.

Harrison, Sandra. *White Plains, New York: A City of Contrasts.* White Plains, NY: Lulu Publishing, 2013.

Harwood, Herbert H., Jr. *The New York, Westchester & Boston Railway: J.P. Morgan's Magnificent Mistake.* Bloomington: Indiana University Press, 2008.

Hay, John. *The Run.* Boston: Beacon Press, 1999.

Henderson, Peter. *Campaign of Chaos…1776.* Haworth, NJ: Archives Ink, Ltd., 1975.

Hillzik, Michael. *Colossus: The Hoover Dam and the Making of the American Century.* New York: Free Press, 2010.

Hoffman, Renoda. *The Battle of White Plains.* White Plains, NY: White Plains Historical Society, n.d.

Hornaday, William Temple. *Our Vanishing Wildlife: Its Extermination and Preservation.* New York: C. Scribner's Sons, 1913.

Hudson-Fulton Celebration Commission. *Official Minutes.* Vol. 2. Albany, NY: Hudson-Fulton Celebration Commission, 1911.

Hudson River Museum. *In the Mill.* Exhibition catalogue. Yonkers, NY: Hudson River Museum, 1983.

———. *Westchester Landscapes: Pastoral Visions, 1840–1920.* Exhibition catalogue. Yonkers, NY: Hudson River Museum, 1993.

Hufeland, Otto. *Westchester County during the American Revolution.* White Plains, NY: Westchester County Historical Society, 1926.

Isenberg, Nancy. *Fallen Founder: The Life of Aaron Burr.* New York: Viking Press, 2007.

Jackson, Kenneth T., ed. *The Encyclopedia of New York City.* New Haven, CT: Yale University Press,, 1995.

Jaffe, Eric. *The King's Best Highway: The Lost History of the Boston Post Road, the Route that Made America.* New York: Scribner's, 2010.

Jakle, John H., and Keith A. Seulle. *Motoring: The Highway Experience in America.* Athens: University of Georgia Press, 2008.

Jenkins, Stephen. *The Story of the Bronx from the Purchase Made by the Dutch from the Indians in 1639 to the Present Day.* New York: G.P. Putnam's Sons, 1912.

Jonnes, Jill. *South Bronx Rising: The Rise, Fall, and Resurrection of an American City.* Bronx, NY: Fordham University Press, 2002.

Joseph, May. *Fluid New York: Cosmopolitan Urbanism and the Green Imagination.* Durham, NC: Duke University Press, 2013.

Koeppel, Gerard T. *Water for Gotham: A History.* Princeton, NJ: Princeton University Press, 2000.

Krech, Shepard, III. *The Ecological Indian: Myth and History.* New York: W.W. Norton & Co., 1999.

Kruk, Jonathan. *Legends and Lore of Sleepy Hollow and the Hudson Valley.* Charleston, SC: The History Press, 2011.

Kurlansky, Mark. *The Big Oyster: History on the Half Shell.* New York: Ballantine Books, 2006.

Lederer, Richard M., Jr. *The Place-Names of Westchester County, New York.* Harrison, NY: Harbor Hill Books, 1978.

Leggett, Theodore. *Early Settlers of West Farms.* New York: self-published, 1913.

Lenik, Edward J. *Picture Rocks: American Indian Rock Art in the Northeast Woodlands.* Lebanon, NH: University Press of New England, 2002.

Leopold, Luna B. *A View of the River.* Cambridge, MA: Harvard University Press, 1994.

Lossing, Benson. *Pictorial Field-Book of the Revolution.* New York: Harper and Brothers, 1853.

Mabbott, Thomas Ollive, ed. *The Collected Works of Edgar Allan Poe.* Vols. 2 and 3. *Tales and Sketches.* Cambridge, MA: Harvard University Press, 1978.

McAuley, Kathleen A., and Gary Hermalyn. *The Bronx (Then and Now).* Charleston, SC: Arcadia Publishing, 2010.

McCool, Daniel. *River Republic: The Fall and Rise of America's Rivers.* New York: Columbia University Press, 2012.

McNamara, John. *History in Asphalt: The Origin of Bronx Street and Place Names Encyclopedia.* Harrison, NY: Harbor Hill Books, 1978; 4th revised edition, 2010.
———. *McNamara's Old Bronx.* Bronx, NY: Bronx County Historical Society, 1989.

Mullaly, John. *The New Parks Beyond the Harlem.* New York: Record & Guide, 1887.

Müller-Schwarze, Dietland, and Lixing Sun. *The Beaver: Natural History of a Wetlands Engineer.* Ithaca, NY: Cornell University Press, 2003.

Museum of the American Indian, Heye Foundation. *Indian Paths in the Great Metropolis.* New York: Heye Foundation, 1922.

Ostrom, John Ward. *The Letters of Edgar Allan Poe.* New York: Gordian Press, 1966.

Otto, Paul. *The Dutch-Munsee Encounter in North America: The Struggle for Sovereignty in the Hudson Valley.* New York: Berghahn Books, 2006.

Panetta, Roger, ed. *Dutch New York: The Roots of Hudson Valley Culture*. Bronx, NY: Hudson River Museum and Fordham University Press, 2009.

———. *Westchester: The American Suburb*. Bronx, NY: Hudson River Museum and Fordham University Press, 2006.

Powell, Morgan. *Parks and Recreation Historical Sign Proposal for West Farms Rapids*. New York: self-published, 2011.

Pritchard, Evan T. *Henry Hudson and the Algonquins of New York*. San Francisco, CA: Council Oak Books, 2009.

———. *Native New Yorkers: The Legacy of the Algonquin People of New York*. San Francisco, CA: Council Oak Books, 2007.

Riker, James. *Revised History of Harlem*. New York: New Harlem Publishing Company, 1904.

Sanderson, Eric W. *Mannahatta: A Natural History of New York City*. New York: Harry N. Abrams, 2009.

Sandlin, Lee. *Wicked River: The Mississippi When It Last Ran Wild*. New York: Pantheon Books, 2010.

Schuberth, Christopher J. *The Geology of New York City and Environs*. Garden City, NY: Natural History Press, 1968.

Schuyler, David. *Sanctified Landscape: Writers, Artists and the Hudson River Valley, 1820–1909*. Ithaca, NY: Cornell University Press, 2012.

Seymann, Jerrold. *Colonial Charters, Patents and Grants to the Communities Comprising the City of New York*. New York: Board of Statutory Consolidation of the City of New York, 1939.

Shonnard, Frederick, and W.W. Spooner. *History of Westchester County*. New York: New York History Co., 1900.

Shorto, Russell. *The Island at the Center of the World*. New York: Doubleday, 2005.

Smith, Drew. *Oyster: A World History*. Stroud, UK: The History Press, 2010.

Smith, Francis Hopkinson. *A Day at Laguerre's and Other Days*. New York: Houghton, Mifflin and Company, 1892.

Soll, David. *Empire of Water: An Environmental and Political History of the New York City Water Supply*. Ithaca, NY: Cornell University Press, 2013.

Spear, Moncrieff J. *To End the War at White Plains*. Baltimore, MA: American Literary Press, 2002.

Spiro, Jonathan Peter. *Defending the Master Race: Conservation, Eugenics, and the Legacy of Madison Grant*. Burlington: University of Vermont Press, 2009.

Steinberg, Ted. *Gotham Unbound: The Ecological History of Greater New York*. New York: Simon & Schuster, 2014.

Steuding, Bob. *The Last of the Handmade Dams: The Story of the Ashokan Reservoir*. Fleischmanns, NY: Purple Mountain Press, 1985.

Stewart, John C., et al. *An Introduction to the Geology of the Bronx Zoo*. Bronx, NY: Wildlife Conservation Society, n.d.

Sze, Julie. *Noxious New York: The Racial Politics of Urban Health and Environmental Justice*. Cambridge, MA: MIT Press, 2007.

Thomas, Dwight, and David K. Jackson. *The Poe Log: A Documentary Life of Edgar Allan Poe, 1809–1849*. Boston: G.K. Hall, 1987.

Titus, Robert, and Johanna Titus. *The Hudson Valley in the Ice Age: A Geological History and Tour*. Delmar, NY: Black Dome Press, 2012.

Torres, Louis. *Tuckahoe Marble: The Rise and Fall of an Industry, 1822–1930*. Harrison, NY: Harbor Hill Books, 1976.

Twomey, Bill. *The Bronx in Bits and Pieces*. Bloomington, IN: Rooftop Publishing, 2007.

———. *East Bronx*. Charleston, SC: Arcadia Publishing, 2009.

———. *South Bronx*. Charleston, SC: Arcadia Publishing, 2002.

Ultan, Lloyd. *The Beautiful Bronx, 1920–1950*. Bronx, NY: Arlington House, 1979.

———. *Blacks in the Colonial Bronx: A Documentary History*. Bronx, NY: Bronx County Historical Society, 2012.

———. *The Bronx in the Frontier Era: From the Beginning to 1696*. Dubuque, IA: Kendall/Hunt Publishing Company, 1993.

———. *The Northern Borough: A History of the Bronx*. Bronx, NY: Bronx County Historical Society, 2009.

Ultan, Lloyd, and Gary Hermalyn. *The Birth of the Bronx, 1609–1900*. Bronx, NY: Bronx County Historical Society, 2000.

———. *The Bronx in the Innocent Years, 1890–1925*. New York: Harper and Row, 1991.

———. *The Bronx: It Was Only Yesterday, 1935–1965*. Bronx, NY: Bronx County Historical Society, 1992.

Ultan, Lloyd, and Barbara Unger. *Bronx Accent: A Literary and Pictorial History of the Borough*. New Brunswick, NJ: Rutgers University Press, 2000.

Venema, Janny. *Beverwijck: A Dutch Village on the American Frontier, 1652–1664*. Albany: State University of New York Press, 2003.

Walsh, Kevin. *Forgotten New York: The Ultimate Explorer's Guide to All Five Boroughs*. New York: Collins, 2006.

Westphal, Lynne M. "Growing Power?: Benefits from Urban Greening Projects." PhD diss., University of Chicago, 1999.

Willis, Nathaniel Parker. *Hurry-Graphs*. New York: C. Scribner, 1851.

Wohl, Ellen. *Disconnected Rivers: Linking Rivers to Landscapes*. New Haven, CT: Yale University Press, 2004.

Articles

Albee, Allison. "Mining in Westchester." *Quarterly Bulletin of the Westchester County Historical Society* 11, no. 2 (April 1935).

Austin, Henry. "A Day Off at Bronx." *The Illustrated American* 18, no. 287 (August 17, 1895).

Beauchamp, William Martin. "Aboriginal Use of Wood in New York." *New York State Museum Bulletin* 89 (1905).

Bell, Blake A. "There Were No Native Americans Known as Siwanoys." Historical Pelham, January 29, 2014. http://historicpelham.blogspot.com.

Bouza, Anthony V. "Trees and Crime Prevention." In P.D. Rodbell, ed., *Proceedings of the Fourth Urban Forestry Conference: Making Our Cities Safe for Trees.* Washington, D.C.: American Forestry Association, 1989.

Britton, N.L. "The Hemlock Grove on the Banks of the Bronx River, and What It Signifies." *Transactions of the Bronx Society of Arts and Sciences* 1, part 1 (May 1906).

Burtnett, Bertrand G. "The Masterton Homestead—Bronxville." *Quarterly Bulletin of the Westchester County Historical Society* 7, no. 2 (April 1931).

Canny, James R. "Statue of a Soldier in the Bronx River" *Bronx County Historical Society Journal* 8, no. 1 (January 1971).

Chronopoulos, Themis. "Paddy Chayefsky's 'Marty' and Its Significance to the Social History of Arthur Avenue, The Bronx, in the 1950s." *Bronx County Historical Society Journal* 44, nos. 1 and 2 (July 1970).

Cohn, Michael, and Robert Apuzzo. "The Pugsley Avenue Site." *Bulletin and Journal of Archaeology for New York State,* no. 96 (Spring 1988).

Comparato, Frank E. "Brightside: A Busy Inventor's Return to Nature." *Bronx County Historical Society Journal* 15, no. 1 (Spring 1978).

Croce, John. "Hunts Point: Wilderness Transformed, 1663–1930." *Bronx County Historical Society Journal* 18, no. 2 (Fall 1981).

Croft, Michael R. "The Origins of the Motion Picture Industry in Bronx County." *Bronx County Historical Society Journal* 22, no. 1 (Spring 1985).

Dart, Joseph. "The Grain Elevators of Buffalo." Paper presented to the Buffalo Historical Society, 1865.

De Kadt, Maarten. "The Bronx River: A Classroom for Environmental, Political and Historical Studies." *Capitalism, Nature, Socialism* 17, no. 2 (June 2006).

Diamond, George. "I Remember Tremont." *Bronx County Historical Society Journal* 11, no. 2 (Fall 1974).

DiRienzo, Paul. "The Haunted Mansion of Hunts Point." Slide Share. www.slideshare.net.

Dorney, George N. "Bronx River Has an Interesting History." *Bronx Home News,* September 5, 1918.

Duffy, Edward J. "I Remember Old Hunts Point." *Bronx County Historical Society Journal* 2, no. 1 (January 1965).

Dunlap, David W. "Ancient Bronx Turtle Finds a Home." *New York Times,* March 25, 1988.

Farkas, Diana. "The Zoological Park, Bronx, NY." *Bronx County Historical Society Journal* 11, no. 1 (Spring 1974).

Fluhr, George J. "Bronck Our First Settler." *Bronx County Historical Society Journal* 1, no. 2 (July 1964).

Forliano, Richard. "Italian Contractors, Builders, Masons and Workers: The Story of Luigi DiRenzo and Carmella Fiore DiRenzo." Eastchester 350. www.eastchester350.org.

Garvin, Agnes P. "West Farms in the '90s." *Bronx County Historical Society Journal* 8, no. 2 (July 1970).

Gonzalez, Evelyn. "From Suburb to City: The Development of the Bronx, 1890–1940." In *Building a Borough: Architecture and Planning in the Bronx, 1890–1940.* Exhibition catalogue, Bronx Museum of the Arts, 1986.

Gray, Christopher. "The New York Coliseum; From Auditorium to Bus Garage to…." *New York Times*, March 22, 1992.

Greene, Anthony C. "The Black Bronx: A Look at the Foundation of The Bronx's Black Communities Until 1900." *Bronx County Historical Society Journal* 44, nos. 1 and 2 (Spring/Fall 2007).

Griffin, Guy, James Brown and James M. Brown. "Westchester County Solves Some Sewerage Problems." *Sewage and Industrial Wastes* 28, no. 1 (January 1956).

Hadaway, W.S. "The Derivation of 'Cow-Boy.'" *Quarterly Bulletin of the Westchester County Historical Society* 5, no. 3 (July 1929).

Hepting, George H. "Death of the American Chestnut." *Journal of Forest History* 18, no. 3 (July 1974).

Hermalyn, Gary. "Bronx Place Names Around the Northern Hemisphere." *Bronx County Historical Society Journal* v. 41, no. 1 (Spring 2004).

———. "History of the Bronx River." *Bronx County Historical Society Journal* 19, no. 1 (Spring 1982).

Hershkowitz, Leo, ed. "Selected Documents Relating to Jonas Bronck." *Bronx County Historical Society Journal* 1, no. 2 (July 1964).

Horenstein, Sidney. "History of the Bronx River." *Notes on Natural History* (Spring 1978).

Horn, Axel, and John Sedgwick. "The Bronx River Project: Studying Pollution at Work—An Autopsy or a Rebirth?" *Garden Journal* 4, no. 2 (April 1974).

Houlihan, James J. "The Glory Days of Boxing in the Bronx." *Bronx County Historical Society Journal* 41, no. 2 (Fall 2004).

Jones, E. Alfred. "Letter of David Colden, Loyalist, 1783." *American Historical Review* 25, no. 1 (October 1919).

Kazimiroff, Theodore. "A Bronx Forest 1000 Years B.C." *Garden Journal* (January-February 1955).

Kessler, Barry. "Building Suburbia: Scarsdale, 1890–1940." *Westchester Historian* 61, no. 2 (Spring 1985).

Ketchum, William C. "The Old Potteries of Westchester County." *Westchester Historian* 80, no. 1 (Fall 2004).

Lutts, Ralph H. "Like Manna from Gold: The American Chestnut Trade in Southeast Virginia." *Environmental History* 9, no. 3 (2004).

MacDonald, Barbara Shay. "The Bronx River: Boundary of Indian Tribes, Colonies, Manors, Cities and Villages." Scarsdale History. www.scarsdalehistory.org.

MacQueen, Peter. "The Bronx Valley." *Frank Leslie's Popular Monthly* 35, no. 5 (May 1893).

Manson, George J. "The 'Foreign Element' in New York City, Part III: The French." *Harper's Weekly* (January 26, 1889).

McNamara, John. "Lost Islands of the Bronx." *Bronx County Historical Society Journal* 7, no. 1 (January 1970).

Merguerian, Charles, and John E. Sanders. "Bronx River Diversion: Neotectonic Implications." *Int. J. Rock Mech & Min. Sci* 34, nos. 3–4, paper no. 198.

Meyers, John Hans. "Recollections of Bronxdale and West Farms." *Westchester Historian* 34, no. 3 (September 1958).

Newlove, Donald. "I Got a Right to Fish the Blues." *New York* (October 1, 1973).

Olmstead, Robert A. "A History of Transportation in the Bronx." *Bronx County Historical Society Journal* 26, no. 2 (Fall 1989).

Olson, Shelly L., and Dilip K. Kondepudi. "The Origin and Genealogy of Jonas Bronck." *Bronx County Historical Society Journal* 50, nos. 1 and 2 (Spring/Fall 2013).

Rosenberg, Elissa. "Public Works and Public Space: Rethinking the Urban Park." *Journal of Architectural Education* 50, no. 2 (November 1996).

Roth, Robert. "The Ecology of an Empty Lot." *Bronx County Historical Society Journal* 10, no. 1 (January 1973).

Rub, Timothy. "The Institutional Presence in the Bronx." In *Building a Borough: Architecture and Planning in the Bronx, 1890–1940*. Exhibition catalogue, Bronx Museum of the Arts, 1986.

Sack, Bert. "Restoration of the Bronx River Soldier." *Bronx County Historical Society Journal* 8, no. 1 (January 1971).

———. "West Farms Village." *Westchester Historian* 50, no. 2 (Spring 1974).

Scientific American 92, no. 19. "The Making of a Gobelin Tapestry" (May 13, 1905).

Shanley, Michael. "A River Runs Through It." *Island Current* (July/August 2006).

Troetel, Barbara R. "The Bronx River Parkway" (Part I). *Westchester Historian* 75, no. 4 (Fall 1999).

————. "The Bronx River Parkway" (Part II). *Westchester Historian* 76, no. 1 (Winter 2000).

Tucci, Attilio B. "Boyhood in the Bronx." *Bronx County Historical Society Journal* 26, no. 1 (Spring 1989).

Ultan, Lloyd. "The Grand Reconnaissance." *Bronx County Historical Society Journal* 39, no. 1 (Spring 2002).

————. "Jonas Bronck and the First Settlement of the Bronx." *Bronx County Historical Society Journal* 26, no. 2 (Fall 1989).

Wang, Jingyu, and Hari K. Pant. "Estimation of Phosphorus Bioavailability in the Water Column of the Bronx River, New York." *Journal of Environmental Protection* (April 2012). www.SciRP.org/journal/jep.

Wuttge, Frank, Jr. "Attachment for Hunts Point." *Bronx County Historical Society Journal* 6, no. 2 (July 1969).

————. "Incubator of the Silent Screen." *Bronx County Historical Society Journal* 5, no. 2 (July 1968).

Newspapers

Bronx Home News.
Bronx Press-Review.
Bronx Times.
Brooklyn Eagle.
Connecticut Courant.
Dallas Morning News.
Hudson River Chronicle.
Los Angeles Times.
New York Amsterdam News.
New York Courier.
New York Daily News.
New York Evening Post.
New York Herald.
New York Times.
New York Tribune.
Norwood News.
Parkway News.
Philadelphia Inquirer.
Riverdale Press.
The Sun (Baltimore, Maryland).
The Sun (Pittsfield, Massachusetts).

INDEX

A

ABC Carpet & Home 210
Abrams, Robert 201
Acre of Roses 88
Adams, John 73
"A Day at Laguerre's" (story) 100
African American burial ground 128, 211
Agassiz, Louis 135
alewife herring 53, 212
Algonquins 33, 34, 35, 39, 48
American Banknote Company 126
American bison 136
American Mutoscope & Biograph Company 141
American Real Estate Company 126, 127
American Safe and Lock Company 127
Anderberg, Ruth 199, 200, 208
Anderson, Mignon 141
Annexed District 130, 145, 146, 160
Archer, John 54
Armonk 163
Army Corps of Engineers 210
Arthur Aviles Typical Theater 208

Arthur Suburban Homes Company 108
Asbury Centennial Methodist Church 91
Ashcan School 101
Ashokan Dam 165
Asiatic bittersweet 193
Astor, William Waldorf 148
Aubisson 116
Augustoni, Charles 121
Avalanche Hose 108
Aviation Hose 154

B

Bambaataa, Afrika 197
Barnett's Creek 158
Barney, A.S. 101
Barretto Bay 123, 126, 127
Barretto Point 124
Barretto Point Park 204
Bates, William 106
Battle of Kingsbridge 68
Battle of White Plains 57, 63, 64, 66
Baudoin, Contant Aresene 112
Baumgarten, Emil 119
Baumgarten, Paul 120, 179, 183
Baumgarten, William 113, 116, 117, 118, 119, 120, 179

Bear Den 72
Bear Gutter Brook 160
Bear Swamp 35, 81
beaver, American 46, 136, 212
beaver, Eurasian 48
Bedford Park 194
Bellevue Park 113
Bell, Rudolph 137
"Bells, The" (poem) 99
Berlin, Ed 196
Birchall, William 132
Birch, Harvey 64
Black Rock 158
Block, Adrian 40
blockhouse (DeLancey) 67, 70, 84
Blue Bridge 134
Bluemner, Oscar 101
boathouse (Bronx Zoo) 136, 138, 146
Bolton Bleachery
 Bronxdale 81, 100, 132, 135
 West Farms 128, 194
Bolton, James 79, 80
Bolton, Mary Frances Johnson 194
Bolton, Thomas, Jr. 194
Bolton, William 194
Boop, Betty 155
Boston Post Road 36, 56, 57, 72, 74,
 75, 76, 80, 82, 83, 137, 138, 145
Boulder Bridge 134
Bouza, Anthony 198, 199
Bowery, the (Kensico) 164
Boy Scouts 202
Brice, Fanny 151
Brightside 126
Britton, Nathaniel L. 178
Bronck, Jonas 40, 42, 43, 44, 45, 51,
 52, 55, 148
Bronck, Peter 45
Bronck's River 53
Bronx Activist Committee 202
Bronx Bleaching and Manufacturing
 Company 80
Bronx Boulevard 175, 180, 181
Bronx Casino 146
Bronx Cocktail 156

Bronx Council for Environmental
 Quality 202
Bronx Council on the Arts 101
Bronx County Historical Society 121
Bronxdale 74, 80, 81, 128, 132, 137,
 138, 187, 194
Bronxdale Paper Mill 80
Bronx Environmental Stewardship
 Training (BEST) 204
Bronx Exposition and Amusement Park
 150
Bronx Expositions Corporation 149
Bronx Finishing Corporation 195
Bronx International Exposition of
 Science, Art and Industries 149
Bronx Lake 135, 136, 146, 147, 172,
 180
Bronx Mill 90
Bronx Oval 128
Bronx Park 128, 131, 132, 140, 175
Bronx Parkway Commission Act 176
"Bronx" (poem) 97
Bronx Queen 196
Bronx River Action Plan 207
Bronx River Alliance 209, 210, 213
Bronx River Amazing Boat Flotilla 208
Bronx River Art Center 101, 144, 202
Bronx River BioBlitz 212
Bronx River Biweekly 207
Bronx River Classroom: The Inside Track for
 Educators 210
Bronx River Conservation Crew 212
Bronx River Estuary 150, 188, 189
Bronx RiverFest 206, 208
Bronx River Forest 115, 133, 144, 212
Bronx River Foxtrot 156
Bronx River Gorge 32, 33, 87, 99, 134,
 138
Bronx River Greenway 110, 201, 202,
 207, 208, 210
Bronx River Greenway Plan 210
Bronx River House 189, 213
Bronx River Houses 197
Bronx River Intermunicipal Watershed
 Management Plan 210

Bronx Riverkeeper Program 203
Bronx River Organization 197
Bronx River Paint Company 83
Bronx River Park 206
Bronx River Parkway 93, 108, 115, 120, 121, 132, 137, 171, 173, 174, 176, 177, 181, 183, 184, 186, 188, 189, 190, 206, 215
Bronx River Parkway Commission 174, 175, 176
Bronx River Parkway Drive 184, 187
Bronx River Parkway Reservation Conservancy 206, 210
Bronx River Powder Mills 89
Bronx River Rambles 211
Bronx River Red 83
Bronx River Restoration 101, 199, 200, 201, 202, 203, 206, 207
Bronx River Restoration (film) 144
Bronx River Restoration Master Plan 201
Bronx River Sankofa 211
Bronx River Soldier 120, 121, 122
Bronx River Working Group 207, 209
"Bronx Sporting" black powder 89
Bronx Station 103
Bronx Valley Sewer Commission 171
Bronx Valley Trunk Sewer 171, 172, 173, 175, 184, 192
Bronxville 36, 48, 54, 90, 91, 106, 107, 108, 167, 168, 181, 183, 186
Bronx Zoo 55, 66, 74, 89, 135, 137, 146, 147, 154, 167, 170, 172, 175, 177, 178, 187, 209, 212
Browning, "Peaches" and "Daddy" 107
Brown, Joseph 77
Bruckner Expressway 189
Bungay Creek 42
Burke Bridge 133
Burke, Josie 202, 203
Burnham, Daniel 126
Burr, Aaron 70, 74, 76, 77
Butler, Emily 181
Butler Woods 181

Byram River 160, 166
Byrne, William J. 215

C

Cameron's Line 33
Cannon, James G. 175
carpet factories (West Farms) 84
Carter, Juanita 206
Carter, Majora 204
Casanova, Emilia 124
Casanova, Innocencio 124
Castle Hill Speedway 151
Catskill Aqueduct 163, 164
Cedar Brook 158
Chappaqua 75
Chatterton Hill 59, 60, 61, 62
Chayefsky, Paddy 143
chestnut blight 170, 171
chlorine bleach process 81
Christodora 212
Claremont Park 131
Clason Point 35, 65, 188
Clason Point Park 154, 156
Coliseum (Starlight Park) 150, 151, 153
Collect Pond 76, 78
Colombian Exposition 126
combined sewers 192
Common Path 36, 59
Communist Party 151
Conangungh 36
Concrete Plant Park 129, 210
Con Edison 203, 208
Cooper, James Fenimore 63, 97, 172
Cope, Edwin Drinker 135
Cope Lake 89, 135, 172
Cornell, Elijah 65
Cornell's Neck 65
Corpswork 2000 208
Corpus Christi Monastery 127
Corsa, Andrew 71
Cotton Mill 91
cow-boys 67, 139
Cowslip Island 114
Cranberry Lake 163
Crestwood 91, 93, 105, 136, 215

Crestwood Lake 215
Croes, John 131
Crosby, Enoch 64
Cross Bronx Expressway 153, 188, 189
Cross County Parkway 183
Crotona Park 131
Croton Reservoir 163
Croton River 54
Cuba 124
"Culprit Fay, The" (poem) 97
Cuneo family 181
Custer, Elizabeth Bacon 106

D

Dairy Creek 158
Dark Hollow 162
Davis Brook (Valhalla) 166
Dead Man's Lake 68, 169
DeLancey, Charlotte 56
DeLancey, Colonel James 55, 66, 67,
 69, 70, 71
DeLancey Dam 83
DeLancey, Elizabeth 66, 71
DeLancey, Governor James 55
DeLancey, John Peter 63
DeLancey, Peter 55
DeLancey Pine 72
DeLancey's Bridge 67, 71
DeLancey's Refugees 70
DeLancey, Susan Augusta 63
DeLancey, Warren 55
Delaware Aqueduct 165
Del Bello, Alfred 201
Demsky, Hilda Green 101
Department of Environmental
 Protection 202
Devil's Belt 155
"Domain of Arnheim, The" (story)
 100
Doucet, Father Edward 99
Downer, Jay 181
Downing Brook 36
Draft Riots 93
Drake, Joseph Rodman 96, 97, 98,
 100, 127, 128, 172

Drovers Inn 74
duck cholera 172
Duck Island 124
Ducky Boys 144, 197
Duden & Company 113
Duncombe Bridges 185
Dutch elm disease 171

E

East Bay Land Improvement Company
 125, 126, 127
East Bronx History Forum 211
Ecological Restoration and Management Plan
 210
Edison Studio 141
"11 from 39" 101
Emmaus 42, 44, 45

F

Fairyland (Clason Point) 155
Ferro, Joseph P. 156
Film Players Club 143
First Rhode Island regiment 70
Fishers Hill 61
fish passage 213
Fleetwood 104
Floating Pool 127
flooding 171, 175, 190, 192, 213
flour milling 82
Flushing Meadows Park 126
Fordham 98, 103
Fordham Baldies 144, 197
Fordham, Manor of 54
Fordham University 99
Fort #8 71
Foussadier, Adrienne 119
Foussadier, Jean 117, 118
Fox, Frederick 194
Fox Meadow 181
Franklin, Benjamin 56
Free Open Air Opera of New York
 152
French Charley's 110, 114, 115, 144,
 197

French Charley's Island 114
Friends of Westchester Parks 212
fur trade 49

G

Gala Park 155
game warden (Bronx Park) 137
garlic mustard 193
Garrett Place Association 206
Garth Woods 39, 180
Garth Woods Conservancy 180, 206,
 211
Gaynor, William Jay 177
Gibbons, Peter 152
Gifford, Sanford 100, 202
Gilligan's Pavilion 154
Gobelin tapestries 113, 116, 118
Golden Ball Festival 208
Gold Medal Studios 141
grain elevators 82
Gramatan Hotel 106, 181
Gramatan (sachem) 36
Gramatan Spring 36, 106
Grand Reconnaissance 70
Grant, Madison 137, 175, 178, 181
Green, Adam 204
greenbelts 131
Griffith, David Wark 141
Grignola, John 120
Grossman, Connie 208
Guinzburg, Victor 162
Gun Hill 66, 162

H

Haffen, Louis 168, 173
Halleck, Fitz-Greene 97, 172
Halsey, Miss 100
Halve Maen (Half Moon) 146
Hamilton, Alexander 59, 62, 77, 78,
 79
Hanson, Ann 129
Harding Park 156, 157, 158, 188
Harding Park Homeowners Association
 158

Harlem River 64
Harriman, Edward H. 119
Harrison, William Welsh 119
Harte, Bret 112
Hartland Formation 33
Hartsdale 59, 89, 186
Hart, William (painter) 101
Hart, William S. (actor) 139
Hatch, Lorenzo 106
Haubold, E.F. 89
"Headless Horseman" 62
Heathcote, Caleb 54
Heath, William 66
helicoidal flow 191, 192, 202
Hell Gate 40, 95
Hemlock Forest 171
hemlock wooly adelgid 171
Hermalyn, Gary 201
Hertier, Albert 120
Hessians 57, 59, 60, 61, 62
Hester Bridge 134
Higgs' Beach 156
Higgs' Camp Grounds 154
Higgs, Thomas 157
Hoe, Mary 126
Hoe, Richard March 126
Hoffner, Jenny 207
Holland 9 152
Hollow, the 93, 178
Holy Cross Church 155
Hommock Manor 123
Hone, Philip 88
Hornaday, William T. 135, 137, 168
Horn, Axel 201
House of David 151
Howe, William 60
Howe, William H. (painter) 106
Hudson-Fulton Celebration 146
Hudson River Foundation 213
Hudson River School 100, 202
Hudson River Valley Greenway Trail
 202
Huguenots 75
Hunt family cemetery 97, 128
Hunt's Bridge 69, 91

Hunts Point 35, 52, 94, 97, 123, 124, 126, 127, 142, 180, 196, 208
Hunts Point Plaza 127, 128
Hunts Point Riverside Park 204, 205, 208, 210
Hunts Point Set 95, 123
Hunts Point Terminal Market 196
Hunt's Tavern 69
Hunt, Thomas 52
Hussar 95
Hutchinson, Anne 44, 51
Hutchinson River 171
Hutchinson River Greenway 202
Hutchinson River Restoration Project 211
Hyacinths Club 183

I

ice harvesting 89, 139
Indian Cave (Hunts Point) 35
Industrial Home Association No. 1 102
Infante, Josephine 204
Interborough Rapid Transit Company 170
invasive plants 193
Inwood Marble 91
Irish Alps 93
Irishtown 108
Irving, Washington 52, 62

J

Jacobs, Mike 150
James, Henry 112
Japanese knotweed 193
Jay, John 63, 64
Jennings homestead 74
Jerome Park Reservoir 133
Jerry (sea lion) 136
Jessup, Edward 52
Johnson, David 100
Johnson's Tavern 137
Joseph Rodman Drake Park 128
José the Beaver 212
Jupiter Powder Mill 89
Justin Beaver 212

K

Kane, Helen 156
Kane's Casino 155, 156
Kennedy, John F. 107
Kennedy, Joseph P. 108
Kensico 90, 175
Kensico Cemetery 163
Kensico Dam 162, 163, 164, 166, 177, 180, 183, 211
Kensico Reservoir 166
Kensico village 160, 162, 166
Kieft, Willem 44, 52
Killian's Grove 154
Kingsbridge 66

L

Laaphawachking 37
La Bièvre 118
lace-making 113
Lafayette, Marquis de 94
Laguerre, François 110
Laguerre, Lucette 112, 115, 179
Lake Agassiz 135, 172
Lake Heaptauqua 162
Lake One-on-me 162
LaMotta, Jake 150
Lancaster, Burt 150
"Landor's Cottage" (story) 99
Lawrence Park 106
Lawrence, William Van Duzer 106
Lawson, Ernest 101
Lazun, Duc de 70
Lazzari & Barton 120
Lazzari, John B. 120
lead, tetraethyl 192
Leech Beach 197
Leewood Golf Club 183
Leggett, John 53
Leggett's Creek 124
Lehman College 212
Lenapes 34, 36, 38, 212
Lenik, Edward J. 33
lesser celandine 193, 194
Levenberg-Engel, I.C. 202

Lever, Richard Hayley 101
L'Hermitage 110, 111, 112, 113, 114,
 115, 118, 179
Liberty Lace factory 113
Linnaeus Bridge 134
Lipson, Paul 204
Long Island Motor Parkway 176
Long Meadow Brook 90
Lorillard Dam 100
Lorillard, Pierre 86, 87, 88
Low, Will 106
Ludlow Island 72
Lydig, David 80, 135

M

Macomb, Robert 78
Magenta Street 113
malaria 37, 158
Mamaroneck 57
Mangin, Charles "French Charley"
 114, 115
Manhattan Prong 33
Manhattan Water Company 77, 78, 160
Manida Playing Fields 127
Mannahatta Project 212
Mapes Farm 75
Mapes Temperance Hotel 145
Marbledale 93
Marbledale Road 91
Marty (film) 143, 144
Masterton, Alexander 91
Masterton Quarry 91, 93
Masterton & Smith 91
Mauriello, Tami 150
Max Fleischer Studios 156
McAdam, John Loudon 55
McClellan, Mayor George B. 177
Meehan Community Building 126
Melville & Schultheiser 148
Mena, Pepe 158
Merguerian, Charles 32
Merkel, Herman W. 170, 178
Merritt Hill 61
Metropolitan Dye Works 128
Metz, Herman A. 176

microinvertebrates 212
Midler, Bette 208
mile-a-minute 193, 194
Mile Square Road (Kensico) 166
Mile Square Road (Yonkers) 68
Mile Square (Yonkers) 54, 69
Miller, Anthony 90
Miller Hill 61
Miller, William Rickarby 100
Minuit, Pieter 42, 49
model farm (Bronx Zoo) 138
Money Hill 183
Monkey Island 135
Moquette Textile Mills 84
Morgan horse 71
Morgan, John Pierrepont 119
Morgan, Justus 71
Moringville 89
Morrisania 42, 55, 66, 69, 70, 73, 77,
 95, 103, 113, 122, 130
Morris, Catherine 66
Morris, Dave H. 175
Morris, Gouverneur 73, 94, 130
Morris, Lewis 66, 73
Morris, Richard 55
Morris, Sarah 73
Moses, Robert 126, 157, 186, 188,
 189
Mosholu Preservation Corporation
 202
Mott Haven 42, 75, 104, 122, 130
Mount Pleasant 182
Mount Vernon 54, 69, 91, 101, 102,
 104, 108, 168, 172, 186, 187
mugwort 193
Mullaly, John 127, 130, 131, 138, 173
Munsees 33, 34, 36, 39
Murrill, A.W. 170
Muskrat Cove 89, 202, 210
Muskrateers 202, 203

N

Nathan, Gail 202
Natwick, Grim 156
Neutral Ground 64, 68, 71, 72

New Amsterdam 39, 40, 43, 48, 49
New Croton Aqueduct 163
New Haven Railroad 102, 127, 175
New Netherland 40, 50, 51, 54
New Rochelle 57, 75
New York Botanical Garden 31, 34, 39, 71, 88, 99, 133, 134, 135, 170, 171, 177, 180, 187, 197, 200, 208, 212
New York Central Railroad 105, 109, 111, 168, 169, 170, 175, 178
New York City Board of Water Supply 162, 163
New York City Department of Environmental Conservation 200
New York City Parks Department 134, 137, 203, 207
New York Giants soccer team 151
New York Harbor School 213
New York & Harlem Railroad 98, 102
New York Park Association 130
New York State National Guard Auxiliary 200
New York, Westchester & Boston Railroad 127, 149
New York Zoological Park. *See* Bronx Zoo
New York Zoological Society 134
Niles, William W. 172, 173, 174
Ninham, Abraham 68
Ninham, Daniel 68
Noetzli, Fred 165
North Beach 155
North Castle Water Company 162
North Side 145, 146
North Tuckahoe 93
NY/NJ Baykeeper 213

O

Oak Point 127
Oak Street Loop 186
Odell, Nicholas 68
"Old Edgar" (bells) 99

Old Leatherman (hermit) 161
Old Redoubt 66, 69
Old Westchester Path 56
Olin, Stephen 111
Olinville 110, 112, 118, 168, 180, 181
Oliver Tilden Post No. 96, Grand Army of the Republic 120
Olmsted, Frederick Law 125, 131, 180, 202
Oneroad, Amos 35
Osier willows 94
Ostdorp 52
oysters 36, 213, 214

P

Panton, Nessie 206
Parkway Casino 181
Parsons, General Samuel 70
Parsons, Samuel (architect) 134
Partnership for Parks 207, 208
Pataki, George 200, 208
Peabody Home 194
Peekskill 58, 59, 64, 75
Pelham Bay Park 131, 135
Pell, Thomas 52
Pequot Path 56
petroglyph (NYBG) 34
Philipseburgh Manor 54, 69
Philipse, Frederick 54, 55
Philipse, Frederick, III 69
phosphates 192
Pine Bridge 70
Planters Inn 137
Planting Neck 52
Poe, Edgar Allan 98, 99, 100
Poe, Virginia 98
Point Community Development Corporation, The 204
Port Morris 124, 130
Pot Rock 95
pottery plant (West Farms) 83
Powell, J.E. 101
Powell, Morgan 211
Powers, Pat 141

Prescott Brook 36, 167
Price, Richard 144
Primrose Cricket Club 151
Pritchard, Evan T. 39
Pudding Rock 75
Pugsley Creek 35, 128, 159
Pure Food Fair 151

Q

Quakers 75, 108
Quaroppas 36
Queen's American Rangers 68
Quinnahung 35, 52, 97

R

Rachlin, Joseph 212
Rall, Johann 62
Ranachqua 42, 43
Ranachqua Connector 213
Rather, Dan 212
Rat Island 197
Reidinger, August 113
Rensselaerswick 45
Reservoir Oval Park 162
Restoration Park 206, 213
Revere, Paul 56
Revolution House 66
Richardson, John 52
Richardson's Mills 53, 55
Richbell, Ann 54
Riehl, David 89
RKO Chester Theater 143
Robbin's Mills 90
Rochambeau, Compte de 71
Rocking Stone 55
Rocking the Boat 204, 213
Rockwell, Norman 93
Rodriguez, Mel 205
Rogers, Robert 66
Romani/Roma (Gypsies) 138
Romano, Philip 198
Roosevelt, Franklin 181
Roosevelt, Theodore 135
Rorke, Edward 100

Rose, John 137
Rosewood 178, 187
Russian Symphony Orchestra 151
Ruth, Babe 183
Ryawa Avenue 123, 126
Rye Bay 166
Rye Ponds 78, 160, 166

S

Sacherah Trail 36, 56
Sachs, Bert 121
Sackwrahung 42
Sacrahong 35
Sanders, John 32
Sanderson, Eric W. 212
Sandhogs 108
Santiago, Jorge 202
Sargent, Diane 202
Scarsdale 48, 54, 55, 59, 63, 75, 97,
 108, 180, 181, 186, 206, 211
Schultz, Dutch 155
Schwab, Charles M 119
Scout Field 186
Seabury, Samuel 65
Sebastopol (Tuckahoe) 93
Sedgwick, John 201
Seeger, Pete 205
Serrano, Representative José 209, 212
Sesquicentennial Exposition 150
Sheridan, Arthur 188, 189
Sheridan Expressway 189
Shields, G.O. 137
Shoelace Park 34, 180, 206, 210
Shoelace Park Master Plan 210
Shuffler, David 206
Silver Lake 59
Simcoe, John 68
Sims Metal Management 210
Singleton, Fred 202
Siwanoy 33
Skinner, Alanson 35, 37
Skinner, Halcyon 85
Skinners 67, 72
Slaney, J.M. 100

slavery 54, 95
Smith, Abigail Adams 73
Smith, Alexander 84
Smith, Alfred Ebenezer 90
Smith, Francis Hopkinson 100, 112, 113
Snakapins 35, 37
Snuff Mill 88, 99, 100
Society for Establishing Useful
 Manufactures 79
Soundview 72, 158
Soundview Park 37, 159, 188, 204,
 210, 213
South Bronx Greenway 202, 204
Sprain Brook 136
Stardust Ballroom 143
Starlight Park 142, 145, 150, 151, 152,
 189, 210, 213
Starlight Plunge 152
Stedman, Edmund Clarence 106
Stella Park 155
Stern, Henry 207, 208
St. Ives School 101
St. James the Less, Church of 75
St. John's College (Fordham) 99
St. Joseph's Church (Bronxville) 108
St. Mary's Park 131
Stockbridge Massacre 68
Stone Mill, Lillian and Amy Goldman
 88
Storefront Gallery 101
storm water 168, 192, 204, 210, 212
Stoughton, Charles 178, 185
Stuyvesant, Peter 52
Sunset Hill 36
Sustainable South Bronx 204
Swain, James P. 90
Swain's Mill 90
Swan, Bill 95
S.W.I.M. (Storm Water Infrastructure
 Matters) coalition 210

T

tan yards 91
Temperance Hotel 75

Thain Family Forest 71, 171
Thanhouser Studios 141
Thayer, J. Warren 175
Thompson, L.A. 150
"Three Sisters" 36
Throckmorton, John 44, 52
Titanic 142
Titus, Aunt Sarah 129
Torres-Fleming, Alexei 206
Torrey Botanical Club 132
Transit Mix Concrete Company 205
Troetel, Barbara R. 177
True Briton (stallion) 71
Tuckahoe 37, 54, 69, 103, 181, 183
Tuckahoe Marble 91, 93
Twain, Mark 112
Twin Lakes 31, 134, 197
Twomey, Bill 152

U

Unalatohtigos 34
Unamis 34, 39
Underground Railroad 75
Underhill Mill 90
Underhill's Crossing 48, 106
Union Hill 66, 71
Union Railway 142
Universal Zulu Nation 197
Urbanimage Corporation 144
Urban Resources Partnership 207

V

Valentine Hill 69, 172
Valentine, John 98
Valentine-Varian House 122
Valhalla 163, 166
Van Benschoten, Henry 137
Van Cortlandt Park 131
Vanderbilt, Cornelius 103
Vanderbilt, William K. 176
Van der Donck, Adrian 54
Van Doren, Charles 75
Van Wyck, Theodorus 177

Vasser, Chuck 206
Viele, Egbert Ludovicus 125
Villaverde, Cirilio 124
Vinecutters 206, 210
Voelker's Schuetzenpark 113
Vosburgh, Herman 83
Vreedlandt 51, 52, 55

W

Wakefield 103, 108, 168, 180
Wallace, Nancy 201, 208
Wanderers, The (film) 143, 144, 197
Ward, Bob and Hillea 212
Ward's Bridge 69
Ward's Tavern 69
Warren, Bessie 95
Washington, George 56, 57, 58, 59,
 61, 66, 70, 71
Washingtonville 108
Waterbury, David 71
Water Tunnel #3 108
Waterwash Park 210
Waterways and Trailways office 208
Watson Realty 105
Weekguasegeecks 34
Welikia Project 212
Westchester County Convention
 Center 181
Westchester Italian Cultural Center 93
Westchester Refugees 67
Westchester Rowing Club 176
Westchester (town) 52
West Farms 52, 66, 67, 69, 71, 72, 74,
 75, 79, 80, 82, 83, 89, 94, 122,
 128, 139, 145, 146, 148, 194,
 196, 198, 199
West Farms Friends of the Bronx River
 206
West Farms Rapids 213
West Farms Square 148
West India Company (Dutch) 40, 43
Westphal, Dart 202
White, Pearl 141
White Pine Blister Rust 171

White Plains 36, 58, 59, 60, 67, 68,
 84, 90, 103, 132, 161, 167, 176,
 181, 183, 210
White Tower Lodge 182
Whitlock, Benjamin M. 123
"Whitlock's Folly" 123, 124
Whitman, Sarah 100
Wiggin, Kate Douglas 106
Wild Asia (Bronx Zoo) 135
Wildlife Conservation Society 212
Willard, Edwin K. 108
Williamsbridge 36, 56, 57, 59, 66, 69, 74,
 77, 93, 103, 111, 118, 168, 180
Williamsbridge Distributing Reservoir
 162
Williamsbridge looms 120
Williams, John 56
Williams, Michelle 206
Williams, Perquida 206
Willis, Nathaniel Parker 102
Willow Hole 69
Wisconsin Glaciation 31
Wishing Rock 34
WKBQ 152
Woodlawn 122, 175
Woodlawn Brook 109
Woodlawn Building Association 108
Woodlawn Cemetery 66, 109, 120
Woodlawn Inn 109
woolen industry 90
Woolery, Marcel, Jr. 208
Wright's Mills 90
Wuttge, Frank 195

Y

yellow fever 37, 73, 76
Yonkers 54, 85, 130, 206
Yonkers Park Association 105
Youth Conservation Corps 200, 201
Youth Ministries for Peace and Justice
 206

Z

Zaccini, Hugo 151

ABOUT THE AUTHOR

A lifelong Bronxite, Stephen Paul DeVillo grew up along the banks of the Bronx River. He is the former development coordinator at the Bronx River Alliance, for which he contributed a series of monthly "Bronx River Stories" for its online newsletter *Currents*. For the past several years, he has developed and presented walking tours for the Alliance's popular Bronx River Rambles, which explore the history and environment of the river, and has given historical walking tours for a number of other organizations, including the Friends of the Old Croton Aqueduct and NYC H$_2$O. A longtime member of the Bronx County Historical Society and the East Bronx History Forum, *Bronx River History and Folklore* is his first book.

Jane Williams.

CPSIA information can be obtained
at www.ICGtesting.com
Printed in the USA
BVHW040832260619
551797BV00038B/868/P